NATURE'S ENGRAVER

FARRAR
STRAUS
GIROUX

NATURE'S ENGRAVER

A LIFE OF THOMAS BEWICK

Jenny Uglow

FARRAR, STRAUS AND GIROUX

NEW YORK

Farrar, Straus and Giroux
19 Union Square West, New York 10003

Copyright © 2006 by Jenny Uglow
All rights reserved
Printed in the United States of America
Originally published in 2006 by Faber and Faber Limited, Great Britain
Published in the United States by Farrar, Straus and Giroux
First American edition, 2007

Library of Congress Cataloging-in-Publication Data
Uglow, Jennifer S.
 Nature's engraver : a life of Thomas Bewick / Jenny Uglow. — 1st American ed.
 p. cm
 Includes bibliographical references and index.
 ISBN-13: 978-0-374-11236-3 (hardcover : alk. paper)
 ISBN-10: 0-374-11236-3 (hardcover : alk. paper)
 1. Bewick, Thomas, 1753–1828. 2. Wood-engravers—England—
Biography. 3. Illustrators—England—Biography. I. Title.

NE1147.6.B47U94 2007
769.92—dc22
[B]

 2006031878

www.fsgbooks.com

1 3 5 7 9 10 8 6 4 2

For Tom, Hannah, Jamie and Luke

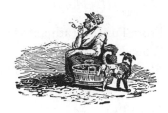

CONTENTS

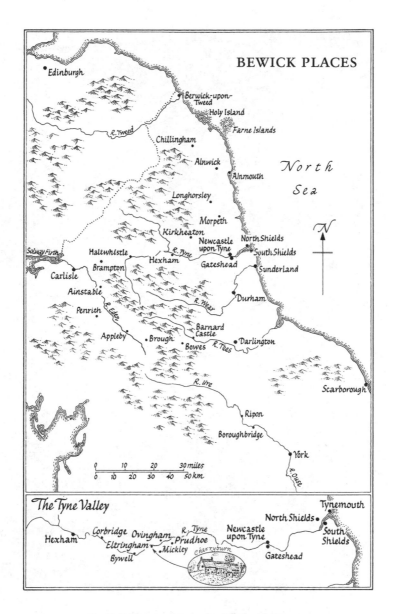

Bewick Places, drawn by Reginald Piggott

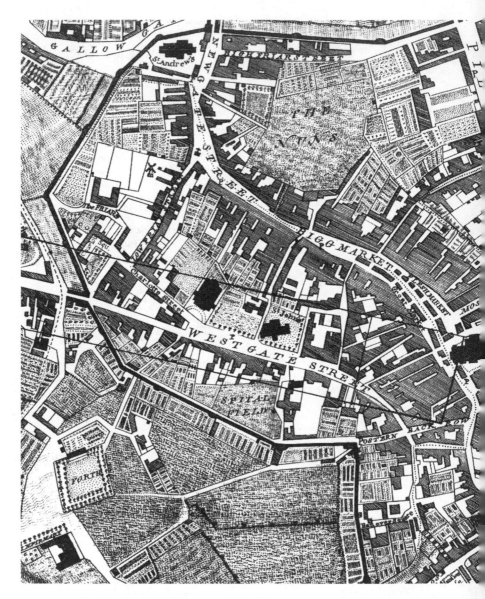

Newcastle in 1788, engraved by Ralph Beilby

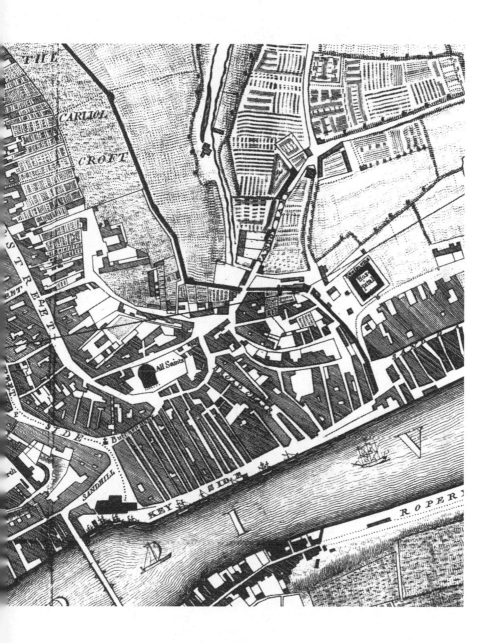

Each picture told a story: mysterious often to my undeveloped understanding and imperfect feelings, yet ever profoundly interesting . . . With Bewick on my knee, I was then happy.

Charlotte Brontë, *Jane Eyre*

I pick out pictures round the fields that lie
In my mind's heart like things that cannot die
Like picking hopes and making friends with all.

John Clare, 'The Moorhen's Nest'

PROLOGUE: A PLAIN MAN'S ART

Printing from woodblocks is the oldest way of all. Before Gutenberg invented moveable type around 1450, books and broadsheets were produced by writing the text on wood in reverse, as in a mirror, and then cutting painstakingly round the letters, dabbing the block with ink and pressing paper on top. With the new metal type, printers still used the blocks for illustrations and a single block could be used over and over again, on different pages, in different books. The early cutters worked on the 'side-grain' of the wood, a plank cut along the trunk, often of a fruitwood such as pear or cherry, using carpenters' tools – knives, chisels and gouges. When designed by masters like Dürer or Holbein these woodcuts could attain an astounding delicacy, but increasingly book publishers preferred to use copper engravings which gave a finer effect, and the crude woodcuts were banished to broadsides and chapbooks. Slowly, however, craftsmen tried using the dense end-grain of wood, sliced across the trunk or branch rather than along it like a plank. Boxwood proved the best, because box grows so slowly that the growth-lines are very close and on its hard surface the engravers could use the fine tools employed on silver or copper.

Bewick worked on boxwood, sent up in logs by sea from London. Hundreds of his woodblocks still survive, their scenes as sharp as the day he cut them. When I began writing, I went to see Iain Bain, a great

Bewick expert. Outside his book-room rain clouds gathered and drops hung from the washing line; inside, the air smelled of leather bindings, ink and linseed oil. From a drawer Iain took a blackened wood block, its fret of thin lines shining in the light and its bark still rough around the edges, and fixed it in the bed of an old hand-press, ready to be inked. On the windowsill were pots of ink so thick that the roller made a slick, slick sound as he dabbed it on the block. The methods and materials were those of Bewick's time: vellum skins for the press tympans – the frame that holds down the sheet for printing – fine woollen blankets to pad them and carefully damped paper. After we ran the bed of the press under the heavy plate, I pulled the lever firmly, to lower the plate with a slight 'dwell' on blankets, paper and block. Then we ran the press back, raised the covers and gently peeled off the paper, holding it up like washerwomen about to peg it on the line. And there it was.

Before me was a tiny scene, not a lyrical country lane but a man pissing against a wall – perhaps a fragment of Hadrian's Wall, not far across the Tyne from where Bewick grew up. But was the print good enough? We took another impression, and there was the man again, still casting his shadow on the stones – and there he will be time after time, whenever the block is printed, but every time slightly different. Iain pored over the print to discover what adjustment of pressure, weight of ink or dampness of paper might be needed for a better result. And each impression made me hold my breath. I wanted the perfect print, showing every minute detail, all within the compass of two inches: the variations in his shadow and the arc of his pee, the socks rolling down below broad calves, the widely planted feet and the curve of his back, with the wrinkle in his coat between the shoulders; the tilt of his head and hat as he looks down, the roll of possessions flung down behind him. The wind is from the west, the trees lean and

the grasses flow with the gusts towards the stream. But who is this man, and where is he walking? His stick hangs from a branch, and beyond him a wattle fence leads by the edge of the wood, past tufts of waving grass towards a just-glimpsed horizon.

This woodcut, typically, has no border. Bewick left his vignettes open, as if leaving us free to make our own reading and go on our way. But while his scenes free us they also hold and absorb us. Images like the man by the wall were merely tailpieces – or tale-pieces as he punningly called them – cut by candlelight after a day's work and used to fill empty spaces at the end of a page. They look unassuming but command attention. They ask us to look deep, as children stare at illustrations when they first start to read, drawn into the pictured world. No wonder that Bewick began his career by illustrating books for children. There are hundreds of such scenes: boys flying kites, sailing boats on puddles, tumbling off carts; women chasing geese; men mending nets; old soldiers in unheroic rags; fishermen tangling their line in the trees. Together these scenes make a world, and this book describes the life of the man who created it – an impression, at least, off a Bewick block.

*

Only the wealthy could afford the grand natural history books with their lavish copper engravings, but Bewick's woodcuts were far cheaper and this made his books far more widely available. We are now used to good printed images, colour photographs and astounding natural history films, but if we imagine a time when there were hardly any accurate images of animals and birds, we can begin to feel the amazed thrill of recognition at Bewick's affectionate woodcuts of familiar animals like the field mouse or sheepdog, or the birds of the fields and the woods. Wood engravings were the plain man's art, dismissed by the critic Horace Walpole in a cursory footnote in 1782 as 'slovenly stamps', but Bewick transformed them into images of haunting depth and subtlety. He was a powerful and passionate man, and his woodcuts carry the intensity of his feelings about the landscape and its creatures and his wry affection for the Northumbria he loved. In this book, nearly all the vignettes are the same size as he printed them: where this is not so the illustration list explains that they are reduced. It is tempting to enlarge them, as some lines are so fine that they could have been drawn with a needle. But their miniature intensity is, paradoxically, part of their greatness, and this way, too, they appear as their first readers saw them, the tailpieces floating without captions in the text.

In early May 1825, near Helpston in Northamptonshire, the poet John Clare saw a small brown bird that he could not identify. Did anyone, he asked his friend Joseph Henderson, have a copy of Bewick's Birds? All lovers of birds in these years looked to Bewick. He spoke directly to men like Clare, a former farm worker and lime burner who knew every inch of the fields around his home, and to Henderson, head gardener at the nearby hall. Bewick was in his sixties by then, but he came from the same world as them, growing up on a smallholding in the Tyne valley and spending his adult days in a busy jobbing work-

shop in Newcastle: he would rather be herding sheep upon Mickley fell, he told a friend in middle age, than live in London and be Premier of England. Nothing hurt him more than the enclosure acts that drove the cottagers from the common.

He was a plain, no-nonsense man, who worked in a brown silk cap to hide a bald patch, wore worsted stockings, spoilt his children and went to the pub in the evening. Bluff and direct, warm to his friends and often generous to the point of foolishness, he was a shrewd businessman, brisk with apprentices, cussed in quarrels, stubborn in holding a grudge. But he also possessed an extraordinary talent and his skill has never been surpassed. He was knowing, too, about the mystery of art, the strange process of transferring a scene into a two-dimensional web of lines. One small vignette shows a cottage almost obscured by a fingerprint.

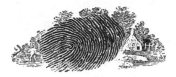

This is Bewick's mark, drawing attention to the maker. But it is also a clever way of reminding us just how tiny this work of art is: though full of detail it can be covered by a finger. The story is hidden – all we can see is that someone is riding into the shadow, towards the cottage. And where is the viewer standing? Perhaps, as one critic has suggested, we are looking through a window, the glass smudged by a passing hand? The image is simple yet playfully ambiguous.

Bewick's own story – sometimes funny, sometimes tragic – seems to demand a simple telling, cradle-to-grave, old-fashioned style. Yet the flow of his life, like all our lives, was shaped by the broad currents of the time. Different stories run together and intermingle. One is the tale

of the workshop and the apprentices. Another is that of the book trade, of how children learned to read through images, how printers and booksellers worked and how the revival of wood engraving fostered the great illustrations of *Punch* and the novels of Dickens. A third describes the fierce political struggles during a time of almost constant war and change. Another strand is the story of Britain's 'Natural History Revolution', as John Rayner put it, 'parallel with, but less noticed than, the Industrial Revolution'. In Bewick's day, the fieldwork of amateur naturalists was just beginning to lay the foundations for modern ecology. As he worked on his books, landowners and vicars, farmers and sea captains sent him birds, both alive and dead, piling on his workbench. He was a fine naturalist himself, and his work combined keen, detailed observation with a new approach, showing animals and birds in their natural settings, as part of the whole great interrelated web of nature. 'Nature' and God fused together in Bewick's vision, as a rolling force that infused every aspect of life, from the habits of an ant to the vastness of the universe, 'this sublime, this amazing, this mighty work of Suns & Worlds innumerable'. He felt its darkness as well as its beauty and his work touched the dawning Romantic age: Wordsworth was among the first to sing his praises and Charlotte Brontë placed his prints of icy seas in the hands of her young heroine, Jane Eyre.

The nation's love affair with nature was a reaction to the way that the country itself was changing. In Bewick's childhood in the 1760s the people of his village sang ballads and told ghost stories in the evening and Highlanders walked their cattle south to the fairs of the Tyne valley. Yet towards the end of his life, in 1825 – the year that Clare asked for Bewick's *History of British Birds* – the Stockton and Darlington railway line opened, cheered by crowds of thousands. While he recorded the birds and animals he also captured a way of life

that was fast vanishing, and as people flooded to the towns in search of work, so his country scenes spoke to the homesick. His images of a reed warbler by a stream or a solitary traveller holding his coat against the gale were at once signals of freedom and tokens of loss.

But town and country were not, as we are sometimes told, direct opposites: Newcastle was full of orchards and freemen grazed their cattle on the Town Moor, while industries like mining were part of the rural scene. The two worlds overlapped: a country boy like Bewick could become a man of the new polite age, collecting prints, going to concerts, attending lectures, signing petitions. With the artisans and radicals of Newcastle, Bewick raged against war, injustice and repression. Yet the politics of ordinary people, which we label 'radical', was often conservative, looking back to ancient rights and fighting to preserve old festivals and ballads, stories and dialect. Bewick dearly loved the music of the streets and the soft Northumberland pipes, and his woodcuts are the visual equivalent of ballads and popular proverbs.

So powerful are these little images that we see them everywhere, probably without knowing it – designers are drawn to use them on posters and jam labels, books and birthday cards. They are woven into our imagined version of a rural past, yet because of their sharpness and flair, their affectionate accuracy and originality, they defy false sentiment. Bewick knew that rural life could be cruel, that breaking stones on the road or finding sheep on the fells in winter was soul-destroying work, that desperate men could hang themselves from trees by sweet-flowing burns. He was tough and so was his art. His greatness, as the artist John Piper said, lay in the fact that he 'registered what he saw with precision . . . he had that rarest of qualities – normal, unhampered, unclouded vision'.

I SOURCE

I THE BANKS OF THE TYNE

The Tyne has changed course often since Thomas Bewick was born here two hundred and fifty years ago. Swollen by floods, checked by salmon weirs, hemmed in by railway embankments, it has swung from side to side of its deep valley, cutting under wooded banks, baring strands of pebbles, tangles of roots and ridges of sand, creating smooth tables lush with grass where once the current ran swift. Across the years the river has flowed on, steely in February gales, glinting under August sun. We can trace its old path, like an individual life, from documents, maps and prints, signs of crossings, relics on the shore, broken walls and lost gates and stories – evidence and guess-work.

Some things we can say for certain. As a boy, Thomas Bewick was down by the river from spring until autumn frost and often in the winter snow. When he ran down the lane, past the Hall and the cottages and across the rough track, he could hear the rushing, tumbling of the water above the barking of the farm dogs. Some days the cottager who acted as ferryman rowed him grudgingly across in his old boat, or he tried to leap over on the thick poles holding the salmon fishers' nets, stepping-stones for reckless boys. Upstream to the west the horseshoe slope of Eltringham Common fanned down the hill: downstream the current surged round a second great bend, past the wood with its

rookery, ash trees and oaks, on to meet the sea tides, on to swirl around the wherries and keels and colliery vessels of Newcastle twelve miles downstream, on past the quays and the glass works and mines to the perilous bars of Tynemouth and the grey North Sea.

At Eltringham, tree roots and willow branches dipped into pools and eddies perfect for fishing. As soon as the trees began to bud, Bewick got his tackle ready, his rods, his night lines and set-gads, the stakes for fixing a net or propping a rod. When dusk fell and the mayflies danced, he waited for the evening rise. In old age he regretted the uneasiness 'which my late evening wadings by the Water side, gave to my father & mother . . . they could not go to bed with the hopes of getting to sleep, while haunted with the apprehension of my being drowned'. In his mind he could still hear his father's summons as he strode clear of the house so that nothing obstructed the sound, and 'whistled so loud, through his finger & thumb – that in the still hours of the Evening, it might be heard echoing up the Vale of the Tyne to a very great distance – This Whistle I learned to imitate & answered it as well as I could & then posted home.'

Home was Cherryburn, a couple of hundred yards up the hill in the hamlet of Eltringham – its 'g' so soft that it was sometimes spelt 'Elterjam'. It was a typical Northumberland farmstead of local sandstone roofed with heather thatch, surrounded by gardens and stackyards, built into the contours of the land. Near the house two ash trees sprang from a single root, the top of one torn off by the wind. A third stood a little way off. At the top of the yard a well drew on a natural spring in the shade of a hawthorn bush, and a thick holly hedge divided the farm from the boggy stream and copse, and the cornfields and pastures beyond.

From the window at his bed-head Bewick looked out over the plum trees in the orchard and listened to the burn rushing down the hill.

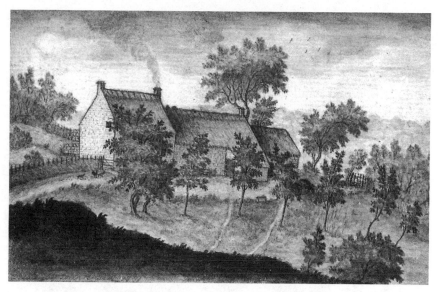

Cherryburn, drawn by John Bewick in 1781

Sometimes, when it was in flood, it roared so loud that he got up to peer out, then crept downstairs and cut a slice of black rye bread to eat in bed (only the quality ate wheaten bread). Every direction had its view, even Bewick's small window. The yards were like terraces running askew along the slope. From the cobbled farmyard he looked over the treetops and the chimneys of the hamlet, straight across the deep valley to the village of Ovington on the fell opposite, where new fields marked out by freshly laid hawthorn hedges criss-crossed the green hillside. From the yard gate Cherryburn gazed west across the Common, fine pasturage 'broken or divided indeed, with clumps of *blossomed* Whins, Fox-Glove, Fern & some Junipers & to the westward with hether in profusion sufficient to scent the Whole Air'.

The buildings stepped sideways down the hillside, the roofs a little

5

lower each time. First and highest was the house, with a stone-flagged kitchen and parlour and rooms above where the family slept. Below them stretched the dairy and the byre, then the stables and outhouse. The ash-closet was across the yard, a chilly dash on winter mornings when the biting wind ripped and moaned through the thatch. But the kitchen, with its window shutters fixed tight, was always warm, heated by the open fire and the great bread oven in the wall. In these years, the empty flagged space that Bewick's son Robert would later draw was crowded, noisy, fuggy, thick with smells of cooking, coal, young children and old dogs, and wet clothes drying by the fire.

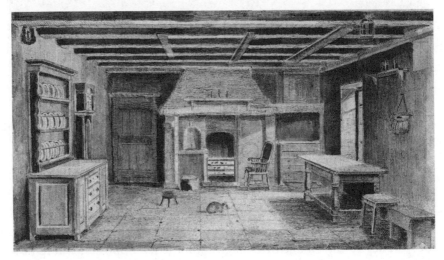

Cherryburn interior, drawn by Robert Bewick, 1847

Bewick's father John had rented the eight-acre smallholding in 1751 for £4 a year and had moved in the next summer with his new wife, Jane. He was married before – his first wife, Anne, had died only a year before and there were no surviving children – and he was nearly

forty when Thomas was born in August 1753 (he thought on the 10th or 11th, but the 12th was always celebrated as his birthday). A week later he was baptised at the Saxon church in Ovingham, across the river a short way downstream. Within a few years the house was full of children, as Thomas was followed by Hannah, Agnes, Ann, John, William, Sarah and Jane. But for seven years, until John was born in 1760, Thomas was the only boy, his father's hope and despair.

When he was old enough his first task on rising was to muck out the cowshed, and if the servant girl was late he tried his hand at milking: 'I was always particularly keen of being there in snow storms. When this was the case, within the Byer Door I snugly watched the appearance of various Birds, which passed the little dean below, & which the severity of the Weather drove from place to place in search of shelter.' In winter, too, he looked after the sheep on the fell, the old long-legged, black-faced upland breed. Part of the flock was given to him for his own, a tradition when a boy reached thirteen. He knew where the sheep huddled from blizzards, under a bank overhung with gorse, and trudged off to find them with hay on his back and oats in his pocket.

The winters then were long and fierce, and snow lay for months on the fells. In the spring came piercing easterly winds and weeks of drought, slowly giving way to mild west and southerly breezes and early summer rains that forced a burst of growth, a greening and flowering and shimmering of leaves. When the thaw came, Bewick was sent out before school, kitted out with an apron, an old dyking-mitten to protect his hands, and a sharpened broken sickle, to cut the shoots of gorse: in the evenings he mashed these with a wooden mallet in a stone trough to the texture of wet grass to feed the horses – those at Cherryburn were famously sleek, shedding their winter coat long before others around. The cows, however, disdained the gorse, and in

7

harsh winters all hands set to work cutting ivy and ash twigs to add to their fodder.

Bewick knew every corner of the common and the moor, the woods and the pastures with their old names: Crook Wood, Toad Pool Field, Spetchins, Boat Hill, Loonces Shank, West Back of the Hills, High Low Field. The rhythm of his life was that of the farm. As the soil warmed his father sent him out to scale the meadows, spreading the fine tilth of the molehills to improve the pasture (countless molehills still dot these fields). This and working the allotment, he said, were 'very hungry work, and often made me think dinner was long in coming, & when, at last, it was sent to me, be what it would I sat down on the *lown* side of a hedge & eat it with a relish that neaded no Sauce'.

We do not need to know a river's source to appreciate its power but it helps to draw a map, to understand the flow, the shallows and deeps. So it is with families. Bewick's grandparents, Thomas and Agnes, had come down to the lush Tyne valley from the edge of the high moors near Kirkheaton, about twenty miles north. Here, in a gale-swept village of farm cottages at the end of a one-way lane, straggling around a heart-shaped common with the church and the manor at the top in medieval style, Bewick's father John was born. At one point, thirty or so years before Bewick was born, Thomas and Agnes had lived briefly at Cherryburn, when it was just a low cottage with the dairy behind, but they prospered and moved to Birches Nook – or Burches Neuk, as Bewick spelt it – a mile or so upriver at Stocksfield, near the village of Bywell. His grandfather, who died in early 1743, was one of the most resourceful farmers on Tyneside and was said to have 'got to be very rich' (although Bewick was more impressed that he was a great angler).

Bewick was a common name and several apparently unrelated families lived near Eltringham, from the grand folks of Close House

– who added an 'e' to the end of their name – to a poor cottager on the common. But Bewick's own family were tenant farmers, a class that had breasted the tides of fortune for centuries. During the long border wars with the Scots, from the thirteenth to sixteenth centuries, Northumbrian lairds had granted long tenures in return for a body of fighting men. The farms had low rents and unusual rights of inheritance, passing first to the widow then to the sons or even the eldest daughter. And while this custom of 'tenant right' had long ago ended officially, the tradition remained: Northumbrian leaseholds were set for a long stretch of years, usually twenty-one, encouraging good practice by tenants who wanted to hand the lease on to their sons. Most of the moors above Cherryburn belonged to the Duke of Northumberland, an enlightened landlord praised by Bewick for granting small plots of land at cheap rates to mechanics and labourers, but the land around Mickley, where Cherryburn lay, belonged to the Fenwicks of Bywell. By the mid eighteenth century it had passed to a daughter of the family, Isabella Wrightson, now living in Yorkshire.

Northumberland was known for its progressive farming. The sandy soil on the Tyne's north bank was ideal for turnips, a newfangled crop, while the darker loam of the southern bank was good pasture land, limed and manured and enriched with clover, trefoil and rye. John Bewick employed local cottagers as seasonal labourers, paying the men their 10*d.* a day, and women 8*d.*, and Jane was helped by her sister Hannah and by a girl from the village. But Cherryburn was only a few acres, while substantial farms could reach seventy or more: the Bewicks' real income came not from the land at all but from the mines. The banks of the Tyne were scarred by pits as well as grazed by cows, and from the start Bewick's was a double inheritance, of agriculture and industry.

Many farmers earned money from other trades: some worked as carriers or blacksmiths; some rented salmon fisheries, fixing wooden poles across the current and building weirs with stones and wicker-work; others, like the Bewicks, managed coalmines. Since 1715 Bewick's grandfather had rented collieries on Eltringham Common and at Mickley Square, by the crossroads above Cherryburn, and John took these over. On New Year's Day 1760, when Bewick was six, John was negotiating with John Batty, the Wrightsons' son-in-law, about renewing the leases. 'I'll give as Much for them as I can afford,' he wrote bluntly. He already had four children and Jane was pregnant again, and, he complained urgently, 'the Conveniences my Dwelling house affords, are too small for my family, and if you please to make any Reasonable addition to it, as to make it only commodious, I shall Esteem it a favour, as I Assure you their is a necessity for it'. John was a stout, square, strong and active man who never seemed to have a day's illness. He was known for his cheerful temper, broad humour and immense fund of stories, but he had a passionate temper and was fierce with anyone stealing his coals, like the young farmers scooping basket-fuls under cover of night.

The Bewick collieries were shallow 'land-sale collieries', on the western fringe of the great coal field, selling only to people of the neighbourhood, who loaded carts or filled their panniers and carried off their coal on the back of a donkey. By contrast, the sea-sale col-lieries to the east, like those owned by the Humble family who ran a wagon-way near Prudhoe Castle, a mile or so downriver, loaded their coal from high staithes into flat-bottomed keels that carried it to the vessels at Newcastle Quay. The trade had been monopolised since Tudor times by the merchants of the Hoastmen Company, who con-trolled and collected the local tax on all the ships on the Tyne. These vessels sailed to London, Scandinavia, western Europe – in the early eighteenth-century it was said that most of French manufacturing

depended on Newcastle coal. Over a hundred mining companies now worked here and small owners like the Bewicks were mere sparrows picking the crumbs from a great table.

In later life Bewick told his friend John Dovaston that he remembered 'lying for hours on his side between dismal strata of coal, by a glimmering and dirty candle, plying the pick with his little hands'. He may indeed have had to learn the hard way, although his father was more of a manager than a pitman, employing half a dozen hands. The pitmen were a breed on their own, with their own slang and songs. Many were immigrants from high valleys and moors, drawn down by the promise of work, like the 'Sinker', the man who sank the shafts at the Mickley pit (who later turned up often at Bewick's door in Newcastle), who thought nothing of being let down on a frosty morning into a flooded pit up to his chest, baling the water into buckets to be drawn up to the top. To let off steam he saved his wages for a month or so then headed for the town to blow them all on beer, which he called 'lowsening his skin'.

Mining was a risky business and even in the small pits there were frequent accidents. An entry in the Ovingham parish burial register tells a grim tale: 'William Scott of Prudhoe labourer, killed by horses running away at J. Bewick's pit 29 Aug 1763'. Such horror, so close to home, must have made a deep impression on a child. And one of the men Bewick most admired, a cottager from the common called Will Bewick (no relation), was famous for saving the life of a Mickley pitman lost in the coal-workings. As Will hunted for the missing miner in the twisting tunnels below, Bewick's mother, Jane, trembled at the pit side, and fellow miners, wives and children and neighbours crowded round the shaft, waiting to hear Will's thundering voice shout out that all was well.

*

Jane Bewick was not from this coal-rich land. She came from Ainstable in the Eden valley in Cumberland, a day's ride across the fells, one of eight children of a schoolteacher, Thomas Wilson, who allegedly taught his own children Latin. At his death he left little but learning: the eldest brother took over the house and few fields, and the rest had nothing. Jane and her youngest sister Hannah had stayed with a relation in nearby Appleby until 1747, when Jane crossed the Pennines to become housekeeper to a distant cousin, the Revd Christopher Gregson, the new Vicar of Ovingham. It was here that she met John Bewick.

After their marriage Jane's sister Hannah also came to live at Cherryburn, and when Thomas was born he was 'mostly intrusted to the care of my Aunt Hannah . . . & my Grandmother Agnes Bewick – and the first thing I can remember was that the latter indulged me in every thing I had a wish for, or in other Words made me a great Pet'. Agnes was the daughter of a small laird, a landowner in Kirkheaton, and was clearly a grand old lady, not to be trifled with. She insisted that this cherished grandson was not to be 'snubbed' whatever he did, 'and in consequence of my being thus suffered to have my own way, I was often scalded & burnt, or put in danger of breaking my bones by falls from heights I had clambered up to'. But his doting grandmother died in 1756, when he was three. Jane was preoccupied with the toddlers, Hannah and Agnes, and baby Ann. Bewick was packed off to school very young, less, he said, with a view to learning than 'to keep me out of "*harm's way*"'.

Far from keeping him from harm, the small classroom up the hill at Mickley inflicted it, leaving a lasting image of oppression. It was run according to 'a senseless System of severity', he later said, 'where ignorance and arrogance were equally conspicuous, – conduct like this sours the minds of some Boys – renders others stupid & serves to

make all, more or less disgusted with Learning'. At first, because he was so small, no one took much notice of him, so he was slow in learning the alphabet and spelling simple words, but soon his schoolmaster – *Shabby Rowns*, as the boys called him – grew increasingly impatient.

This was a man in a panic, unable to subdue unruly boys. He was tall and thin, 'and with a countenance severe & grim he walked about the School Room with the Taws or a switch in his hand, and he no doubt thought he was keeping the Boys to their Lessons. While the gabbering & noise they made was enough to stun any one, and impressed the people passing by, with the Idea that Bedlam was let loose.' He beat his charges regularly, often for failing to learn things that they could not begin to understand. But when he tried to flog Bewick by 'hugging' – putting him on the back of an older boy, who tugged his arms over his shoulders while his backside was laid bare – Bewick rebelled: 'with a most indignant rage I sprawled, kickt & flung'. He bit the boy on the neck, making him fling him down, kicked the teacher hard on the shins with his iron-hooped clogs and then fled. Meanwhile the older boy's mother – 'a spirited Woman' who lived nearby – rushed furiously into the schoolroom and 'a fierce scold ensued'.

Bewick never went back, although he pretended to. He remembered being clapped on the head on his way to school and told to be good almost every morning by the elderly John Newton, 'the Laird of the Neuk', whose land stretched from Mickley across to his grandfather's old farm (years later Bewick saw Newton's great-grandson in Newcastle trotting off to school, and clapped him on the head in his turn). But after this greeting he dodged away and spent the days in the wood, making dams in the stream and going home in the evening with his schoolmates as if he had been at school all day. As all truants know, this timeless pattern works for a while but not for ever. More beatings followed from his exasperated parents until Shabby Rowns died and a new master, James Burn, took over. Under him Bewick learned happily, but Burn died within a year or so, and with his death the Mickley schooldays were over.

At home there were few children's books apart from the Bible and some chapbooks bought from pedlars, folk tales like 'Jack the Giant Killer', or a vivid, reduced version of *Robinson Crusoe*, and Bewick's favourite, Aesop's *Fables*, edited by Croxall in 1722 with illustrations by Elisha Kirkall: he kept his crumpled copy to the end of his life. Serious reading only began again when his parents sent him to the small school run by the Revd Gregson, his mother's old employer at Ovingham. This was a prosperous village with farms, fishery and pubs, like the Pack Horse inn where the Bewicks collected their mail, and the vicarage, across the road from the church, was at its heart. Bewick took his place upstairs in the book-filled schoolroom, looking south across the garden, a high green terrace on a virtual cliff above the Tyne – which has since meandered away, leaving a smooth field beneath.

Schooling, however, did not much appeal to the ten-year-old Bewick. His father confessed to Gregson that his oldest son was 'so very unguideable' that he had given up and begged him to take over.

Both men agreed in favouring the rod rather than spoiling the child, a system that Bewick felt was too severely acted upon, 'sometimes upon trivial occasions & sometimes otherwise'. He was always in trouble, trivial and otherwise. In church, he shouted his psalms, scribbled on pew-backs and whacked the local deaf mute, the 'Dummy of Wylam', on the head, pretending that a man nearby had done it, whereupon '*poor Dummy* was so enraged, and with a distorted countenance he kept thumping the Man on the face & head, making at the same time a hideous Noise'. Bewick gazed solemnly at his prayer book, while 'perhaps none knew or suspected the cause except my Father & my preceptor in the Pulpit'. He slacked in Latin, he fought, he played truant; he climbed the church tower for birds' nests. With his friend Joe Liddell he drove grazing oxen with a whoop over the high bank into the river. Leader of the gang, he persuaded his friends to crowd on to a huge piece of ice, which they steered downstream opposite the Parsonage garden, enjoying the sight of the Revd Gregson raising his hands in despair.

Beatings were constant: Gregson even caned his own son Philip, 'a youth of an uncommonly mild, kind & cheerfull disposition'. But as flogging so obviously had no effect, the vicar tried new tactics. He shut errant pupils in the bell-tower, but they swung on the ropes and climbed perilously on the parapet. He locked Bewick, the ringleader, in the Church until dusk. This was hard on a boy who still believed in 'Ghosts & Boggles', but he got through the hours by climbing the pillars, perching out of sight on the capital of a column when Gregson came to find him, watching the baffled rector march up and down the aisles 'in great perturbation of mind, frequently exclaiming to himself, God bless me! &c'. In times of bad trouble, Bewick stayed out until dark and then crept home and slept in the hayloft, trusting his father's rage would cool overnight.

Memories are untrustworthy, with their gaps and slippages, and their stories confirmed by frequent telling, yet they convey the shapes of lives as the tellers themselves see them. And in later life, when Bewick tried to recapture the child he had been, he found a true streak of the unruly, 'the overflowings of an active wild disposition'. He remembered charging naked over the fell with his friends, imitating the savages in *Robinson Crusoe*, 'or some other Savages', rushing across country like escapees from Bedlam. Once, he said, he had tried to tame a runaway horse by riding him bareback with his hand entwined in his mane. He felt no fear but a kind of desperation, an attraction to the 'uncommon or frightful exploit' – yet he himself, like the unbroken colt, would soon be jolted hard by the adult world's restraints.

2 NATURE AND DRAWING

Slowly, he was tamed. Christopher Gregson was no fool and Bewick was lucky in finding someone who treated him seriously, who saw that this rough lad at the back of the class had real talent, and refused to give up. A cultivated, patient man, he was the one person who really tried with Thomas and worked to make something of him. And he hit, at last, on the right approach. 'Hitherto', wrote Bewick, 'my whole time at School and at home, might be considered as a life of warfare, & punishments of various kinds had been inflicted upon me apparently to little effect.' But now Gregson tried something new. He invited Bewick to supper:

and after shewing me the greatest kindness, he followed this up in a friendly, plain and open way, of remonstrating with me, on the impropriety of my long past bad conduct, – & the evil tendency of it together with the pain & trouble I had given him, urging me at the same time in such a persuasive tone instantly to desist from it, that I felt quite overpowered with this discourse & then fell into a flood of tears. – this however did my business, for I never durst encounter another of this kind of his friendly meetings.

Bewick was fond of the Gregson boys, Christopher (Kit) and Philip, while their sister Betty was the first person, he said, who made him take girls seriously. Almost by accident, she employed a tactic similar to her father's: driven to distraction by Bewick teasing her dog

('a sleek fat useless animal'), she stuttered and hesitated so much when she tried to confront him that he was mortified. All he could think of was how kind she had always been. He stopped bothering the girls.

He was still a rough, clumsy lad, not one for manners. When he was nearly fifty he had his portrait painted: 'When you see it', he joked to Christopher Gregson, 'you will no doubt conclude that T.B. is turning *bonnyer* & *bonnyer* in his old days.' But indeed Kit could not help knowing this, since there were such indications long ago: 'But if you have forgot our earliest youth, perhaps your brother P. may help you to remember what a *great beauty* I was *at that time*, when the gray coat sleeve was *glazed* from the cuff *towards the elbow*.' This untidy youth, with his hair standing up like a brush from its pronounced widow's peak, an old ribbon round his neck for a tie and ragged trousers hanging baggily behind, was hardly likely to be acknowledged by the Bewickes of Close House. He mocked the contrast in one of his vignettes, his small scenes of local life, according to his daughter Jane: 'The poor lad is sore beset with Madam's dogs – The goats head is the crest of the Bewicks . . .'

Two interests ran like mineral veins through this reckless childhood: drawing and nature. At school, as soon as Bewick had scribbled the answer to a question, he filled the corners of his slate with drawings of anything that took his fancy, rubbing them out quickly for fear of a beating before he handed in his answer. Once he had learned figures up to fractions and decimals he had to tackle Latin, but like many practical men he simply could not see the point of this dead language. Instead he crammed the margins of his Latin books with drawings and rough rhymes. When the books were full he drew on every available surface: on the gravestones and church porch with a bit of chalk, on the backs of the painted pews with an old nail; on the flags of the kitchen floor and the hearthstone, scorching his face.

Everything he saw, he tried to draw. In later life, he was a true adherent to the Hogarthian, English school that placed the particular above the general or idealised, the observed above the academic, and in his memoir perhaps he over-insisted that he learned to draw by copying nature, not art. True, there were no paintings to copy, 'besides the King's Arms in the Church, & the Signs in Ovingham of the Black Bull, the White Horse, the Salmon & the Hounds & Hare' (he always thought he could make a better hunting scene than that crude inn sign). But there were woodcuts and prints all around him too. He studied the cuts in the chapbooks and the crude copperplate reliefs in the popular *A Description of Three Hundred Animals,* a standard text published by the London bookseller Thomas Boreman in the 1740s, which reached its tenth edition in 1773, whose inaccuracies drove him to distraction. And he looked carefully, too, at the large block prints 'common to be seen, when I was a boy, in every Cottage & farm house throughout the whole country'.

Bewick always regretted that these prints, cut boldly on a plank of beech or close-grained wood and printed cheaply in large numbers,

often with songs attached, had gone out of fashion. Almost every house had old favourites like King Charles's 'Twelve Good Rules', historic battles on land and sea, and portraits of stirring scenes and eminent men, while 'in cottages every where were to be seen, the sailor's farewell & his happy return – youthfull sports, & the feats of Manhood – the old Archers shooting at a mark – the four Seasons &c – some subjects were of a funny & others of a grave character'.

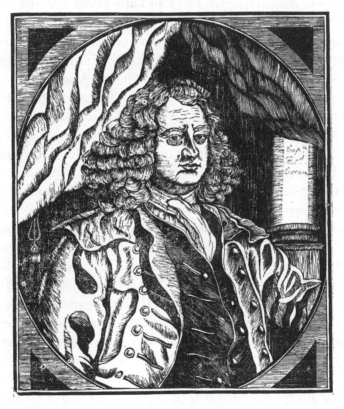

Captain Coram, a woodcut of around 1750, based on Hogarth's portrait

In the gardener's house at Ovingham where the boys left their lunch, wrapped in a cloth, were portraits of Admiral Benbow and Tom Brown, 'the valiant Grenadier', peppered with bullets as he captured the standard at Dettingen in 1743, and also of the Rebel Lords of the '45 and 'Duke Willy', the Duke of Cumberland. Another print showed the flagship *Victory*, which defeated a French squadron off Spain in 1744, but sank with eleven hundred men in October gales in the Channel: this was 'accompanied with a poetical lament of the catastrophe – part of which was "ah hapless Victory, what avails thy towering masts thy spreading sails"'. Many of these were old prints from long before Bewick's birth, but one showed the Battle of Zorndorf where Frederick the Great beat the Russians in 1758, when he was five. Even better, in the Ovingham vicarage kitchen hung a fine print of Hogarth's portrait of Captain Coram, the old sailor who established the Foundling Hospital in London. Nostalgia for these old plebeian prints blended with his political beliefs: 'For all Men, however poor they may be, ought to feel that *this* is their country, as well as it is, that of the first noblemen in the land, & if so, they will be equally as interested in its happiness and prosperity.'

Although Gregson teased him as a 'conjuror' and his father scolded him for wasting time, others were intrigued by his obsessive drawing. A friend gave him the paper he needed: 'pen & Ink and the juice of the Brambleberry made a *grand change* – These were succeeded by a Camel hair pencil & Shells of colours & thus supplied I became completely set up.' In the view of his country neighbours, he was now 'an eminent Painter':

and the Walls of their Houses were ornamented with an abundance of my rude productions, at a very cheap rate – These chiefly consisted of particular Hunting scenes, in which the portraits of the Hunters, the Horses & of every Dog in the Pack, were in their opinion, as *well as my own*, faithfully delineated.

21

Bewick was gripped by the stories told by the hunters, with their knowledge of the country and their prey. On holidays, or when Tyne floods stopped the Ovingham ferry and he could not get to school, he joined whatever chase was on the go, hunting the fox or the hare, the polecat in the snow or the badger in the dark, or holding his breath as the game birds were flushed out of the frozen bushes and the terriers dashed to snap them up when they fell. He never thought it cruel. And he never lost his early sense of romance, engraving many scenes of hunting in winter amid frozen bogs, ice-covered trees and snow-blanketed fields with the men and dogs small against the lonely, empty skies.

From about the age of eleven, at the same time as his life at school calmed, Bewick's attitude gradually changed. His memoir is couched in the language of 'sensibility' and the movement against cruelty to animals, which grew in momentum towards the end of the century, but the complex trajectory of feeling he describes follows no textbook pattern. In his memory, the turning point came during a hare coursing when he caught the hare in his arms as the pack surrounded it and it 'screemed out so pitiously, like a child, that I would have given any thing to save its life'. A farmer persuaded him to hand it to him, saying he would save it, only to break one of the hare's legs and let her limp off for the dogs to have a 'bit more sport with her'. As the injured hare fled, so Bewick's loyalties shifted

Since earliest childhood he had learned to pay close attention to the natural world from listening to his father. Every morning John was up early to see to the colliery, and when he came back for breakfast – as Bewick later told a young friend – he used to tell them 'all that he had seen in his rambles, describing in such glowing and rapturous terms, the economy of nature, & the habits of natures creatures', that a child

as enthusiastic as Bewick could hardly fail to become a fervent naturalist, alert to the most trifling details of everything that lived. As he grew older, his observation of animals and birds became more complicated. Nature and drawing worked together. With a pencil in your hand you have to focus very closely: the more you draw, the more carefully you look. While Bewick's warm sympathy (and his enjoyment of fables) edged him towards anthropomorphism, he began to look at shape, form and colour, with the detached, enquiring gaze common to both artist and scientist.

In his recollections the contrasting responses intertwine. He used to throw stones at birds without a qualm, until he hit a bullfinch, a 'Little Mathew Martin' as his people called it, and it dropped dying at his feet. At first, he was coolly 'struck with its beauty', but when he took it into the house, 'it looked me so piteously in the face, and as I thought (could it have spoken) it would have asked me, why I had taken away its life'. Then again, when he turned it over and over, he admired 'its plumage – its feet its Bill & every part of it'. This was the last bird he killed, although – remembering the piles of feathered corpses offered up by keen naturalists as models for his *British Birds* – he confessed that 'many indeed have been killed since on my Account'.

From now on, Bewick looked keenly and questioned what he saw. As he tells it, this more analytical, naturalist's interest grew in an uncomplicated way from the common child's love of poking around and seeing what happens, but it also places him very clearly as a child of his age. In the 1750s, across the nation, all kinds of men – country squires and city doctors, dissenting merchants and leisured dukes – were classifying plants, collecting shells, measuring rainfall, noting the seasonal habits of birds. Many country children, later known as distinguished thinkers, built upon such childhood curiosity: Gilbert White's brother-in-law John Barker began keeping a nature diary at the age of ten;

Joseph Priestley's first experiment, his brother remembered, 'was on spiders, and by putting them into bottles, he found out how they could live without fresh air'. Bewick's use of the words 'wonder', 'delight' and 'experiment' were characteristic of this nationwide passion, as were his analogies between animals, insects and human society.

His own first interest was in birds, 'their nests, their eggs & their young', and he was more excited by the rarer visitors to the Cherryburn riverside and meadows, woodcock and snipe or redwings and fieldfares, than by the familiar robins, wrens, blackbirds and crows. Insects intrigued him, too. Walking to and from school on summer mornings and evenings, he stopped, 'lost in wonder', to watch the activities of 'the Nation of pismires', a huge ant heap on the top of Boat Hill, near Eltringham. The ant trails radiated through the grass, he thought, 'like as many turnpike roads, & as busily crouded as any among Men leading from or to a great Faire'. As an experiment he often poked and overturned the heap with a stick and was surprised, next morning, to see that after the first panicky confusion everything was restored to the same order as before. He also watched the ants' chief predators, the village turkeys, noting how the mother turkey briskly led her brood to the anthill every day as soon as they could walk.

There were experts around him, men who lived and worked with nature. Among them was old Tom Forster, who kept hives in sheltered, secret places, even in the middle of a 'whin rush', a thick patch of gorse, which Forster and Bewick crept into on hands and knees through a small opening, stopping it with a gorse bush when they left. One of his own tasks at Cherryburn was to guard the beehives, killing the wasps before they stole the honey: here he watched the bees enter loaded with honey 'but never could see them attack or repel their enemies'. At home, he stopped the servant girl from brushing down the

cobweb by his bed, and substituted a wasp for the usual flies to see how the 'Tyrant' spider would respond: it attacked, but the wasp stung it, and it never appeared again. 'This is only one experiment', he notes cautiously, '& further trials of this kind might be made to come at truth.'

Yet he knew the dangers of childish curiosity. At the opposite end of the scale from the spider, the horses were the largest animals on the farm, their muscles rippling beneath shining coats. He wept bitter tears when a favourite horse, borrowed by a neighbour to carry coal, was galloped furiously all the way home and found dead in the field next morning. It was unceremoniously dumped over a bank for the crows and magpies to peck at, and Bewick stopped every day to mourn it on his way back from school. Horses were symbols of natural power, carrying a hint of danger. One of his vignettes shows his small brother John, still in skirts, tugging a horse's tail: the maid is engaged in a tryst in the bushes and as his frantic mother leaps over the stile, the horse, turning its head with a familiar malevolent glint, is just baring its teeth and raising a hoof. Animals could fight back.

Honesty compelled Bewick to admit that if hunting or stoning birds worried him, he felt differently about the baiting with dogs of otters, polecats and badgers. Here there seemed to be some equality, some chance the aggressor would be beaten 'and I have with pleasure seen that wonderfully courageous animal the Badger (with fair play) beat all the Dogs, of a whole Neighbourhood (one after another) completely off'. Like his father, he used his fists to settle quarrels, and saw little wrong with this until he watched a skinny pedlar being beaten to a pulp after he had 'forgot himself over a Glass'. When the pedlar was laid out cold, Bewick found himself 'so frantic with rage & indignation' with his assailant that: 'I believe, at the moment, if I had had a Pistol at hand I would have shot him.' It was not the violence that roused this rush of fury but – as in his schooling, and as in the hunting of the wounded hare – the overmastering, the imbalance of strength, the battering of the weak.

3 THE COMMON

Bewick learned less from books than from watching the world and the people around him – the pedlars and vagrants, the hunters, the farmers, the cottagers on the common. Eltringham Common had been open land since medieval days, as the age of the hollow oaks, alder, ash and willow that grew beside the burns bore witness. As on commons across the country, the poor kept a few sheep here, a flock of geese and a stock of beehives, and squatters built rough shelters of wattle and daub, thatched or covered with turf. They fenced off small plots – illegal but accepted 'intakes' – collecting horse manure from the cart tracks, and living fairly well on bread and potatoes, porridge and milk, with vegetable broth on Sundays. Their clothes were stout homespun: the men wore breeches and leather jerkins, woollen shoes and kerchiefs and on holidays the women put aside their linsey-woolsey petticoats for brightly patterned cotton and straw bonnets. After Bewick moved away he loved to come back and hear them talk over their beer, tracing the lives and pedigree of neighbours back in time.

If this was Britain's 'bold peasantry', as Bewick romantically put it, borrowing Goldsmith's words, it was an eccentric and individual one. Literacy rates were high throughout the north-east and nearly all the cottagers could read their Bible and knew the local histories and ballads. One of them, Will Bewick, a striking figure with long face, stern

brows and high cheekbones, admired the boy's pictures, was kind to him, 'and was the first person', Bewick wrote:

from whom I gathered a kind of general knowledge of Astronomy & of the Magnitude of the universe – He had, the Year through noticed the appearances of the stars & the Planets & would discourse *largely* on the subject.

I think I see him yet, sitting on a mound or seat, by the Hedge of his Garden, regardless of the cold, and intent upon viewing the heavenly bodies, pointing to them with his large hands and eagerly imparting his knowledge to me, with a strong voice, such a one as one now seldom hears –

As well as astronomy, Bewick could learn politics here, from Anthony Liddell, called 'the Village Hampden' after the charismatic Parliamentarian MP who resisted Charles I's demands for ship money. Liddell always wore a handed-down black coat, leather waistcoat and 'buck-skin Breeches turned black and glossy with long wear', and a wide-brimmed hat on top of a large curling wig 'such as were worn about the time of the revolution'. Learned in the Bible, in military history and in the sermons of the great seventeenth-century divine, Jeremy Taylor, and treating all men as his equal, Liddell argued that the air and waters were free for all and rejected any law that clashed with what he considered the word of God – especially the game laws and regulation of fisheries. A clever poacher, he was a man for whom gaol held no terrors but merely offered more time to read the Scriptures. Any Justice of the Peace who mocked his odd looks caught the lash of his tongue: there was '*nobbit yen* place that he was *flaid* [afraid] of & that was Hell, and he could not send him there'.

Rural life was less harsh and less divided than in the southern counties. Tom Forster, the beekeeper, paid Sunday calls on John and Jane Bewick, while Anthony Liddell took the lead in any discussions where historical knowledge was called for. To Bewick, the labourers often seemed better informed than the farmers, who were so preoccupied

with managing their land that they never read a book; they were kind and hospitable but 'well intentioned plain plodding men, who went jogging on, in their several occupations, as their fathers had done before them'. Above the farmers stood the squires, who held their land by the ancient system of tenure, with rights of inheritance by 'suit & service', and the 'Country Lairds' who actually owned their estates – the ultimate happiness in Bewick's view. He could not forgive the absentee landlords who let old family lands slip away and ancient halls moulder. One reminder of this was Prudhoe Castle, a stronghold of the Percys on the high south bank opposite Ovingham; long disused, it was now let out to the farmers on short leases, providing shelter for their cattle and stones for their walls. By the mid 1770s it was in ruins, with sparrows nesting in the ivy and rabbits burrowing in the banks.

The region tended to look north rather than south, to battles with Scotland rather than alliances with London. From the fourteenth century until the Union of the Crowns in 1603 there was scarcely a generation of peace. The Reivers, clans of border outlaws, swept down to seize sheep and cattle, raiding the fairs, whooping and charging at horse races high on the moors. Later, in the Civil Wars, the Scots infantry poured across the fords at Ovingham, Bywell and Eltringham. Everyone suffered. Royalist landlords were driven into exile during the Interregnum; the gentry who supported Parliament lost their property after the Restoration; farmers who took no side at all were ruined by taxes and forced loans. Land and power passed to new men, whose descendants were powerful in Bewick's day, like the Ridleys and the Carrs.

The bitterness lingered. After the flight of James II and the 'Glorious Revolution' of 1688, the old Catholic families stayed loyal to the Stu-

art kings and their fate was lamented locally, even if their politics were suspect. In 1696 Sir John Fenwick of Bywell was executed for plotting against William and Mary, and later generations took up the cause in the Jacobite rebellions of 1715 and 1745. By contrast, the Corporation of Newcastle was stalwart Whig and Protestant: when the Duke of Cumberland rode through in January 1746 pursuing the 'bog-trotters' trailing home to the Highlands through the snow, cheering crowds burned a Catholic chapel to greet him. In April that year, after the slaughter of the Scots at Culloden 'there were the greatest rejoicings ever known at Newcastle, on the arrival of the news of the great and decisive victory' and four months later 'Butcher Cumberland' was awarded the freedom of the city. All this was only seven years before Bewick was born.

The community carried its past and its culture within it. The Tyne between Newcastle and Hexham was dotted with Roman remains, medieval castles and peel-towers. Hadrian's Wall was just over the hill to the north, and Roman Dere Street was still a much-used road, running straight as an arrow behind Mickley Bank. In the late seventeenth century the lawyer and writer Roger North had remarked that the people around Hexham were 'great antiquaries in their own bounds', as they had such abundant material to work on. This was still true. On winter evenings in Eltringham neighbours gathered to tell stories and recite ballads that celebrated the heroes of border skirmishes or remembered good landlords and neighbours.

One favourite ballad lamented the Jacobite martyr the Earl of Derwentwater, beheaded in 1715, 'a Victim to the Cruelty of the Reigning Family', as Bewick put it (Derwentwater's younger brother was executed thirty years later, in the second uprising). The family seat, Dilston Hall, was only seven miles from Cherryburn, upriver near Corbridge. When the Earl died, it was said, the spouts of Dilston ran

blood, the corn was tinged with red, and the aurora borealis shone so bright that from then on it was known as 'Derwentwater's lights'. In 'Derwentwater's Farewell' the Lord bids goodbye to his house, now in the hands of a stranger, and thinks of his tenants forced to leave their lands, 'or live their lives in fear':

> No more along the banks of Tyne
> I'll rove in autumn grey;
> No more I'll hear at early dawn
> The lav'rocks wake the day.

The lament always touched Bewick's pent-up feelings, prompting tears. And for all his outer hardness, this intensity never left him.

He was also fascinated by the old soldiers tramping the roads, several of whom had fought for the Highland chieftains. Many were descended from soldier-families of the border wars and bore fierce nicknames, handed down through generations: 'the Hawk, Glead [kite], Falcon, Fox, Wolf, Bloodhound, Greyhound – Raven, Crow, Gorfoot [carrion crow], Crowfoot etc.'

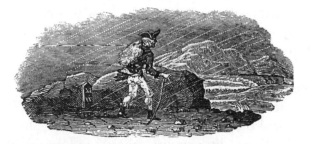

Other travellers were the Rom, the gypsy clans who had settled in the north around 1500. In the winters they stayed in encampments at Kirk Yetholm, across the Scottish border, or at Wooler and Alnwick, north of the Tyne, but in summer they set out on 'walks', each family follow-

ing regular circuits round remote farms and villages, mending tools, selling jewellery and baskets, playing the fiddle and flute and pipes at weddings and fairs. But sometimes they came on less welcome visits. In the upheavals after the 1745 rebellion the notorious Faa gang were blamed for many raids they may never have committed.

Bewick's family had their own Faa story, passed down from the 1720s, when Bewick's grandfather took John, then a small boy, out on his Christmas rounds to collect coal money from the farmers. Agnes was left alone with the other children, guarding the cash already collected. Towards evening, 'a kind of fear' came over her. She fastened the shutters and the doors into yard and orchard, set water boiling on the fire, and jammed a table before the window. Then came a knock, but no answer when she called. Hearing footsteps round the back, she was ready with a dish of scalding water if the intruder chose the door, but instead he smashed the shutter, opened the casement and put one hand on the table. Agnes was beside the window, armed with a bill-knife for hacking undergrowth, and before he moved again 'down went the knife – full force – on the back of his hand . . . he made his exit in quicker time than he came'. The blow was fierce and the trail marked by blood, but he was never caught 'tho' it was suspected he belonged to a Faa gang then encamped in the neighbourhood & at that time a source of great terror and annoyance all over Northumberland'. True or not, the knife kept pride of place at Cherryburn for three generations.

Bewick shared the region's love of stories and he also imbibed its superstitions. A fear of portents, ghosts and spirits affected the strongest souls, from the Cherryburn farm servant, a 'Village Caesar' unafraid to fight any man, to the rough pitmen. In his grandfather's generation, the Newcastle curate Henry Bourne had listed stories of bogles, ghosts and fairies who made cakes and were 'very noisy' and

stole babies. 'Nothing is commoner in Country Places', he wrote, 'than for a whole Family in a Winter's Evening, to sit round the Fire and tell stories of Apparitions and Ghosts . . . From this, and seldom any other Cause, it is, that Herds and Shepherd have all of them seen frequent Apparitions.' Bewick teased the burly farm hand with whisperings of Silkeys, swaying, sea-born wraiths, and frightened the gullible pitmen by swaddling the farm dog in an old straw sack to make it look like a headless body. But he was not immune to fear himself. It took him a long time to shake off the dread of the local tales, however much his rational father mocked them: 'He would not allow me to plead fear as any excuse, when he had to send me any errand at Night, and perhaps my being frequently exposed to being alone in the dark might have the effect of enabling me to rise superiour to this kind Weakness.'

He could not always rise above it. When he and his friends visited each other's houses to play cards a 'religious or bigoted old Woman' took them to task, declaring cards the 'Devil's Books'. If he looked under the table as he gambled, she told Bewick, he would see the Devil: 'and I recollect of my having several times, peeped under the Table that night to see if he was there'. Worse followed. The two friends who set out home with him across the fell disappeared and he walked on alone to the Sandholes, a field just east of Cherryburn. Then he turned towards home:

When behold, to my utter amazement, I saw the Devil – it was a clear Moonlight Night – I could not be mistaken – his Horns – his great white goggle Eyes – and teeth & tail & his whole person, stood fairly before me – As I stood and gazed – I thought the Hair lifted the Hat on my head – he stood & I stood for sometime, and I believe if he had then come up to me I must have dropped down – certain it is however that desperation succeeded fear – I moved to aside & he did the same thing – the first thing I bethought of, or rather in an

involuntary way, was getting out my *Jackleg Knife* & if he had then approached or laid hold on me, he to a certainty would have got himself stabbed – I then slipped off my Clogs – made a run in a bending direction & then at full speed ran directly towards home. He pursued me nearly to the door, but I beat him in the race.

In the warm kitchen he was safe. He had been told that if you saw a spirit and then came into a house with a fire in it you would faint – but he did not. And when he told his father he had seen the Devil, John gave him, 'perhaps without thinking', a quick slap on the head. But John Bewick was not one to have his son bullied: on discovering that the apparition was a local man dressed up for mumming at a harvest supper, 'he wrought himself up into a great rage', and beat the man publicly in the street at Corbridge. Onlookers, astonished at the transformation of respectable farmer to man of rage, took his side and Usher was drummed from the village.

So much lies under the surface here: the card-playing lads, moving between each other's houses; the Puritan disapproval; the stern father's love for his wayward son; the 'desperation' in the boy, armed with his pocket jackknife with its broad, square blade; the rough justice of the village. Local people feared the Devil as a real force, not to be mocked, and the little devil with his spiky tail and punishing leer often crept into Bewick's vignettes. There is a darkness in many of his scenes, a sense of loneliness and threat, of strange things stirring in the moonlight, a Gothic haunting.

The folk beliefs of the country ran alongside conventional Christian practice. The church still policed local morals. When Bewick was six, the Archdeacon of Northumberland called on the congregation to denounce one couple 'for the crime of fornication, by them severally committed'. Doubtless they responded with gusto, but by and large Gregson's congregation were a tolerant lot: they accepted the

Catholics and dissenters, like the Atkinson family who worked the ferry at Wylam boathouse, as well as odd types like the Dummy of Wylam. Although the farmers took their families to church each Sunday, their faith was more social form than feeling. True devotion was left to the women, like Bewick's mother, Jane, who was, he said, of a religious turn and tried hard to make him follow her, 'but as I did not clearly understand her well intended lectures, they made little impression'.

The local squires and magistrates protected the men they knew, turning a blind eye to rough justice, putting community above law. John Bewick valued his workers and cared for their safety and after a fault with the Gin – the horse-drawn pulley that let out a rope attached to a chain, which the men wrapped round them to be lowered into the pit – he always let the men down himself. One day, his best worker, George Parkin, had fixed himself in the chain with his son, and had given the signal 'wiseaway' to let them down, when he saw that the pit rope had been cut: 'on this he shouted "stop"! & started back on the *"seddle boards"*; just in time to prevent their being precipitated to the bottom of the Pit'. John pulled them back and dealt with the vandal himself. When the bruised culprit complained to the justices, they were surprised to learn that the assailant was John Bewick until they recognised the victim as a man they had already tried for robbing Bywell Lock: 'and was not this master of yours', said one, 'the very friend, by whose unceasing endeavours & influence you were saved from transportation? – Begon! leave the country & let us never see you more.'

Such a story was told and re-told. The pit at Mickley crossroads had a hut, known as the 'Ludge', or lodge, with a fire and benches packed with straw. This warm, stuffy refuge was the neighbourhood forum, where the old men came to gossip with the carters driving in to pick up coal. Bewick was 'very much amused at the avidity with which they

gathered News – *they seemed to live upon it*'. The pedlars and gypsies
also brought news, and on market days and fair days people gathered
from across the region, from Cumberland across the Gilsland Gap,
from the lead-mining valleys of Weardale, from the hills north of
Hadrian's Wall. The biggest, and oldest, of these gatherings was
Stagshawe Bank fair, dating from Norman times and now the greatest
livestock sale in the north, held at Whitsun and midsummer, where in
three days over 100,000 sheep, cattle, horses and swine changed
hands. A flood of cattle trampled the peaty upland: the black Kyloe
oxen from the Highlands, the brown and white Longhorns from Lan-
cashire and Westmorland. A mass of people too: Gaelic-speaking
Highland drovers, Shelta-speaking tinkers, Romany-speaking fortune-
tellers, Durham prizefighters and Cumbrian wrestlers, showmen with
exotic animals, beer sellers and pedlars. When Bewick compared the
lines of ants in Eltringham wood to people 'crouding to a great fair',
this was what he meant. Ovingham had its own fairs in April and
October. In April, a procession headed by pipers beat the parish
bounds before returning to the inn. There was 'a Punch and Toby'
show, fire-breathers and sword-swallowers, and punch sellers shout-
ing, 'Hearse a' yer rale dandy candy, made ap wa sugar an' brandy'.

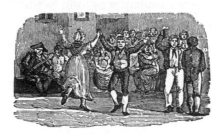

Everyone danced – reels, jigs and hornpipes – and after electing a
mock mayor, who was carried in triumph to the vicarage, the foot-

races began. And all day the musicians played: 'The Reel Rawe', 'The Bonny Bit', 'Laddie Wylam Away'.

There was nothing isolated about this area. The smallest inn had the newspapers from town, and the new turnpike road linked Newcastle to Hexham. There was plenty of local drama: marriages, harvests, children, races. But often the news was of national events. In Bewick's early childhood, from 1756 to 1763, Britain was embroiled in the Seven Years War, supporting its ally Prussia against France and Austria. Sometimes the tales were of disasters, like the surrender at Minorca of Admiral Byng in 1756, later shot on his own quarterdeck 'to encourage the others'. The trading communities of Newcastle took the loss of this vital Mediterranean base hard and crowds burned Byng in effigy, scattering the ashes in the streets. But they celebrated triumphs with equal fervour: Clive's conquests in India; the death of Wolfe, capturing the heights of Quebec; and the accession of George III in 1760, the first Hanoverian king to be born in Britain.

News came, too, of more technical feats, of the Duke of Bridgewater's canal in 1761 and later of James Watt's improved steam engine that would replace the old ones draining the mines: a huge new pump, the 'Rise Moor Colliery Engine', was installed near Hedley Fell. Upstream, at Hexham and Corbridge, there were already large textile works, while on the Tyne estuary there were salt pans, ironworks and glass works as well as the lead mines inland. At one point an entrepreneur who had made a fortune in London and set up an ironworks near Newcastle, decided that Eltringham itself would be the 'new Birmingham'. Navvies set to work, a mill race was dug, machinery was brought in. The projector stayed with the Bewicks while the work was going on, and the men came to Cherryburn to get their wages. But as soon as the Tyne flooded, the sides of the mill race caved in completely. The local farms, which had thought to profit by becoming

inns, had to shut up shop, 'and among the rest, my fathers house, &
its sign of the seven Starrs, hung up between the two ash Trees, was
taken down'. Everything was sold off and finished as suddenly as it
had started, '& my father came to some loss, after all the turmoil &
trouble he had been put to'.

Bewick grew up among a close-knit community of landlords, tenant
farmers, commoners, pitmen and country tradesmen: ferrymen,
innkeepers, dyers, carters and salmon fishers. A rebellious child, he fol-
lowed his father's staunch criticism of entrenched authority. Yet
the things that touched his heart were the old traditions that bound the
community together: the rights of tenure and the freedoms of the
common; the gossip at the pit and the collective justice; the fading
prints on the cottage walls, the ballads and stories. As well as depicting
the animals and birds, his woodcuts preserved the life of village and
common, rooted in a particular place.

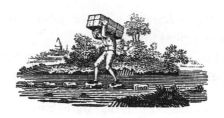

4 'BEILBY'S WILD LAD'

Thomas was not cut out to be a farmer. He was too wayward, too set on the 'idle pursuits' of art. As he neared fourteen his parents worried what to do with him. Their two other sons – John, aged seven, and William, five – might show more interest in the land and mine, and although it was an unusual decision for such a practical man, John Bewick accepted that the best course for Thomas was to follow his talent. All he wanted was to be somewhere connected with pictures.

The chance came in the summer of 1767, when William and Ralph Beilby, who ran a jewellery, enamelling and engraving business in Newcastle, called on Bewick's godmother, Mrs Symons, widow of the late vicar of Bywell, and she took them to Cherryburn to drink tea. The Bewick family already had connections in the jewellery trade since Thomas Blackett, husband of John's sister Sarah and one of Bewick's godfathers, had been foreman to a leading Newcastle silversmith. Trotting down the lane on their horses, the Beilbys had a touch of the gentry that would have impressed Bewick's father, and when they left Bewick was asked which brother he would like to be apprenticed to. He thought first of the oldest, William, but then chose Ralph – always pronounced 'Rafe' – because he liked his manner. Within a month the terms were agreed. Bewick's grandmother had left him twenty guineas

as an apprentice fee: a sizeable sum for John Bewick to pay and a healthy injection of capital for Beilby.

Bewick wanted to go, but when 1 October arrived, the set day for hiring, the parting was terrible:

I can only say my heart was like to break, and as we passed away – I inwardly bid farewell, to the whinney wilds – to Mickley Bank, the Stob Cross hill, to the water banks, the woods, & to particular trees, and even to the large hollow old Elm which had lain (perhaps) for centuries past, on the haugh near the ford we were about to pass & had sheltered the Salmon-fishers while at work there, from many a bitter blast –

They crossed by the ferry to Ovingham where Revd Gregson was waiting with his son Kit, who was also leaving to become an apprentice to Doughty and Wiggins, Chemists and Druggists. Among the neighbours who saw them off was old Betty Kell, who gave them her blessing and a penny for good luck. Then they mounted their horses, both fathers solemnly lecturing their sons on honour and honesty, duty and industry – the first time a startled Bewick had ever heard his father mention religion outside church.

As they rode east along the ridge Bewick's childhood fell behind him. Occasionally the road gave glimpses of the river and when they neared the town they saw windmills on the hills and a ring of market gardens below. The main roads still entered through stern gates in the medieval walls, eight feet thick to defend against the Scots, and after passing through the West Gate they clattered down the long paved road between tall houses, many with large gardens behind. Newcastle was a thriving, smoky town: around 24,000 people lived in the narrow streets, alleys and lanes – 'chares' and 'lonnens'.

All these streets, packed with carts and wagons, street-sellers and sedan chairs, converged on a web of markets, first the Bigg Market,

then a trio of lanes – Groat Market, Middle Street and Flesh Market – stretching like a three-pronged fork down to St Nicholas church, its lantern spire soaring above the Black Gate and the keep of the Norman castle. Shop fronts opened on to cobbles and the top storeys leant so close that it was said you could light your pipe from a match in the window opposite. From the churchyard, the drivers of coaches and carts reined in their horses as they clattered down Side, the perilously steep and narrow street curving down to the open space of the Sandhill, where the Guildhall stood, and across the medieval bridge with its seven arches, lined with houses and shops. On the opposite bank, below the small town of Gateshead, stood workshops for boiling sugar, mills for spinning broadcloth, glasshouses producing bottles and vats.

The tidal river was deep and sheltered, a safe haven for shipping. Upstream, fisheries netted the salmon, scooping up hundreds at a time, over two thousand in a season: the fish was so cheap that a legend arose that some indentures promised that apprentices would not have to eat salmon more than twice a week. Above the bridge, the old mansions and warehouses of the Close hung over the water, while on the seaward side vessels lay in ranks at the quay, their rigging clacking against spars and masts, the heavy hemp ropes thudding and groaning in the wind. Further downstream stretched the roperies and shipbuilding yards of 'the shore', and beyond that were the domes of glasshouses, their chimneys belching smoke. From here the Tyne flowed between steep dusty banks, heaped with ballast dumped by the returning colliers: gravel from the Thames, rubble from the chalk quarries near Gravesend. Instead of tall trees, long-legged staithes strode out in the water, where the wagons tipped their coals into the waiting keels. This was very different from the richly wooded river that Bewick knew.

*

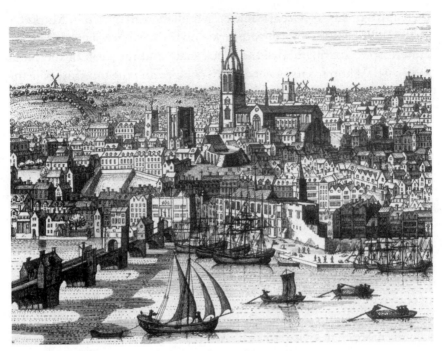

Newcastle in 1745, by Nathaniel Buck. The Amen Corner workshop was just
south of St Nicholas Church. Left of the castle keep is St John's church, where
Bewick was married, and on the far left is the Forth, where he later lived.

The binding of the apprentices was to take place at the Cock Inn, in
the heart of the town. Christopher Gregson was dealt with swiftly. But
when Bewick's papers of indenture were laid on the table, Beilby and
John Bewick began to argue about the terms. Beilby now seemed
reluctant – 'perhaps from his having heard of some unfavourable
account of me', said Bewick – and Revd Gregson stepped in to defend
him, 'interfered very ardently – spoke warmly in my praise, and dwelt
forcibly in particular, (notwithstanding my boyish wild behaviour at

school) upon my never being saucy or sulky, nor in the least indulging in any thing like revenge'. The awkwardness over, his father and new master took up their pens and signed.

Beilby was tall, lean and elegant, an ambitious and confident young man who had set up in business with his brothers and sister seven years before, when he was only seventeen. The Beilbys were a talented family but they had to struggle for success. Their father William, a respected goldsmith and jeweller in Durham, had sent his sons to Durham Grammar School, where they learned to read Latin, speak French and enjoy music. The oldest two went as apprentices to Birmingham, the heart of the trade in small, precious metal goods, Richard to learn seal engraving and William enamelling and drawing. On their return they taught these skills to Ralph. But their father's business failed in 1757, and although he tried to start again in Gateshead, he was broken and dispirited until his death eight years later. After Richard, too, died, Mrs Beilby started a small school. William and Mary worked as enamellers for the local glass makers, producing work of great flair, much valued today, and William and the youngest brother, Thomas, also taught drawing.

Ralph specialised in silver engraving: 'in this', wrote Bewick, 'as far as I am able to judge he was one of the first in the Kingdom'. He was equally skilled at seal-cutting, becoming an acknowledged expert on heraldry, and was now branching out into copperplate printing. For years the bookseller Joseph Barber had dominated this trade, but he had sold his engraving business to another skilled man, Thomas Jameson, who was now in deep trouble, having been caught cashing a dozen £5 notes that he was printing for the Newcastle Old Bank. Jameson fled to Edinburgh, where he was arrested for counterfeiting. At Newcastle Assizes, he was saved from the death sentence by the testimony of Jean Bell, who lodged with him and kept a nearby pie shop,

but while Jameson went free, Jean was found guilty of perjury and set in the pillory on the Sandhill – drawing a sympathetic crowd of thousands – then sentenced to transportation. (After a spell in Botany Bay she returned to the Tyne, and to pie-making.)

Into the gap left by Jameson's disgrace stepped the twenty-two-year-old Ralph Beilby. Since his brother Thomas had now left the town, Beilby urgently needed help and his new apprentice at once took his place in the workshop. To Bewick the three-gabled house at Amen Corner, near the top of Side in St Nicholas churchyard, was a new world, of cluttered workbenches, metal, wax, oil and acid, a rush of demands and deliveries. Bewick remembered that in his anxiety to succeed, Beilby 'undertook every thing & did it in the best way he could – he fitted up & tempered his own tools, which he adapted to every purpose & learned me to do the same'.

Like William Hogarth fifty years before, Bewick began by engraving coats of arms on metal. Engraving the family plate was an essential anti-theft device, to deter pilfering servants or to identify cutlery if a thief tried to sell it, but the crests and inscriptions also made an item special, whether it was a ring or a brooch, a silver comb or an ordinary teaspoon. One of Bewick's first jobs was etching blades for the German Oley brothers, who made swords at Shotley Bridge. In the work book for his first week, 5 to 12 October, the scrawled orders included a seal to be cut for the local regiment, names on dog collars and whips; crests and ciphers on seals, tankards, a teapot, punch ladle, knife and set of soup spoons; brass plates for a tea chest; engraving for a £20 note. A separate, shorter, entry listed the printing work.

It was a good training. 'I think he was the best master in the World, for learning Boys,' Bewick decided, because they had to put their hand to every kind of work that came their way:

44

the coarsest kind of steel stamps – pipe Moulds – Bottle moulds – Brass Clock faces – Door plates – Coffin plates – Book-binders Letters & stamps – Steel, Silver & gold Seals – Mourning Rings – Arms crests & ciphers on silver & every kind of job, from the Silver Smiths – writing engravings of Bills, bank notes, Bills of parcels, shop bills & cards.

Pattern books lay open for copying devices, borders and ornaments: in years to come each apprentice would build up his own notebook of the crests and coats of arms used in the workshop, and at his death Bewick's library still contained five books on heraldry and many on penmanship. Instead of the drawing lessons he had hoped for, he had to copy the *New Book of Ornaments*, 1752, by Lock and Copeland, who also produced designs for Chippendale's best-selling *Cabinet Maker's Directory*. In the freezing winter of 1767–8, when the Corporation gave extra funds to the poor to allay their hardship, the workshop was warm and busy. Learning was mixed with drudgery and Bewick spent hours polishing copper plates with charcoal, and hardening and polishing steel seals, until, he said, his hands became 'as hard & enlarged as those of a blacksmith'.

To begin with, Beilby handed over the rough or boring tasks to his boy, and kept the finer work himself. Bewick's friend Robert Pollard remembered him in these early days as a 'canny lad' who began by cutting out the hour figures on brass clock faces, where 'strength of hand more than skill was needed'. But slowly he was given more interesting things, like engraving mottoes on rings and arms and crests on silver. 'We had a great deal of seal cutting,' he remembered, 'in which my master was accounted clever & in this I did my utmost to surpass him'.

The workshop was also in the middle of a web of booksellers and printers, enquiring, self-taught men and women, many of them belonging to the flourishing dissenting sects. As well as newspapers, bills for traders and cards for gentlemen, the printers sometimes

undertook work for the booksellers and on occasions acted as publishers on their own. Bewick had a flurry of names to learn. Among the booksellers, the nearest, just next door in Amen Corner, was Joseph Barber, who also ran a stationer's business, a very profitable pharmacy – as many early printers did – and a circulating library boasting 'above 5000 volumes'. (He also sold 'a variety of Spectacles and Reading-glasses'.) Barber was now nearly sixty: highly respected, he 'knew Latin and Greek, and was well acquainted with the "Belles Lettres", or polite literature'. A second bookseller, William Charnley, ran a competing circulating library at the foot of the Groat Market and a shop on Tyne Bridge, where booksellers had clustered in earlier days.

While these booksellers liked to be thought of as men of letters, the printers were more down to earth. The oldest was John White, who for many years had published a stream of sermons and tracts, and ballads and broadsides embellished with woodcuts, at his shop on Side, and whose young partner was the keen, go-ahead Thomas Saint. Next in seniority was the Quaker printer Isaac Thompson, whose son John ran their shop in Burnt House Entry, a narrow lane winding from Side towards the churchyard, and just up the hill, at the head of Middle Street, the Cumbrian Thomas Slack, Thompson's ex-apprentice, ran 'The Printing Press', established in 1763. Slack also wrote short business primers like *The Ready Calculator* and *The Commercial Palladium*, while his wife, Ann, 'a woman of uncommon abilities & great goodness of heart' according to Bewick, helped run the business, looked after their nine daughters and wrote pioneering children's books and grammars under her maiden name of Ann Fisher. Newcastle was the chief centre outside London, Oxford and Cambridge for book publishing (although most of these 'books' were White's broadsides and primers) and the printers also published the local newspapers: the *Newcastle Courant,* a Tory mouthpiece, founded by White in 1711; the

Whig-inclined *Newcastle Journal*, started by Isaac Thompson in 1739; and the more radical *Chronicle*, launched by Thomas Slack in 1769.

Bewick had entered an inky, bustling, competitive milieu. And although engraving for printers was only a fraction of the work at Amen Corner, right from the start he found his own niche. Occasionally the workshop took on wood engraving: a single cut, for the Newcastle arms, featured in the first week of Bewick's indentures. Beilby disliked cutting wood – it was coarse, rough work, demeaning compared to his fine work on metal – so he gave it to Bewick. In the fifth week of his apprenticeship he was asked to cut round the borders of the geometrical diagrams for Charles Hutton's *Treatise on Mensuration*, which began publication in weekly parts in 1768. Soon he was given all the engravings in the book. Now and then he added details such as a boat, or a house, or a figure, or a carefully drawn but slightly askew illustration of St Nicholas church spire. There was room here for fancy, for play.

Hutton was an intellectual from unlikely surroundings. The son of a colliery manager, he ran a school specialising in the modern skills of mathematics, mechanics and surveying: his high-ranking pupils included John Scott (later Lord Chancellor as Lord Eldon), and the banker's daughter Bessie Surtees, with whom Scott eloped dramatically in 1772. A year after this local scandal, Hutton won a competitive exam to become Professor of Mathematics at Woolwich Arsenal and

set about publishing his *Treatise*. Fifty years later he took the credit for introducing Bewick to wood, saying that he had seen books with similar diagrams produced in London; he had bought the blocks and tools, and explained the techniques. In fact all the tools were already on his workbench, but Hutton may have shown him how to use the clever double-pointed graver that could cut along each side of a line at the same time. Bewick remembered him as a friend of Beilby, a grave, shy man who appeared from time to time to inspect the work. Dull though this work seemed, it could not have been a better training. In two hundred diagrams Bewick had to concentrate on the basics, cutting fine lines absolutely straight or embellishing triangles with tiny letters 'A', 'B', 'C' – all his life he was an expert in the immensely difficult art of cutting reverse writing in wood.

At this stage Bewick would perhaps have agreed with Beilby in seeing his work as a poor relation, a childish art. Woodcutting was at its lowest ebb in this country, and indeed in Europe, and he never imagined that it could compete with copper. Paradoxically, this may have been an advantage. He could go his own way: in this plebeian craft there were no models, no rules, no supercilious critics. He had the freedom to express himself directly in a medium that suited him. His strong, youthful designs for bar bills, for the George & Dragon pub in Penrith and the Cock Inn in Newcastle, caught the eye of local merchants and traders. Orders rose and takings tripled over the following year. As he put it, 'My time now became greatly taken up with Wood cutting.'

After the boxwood logs were brought up from the quay a local carpenter came into the workshop to help them slice the hard wood to the height of the type, and plane and polish the surface. The blocks were kept carefully away from damp and heat, which might warp and crack them. Thinking hard, trying out his ideas in rough, Bewick drew the design on a scrap of paper. When he was satisfied he rubbed the back

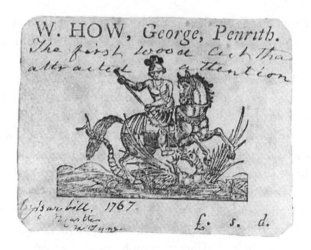

of the drawing with black lead, turned it over, placed it over the block
and redrew the outline with a fine point, leaving a shadowy tracing on
the wood. (You can see the lines in the drawings, where the paper was
folded over the edges.) Now he was ready to begin. In the light from
the window he placed the block carefully on a leather pad filled with
lead shot. This let him wedge the wood against the soft pad to get dif-
ferent angles as he pushed his sharp-pointed graver around, and to
move the block, like a potter with his wheel, to get beautiful curves,
dusting away the tiny shavings as he worked.

With the use of the end-grain and the proper graver's tools, people
had begun to talk not of woodcuts but of 'wood-engravings'. Bewick
was not the first to try the new techniques, but he developed and per-
fected them. He saw that a more fluid, intricate design could be made
if instead of thinking of black lines and cutting away around them,
you thought of the background as black and concentrated on making
the design with the white lines – the slivers of wood that were
removed. These lines take their shape directly from the tools used and

49

the movement of the hand, and by adjusting these he could get a far greater variety of tone. Sometimes he used both black line and white, getting even more subtle effects.

Because Beilby left the whole business to him, he had to learn about the printing as well as the cutting. Woodcuts were the same height as the type so that they could be printed on the page at the same time, and when he took the blocks to the printers Bewick saw how the letter-press men worked. First they made up the page, taking their type from the rows of little cases, letter by letter, to form a word and then a line: capitals from the upper case, small letters from the lower case, and sometimes italic script, Greek typefaces or Roman numerals. They kept the lines apart with strips of lead (this spacing is still called 'leading'). For posters or broadsheets, which could take up a whole sheet, they wedged a single page of type tightly into the rectangular frame, or forme, but for books they placed several pages of type in the forme at once, side by side in a complicated fashion – eight, twelve, sixteen or thirty-two pages – so that when the sheet was folded, and the folded edges cut, the pages came out in the right order.

When the forme was made up it was laid on the press and fixed in place, ready for printing. First it was beaten with two heavily inked leather-covered balls, then a sheet of dampened paper was placed on a tympan, the two-part frame, each part covered with stretched calf- or sheepskin. The paper was held in place by a hinged arm called a frisket, and after it was lowered on to the type, the printer ran the bed of the press forward and pulled on a heavy handle. This slowly forced down a heavy plate, or platen, through the action of a large screw, on to the covered forme, pressing the paper on to the inked forme. The large wooden presses still had platens half the size of the press bed, so a forme often had to be printed half at a time. It was not difficult, but tiresome – running the bed in halfway, pulling, then running to the full

length of the rails for the second pull. Then the page was lifted free, ready to have the second side printed as soon as it was dry. (In a bill head for one Newcastle printer, as the bookseller John Bell explained, 'two "gentlemen of the press" are hard at work, dressed in billycock or wide-awake hats, Chesterfield coats, and knee breeches – one of them is beating the forme with the balls, while the other is laying the paper on the tympan, and about to bring down the frisket'.) Again and again the process was repeated. Slowly the sheets were piled high, to be folded and gathered and sent to the bookbinders, a separate tribe whose workshops clustered in the same mesh of streets.

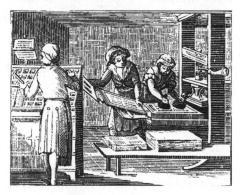

Letterpress printing in the eighteenth century

'The first difficulty, I felt, as I proceeded', Bewick remembered, 'was in getting the cuts I had done, printed so as to look any thing like my drawings, on the blocks of wood, nor in corresponding to the labour I had bestowed upon the cutting of the designs.' To test his cuts he took the blocks to his friend William Bulmer, four years his junior, who was an apprentice to John Thompson. The boys became friends and Bulmer often ran off proofs of Bewick's first woodcuts, encouraged by

Thompson, 'who was himself extremely curious & eager to see this succeed' – and who also doubtless noted how useful Bewick's clever cuts might be. But 'at that time', as Bewick noted dryly, 'the printing of woodcut properly was very imperfectly known'. If the paper was not damp enough, or had dried out overnight, the impression was faint; if it was inked too heavily it became blotchy and dark; if the ends of the block were too high they left an untidy rim: 'the common Pelt balls then in use, so daubed the cut & blurred & overlapped its edges, that the impression looked disgusting'. Bewick solved this, at Bulmer's suggestion, by shaving down the edges.

Slowly he mastered the other problems too: delicately cutting down some areas so that the ink was slightly fainter on the lowered surface and looked grey instead of black, giving the effect of distance, or putting tiny slips of paper beneath the blocks to raise them and get the fine black lines needed, for example on the outline of a church spire. The printers watched, gradually realising that this young, untested apprentice was bringing something entirely new to their trade.

At fourteen, Bewick had to learn about life in the town as well as in the workshop. An apprentice generally signed on for seven years, receiving wages only for the last three, agreeing not to swear, or gamble, or fight, or betray trade secrets. In return he was taught the mysteries of his trade and provided with lodgings. To begin with Bewick lived with the Beilby family, and Ralph took his role as mentor seriously, as Bewick soon found out. When he trailed home one Sunday with a scratched face and black eye after a fight with three apprentices who jeered at him when he set out to explore the town, Beilby laid down his Sunday routine. He must go twice to church and in the evening read the Bible to old Mrs Beilby and Mary.

Beilby also took Bewick to concerts and let him listen when he

played his double bass at the musical club in the Close, whose members included the sons of the composer Charles Avison. But Bewick was out of his depth among this cultured, more sophisticated clan, and over the years he became silently smitten by Mary Beilby, which did not help. There was a row about his care of William Beilby's horse, which he could not forgive: 'this I instantly resented & refused attendance there any more'. He had tried to fit in, but they 'treated me with great hateur, tho' I had done everything in my power to oblige them – I had like a stable boy waited upon their Horse & had cheerfully done every thing they wanted at my hands'. While he lived here he could make no close friends. He 'neaded none' he declared: in any free hours, he wrote, 'I wandered in the fields & on the town Moor alone.'

He moved out as soon as he could, going to lodge with his Aunt Blackett in Pudding Chare, a lane just across the Groat Market. Because her silversmith husband had been a guild member and thus a freeman she had the right to keep a cow on the Town moor, and Bewick remembered living mostly on milk. Morning and evening, and during his hour's lunch break, he dashed through the West Gate up to the pastures of Elswick, where he paid a penny for bread and milk. In their sixties William Bulmer reminded him of their 'anxious and early visits to Goody Coxon's to partake of her sour milk and hot brown cakes at a place generally known (in our day) by the polite designation of the "Hog's Tavern" at Elswick'.

After work he ran 'without a cap' across town – through Denton Chare, opposite the workshop, across to the Spital Field. As he went, shopkeepers nodded, 'There goes Beilby's wild lad.' And each weekend he walked back to Cherryburn. Sometimes he followed the river to Wylam; sometimes he strode up to the toll bar on to the moors, past lonely Walbottle, on to Heddon-on-the-Wall and down long Horsley Lane to Ovingham and the ferry, and home.

5 LIFE IN THE TOWN

In the decade after the Seven Years War demand for Tyneside coal rose yearly. Nearly a thousand ships passed through Newcastle each year during Bewick's apprenticeship. Colliery vessels set out for ports from Russia to Spain. Whalers set off for icy Greenland seas, while entrepreneurs shipped wares to America and the West Indies: 'crown glass, bottles, lead shot, all kinds of woollens . . . nails, edge tools and every kind of iron ware, coarse felt hats and coarse earthenware'. Returning ships brought wine from Portugal, raisins and almonds from Malaga, timber, iron, pitch and hemp from the Baltic, and brandy from France.

It was a place, as one visitor said, where 'the conversation always runs upon money; the moment you name a man, you are told what he is worth; the losses he has had, or the profit he has made by the coal mines'. The blue-stocking Elizabeth Montagu, whose wealth came from her late husband's coal and whose fine old house at Denton Burn stood by the high road towards Cherryburn, called Newcastle 'the ugliest town in Britain, but full of wealth and business'. Stagecoaches from London to Edinburgh rattled under the arches of the inns three times a day. Along Side, where Bewick worked, there were hairdressers and peruke makers, shoemakers and booksellers, flax and corn merchants. On the pleasure gardens at the Forth, there was a

bowling green and an archery field. In the inns, travelling show-
men put on exhibitions and demonstrated the new knowledge of elec-
tricity, magnetism, hydraulics.

Yet for all its free discussion the town stayed solidly hierarchical.
Since the fourteenth century it had had its own mayor and burgesses,
and it was also a separate county, with a Lord Lieutenant and sheriff.
The Corporation, a self-perpetuating oligarchy composed of families
like the Fenwicks, Blacketts and Ridleys, controlled the port and the
river and the trades – coal, lead, iron, glass, salt and brewing – and
they lined their pockets without shame. They imposed their rule
through regulations, paternalistic charity and extravagant street pro-
cessions, and their families flaunted their riches like courtiers.

Newcastle also still had its 'freemen', granted the right to trade and
to vote in parliamentary elections as members of the ancient guilds.
Conservative and self-protecting, the guilds enshrined many preju-
dices: the shipwrights and weavers swore 'to take no Scotsman born,
or other alien, to apprentice', while the coiners and armourers vowed
'that no Quaker should be taken as apprentice on pain of forfeiting
one hundred pounds'. Nearly three-quarters of the inhabitants, how-
ever, were not freemen but labourers, led by the ferociously articulate
keelmen, who rowed the coal from the staithes in their great flat-
bottomed boats to the waiting colliery vessels. This vital role gave
them sufficient power to bring the whole trade to a halt. In 1768 the
quayside was shaken by 'a dangerous insurrection of the sailors . . .
under pretence of raising and regulating their wages'.

The town was known for its friendliness and intimacy but was also
notorious for fights and drink. Violence was common and each
August, after the Assizes, the papers gave a list of executions. As the
sixteen-year-old Bewick sweated in the summer heat at Amen Corner,

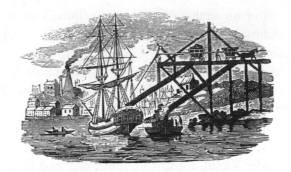

the body of a mail-coach robber hung in chains on a dreary spot on Gateshead Fell, where many highway robberies were committed.

Life was fast, noisy, sometimes dangerous, but as he grew more confident, Bewick began to enjoy the town. He left Aunt Blackett's and rented a room from Ned Hatfield, a flax dresser who lived on the north side of the churchyard. Ned's wife, 'an excellent Cook and Market woman', also took care of the dancing school on the floor below, selling oranges to thirsty pupils. He was happy here. As well as the travelling flax workers (who cheated him), Ned let rooms to John Hymers, a retired sergeant in the lifeguards, and the watchmaker and musician Whitaker Shadworth. Bewick thought Shadworth pasty and thin, and dosed him with camomile tea and tobacco. Together they stripped to the waist for exercises, drilled by the old sergeant, who tired before they did, first lying in bed to shout instructions then abandoning his drilling altogether. 'Wild, enthusiastic and romantic', Shadworth soon left for America, where he fought for the rebels in the War of Independence.

Ned also bred canaries, which a merchant took to Edinburgh and Glasgow. The house was always full of bird catchers and dealers, 'whose narratives regarding their pursuits, I listened to with some

interest while they were enjoying themselves over a Tankard of Beer', wrote Bewick. As well as beer, the bird catchers enjoyed the local prostitutes and, almost without fail, caught syphilis. They teased the earnest young Bewick as 'the old man', and in his memoirs he took a late revenge by lambasting their wicked ways. This was a tough area for a young man nervous of girls and sex. Newcastle was known for its independent women, like the girls of the building trade, hod carriers, bricklayers and slaters, whose antics made critics call for 'employment more suitable and becoming for these poor girls than that of mounting high ladders and crawling over the tops of houses'. At the bottom of Side, where Butcher's Row opened on to Sandgate, women dangled freshly butchered carcases over their brawny arms. In the churchyard and on the quay, prostitutes gathered, mixing with the fishwives and women barbers, who shaved the sailors outdoors on the cobbles.

The year was a round of festivals. On Ascension Day the Mayor and Corporation and Hoastmen took to the river in great barges, surrounded by pleasure boats, to measure the port bounds, a pageant mimicking those of Venice. On St Crispin's Day, at the start of September, the shoemakers marched in procession, and twelve days later the glassmakers had their feast. In October everyone flocked to the Hopping, the horse and cattle fair on the Town Moor. One of the liveliest holidays was at Newcastle Races, which took place on the Moor in the third week of June. At fifteen, Bewick engraved on copper a trophy of Matchem, the famous racehorse owned by William Fenwick of Bywell.

A great deal of workshop trade concerned dogs and horses: engraving collars, whips, the stocks of sporting guns, trophies, hunt cards and racing advertisements. Bewick cut the heading for race cards for many years, and his new version of the old device, showing two cocks

head to head, topped all the press announcements for cockfights. Despite his feeling for wild creatures, he was still a great one for 'a main of cocks' at the Turk's Head hotel, Loftus's Pit in the Bigg Market or 'Mordue's New Pit' in the Flesh Market. The cocks were carefully trained and fed; their wings were clipped, wattle and comb cut off, and spurs attached to their feet. At the 'mains', a contest between rival teams, combats continued all day, accompanied by frenzied betting. The gentry spent fortunes on prize birds, watching them compete amid blood and flying feathers for gold cups and silver punchbowls.

The Duke of Northumberland was a devotee and so was Squire Fenwick – but so were the farmers, carriers, apprentice boys and miners who gambled on anything they could, including donkey races and grabbing a slippery pig:

> On cock-fight, dog-fight, cuddy-race
> On pitch-and-toss, trippet-and-coit,
> Or on a soap-tailed grunter's chase.
> They'll risk the last remaining doit.

Yet Bewick remained rather innocent, never staying in an inn, or drinking a pint until he was into his twenties. He stood on the fringes of the raucous jollity that roared through 'The Collier's Wedding', the swift-paced local poem that described how all 'the Colliers and their Wives'

> Liv'd drunken, honest, working lives;
> Were very fond of one another
> And always marry'ed one thro other . . .

At the wedding feast the music sounds out loudly, as the bride takes the floor and the pipes play her favourite jig:

. . . Then Tommy goes and kisses Jenny,
And says to her, How do you, Hinny? . . .
. . . Then knack'd her Thumbs and stood her Trig;
Then cock'd her Belly up a little,
Then wet her Fingers with her Spittle
So off she goes; the Collier Lad
Sprung from the Floor, and danc'd like mad.

Bewick himself was not a keen dancer, but music was his deepest pleasure. There is a musical movement, a harmony, a rhythm in all his work. His vignettes are lyrics without words, songs on wood. The only thing that baffled him about the Quakers, whom he admired, was their shunning of music: 'Music is an emanation from heaven – it is perfectly natural to man, to drive away gloom & to solace & to chear him – The beautifull choristers of the Woods & Fields lead the way & set us the example.'

Pitmen sword-dancing

59

As a poor apprentice, Bewick could only dream of putting his name down on the early subscription list for the fine new assembly rooms, temple of the 'polite arts' and 'most elegant recreation' (a venture that made working men grumble since the money was needed to repair the decaying quays). But he was young, '& the spirits being bouyant every thing pleased me'. In Newcastle there was music everywhere. The masters who ran the dancing school at Ned Hatfield's, first Neil Stewart and then Ivie Gregg, employed fiddlers, and they too were Bewick's fellow lodgers: 'to whose performances (the scottish tunes especially)', he wrote, 'I listened with great delight'. Outside, ballad singers clustered round the Tuesday and Saturday markets, and with their singing, 'the streets of Newcastle were long greatly enlivened, & many market day visitors, as well as the town's people, were highly gratified'. All the well-known tunes were in their repertoire, from scurrilous topical ballads and sexy come-hithers to the great songs of the past, like 'Chevy Chase' and 'The Laidley Worm' and the lovely, sad 'Binnorie', the tale of two sisters, the older of whom drowned the younger because the knight they both loved chose her.

Just as dear to Bewick was the light, lilting sound of the Northumbrian pipes, much smaller and mellower than their Scottish counterpart, said to sound like a cross between an oboe and a clarinet, 'piquantly charming, perhaps the most *loveable* quality of tone of any species of bagpipe'. Each player had his own set of variations and embellishments, with staccato pauses and rapid runs and lilts. He did not play himself (Aunt Blackett would never let him try any instrument or whistle indoors), but his friend the glassmaker and enameller Anthony Taylor shared his devotion to whistling, an art of the people that Bewick felt was sadly ignored. He was proud of his good ear: he could pick up any tune at a fair or a hopping, and whistle it without fault the next morning, copying the different performers. Many of the

tunes were of the past, or the sea or the mines, but some took Bewick back to the farm, like 'Bonny at Morn'. This is a cradle song unlike any other known, the tender, tired song of a mother looking after the farm while her husband is away: the cows have trampled the corn, the sheep have strayed, the boy – whom she addresses in her asides – won't get up and the girl won't learn her lessons. Even the baby, with whom she cannot be cross, is stopping her setting things right:

> The bird's in the nest
> The trout's in the burn
> Thou hinders thy mother
> In many a turn.
> *Canny at neet, bonny at morn*
> *(Thou's ower lang in thy bed.) Bonny at morn*

> We're all laid idle
> Wi' keepin the bairn
> The lad winnot work
> And the lass winnot lairn
> *Canny at neet, bonny at morn*
> *(Thou's ower lang in thy bed.) Bonny at morn*

At home at Cherryburn his own mother was busy with children aged from three to fifteen, and a new baby: Bewick's youngest sister, Jane, was born in 1769.

The Tyne was the lifeline between Newcastle and Cherryburn, the two poles of his life. Sometimes at weekends, if he set off at dawn and reached Ovingham before the boatman was up, he would borrow the stilts that old Billy Walker kept to fetch his cow if she got stuck on the island, and stagger across, balancing above the water, hiding the stilts in the bracken until he came home. But in the late autumn of 1771 there were great storms inland, and after a week of rain on the western fells the Tyne was swollen and dark. Around eleven o'clock on the

night of Saturday, 17 November, the people on Newcastle Quay noticed that the river was rising fast, well above the height of a good spring tide. By two in the morning ships and keels had been driven from their moorings, four of them swept up on to the quay, while a mass of timber, tar, planks and rope swirled into the narrow chares behind. The roar woke people in their beds. At three the arches of the bridge began to fill, and the section nearest Gateshead collapsed, the houses crumbling into the black waters. It was dark, and bitter cold. Seven people were drowned, including a maidservant who reached safety but ran back to get a bundle, and her master who went to help her. One by one, the shops and their owners vanished in the darkness: the mercer and shoemaker, the milliner and cheesemonger.

The collapsed arch formed a dam, which caused a violent current to swirl on the opposite side, rushing through the flooded streets. At five o'clock the northern arch next to the toll booth fell in; among the wrecked buildings was Charnley's bookshop, its stock floating away on the tide, a drift of sodden pages. Men, women and children shivered on the stranded central section. A flotilla of small boats set out to save people and goods, with Bewick among the oarsmen. By dawn the Close and Sandhill were under seven feet of water. Slowly, next day, the flood subsided, leaving tales of drowning and miraculous escapes: one of the bridge's wooden houses was carried eight miles downriver to Jarrow Slake, 'nothing was left in it but a dog and a cat, both alive'; near South Shields a ship at sea picked up 'a wooden cradle, with a child in it, which was alive and well'. But the bridge was damaged beyond repair. Two weeks later more houses from the southern end fell in. Workmen began removing the ruins and the Corporation fixed up a ferry, assuring merchants that it would 'forward dispatches from the post office at any hour'. William Beilby drew the scene, and Ralph engraved it. Great sums were collected quickly,

'almost equal to the rapidity of the immolation', to help those who had suffered.

Upstream, Bywell was flooded, houses tumbled and six people drowned. Several horses, including Fenwick's valuable stud, were brought for safety into the church, allegedly saving themselves by clutching the pews with their teeth. Part of the churchyard was swept away, 'and the living and the dead promiscuously clashed in the flood'. At Ovingham the Tyne crashed through the boathouse, and eight of the ferryman's family were lost. Only the boatman and his brother were saved, clinging to the thatch. All of these were people Bewick knew. On his next walk to Cherryburn the course of the river – the landscape of his life – had completely changed, with banks and gullies never seen before.

6 PRETTY HISTORIES

When the Tyne flood struck, Bewick was eighteen. He had mastered many skills, and continued to engrave exquisitely on copper and silver as well as on wood for the rest of his life. But he was impatient, and although he admired and was fond of Beilby, he had a hot temper. Early in 1772, having served five years, he drafted a brusque petition on the back of a letter from Kit Gregson: he may never have sent this, but it expressed his frustration. 'My time of apprenticeship draws nigh to an end,' he wrote, '& I am not half master of Engraving, neither is there any likelyhood of my ever being much better so long as you continue to do the finer parts & I the coarse.' He was worried that he would serve his time '& be good for nothing in the end, for if you can't employ me then I must be obliged to *tramp* to where I can'. He complained angrily that he was still a stranger to copper engraving – and a few months later a copperplate press was installed. But although he became adept on copper, by now his skills were perfectly adapted to wood.

'Fumbling is ruinous,' wrote one later wood engraver. But from the start, Bewick had confidence. His truanting childhood had made him self-reliant; his neighbours' praise had confirmed he was an artist; his apprenticeship gave him multiple skills. Full of disdain for the crude woodcuts he had seen as a child, he looked for different models, like copperplates, or the type-metal oval vignettes in his treasured copy of

Croxall's *Aesop's Fables*. He began to take his craft seriously, studying Dürer's fine woodcuts and puzzling over their effects. In the early 1770s, the elderly engraver Jean-Baptiste Jackson, who had worked in Venice and in France under the great Jean Papillon, arrived in town 'in great poverty and distress': 'at that time I was an Apprentice Boy, & put myself to him to learn French'. Jackson left Newcastle after a short while, but stayed long enough to give Bewick some of his own large, coloured woodcuts printed with double or triple blocks. All the time his view was broadening. Then in 1771 he began cutting emblematic blocks for children's books, and in these, over the next five years, he developed his own style.

Since the 1740s British booksellers had gradually woken up to the fact that there was a market for works for children. Although we now think of folk tales like 'Jack the Giant Killer' and 'Dick Whittington' as children's stories, these chapbook tales were originally written for adults, as were Puritan spiritual adventures such as *Pilgrim's Progress*. At school children had 'hornbooks', primers with simple prints pasted on wood and protected by a thin sheet of animal horn. Children enjoyed them, but had few special books of their own, apart from brave, if lugubrious, attempts by Puritan writers to woo them with narrative such as James Janeway's *A Token for Children* of 1672, with the engaging subtitle 'An Account of the Conversion, Holy and Exemplary Lives, and Joyful Deaths of Several Young Children'.

Shortly after this new ways of thinking began to challenge entrenched ideas. In theological debates the idea was put forward that, far from being born into original sin, a child arrived innocent, with inborn human tendencies towards sympathy and benevolence. To Locke, who published his hugely influential *Some Thoughts concerning Education* in 1693, a child's mind was a tabula rasa, a blank sheet on which experience made its mark. This made early education enor-

mously important. Children learned best, Locke suggested, if they found gaining knowledge enjoyable and the best way to learn was through the senses: pictures were as important as words. The first known British book of this kind, A *Little Book for Children*, was published around 1712, using pictures to teach letters and words. In addition, teachers hoped that virtues such as common sense, thrift, hard work and kindness to animals could all be learned through stories, and through songs like the hymns of Isaac Watts, much parodied later, but pioneering in their easy simplicity and direct appeal to children:

> Let Dogs delight to bark and bite
> For God has made them so;
> Let Bears and Lions growl and fight,
> For 'tis their Nature, too.
> But children, you should never let
> Such angry passions rise . . .

At the same time, the vogue for fables and fairy tales had been growing across Europe. The late seventeenth century saw several new editions of Aesop, including La Fontaine's brilliant, finely illustrated version, which was soon translated into English. More wonders came from France, with translations of the fairy tales collected by Charles Perrault in the 1690s, including 'Cinderella', 'Sleeping Beauty', 'Puss in Boots' and 'Little Red Riding Hood'. Perrault's frontispiece, showing an old woman by the fire telling tales to three children, contained a plaque 'Contes de ma mere l'Oye', and from now on British booksellers' lists were sprinkled with Mother Goose's tales. In the 1720s *The Thousand and One Nights*, collected by the French Ambassador to Constantinople, was published in London, joining abridgements of popular works like Defoe's *Robinson Crusoe* and Swift's *Gulliver's Travels* on the bookstalls and in the pedlars' packs.

London booksellers saw a new opportunity – among them the energetic Mary Cooper, who believed in light-heartedness, publishing the first collection of nursery rhymes, *Tommy Thumb's Pretty Song-Book,* in 1744, and Thomas Boreman, who produced his very popular and tiny 'Gigantick Histories', as well as the *Three Hundred Animals* that Bewick so disliked. But the key figure was John Newbery, a London bookseller who had already made a fortune from selling the patent medicine James's Powders, an ebullient, bouncy, generous man who bailed Goldsmith out of debt and published Samuel Johnson's *Rambler* and *Idler.* Johnson mocked him affectionately as

that great philosopher Jack Whirler, whose business keeps him in perpetual motion, and whose motion always eludes his business; who is always to do what he never does, who cannot stand still because he is wanted in another place, and who is wanted in many places because he stays in none . . . overwhelmed as he is with business, his chief desire is to have still more.

He certainly had more with his children's books. He began with the *Little Pretty Pocket Book,* published in 1744, in floral-patterned and gilded Dutch paper covers, complete with 'a Ball and Pincushion, the use of which will infallibly make Tommy a good boy, and Polly a Good Girl'. The *Pocket Book* was still selling well thirty years later. Newbery's stepson Thomas Carnan took over on his death in 1767, while his nephew Francis Newbery and his wife Elizabeth also extended the children's book trade, reprinting favourites such as *Goody Two Shoes* and commissioning new titles in soaring numbers. Even the poor bought the stirring chapbook tales, like 'Sir Bevis of Hampton', and the romances sold by the pedlars, as the poet John Clare bore witness. Clare's father loved singing ballads and telling superstitious tales but he himself gleaned all his learning, he said, from the Psalms and his favourite Book of Job and

from the sixpenny Romances, of 'Cinderella', 'Little Red Riding Hood', 'Jack and the Beanstalk', 'Zig-Zag', 'Prince Cherry', etc., etc., and great was the pleasure, pain or surprise increased by allowing them authenticity, for I firmly believed every page I read.

Sir Bevis of Hampton, from a Newcastle chapbook of 1696

Long before this, schoolteachers and parents had put aside the old hornbooks and replaced them with fold-out alphabet games and 'battledores', stiff pieces of card folded twice to make a booklet, with different alphabets, writing exercises and a story, and with 'Lotteries', printed sheets of images that could be cut out and coloured, perhaps depicting street-sellers or children's games. Books became delicious treats in pretty gilded covers, small enough to fit into a child's hand, be lost in a boot, or propped in the hands of a doll. A new mood of sensibility fostered indulgence: all Europe was galvanised by Rousseau's *Emile*, published in 1762, which asserted that nature was inherently good, and that 'civilisation' could warp this. Rousseau felt that traditional childcare began with the physical swaddling of a baby and

continued with intellectual bondage, and in contrast Emile's tutor decreed that a boy should run free, in loose clothes, learning from nature and experience. Reading this, many parents felt that children needed more freedom and sensual delight: books should feed their imaginations and release their sympathies.

In this period of relative peace, better-off artisans as well as professional and gentry families had more money to spend and were happy to pay 6d. or 1s. for one of Newbery's volumes. In Newcastle, Thomas Saint was the first printer to seize on this lucrative trade. Once the engravers had made the woodcuts, the actual blocks belonged to the printers who paid for them, and on John White's death in 1769 Saint inherited a store of old woodblocks for the chapbooks and ballads. But he also branched out into sermons and grammars, mathematical and scientific works, poetry and prayers, and soon began to print his own versions of the books that he distributed locally for the Newberys. The London publishers turned a blind eye, possibly finding him a useful outlet and overlooking his piracies as a perk of the job. The fragile children's books were pretty and disposable; the reading manuals were serious and solid. But for all of them Saint needed illustrations. Woodblocks were striking, durable and far cheaper than copper, and he could see, especially after publishing Hutton's *Mensuration,* that young Bewick was the best person to provide them.

In June 1769, as Bewick sat at his workbench, his broad shoulders hunched and his hat firmly on his head, always whistling, he was working on '24 Alphabetical cuts' for the bookseller William Charnley at 6d. apiece. Among the first cuts were some for *The New Invented Horn Book,* and the *New Lottery Book of Birds and Beasts,* which Saint printed for Charnley in 1771 (a copy of Newbery's version of four years earlier). Many reading books, like the battledores, included

an alphabet in a frame. The woodcuts were no bigger than a thumbnail, but in Bewick's hands they came comically alive, showing animals and birds jumping down the letters from the Ass, the Bull and the Cat, to the Wolf, Yellowhammer and Zebra, or a galaxy of household objects: Breeches, Cradle, Drum.

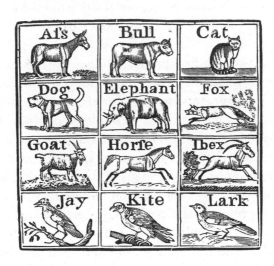

Saint also published fairy tales, like 'Cinderella' and 'Little Red Riding Hood', for which Bewick created a rather solid little heroine and a wolf who looks about to wag his tail. His woodcuts were admired. And once a printer had paid for the blocks, he maximised his investment by using them as often as he could, often mixing up sets without any apparent rhyme or reason just to fill pages. Year by year the work grew. A trail of small treasures, most of them lost for ever, used and chewed, dropped in a puddle, loved and discarded: *Goody Two Shoes, Robinson Crusoe, Story Teller, Fables, Mother's Gift, Be Merry and Wise, Cries of London, Robin Goodfellow, King Pippin, Easter Gift,*

Cinderella, Jack Horner, Christmas Tales, Holiday Presents, Apple Pie, Goody Goose Cap, Primrose Pretty Face and *Peg Top.*

With his bitter memories of his first school at Mickley, Bewick lavished care on all the little books. Some of these were known as a 'reading-easy', so-called from the title, such as *The Only Method to make Reading Easy, or Child's best Instructor,* by T. Hastie, a Newcastle schoolmaster. But often teaching and entertainment were mixed. Thus *Moral Instructions of a Father to his Son,* which appeared in 1772, and *Youth's Instructive and Entertaining Story-Teller* of 1774, both included fables.

The fable form was both popular and venerable. Fables, story-epigrams of moral certainty, had appeared in the Bible, in Greek epics and Indian stories, in Italian romances and Arabian fantasies, in Italian and French literature. A fable contained a single action, solely to demonstrate one main moral point that could be easily grasped – the crow who gets his beak stuck because he is too greedy; the man who takes his coat off when the sun shines but clings to it when the wind blows, showing that kindness is more persuasive than hostility. But constraint of action is matched by freedom of character: in a fable the actors can be human, animal or supernatural – even a tree can speak. In a compendium of 240 fables, ancient and modern, published not by

71

Saint but by Thomas Slack and probably compiled by his bookbinder Gilbert Gray, the introduction explained that they worked because they were like easy personal conversation or good jokes rather than a didactic harangue. They appealed to self-interest as well as virtue: they 'furnish us with rules for our conduct in every season of life; and may properly be called the emblems of pure morality and sound policy, expressed in the most pleasing and engaging manner'. This is how Bewick's vignettes often work too: not as sermons, but as visual proverbs, comic and dry.

The solemn *Moral Instructions*, which Bewick illustrated for Saint, was followed, in 1775, by a version of Aesop by the indefatigable writer and publisher Robert Dodsley. For the woodcut above each fable – such as 'The Sun and the Wind', 'The Crow and the Pitcher', 'The Wolf in Disguise' – he adapted Kirkall's designs from the 1722 *Aesop*. Artists felt no shame in imitation – indeed it was considered a virtue, an upholding of tradition, and Kirkall himself had copied from plates in a French edition, but in Bewick's hands the familiar images were full of wit and energy: the fox became a real fox, the ass a recognisable beast. And the following year, for a new, improved *Select Fables*, he took yet another step forward. This time he used some old, simple cuts from *Moral Instructions* and a few small and beautiful ones from the 1775 fables, but he also added fourteen larger cuts, completely redrawn within an oval frame. He was twenty-three now and his work showed how far he had advanced from his 'Little Red Riding Hood' of only a year or two before. The extra size of the new cuts gave him room to try out his new method of lowering the surface to evoke distance, creating varying tones such as no wood engraver had achieved before, adding background scenes behind the vivid foreground story. His lovely ovals, such as 'The Bear and the Bees', brimmed with poetry and fun.

For these new cuts Beilby charged 5s. each, a great rise compared to the modest 1s. 6d. for Bewick's early work. He was beginning to be valued. And even as he worked, Thomas Saint had a yet more prestigious project in mind, an edition of the witty modern fables by Thomas Gay, directed at a more sophisticated family audience. Gay's *Fables*, first published in two volumes in 1727 and 1738, retold the old examples of human foibles and vanity in verse. In 'The Beauty and the Wasp', his fashionable socialite swoons at her mirror while her maid flaps at a wasp, who has won her mistress over by ludicrous flattery:

> Strike him not, *Jenny*, *Doris* crys
> Nor murder wasps, like vulgar flys
> For, tho' he's free (to do him right)
> The creature's civil and polite.

Of course, Doris pays the penalty for devouring the sweet words, since other wasps now swarm to her too. Such stories were immensely appealing, unleashing a flood of over 350 editions over the next hundred and fifty years. Bewick lived up to the challenge. He looked carefully at the fine copper engravings of Gay's original edition, after

73

designs by rococo artists like William Kent, John Wootton and Henri
Gravelot, and he made them his own. His ovals had witty embellish-
ments, like a spade, rake, scythe, pitchfork and dibber for a rural
scene. In empty spaces at the end of stories he placed smaller vignettes:
a child and dog under a tree, a stag, a man on a donkey, and a fox on
a rock by the river. For each of the thirty fables he created a scene. For
'The Mother, the Nurse and the Fairy' he drew an interior with a spin-
ning wheel and a pygmy sprite on the cradle; for 'The Butterfly and the
Snail' a scene of digging in a walled garden; for 'The Elephant and
the Bookseller' a comic encounter among shelves piled with books.

Illustrating Gay, Bewick copied his predecessors, but his invention
took flight and his observation found a home: stacked corn and bales
in a barn, packhorses in a stable, a sexton in the graveyard, a fop in
front of a grand house. And everywhere there are animals and birds
and insects, peacocks, wasps, mastiffs, butterflies, owls and a sparrow,
turkeys and ants, hounds and huntsmen. His illustrations for the dif-
ferent sets of fables were full of tender observation of the natural
world and the behaviour of creatures wild and tame: an otter carrying
a fish on to a rock, holding it down with its paws; bulls warily circling

each other, ready to fight, tails raised in the air; a lamb on its knees, sucking greedily; an eagle ripping its prey to feed to its young; an old spaniel, ears back and head cocked, watching the snipe and partridge scatter as its master fires. And as he worked he decided to make his own book, one that no one would forget.

A few years later another of Saint's piracies would give him an even greater opportunity. This was a reissue of *A Pretty Book of Pictures for Little Masters and Misses or, Tommy Trip's History of Beasts and Birds*, which Oliver Goldsmith was said to have written for Newbery in the 1760s. It was really a brief encyclopedia of animals, prefaced by the story of little Tom Trip 'and of his Dog JOWLER and of WOGLOG the great GIANT'.

Here the lion and the jackal glared and the leopard padded quizzically along against a background of mountains. Sometimes, when Bewick had not seen the animal himself, he went very wrong, as with the rhinoceros, exotic, spiky and scaly, following the text's insistence that it is 'covered with a kind of Armour, like the Shell of a Tortoise which is of a Hardness sufficient to turn a Bullet'. The little porcupine, however, with his spikes opening like a burr, was comically endearing, and often appeared in later books. From the frontispiece, showing the

Giant Woglog carrying off the little boy, to the final page, Bewick's pictures rippled with life.

There was such enjoyment in these tiny engravings, a kind of excitement pent up in the small scale, in the fox hiding on its ledge by the river, or in the horse, rearing to go:

> Exulting! With what Fire and Force
> He stretches o'er the Plain;
> And foaming in his rapid Course
> Derides the Bit and Rein

Here too, were Bewick's first vivid studies of birds: the threatening vulture standing over picked bones; the magpie and jackdaw with a castle beyond; and the robin and wren with the thrush and the blackbird, all in one picture, singing like a choir.

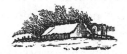

7 'GOD GAVE THE EARTH TO YOU'

In the later years of his apprenticeship Bewick found good friends in the circle that formed around the bookbinder Gilbert Gray: 'the most valuable (perhaps the most invaluable) acquaintance & friend I ever met with'. Gray had trained as a preacher in Aberdeen but abandoned this ('of a trouth, Thomas, I did not like their ways') to work for the Edinburgh poet and bookseller Allan Ramsay. Here he was fired by the new ideas that would flower in the Edinburgh Enlightenment of the 1750s and in the work of David Hume and Adam Smith, but he also learned to value the older culture that Ramsay had been passionately trying to save since the 1720s, especially the Gaelic language and the folk traditions of the Highlands, with their ideal of 'heroic valour'. Ramsay's *Tea Table Miscellany: A Collection of Scottish Songs* (which managed to smuggle in considerable ribaldry and violence under its bland title) went through countless editions. Gray admired this pioneering, racy man who was not afraid to defy the Kirk by selling 'profane books', and he brought his feeling for the common people south to Newcastle, a natural move since one of Ramsay's sons had worked on Tyne Bridge for the bookseller Martin Bryson, 'an upright, downright, honest Whig'.

In the late 1760s Gray was binding books for Thomas Slack in his workshop in Pudding Chare. He lived frugally, saving his wages to

bail out artisans imprisoned for debt and to get small, cheap books printed, which he sold in the market on Saturdays. His influence on Bewick was profound: from now on almost everything he thought, wrote and drew would be governed by a desire to educate the young and to fight against corruption and oppression. At Gray's workshop he met William Bulmer, later to become the most famous printer of the age, founder of the Shakspeare Press (spelled thus), and Robert Pollard, a flax dresser's son, two years his junior, who was apprenticed to the silversmith John Kirkup. Bewick spent many evenings at his house, which, he said, 'to me was a kind of home'. Pollard was fascinated by engraving and when Kirkup's business failed, he transferred his indentures to a London engraver, and headed south, his head full of dreams of becoming an artist.

With these friends, Bewick was eager to learn. He could afford few books, although at sixteen he did obtain a seventeenth-century Latin edition of Aesop, which was still in his library at his death, inscribed 'T. Bewick 1770'. During winter evenings he worked his way through Gray's bookshelves and in the mornings the Beilbys' servant girl let him in early to read Smollett's new *History of England* in the parlour. On other mornings he whistled for Gilbert's son William, who was also a bookbinder, 'a most active & industrious man; of an ardent but changeable temper', and they went together to William's binding-shop 'often filled with the Works of the best Authors, to bind for Gentlemen', where Bewick read them while they awaited their marbled endpapers, leather bindings and gold tooling. He shared the scrabbled learning of many artisans, like the journalist William Hone, who helped at a copperplate printers and borrowed old books from a cobbler, or the artist John Flaxman, who read his way surreptitiously through volumes on Covent Garden stalls.

Bewick's only regret was that he plunged into a mass of religious

tracts and sermons and 'got myself into a labyrinth, bewildered with dogmas, creeds and opinions'. In reaction, under the influence of Gray and other nonconformist friends, he formed his own religious and ethical doctrine. At its base was Locke's belief in a natural law, discoverable through the senses, and his argument that the evidence they bring of order all around us implies the existence of a benevolent creator. Accepting this, Bewick came to believe that there was a divine force driving the universe, a single God to whose will we must submit (although patient resignation was never his strong point). As far as ethics were concerned, the best way to serve him was simply to be 'good Sons, Brothers, Husbands, Fathers, Neighbours & members of society'.

He also hit upon a creed for physical as well as spiritual health. Hours of sitting bent over a workbench were hard on a tall, active youth, and when Bewick caught some minor illness, the doctor, Nathaniel Bayles, took Beilby to task: 'What! said he, & have you no more sense than to set a growing country lad to work, doubled up at a low bench, which would inevitably destroy him & in his passion cursed poor Beilby for his ignorance – or for something worse.' Bayles could have been wrong in blaming Beilby, as mild chest infections often masked tuberculosis, which infected nearly all city dwellers at some stage and touched Bewick's own family even in the country. However, he saw that in essence Bewick was 'strong as a Horse', and decreed a regime of moderate eating and drinking, exercise and fresh air, which may have saved him. Bewick also eagerly took to heart the best-selling book *Sure and certain methods of Attaining a Long and Healthy Life* by Luigi Cornaro, a Venetian doctor – who, reassuringly, lived to be nearly a hundred.

Bayles was a remarkable man. A surgeon, practising rather like a general practitioner today and treating the poor for free, he was also an

engraver, mechanic and inventor of a fearsome triangular harpoon, and he managed to remain official sword bearer in the Corporation's processions for over thirty years, while fighting its leaders openly. In these years, Bewick met extraordinary people at every turn, like Bayles, or the bony, kindly, impoverished 'pastoral poet' and strolling player John Cunningham. Ann Slack, with her brisk good-heartedness, gave the unworldly Cunningham money and clothes, and tried vainly to persuade him to dedicate his poems to Elizabeth Montagu, a patron with strong local interests, instead of to the actor he most admired, David Garrick, who inadvertently wounded him by brushing aside his approaches. Bewick greatly admired his poems, published by Thomas Slack, and sketched Cunningham in the streets just before he died in the Slacks' house in 1773.

The character who impressed him most was Thomas Spence, a young schoolteacher from the quayside, three years his senior and one of the circle around Gilbert Gray's workshop. To Bewick, Spence would always seem

one of the warmest Philanthropists in the world – the happiness of Mankind, seemed with him, to absorb every other consideration; he was of a most cheerful disposition, warm in his attachments to his friends & in his patriotism to his country – but was violent against people, who he considered to be of an opposite character – with such he kept no bounds.

Spence's father, Jeremiah, was a netmaker on the quay. Like Gilbert Gray he was born in Aberdeen, while his wife, Margaret, who helped to keep the family afloat by running a stocking stall, came from Orkney. Thomas was one of their nineteen children, and he had to work from childhood to contribute, but Jeremiah (a pious Calvinist who later joined the Sandemanian sect, which believed in the communist principles of primitive Christianity), made all his children read, and

Spence gained enough education to become a clerk, before opening his own school in the alley of Broad Garth behind the quay. His mentor was the Revd James Murray, who arrived in Newcastle in 1764, preaching fiery sermons on the equality of man, 'in a loud manner with a Scottish accent'. His admirers built him his own meeting house on High Bridge, where he addressed a packed audience. Tall and skinny, clumsy in his gestures, with his clothes always showered in snuff, Murray knew the power of laughter as well as fire and brimstone, and Bewick, like Spence, admired his satire and his playful ways.

Spence was thin and small, hardly five feet tall to Bewick's six, with a limp and a stutter. He was a warm-hearted idealist, whose passionate egalitarianism was steeled in a great local battle over customary rights on the Town Moor, in which Murray and Bayles – known ever after as 'the eloquent Sword Bearer' – were also involved. Some years before, the Corporation, led by the Mayor and MP Sir Walter Blackett, had tried to enclose the moor and take profits from leases, mines and turnpikes: a Freemen's Committee met to oppose them and in late 1771 Bayles and another surgeon, Henry Gibson, led a mass trespass, burning down hedges and letting in the commoners' cattle to trample crops in the enclosures. The fight went to court and at the Assizes, on 10 August 1773, the Freemen's Committee won their case, to the delight of the townsfolk: 'ringing of bells, firing of guns, illumination of houses, and other public rejoicings'. Next year an Act decreed that although the Corporation were technically the owners, each freeman had the right to graze two milch cows on the Moor in perpetuity. The 10 August became a people's holiday.

The radical groups were elated. In the election of 1774, their candidates John Phipps and Thomas Delaval contested the Newcastle seats against the sitting MPs, the powerful Sir Walter Blackett and Sir Matthew White Ridley. James Murray started a blistering monthly, the

Freemen's Magazine, attacking despotism, greed and exploitation and Jean Paul Marat, then living in the town, published his *Chains of Slavery*, with a vehement address to the Electors of Great Britain to be vigilant against parliamentary corruption. Feelings ran high. To add to their own grievances, Newcastle voters were inflamed by the government's high-handed treatment of the American colonies, where newly imposed taxes had led to the defiant dumping of tax-carrying East India Company tea in Boston harbour. In early 1775 Massachusetts and other states were declared in rebellion and after British redcoats fired the first shots in Lexington that April, conflict was inevitable. When the Newcastle Constitutional Club met in the Long Room at the Black Boy inn at the start of the war, after drinking to the King and the Freemen and Burgesses of Newcastle, their toasts became loud, even dangerous, including 'Success to the brave Americans in their constitutional resistance' and the hope that the heads of the contrivers of the storm against America might 'be speedily placed on Temple-Bar'. They also toasted 'The Glorious 10th of August, 1773' and cast down a final gauntlet to the government: 'May the embers of British Liberty be rekindled by American fire.' When the proclamation of war with America was read out in the streets of Newcastle, it was greeted with grim silence. Spence and Bewick walked up together to sign the petition against the war and stood shoulder to shoulder as they wrote their names. Many of Bewick's friends signed, including Ralph Beilby, William Bulmer, James Murray and John Hymers from Ned Hatfield's.

Earlier that year Spence had started an informal debating society in the evenings in his schoolroom, with a number of young men, including Bewick. They argued over the war, but also over other issues, especially the 'theft' of the land. In recent decades thousands of acres of common land had been carved up by enclosures into neat and tidy fields. Each enclosure was authorised by a private Act of Parliament:

nearly four thousand were passed between 1750 and 1810, at the expense of the cottagers and day labourers who worked strips in the common fields and grazed livestock on the common, and the squatters who built shacks and made gardens on wastelands and heaths. 'Improvement' was the word on everyone's lips. 'What an amazing improvement would it be', wrote the agricultural campaigner Arthur Young, gazing over Salisbury Plain, 'to cut this vast plain into inclosures, regularly planted with such trees as best fit the soil!' In 1775 the land Bewick himself loved was under threat. On 8 February the *Courant* printed a notice of the proposed enclosure of Falcherside, Rise-moor, Mickley Moor, and Prudhoe Moor, on the petition of the Duke of Northumberland, Lord of the Manor, and others. Bewick mourned the loss of fells and wild spaces. 'The poor man was rooted out', he wrote later of enclosure, 'and the various mechanics of the villages deprived of all benefit of it.' Like so many, he took Goldsmith's lament in 'The Deserted Village' of 1770 as his anthem:

> Sweet smiling village, loveliest of the lawn
> Thy sports are fled, and all thy charms withdrawn;
> Amidst thy bowers the tyrant's hand is seen,
> And desolation saddens all thy green:
> One only master grasps the whole domain,
> And half a tillage stints thy smiling plain.

At the end of his first major book, the *General History of Quadrupeds*, Bewick placed a telling vignette. A boy holding out his hat leads two blind fiddlers past the smooth walls of a new estate, adorned with urns and busts: the land is firmly guarded, with a signboard on the wall announcing 'Steel traps and Gins'. But beneath the sign an ominous crack has appeared. Some day that wall will shatter and fall.

Spence had worked out his own position during the Town Moor fight, arguing that private property should be abolished and each parish should control its land for the good of all. When he proposed this topic, 'property in land being everyone's right', for a debate at the club he reckoned on Bewick as one of his backers, but to the farmer's son the idea that everything be administered by public officials was almost worse than enclosures: it might be a fine idea on a desert island or in a new colony, but surely it would be wrong, and dangerous, to take land away from people who tended it lovingly. Bewick was a radical of the old 'Liberty and Property' school, valuing traditions and seeing ownership of land as part of a healthy society. When Spence – inevitably – lost the debate and the room emptied, he spun round on Bewick, calling him a 'Sir Walter Blackett' (the worst abuse for a Tynesider) and shouting, 'If I had been as stout as you are I would have thrashed you.' Both lost their tempers. Spence produced a pair of cudgels and shamefully – given that Spence was bow-legged and rickety and Bewick was a six-footer, expert at cudgels – Bewick beat him black and blue, claiming he had cheated.

Spence bore no grudge: the fight over and bruises healed, he and

Bewick stayed close. But he was always in trouble and was soon embroiled in a row with the grandly named Newcastle Philosophical Society, founded in March 1775. This was a more formal club (no drink allowed, voting by ballot, no one to speak twice before everyone had their turn), whose twenty members met fortnightly in rooms in Westgate Street. Spence and Murray both joined, with young tradesmen such as the bookseller Richard Fisher, the surveyor John Fryer and John Collier, a drawing master, coach painter and combative local historian. Ten years older than Bewick, he was the son of John Collier, the Lancashire signwriter and caricaturist known as 'Tim Bobbin', an early promoter of dialect writing whose character 'Tummus' was rather like the country folk in Bewick's vignettes – obtuse, stubborn, unaware of the consequences of his actions.

The society argued over topics such as 'whether the practice of imprisonment for debt be a disadvantage or an advantage', or 'whether the Civil War in the reign of Charles I and the present contest with America be similar'. Unanimously, they agreed they were similar. With America still in mind, they asked, 'Which is the better form of government, a limited monarchy as in Great Britain, or a republic?' The *Chronicle* reported laconically, 'By a majority of two – a republic.' But although Bewick supported the colonists, the uproar over America perturbed him. At sixty he was still musing over the debates, which, he said:

served greatly to alter the notions & the opinions of the people concerning the purity of the British government & its representative system and this attempt at doing it away altogether in America seemed a prelude or forerunner to the same system of misrule when by slower degrees a future opportunity offered of doing it away at home.

There was much to be said on both sides. If kings would only follow the example of Alfred the Great, 'the wisest the bravest and best, the

World ever knew', and foster the arts and sciences, then they would rule in the hearts of the people: if they surrounded themselves with flatterers and bad counsel, they could not hope to rule justly and must be opposed. The infant America, however, stayed in Bewick's mind as a beacon of hope, whose government would one day be 'like a Rock founded on the Liberties & Rights of man'.

At the Philosophical Society Spence also held forth on land. But since he violated its rules by printing his talk as a pamphlet, *Property in Land, every Man's Right*, reading it in pubs and hawking it in the streets 'like a halfpenny ballad', the mood turned against him. On 25 November, after an unrelated debate on 'What is Virtue?', the club expelled him, claiming he had only become a member 'for the purpose of obtruding upon the world, the ERRONEOUS *and dangerous levelling principles* with which the lecture is replete'. Despite a fierce defence by James Murray – who asked for responses to be sent to Bewick at Beilby's workshop – he was not reinstated. Bewick was working in Eltringham for much of this time and was not at the crucial meeting. November had begun with terrible gales and ended with heavy snow – the bodies of a young woman and a man were found in drifts on the fells. This was not the weather to walk down the Tyne from Cherryburn. Yet he stood by his friend, now and in the days to come.

Like Gilbert Gray, Spence was a passionate believer in self-education for poor adults and had worked out a way to teach English through a phonetic alphabet of forty characters. But for a new alphabet he needed new type, and for this new moulds were required, stamped by punches cut to the right shape. Bewick cut the steel punches for Spence's *Grand Repository of the English Language*, published in 1775, and for the Supplement to his mock-classic *History of Robinson Crusoe, and Rise in Progress of Learning in Lilliput* – (Or, R'OB'IN-S'IN KRUZO'z IL'IND/Doun too thĭ prĕzint Tim). Even in Lilliput,

land was of prime importance, as Spence's verse emphasises (this one swings along well to 'God Save the King'):

> The Parson's Rate is all
> Paid now by Great and Small
> For House or Land
> No more by Nature's due
> God gave the Earth to you
> And not unto a Few
> But all Mankind.

Bewick and Spence, like many of their group, looked back to 'old British rights', to Alfred and the Saxons and the Peasants' Revolt of 1381, as well as the 'Glorious Revolution' of 1688. They saw that old customs, as well as land, were under threat and felt that at some deep level even their language was being stolen and their voices silenced. Spence's phonetic alphabet was not the only expression of this: John Collier published his own surreal Alphabet, 'By a Supposed Lunatic', with a preface praising Saxon simplicity and damning complex grammars that stunned schoolchildren:

For instance, take up a stone or an axe and knock it against a tree and I cannot help fancying but with the breath of the stroke it says *Wood*! as plain as the letters can form it or we can pronounce it . . . This I call the language of *God*, of *nature*, of *common sense* –.

Much later, Spence would defy Edmund Burke's description of the masses as 'a swinish multitude' by editing an anthology, *One Pennyworth of Pig's Meat*, full of poems and songs as well as extracts from Locke and Milton, Goldsmith and Shakespeare. And just as Spence used the people's songs to intervene in politics, so in years to come, Bewick used popular woodcuts.

II STREAM

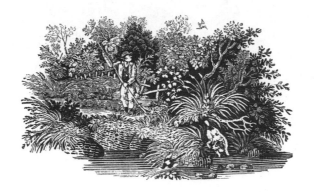

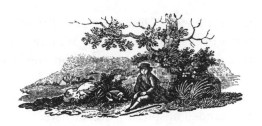

8 NORTH AND SOUTH

In the summer of 1774 Beilby went to London for two months to study illustrative engraving, trusting Bewick enough to leave him completely in charge. He worked happily on with their new apprentice, young David Martin, from a nonconformist family in Gateshead. But on 1 October Bewick's own seven-year indentures finally ended. He stayed on at Amen Corner for a few weeks as a journeyman, while the radicals fought – and lost – the election. Then he packed his bags and walked home.

One of the charms of woodcutting is that it is so portable: it involves no complicated processes and you can do it anywhere, provided you have the wood, the tools and the light. Bewick could work easily at Cherryburn even though the house was full of brothers and sisters, running down through the years. His eldest sister, Hannah, had married and Agnes, too, would soon leave, to marry a farmer from Hedley, up on Mickley moor, but sixteen-year-old Ann was still at home. John and William were fourteen and twelve, and Sarah and Jane were eight and five. Another member of the household was his cousin, nine-year-old Sally Dicker. His aunt Hannah, 'a very beautiful woman, & like the rest of the family a very handsome tall figure', had married an East India Company surgeon, Abraham Dicker, and settled in Chelsea, but Abraham died while Sally was a baby, and Hannah a

short while later. In the dark of December, Jane Bewick sailed to London and brought her orphaned niece home. With help from the Revd Gregson, John managed to claim £20 a year from the East India Company for this extra mouth.

At Christmas Bewick went with John to collect the payments for coal, meeting open-handed hospitality everywhere:

The countenances of all, both high & low, beamed with cheerfulness, and this was heightened every where, by the music of old Tunes from the well known exhilerating wild notes of the Northumberland pipes, amidst the buz occasioned by various *foulploughs* (morrice or sword dancers) from various parts of the Country – These altogether left an impression on my mind, *which the cares of the World* have never effaced from it.

For the next year he worked from home apart from a few stints as a journeyman for Beilby in Newcastle, when he stayed in town to see friends. Beilby was proud of his newly fledged apprentice and keen to raise the workshop's profile. When Bewick was working on *Select Fables by the late Mr Gay* he had set up some sample pages, with a headpiece and tailpiece, and sent them to the Society for the Encouragement of Arts, Commerce and Manufactures in London, which gave awards to encourage design in the provinces. One headpiece was 'The Hound and the Huntsman', whose decorative borders, quick movement and active scene showed how talented the young artist was and how well he knew such country scenes.

For a long time they heard nothing, and then, in January 1776, the post boy brought a letter to the workshop. It was from Samuel More, Secretary of the Society, summoning Bewick to receive a premium. He had won joint first prize. Revd Gregson 'flew from Ovingham when the news arrived', Bewick noted, 'to congratulate my father & mother upon the occasion; and the feelings & overflowings of his heart – can

be better imagined than described'. Bewick could choose between a gold medal and seven guineas. He took the money and Kit Gregson, now apprenticed to a London apothecary, went in his place to receive it, sending back a draught in the Revd Gregson's name. Bewick cashed it, and, he wrote, 'I never in my life felt greater pleasure than in that of presenting it to my mother.'

Bewick's books, as well as the money, appealed to his family. Among the surviving books is a scuffed copy of *Moral Instructions*, marked 'John Bewick his Book 1775', with a sketch of a sportsman shooting a bird in a tree on the fly leaf, and an epigraph in John's best handwriting: 'Remember man as thou goest by! As thou art now so once was I'. The brothers are linked on the page, as they were in life. Through children's books and fables Thomas had set sail and John would follow in his wake.

After Bewick heard of his prize, the winter closed in. Apprentices slithered down the icy stairs to Newcastle Quay to skate on the Tyne,

which was 'totally frozen and fixed' from bank to bank. In late January drifts closed the roads and icicles as long as spears hung from the barns. Once again pedlars perished in the snow, like poor Ralph of Winlaton, well known for selling fishing rods and walking sticks on the streets of Newcastle. But despite the storms, Bewick was happy, 'like a bird which had escaped from its Cage'. In winter he hunted and when spring came he fished. He worked on his cuts but more often, he wrote: 'rambled about among my old neighbours, and became more and more attached to them, as well as to the country'.

Tragedies, however, broke into the idyll. In April 1776 his old schoolmate Betty Gregson died, and her father sent a heartbroken little note, inviting Bewick to the funeral. A shadow fell on the spring, and now that he had all the time in the world even the things he had longed for, like fishing, began to pall. He was twenty-two, and restless. On a hot day in June he put down his rod, tied up his fishing tackle and walked home. To his mother's dismay he asked her to pack a shirt, and informed her he was off to see her brother in Cumberland. With three guineas, which Jane sewed into his waistband, he walked off, his dog, Witch, by his side, a lolloping springer–lurcher cross. At Haydon Bridge he visited Spence, who now ran a school there but closed it for two days so they could see the neighbourhood, and walked with him as far as Haltwhistle. From here Bewick set off south-west across the fells, losing his way and stumbling into Ainstable in the dusk.

This was Bewick's Grand Tour – not to Italy or France, but to the west and the north of his own country. He had no plan. After a week, meeting friends and fishing, he walked north with his cousin, a famous Cumbrian wrestler, to Carlisle. There he called on Lowrey the watchmaker, who knew him as the boy who engraved the clock faces at Beilby's, and when a man in the shop asked him where he was going, he

heard himself say 'Scotland'. He strode off with this chance acquain-
tance, who turned out to be 'one of those vapouring fops who was
very proud of his great prowess as a pedestrian – I could soon see that
he wanted to walk me *off my foot*'. He was equally proud of his
capacity for drink, stopping at every pub while Bewick lounged on the
bench outside, but together they reached Langholm, across the Scot-
tish border. Now Bewick was on his own, crossing the sheep-nibbled
hills of the Borders, reflecting on the pointless, bloody battles of the
past and drinking from the streams in the 'flipes of his hat', as he later
told his daughter Jane.

In Edinburgh he stayed at the George Inn, on the recommendation
of a Newcastle silversmith. But it was the first inn he had ever stayed
in, and it took courage to call for a pint, 'when lo! A good looking
Girl, bare footed & bare legged entered with a pewter pot almost the
size of a half leg of a Boot – this I thought I could not empty in a
week'. He fled, taking refuge with widow Hales, another Newcastle
acquaintance, and calling on the engraver Hector Gavin. The Tyne
web spread wide. In Glasgow he bumped into a cutler who had lodged
at Ned Hatfield's and whom he had thought long dead: 'he was not

like me, for he could drink plenty – so that I was at no loss what to do at the Inn, as I had been in Edinburgh'.

Everywhere he went, from Dumbarton up into the Highlands, his preconceptions were constantly overturned. When he stood mortified on the banks of the Leven, unable to translate the Latin inscription to Smollett, his favourite author, a young Highlander jumped down and helped him make it out. As he zigzagged by lochs and through passes, the Gaelic-speaking families of farmers and shepherds pressed him to stay – 'often, the Mistress of the House, in these remote places, never having seen any person from England, examined my dress from head to foot' – and questioned him in halting English. In these crofts, where three generations lived side by side, adding a new house with each marriage, surrounded by vegetable gardens and peat stacks, no one would accept payment for their kindness. And everywhere they played their skirling pipes, while he whistled Tyneside songs in return.

It was a romantic odyssey and girls were on his mind. He had just wept for Betty Gregson, the first girl to make him notice the opposite sex. He had smarted in his silent admiration for Mary Beilby, when he was too shy to tell her. To the talented Beilbys, proud of their education and social standing, he was a country-bred apprentice, beneath notice. This rankled: 'I would have married her before I was done with my apprenticeship without any fears on my part – but I felt for her & pined & fretted at so many barrs being in the way against any union of this kind.' It was not to be. Mary herself suffered a slight stroke; her face was affected by palsy and before Bewick finished his indenture she fell into depression. Nothing was, or could be, said.

He had paled, and dodged the Newcastle prostitutes. But now he had no fears of any kind, social or physical, and the girls he saw seemed embodiments of the freedom he had always yearned for. The Edinburgh inn girl, the ruddy-faced girls dancing at Tyneside fairs; the diffi-

dent Highland girl who followed him to offer him food for his journey. When he kissed her, impulsively, she sprang away 'with her bare leggs, like a Deer' and her sandy brown hair, tied with a ribbon 'dangled down her back, and as she bounded along it flowed in the air'. The girls, the music, the mountains, the 'unpolluted, unspoiled, honourable & kind people' became an image of the ideal land. Even in old age, Bewick admired the Highland clans' refusal of the great bribe – thirty thousand pounds – to betray Bonny Prince Charlie when he fled north in 1746. He raged against the clearances, so-called improvements that allowed Scottish landlords to drive crofters off their land and overseas: this was 'despotism, the offspring of misplaced aristocratic pride'.

As he walked, he made many small drawings of Highlanders in their bonnets or crofters framed by the trees. He always kept to this habit of making tiny sketches on odd scraps of paper, or making rough drawings from memory later, laying them by, sometimes for years, to use later as the basis for tailpieces. At last, hungry and nearing the end of his three guineas, Bewick reached Stirling (where the landlord told him he could have earned good money if he had brought his tools with him, engraving coats of arms for the Lairds). As he turned south he met the modern side by side with the past. He saw the great Carron steelworks and marvelled at the new canal, where the boats ran over his head – but he also passed the site of Bannockburn, where Robert the Bruce defeated the English in 1314. In Edinburgh he got a berth on a Leith sloop and nursed an infant through a storm while its mother was sick over the side. After landing at South Shields he headed up river and walked up Side through the crowds of Assize week with a few shillings left in his pocket.

Bewick was home, but not to stay. He did not want to work on as a journeyman, and could not stay at Eltringham and live on piecework.

Accepting that the place to show his skill was in London, he stayed to earn money for his passage, then in September 1776 he boarded a collier, suffering three weeks battered by storms down the east coast. When the boat finally moored in the Thames, Bewick hired a scull to take him up to Temple Bar. The river was thick with vessels, a forest of masts, with the shouts of sailors echoing across the wind. As they approached London Bridge, the notorious 'gulf', where the waters swirled dangerously between the arches, the scullerman asked him if he was '*affeared*': 'but not knowing what I was to be affraid of, I asked him the same question at which he looked *quere*'.

Bewick was indeed scared, not of the river currents but of the city itself. Yet he had no need to be. After centuries of the coal trade, many Newcastle families had a foothold here and Bewick was immediately made welcome. Kit Gregson was working for the Society of Apothecaries in Blackfriars; his brother Philip was a Custom House clerk; William Gray was a bookbinder near Fleet Street. Robert Pollard, after training briefly with the painter Richard Wilson, was apprenticed to the engraver Isaac Taylor, and William Bulmer's older brothers, Fenwick and Blackett, had a flourishing business in the Strand. The Gregsons found him lodgings and Pollard found him work through Isaac Taylor.

London was vast, the biggest city in Europe, its population thirty times that of Newcastle. The crowded streets were jammed with carriages, street-sellers, servants on errands, but even in this baffling maze Bewick met friends. After tramping the streets on his own, he bumped into Serjeant Hymers – the old drill sergeant from Ned Hatfield's. It was a puzzle who was more surprised: 'He held up both his hands – he looked – he laughed – shook me by the hand over & over again & seemed not to know how to be kind enough.' The sergeant rushed him back to his own lodgings where he dressed in all his military finery, and

off they set, first to see the 'blackguard' haunts of the city, Hymer's warning to the bumpkin, and then the more respectable quarters.

Soon he learned his way around. In the City, the merchants circulated round the Exchange; around St Paul's, the booksellers clustered. Across the Fleet Ditch lay the Inns of Court, and the Strand with its glittering shopfronts. To the north, in Clerkenwell and Holborn, writers worked in garrets and presses ran without cease, and beyond Covent Garden, with its coffee houses and bagnios, lay St Martins Lane, Leicester Fields and Soho, the quarter of artists, furniture makers and craftsmen, where Josiah Wedgwood had just opened new showrooms for his classical vases. There were exhibitions at the Royal Academy and the Society of Arts. New squares and avenues stretched to the west; over the river lay the lighted walks and bandstands of Vauxhall, and upstream the new pleasure gardens of Ranelagh.

Amid this bustle, Bewick began work in his rooms in Wharton's Court, off Gray's Inn Road. Not far away, in Lincoln's Inn Fields, the young William Blake was coming towards the end of his apprenticeship and copying the sculptures in Westminster Abbey. Bewick, too, often went to the great echoing abbey on Sunday afternoons, loitering among the coloured waxworks of old monarchs, the suits of armour, the tourists, the schoolboys playing skittles in the nave. Here and in the streets of Holborn the two very different young engravers crossed without knowing it. Both were radicals, firm believers in the art of the particular, the light in the mundane detail. But Blake was seeing visions, while Bewick was rooted to the Tyneside world he knew and yearned for.

First he set about woodcuts commissioned through Isaac Taylor, who ran a bookselling and publishing business at the Bible and Crown in Holborn. A famous engraver on copper, Taylor had engraved the illustrations for Oliver Goldsmith's *Deserted Village* in 1770, and

Bewick and Pollard were in awe of him, thinking his frontispiece for John Cunningham's *Poems, Chiefly Pastoral*, 'the best thing that ever was done'. A good businessman and stout radical, he was a fervent supporter of Wilkes, and had many friends in the arts, including Goldsmith, Fuseli and David Garrick. Another employer was the Newcastle printer, Thomas Hodgson, 'a most assiduous, carefull & recluse man' who worked in Georges Court in Clerkenwell, and had recently received a prize from the Society of Arts, for his work on Sir John Hawkins's *History of Music*. Overwhelmed with orders, he had waited impatiently for Bewick's help; he was generous and welcoming and Bewick always remembered him warmly. The affection was mutual: when Hodgson died he left Bewick £5: 'the first money I ever received that I had not wrought for'.

Bewick discovered that London was a place of increasing specialism: 'one man does one branch of business & another another . . . & it is by this division of labour they thus accomplish so much & so well'. With his many skills on silver, copper and wood, Bewick was used to seeing the whole task through: he did not want to work on a single part of the process or to be a slave to wage labour. Nor did he want Elizabeth Beilby's husband, William Watson, to get him work at the Royal Mint. Instead, he worked for himself, picking up commissions from Thomas Carnan and Francis Newbery in St Paul's Churchyard, and creating delightful cover designs for books like *The Polite Academy: or School of Behaviour for Young Gentlemen and Ladies*, for another London bookseller, Richard Baldwin. But he found it hard to settle, telling his godmother's daughter, Elizabeth Hymers, in November that the Lord Mayor's show and all the shows put together could not give him half the pleasure he felt in the Eltringham woods.

Still, he was earning good money and was surrounded by friends. He drank his pint of porter with the tradesmen at the George Inn in

Brooke Street just behind his courtyard, where the landlord's wife came from Cumberland and claimed to be a distant relation. He saw William Gray, who had married and had a baby girl, and whose house became Bewick's second home. Every Monday night he read the Tyneside papers and met other Newcastle friends at the Hole in the Wall in Fleet Street. Before the Fleet River was filled in, the colliers had unloaded nearby, and in Lent Newcastle men gathered here to celebrate Carlin Sunday, eating carlings – grey peas – to celebrate the relief of a famine long ago.

Bewick's friends took him to see the shows, the art, the sculptures. Out of curiosity, he went with Pollard and William Watson to hear leading preachers, a popular Sunday pastime, drawing huge crowds. But for all its bold display, London in 1776 was an anxious city. On 4 July, the American Congress approved the Declaration of Independence. The navy was on the alert, and soon after Bewick arrived, one of the crew from the boat that brought him from Newcastle took refuge with him from the press gang: 'This poor fellow, a decent man, had in his youth been on board of a Ship of War & as far as concerned himself he said he did not mind going again, but the thoughts of being digged from his family threw him into very great distress.'

In the gloom of January 1777 Bewick received a letter from David Martin, who was 'not much surpris'd' at his lukewarm response to the capital, he said, when he considered Bewick's 'natural love of sincerity

& simple Honesty'. He passed on the encouragement of Gilbert Gray, gossiped of friends and told him that the Beilbys had moved house, to the top of Northumberland Street, 'so that I have a long tramp for the Key every morning'. The workshop had been busy – 'very throng about Christmas time' – and Martin missed Bewick, hoping his dislike of the south might bring him home to his old walks by the Tyne which he believed he would have 'more pleasure in than viewing some of the grandest Scenes that is exhibited in London'.

Then in March Bewick's mother wrote. She had heard that he was suffering from a fever: for two months he had not written and Jane's letter, with her idiosyncratic spelling, rings with the hurt of a mother kept in the dark:

I fancy if you had Dy'ed, I was to be cept in the secret . . . you may be well asured that nothing givs me more Pleasure than to hear of your well dooing, and, as your aquentance gets those news, I think it woud be as proper that a Father & Mother had the same, who spends many an Hower in talking about you, I think I never seed your Father so discomposed at any one thing, as he was at your long Silence.

But it was not all scolding. Bewick had been sorting out business at the East India Company with regard to Sally Dicker's allowance and Jane was relieved, 'for we are both Sinking a Pit & Breaking a Groov at this time, and the Rent Day coming on so that I am not a little elligated [elated] at the good News, and I dare say it will be a means for me to Sleap, when I shoud been cept awake'. She wrote, too, about the hotly contested election of 1777, caused by the death of Sir Walter Blackett, whose nephew, Sir John Trevelyan, only just scraped in: 'such a Contest I fancy was never in Newcastle'.

For Bewick, these letters brought Amen Corner and Cherryburn and the arguments in the clubs vividly before him. By now he was

already thinking of returning. David Martin was surprised at the lack of opportunity for woodcutting in London, having thought, admiringly, that there was no wood engraver there 'who could doo anything worth looking at & yours being so much superior thereto that you would get any price you asked'. It was not quite the case. Most of the trade work in London was on copper: invitations and trade cards, illustrations and bills. Bewick had come to London hoping to see the 'Cockneys' at work and discover something new. He was used to co-operative work, the old workshop system of sharing tasks, pooling knowledge. In this new system he found that his fellow engravers were jealous of their techniques and tried instead to spy on him: 'and I thought such of them as did so were a most saucy, ignorant & impudent set'.

He was teased as a 'Scotchman' – a term of abuse since there was great resentment of Scots in positions of power, especially the Earl of Bute, seen as a malign influence on George III. Always prickly when taunted, Bewick often got into fights. When a man at the George spoke disrespectfully of Scotland and its 'filth & dirt', Bewick told him of the kindness he had met with there, adding that if he wanted filth, 'such might be found without going much beyond the street we were in'. London was too full: it had no edges, no escape. 'It appeared to me to be a World of itself where everything in the extreme might at once be seen – extreme riches – extreme poverty – extreme Grandeur & extreme wretchedness.' All transactions were cold and selfish and even good men became hardened, their softer feelings crushed. He felt himself dwindling to nothing in the 'great mass of moving humanity'.

The city pressed on him physically. He was very aware of his body, nearly six feet tall, broad shouldered and muscled, trained by Serjeant Hymer's drill, Nathaniel Bayles's regime and his Highland trek. He had toughened himself by sleeping on a stiff mattress with his window

open to wind and even snow, stripped to 'bare buff except being rolled in a blanket', but the windows of Wharton's Court opened on to damp air, stinking of the gutter, and he succumbed to fever – perhaps the smallpox that left his face scarred. His bodily unease focused on women. When the writing of his memoirs forced him to look back, he slipped into a tormented, muddled analysis. He had a strange, idealised view of women, and from Betty Gregson and Mary Beilby on he was often tongue-tied before them: 'for my part I often felt myself so overpowered with reverence in their prescence that I have been almost unable to speak & they must often have noticed my embarresment'. The London streetwalkers, he said, 'constantly hurt my feelings'. These were not desperate wretches but fine-looking women, and when he questioned them 'their common replies was that they had been seduced & then basely betrayed'. Sometimes this was true, but London's three thousand prostitutes also included many adding to wages as shop girls, servants and stall holders.

As in Newcastle, what upset Bewick most – coming from the farm where his mother, all his childhood, had a new baby on her knee – was the prevalence of disease: '& I was grieved to think that they were thus prevented from becoming, perhaps the best of mothers to an offspring of lovely & healthy children'. Sometimes the girls he met cried, and if they were poor, he gave them money. Many, however, were well dressed, like the girls in the doorways of the Strand, decked in colourful finery to entice country men. In old age he told John Jackson that he deliberately played up to this 'and would ask, with an expression of solid gravity, if they knew "Tommy Hummel o'Prudhow, Willy Eltringham o'Hall-Yards, or Auld Laird Newton o'Mickley"?'

The names from home were like a charm against harm. He was straightforwardly homesick: 'The Countrey of my old friends – the manners of the people of that day – the scenery of Tyne side seemed

altogether to form a paradise for me & I longed to see it again.' This was also, perhaps, a shrewd and calculated choice, a realisation that he could do better in a provincial milieu than in the highly competitive capital. But when Bewick told Isaac Taylor he was going home, Taylor was aghast: he had been a generous patron and had just arranged for him to attend the school of drawing opened by the Duke of Richmond – here at last were the lessons he had long wanted. But the more Taylor urged him to stay, the more adamant he became. He would enlist as a soldier, he said, 'or go and herd sheep at five shillings per week' as long as he lived, rather than stay. Taylor never quite forgave him, and although Bewick tried to make amends by sending him *British Birds* with a generous letter, the old man never answered and did not call when he came to Newcastle. It was not done to reject London.

The city was making him sick: another bout of fever tied him to his dingy rooms for a few weeks longer. He ached to be gone, knowing summer was coming, so beautiful among the golden whins and bracken of the fells, so foul and stench-ridden in London. By June, he was at last better. He spent a final evening with his friends at the George in Brooke Street and took leave of his landlord and landlady. At the Pool of London he found a collier heading home and this time the journey was short. The winds sped him north along the coast. On the morning after Midsummer Day his ship passed the cliffs of South Shields and the familiar landmarks – Frenchman's Bay, Trow Point and the long, treacherous sandbanks – rounded the headland and swept into the Tyne, with the rocks of the Black Middens and the harbour of Tynemouth to the north. On up the estuary they sped, past Jarrow and Wallsend and the narrows of Bill Quay, arriving at last on the tide, 'in sight of St Nicholas Church steeple'.

9 PARTNER

But what should he do now he was back? He liked working alone, and his mother agreed, suggesting that perhaps he could make it a family affair. 'I think you would make more out with John's assistence in seting up for your Self, if you think you have any Prospect for Beausiness then what you woud do with your old Master,' she wrote just before his return. He took her advice, although John was too busy with the farm and pit to help him that summer. As soon as he arrived, he went to see Ralph Beilby at Amen Corner and then set up his bench at Ned Hatfield's, above the dancing school where the music sounded through the floorboards and the girls giggled on the stairs.

The London booksellers sent work, particularly Thomas Hodgson, needing cuts for his *Curious Hieroglyphick Bible*, but almost at once local commissions came in too: a request to engrave a Theban harp on copper for James Murray and orders from the Newcastle silversmiths. It was clear that he would inevitably compete with Beilby. Soon, however, the goldsmith John Robertson, one of the partners in Amen Corner's biggest customer, arrived with a proposal from Beilby himself. Ralph was now thirty-four and was thinking of using his training as a watchmaker and jeweller to make and sell watchmaking tools (known in the trade as Lancaster tools) and watch-crystals, the curved glasses that covered the face. If he did this, he would need a partner to run the

engraving business and Bewick was an obvious choice: he had talent, and as a partner he would not be a competitor.

Robertson assumed that Bewick, at twenty-four, would be delighted with the offer, but Bewick hesitated. Alone, he would have freedom; as a partner, he would have security – valuable in these troubled times. In later years, dreaming wistfully of a life free of the trials of a large workshop, he was never quite sure that he made the right decision. But on 17 September 1777, he signed the agreement. One more step remained. While Bewick was in London, Beilby had taken on a new apprentice, Abraham Hunter, as a junior to David Martin. Now he suggested that Bewick take his own apprentice to balance Hunter, and when the harvests were safely brought home, his brother John left Cherryburn, signed his indentures and joined the team.

Bewick was a master now but he took up the old routines, sorting out the cash books and day books and allocating the multitude of tasks, from coal certificates and shop cards to tickets for Andrew Picken, the dancing master from North Shields. As December came and the Newcastle markets filled with geese and game, they worked on woodcuts for sixteen 'Salutations' and the same number of '3 Kings', but on the day before Christmas Eve a familiar order came in for 'Alphabets w. Figs in wood – £1.4s. 0d.' and '7 Cuts Fables@ 4/6 – £1. 11s. 6d.' In the New Year the pace quickened and the modest profits rose. Beilby specialised in engraving on copper and silver while Bewick produced woodcuts for Saint and for Thomas Angus, who had set up shop on the east side of St Nicholas Churchyard in 1774 and was now the most prolific publisher of chapbooks and songs.

Bewick's work ranged from tiny woodcuts for folk tales to diagrams for weighty texts: in 1778 Charles Hutton forwarded an order for cuts to illustrate Samuel Horsley's edition of Newton's works – *Isaaci Newtoni Opera* (a massive work, which would not be finally com-

pleted until 1785). He was also working on the cuts for Saint's *Tommy Trip* and beginning to think seriously of creating a book of animals that would be completely his own. He conceived this first as a cheap educational book, replacing Boreman's *Three Hundred Animals*, with its feeble cuts. Remembering his own fury with these blotched and distorted illustrations, he thought that other young people might feel the same: 'this whetted me up & stimulated me to proceed – in this, my only reward besides, was the great pleasure I felt in imitating nature'. He put the idea to Ralph Beilby and they tossed it around in many conversations. Beilby had no doubts that Bewick could create such a book, but plenty about the economics: 'being a prudent cautious & thinking man, he wished to be more satisfied, as to the probability of such a publication paying us for our labours'. For the moment the idea lay dormant, but by 1781 Bewick was able to write, with a fair degree of confidence, that at some stage in the future they intended to publish 'a Natural History of Quadrupeds' (using 'history' in the old sense of a general survey, rather than a narrative – a usage that lingers on in the general term 'Natural History').

In 1779, when *Tommy Trip* was published, Beilby was in London taking the Newton cuts to the printer. He was also carrying out errands for Bewick – calling in at the India House about Sally Dicker's allowance and promising to look up Pollard and Gregson – and he wrote warmly to his 'dear Tommy', thanking him for his 'very agreeable Account of things in Canny Newcastle'. The two men got on well, although Bewick felt very much the junior partner, even while he was instructing the apprentices. By now these young men were proving their worth: David Martin was skilled on copper and wood, and joined Bewick at the radical clubs; Abraham Hunter showed promise on metal, and to Bewick's great pleasure his brother John revealed an unexpected talent for woodcuts. From London, William Gray wrote

to Bewick in delight at hearing of John's 'Rapid and Amazing Progress', but he also had some gentle advice, echoing Dr Bayles's chiding of Beilby during Bewick's own apprentice days: 'I need not to Doubt of your Allowing him such Exercise and Relaxation from Business as to Prevent a sedentary Employment and too Close Application from Impairing his Health and Constitution.'

There seemed no need to worry. At seventeen, sunny and easy-going, John was very different from Thomas, who was quick to anger and slow to forgive. Bewick was tall and athletic, browned and taut with energy; John was slight and slender, paler but full of charm. Where Bewick longed for the river and the fells and carried the air of a loner even in a crowd, John loved company and laughter and fashion. He was a good musician, playing the flute and clarinet, and remarkably skilled with his hands. Although he had no practice in drawing and engraving, he took to it at once and developed his own light and playful style, helping Bewick on the children's books on Thomas Saint's list. These were good days. John was more domesticated and eager to take care of them both, and Bewick was touchingly proud of him. 'With my brother,' he wrote, 'I was extremely happy':

we Lodged together, he arose early in the Morning, lighted our fire – blacked our shoes, dusted the Room, made everything clean for breakfast, as well as any servant Girl could have done & he sewed & mended his own clothes &c and to crown all he was constantly cheerfull, lively & very active, & my friends were his friends – Mr Beilby was also as pleased with him as I could possibly be, for besides his affable temper, he took every kind of work in hand so pleasantly & so very soon learned to execute it well that it could not miss giving satisfaction & this he continued to do as long as he was with us.

After this companionable start some frictions did develop. They rubbed each other up as only brothers can, and when John reached twenty-one, in 1781, he felt that he had had enough elder-brotherly

advice. As the bookseller John Gray Bell later put it, John 'was much caressed for his wit and vivacity, though his ardour and playfulness occasionally led him into scenes avoided by the more phlegmatic and prudent'. He had his own friends, and if Bewick did not like them – and he did not – that was hard. Bewick still sounded sore about them many years later, remembering how when his remonstrances proved in vain John 'would not (as he called it) be dictated to by me, but this I persisted in 'till it made us often quarrel'. None the less, John usually walked home with him every weekend. 'He was then a clever springy youth', Bewick remembered, '& our bounding along together was often compared to the scamperings of a pair of wild colts.'

In the early 1780s Gilbert Gray's son George painted a portrait. This was long thought to be of Thomas but now doubts have arisen that it may in fact be of John, of whom he made a pastel drawing around the same time. Both brothers at this point were on the verge of a promising career, looking forward, their determination touched with humour. The doubts about the portrait prevent individual readings, but make the subject appear even more clearly as a type – a young craftsman of the late Georgian era, in his best broadcloth coat and ruffled shirt, his dark hair tied back. Full of confidence, he is a young man on the make with little, it seems, to hold him back.

Teaching his brother John and other talented boys, Bewick was handing on his own techniques and his vision. With some later apprentices – Charlton Nesbit, Luke Clennell, Isaac Nicholson – his influence was so pervasive that it is sometimes hard to distinguish the work they did for the workshop from his own. By the age of thirty, without knowing it, he had begun to create a school that would spread his style across the world. But in the gaps of time and in the evenings, Bewick himself was learning. As he cut new scenes on the boxwood blocks, he began to free them from the constricting rectangles and

ovals of the children's books, adopting William Bulmer's early sugges-
tion that he shave away the borders so that the ink did not build up,
and following the manner of the little ornaments without frames that
followed the fables – the tailpieces – rather than the formal illustra-
tions at their head. He had not yet reached the delicacy of his mature
art, but the background was open, as if the sky had entered.

A simple change of format became a call to liberty. Suddenly, the chil-
dren and animals he had drawn seemed free, even in children's book illus-
trations like the cat bristling on a pillar while the dog barks and paws the
stone below ('Pompey be quiet, and let the Cat alone / Why should you
quarrel about a Marrow Bone?'). Without the frame, Bewick could
heighten the contrast between stone and fur, grass and trees, contrasting
the quarrelling animals with the fisherman behind – his shorthand for
tranquillity – and showing the arched back of the cat against the sky.
Rocks and water and trees, rather than borders, provided structure.

He worked hard, spending busy days in the workshop, and cutting his
animals and tailpieces long into the evenings. But life was not all hard
work. Now that he was a master Bewick sometimes took Monday off,
as well as the weekends, and went fishing. With his friend Jack Roe he

headed for the upland streams, casting his flies 'fine and far off' and letting them drift down to where he stood, or wading into the middle, reaching for the eddies, waiting for the water to bell as the fish broke the surface for a sudden cloud of flies, and coming home in the dusk with a creel full of fish for Newcastle friends.

Gradually the dynamics of the workshop changed. Ralph Beilby's mother died in the summer of 1778, and the following year his brother William left Newcastle to open a drawing school in Battersea, taking with him his sister Mary, the object of Bewick's apprentice fantasies; later he married a wealthy merchant's niece and moved to an estate in Fife, again taking Mary. Now that he was on his own, Ralph officially set up 'Beilby and Company', with John Langlands and Robertson as sleeping partners, making his tools, watch glasses and enamelled clock faces, and in 1780 he took another shrewd step by marrying Ellen Hawthorn, whose late father had left an established business, currently being run by her brother. Since Ellen felt herself a cut above the crowd and never approved of Bewick or of the workshop trade, the partners' old closeness began to diminish although they still remained on good terms: 'I have Rafy with me,' he wrote to his parents a year or so later.

When the Beilbys moved to live in the West Spital Tower, along the city walls among orchards to the west of the town, Bewick, too, felt restless. His peace at Ned Hatfield's, where he had lived so happily, was threatened by workmen demolishing the medieval buildings behind to drive a new east–west street across town, the modern Mosley Street. In the spring of 1781 he finally decided to leave. He could now afford a house of his own, and he wanted a garden, a green space among the streets.

His first plan was to rent the gardener's house and part of the old walled gardens belonging to the Company of Barber Surgeons, Peri-

wig Makers, and Wax and Tallow Chandlers, but by the autumn he had decided instead to take over Charles Hutton's old house near the Forth, only a few minutes' walk from Amen Corner. Hutton's wife had stayed on here while he worked at the Woolwich Arsenal: now, despite the ups and downs of their marriage, she had finally agreed to join him in London. Bewick bought some of Mrs Hutton's furniture and set up house, carefully noting all his costs, including drinks for the carpenters, 9s. for the 'Girl labourer' and 1s. 2d. for a 'Metal Dog for the Oven', a new mechanical spit to turn the meat. Soon all was fitted up, painted and limewashed, with new locks and keys for the door, and his sister Ann, now twenty-three, came to be his housekeeper. Their sister Hannah, who had left the farm as maid to the wife of the Newcastle MP, Sir Matthew White Ridley, wrote excitedly to Bewick when the family planned to come back from London for the races in June: 'to visate you at your little Paradise at the forth will be the greatest happeyness I have met with since I left the North'.

His house organised, the garden was Bewick's next project. At the back, sheltered from the north-east winds by the town walls with their great semicircular bastions, was a large plot with fruit trees and vegetables and roses, and Bewick invested at once in palings for the fence, and paid 2s. 6d. for gooseberry bushes and a shilling to an old man to take away the gravel and the ashes. He had a larger green space at his disposal, too, since the house was only a step or two away from the Forth, the town pleasure garden with its walks and groves. This flat, open ground was first used by housewives for drying and bleaching their linen, and for a hundred years it had boasted a bowling green and a tavern with a balcony, 'from whence the spectators, calmly smoking their pipes and enjoying their glasses, beheld the sportsmen'. From the plateau above the river Bewick looked south across

the valley to the windmill hills of Gateshead and westwards up the hill that carried the road to Cherryburn.

As Beilby married and settled and Bewick strode confidently into his late twenties, around them the apprentices grew from boys to men, discovering women and drink and politics, and eventually leaving to make their own way. In 1780 David Martin left for Sheffield to make tools, engrave copperplates and become a printer. He and his wife, Barbara, a Gateshead girl, brought up six children in the booming steel town, where Martin became drawn increasingly into dissenting politics. Abraham Hunter left in 1782, working for Bewick and Beilby as an independent journeyman until he started a business in St Nicholas churchyard and took apprentices of his own. In his place came John Laws, a quiet boy from a farming family up the Tyne who showed a talent for silver engraving and never caused a flicker of worry.

And so the flow of boys continued. Until he organised a room of his own, in 1801, Bewick shared a room with the apprentices and worked alongside them week after week, year after year. In some ways his relationships with them were among the most intense of his life. He felt responsible for them and became fond of them or furious with them, by turns irritated and indulgent, despairing and proud. He knew from the experience of other tradesmen how easily they could go off the rails. Some were very young when they arrived, like twelve-year-old Jack Johnson who came as a pupil in 1781, waiting for a year or more before he was old enough for his indentures to be signed.

Jack came from a remote hamlet in the lead-mining valley of Weardale in County Durham and was related to the Johnsons of Ovingham, a large local family – Johnsons had lived in Cherryburn in the 1720s and 1730s, and now farmed the land by the river and manned the sporadic ferry. Bewick worried about his new charge, and

after Christmas in 1781 he sent him home because he was ill. His father wrote warmly, thanking him in broad north-country spelling:

John should have return'd this weak with the Carrier but we are disfit of the Taylor the forepart of this weak to make him a new Coat so I hope you'l not take it amis if he stay til Thursday next weak which is longer than he hath any desire it gives me great pleasure to hear him say that he loves the trade better than any he see in Town.

He had another boy to look after when Jack's cousin Robert arrived in 1784. Long ago, when he was eighteen, Bewick had been asked to stand as godfather to Robert, whose mother had been a servant at Cherryburn, 'a great favourite and like one of our own family'. When she married a local cabinet maker her friendship with the Bewicks stayed strong. It was an honour to be asked to be a godfather, Bewick knew, but when it came to the day, he could not face it:

exceedingly bashfull, I could not think of appearing before a congregation of people – and when, on getting to the top of the 'pantin brae' the Bells began to ring in for Church, I felt so abashed at the thoughts of what I had to do that I 'turned tails' – went a little back, and crossed the River upon the top of the Fishermens Weir by stepping from one stob to another . . .

He went sheepishly to Cherryburn to get food and drink and then slunk back along the river, while his mother and father stood as god-parents in his stead.

Robert Johnson had been told since childhood that he was to be apprenticed to Bewick. He looked up to him with awe. Under pressure from home, Bewick agreed to take him on early as a pupil under his 'fostering care' and to give him lodging at the Forth. He was thirteen and had never been strong, and Bewick thought that his parents had made a mistake in placing him in such a sedentary career rather than sending him to sea or some other outdoor work, but he blossomed

under Bewick's regime of plain diet and dumb-bells at dawn. His mother 'held up her hands in astonishment at seeing this change, from a pale pasty, sickly look, to that of having his cheeks blushed with health like a rose'. At the workshop, Bewick took equal care, never inflicting long hours but only insisting that any job had to be done *'perfectly correct'*. He taught Johnson all he knew about watercolours as well as engraving:

indeed, in this way he became super-excellent, & as I conceived he could hard be equalled, in his water coloured drawings of views & landscapes, by any artist – for some time, I continued to sketch in his figures, but at length he neaded none of my help, in this way – I remember of his coming to me & begging I would drawn or sketch in a tree for him – no Robert said I, but I will direct you to a place, where you will see such a tree as you never saw painted by any artist, in your life –

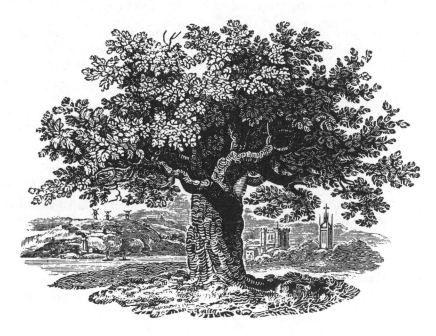

No one, in the proud master's view, could have drawn the tree better. Except, perhaps, himself.

It was not a casual thought to send Robert Johnson to draw a tree. Trees, rather than spires, are Bewick's verticals: bare-branched and bending in winter winds, heavy with foliage in midsummer, hanging over streams, providing shelter for deer and fox. They are resting posts for travellers and backrests for lovers but also the last resort of a forest suicide, throwing his knotted rope over the branch. He had shown his delight in the decorative charm of foliage very early, in the sketches he made on his tour to Scotland, and in his woodcuts, the foliage is like a signature. Instead of cutting the outline he begins within, his graver following the lines of the sap from trunk to branch, chiselling the sprays of foliage and leaves with delicate white lines and curls, or leaving black edges against a pale sky.

Trees were the signposts of his life. In his childhood the Tyne valley was far more heavily wooded than it is today, and its trees were his truant haunt when he skipped school to hunt for birds' nests, but the woodland was also an imaginative realm, the old, wild Britain of hermits and lordly hunters, the greenwood of Robin Hood. When the ancient oaks around the Earl of Derwentwater's castle were hacked down after his execution, the shock reverberated through the county, since to fell such trees was to destroy the planter's name: when Bewick wrote of Eltringham woods, he singled out their great oak, 'one of the tallest and straightest in the kingdom'. And an oak tree was the symbol of the town he now worked in as a partner. He showed it supreme, spreading its broad branches above the Newcastle arms, dwarfing the lantern of St Nicholas behind.

10 'ESTO PERPETUA!'

As soon as he arrived back from London Bewick fell into the swing of the clubs and political arguments once more. In February 1778, when he was settling into his partnership with Beilby, Britain declared war on France for aiding the Americans. That April the privateer Paul Jones – a famous Scottish pirate, who had been an apprentice in Whitehaven before sailing on the North Atlantic vessels and settling in Virginia – raided the Solway Firth and Belfast Lough. Would it be the east coast's turn next? The Corporation met to discuss the defence of the coast 'from the anticipated invasion of the French'; demands sped to Westminster for soldiers and warships, and subscriptions were raised for the defence of the town. Suddenly the conflict seemed perilously near. In June Spain too entered the war, and for the next three years people listened for guns at sea. The colliery vessels were on constant lookout: in May 1778 French cutters fell in with a fleet and took several ships, and four months later Paul Jones himself appeared off the coast, and captured a sloop. With press gangs roaming and ships and coal revenues threatened, anti-government feeling rose.

A month after the Paul Jones raid, Bewick joined Swarley's Club, which met at the Black Boy inn run by Richard Swarley in the Groat Market: Beilby engraved his ticket, marked with the motto 'Honi soit qui mal y pense' and 'The Newcastle House of Lords'. Members paid

fourpence 'to be spent on beer only' and the first unwritten rule was 'to behave with decorum and like a gentleman'. At Swarleys, they tried to avoid politics and to keep the arguments under control, but as Bewick put it later, 'Political writings & debatings sometimes ran very high between those who were advocates for a system of corruption & profitted by the Taxes – and those who were advocates for the liberties of mankind – but it always appeared to me that a very great majority of the people were decidedly against the War.' Local papers printed anti-war pamphlets, including Thomas Paine's *Common Sense*, while James Murray published an impassioned two-volume work, the dryly titled *Impartial History of the Present War in America*, for which Robert Pollard etched the illustrations.

Bewick was ready to be kindled in the cause of Liberty. 'I cannot but compliment you on the Animated Paragraph you inserted on Political Affairs,' wrote William Gray in a long letter of August 1778, roundly blaming 'the perfidious French Rascals' for Britain's predicament. France's entry into the war had made loyalties complicated. Admiral Keppel, for example, who had refused to serve against the rebellious colonists, agreed to command the Channel Fleet against Britain's old enemy the French, but the authorities viewed him with suspicion, and after a dispute with a subordinate he was hauled before a court martial for neglect of duty. The opposition took up Keppel's cause, and when the court found the charge to be malicious there were mass celebrations. In Newcastle, the town hangman flung effigies of government ministers on a bonfire in the Bigg Market before cheering crowds.

A month later the Bewick and Beilby workshop won a commission to engrave a gold 'Freedom' box, presented to the admiral by the Corporation of Trinity House. Keppel's acquittal was good news, too, to Robert Pollard, who had set up business in Spa Fields, Islington, and was specialising in naval prints:

I suppose you have seen my Print of that Deserving Person Who has made such a Fuss in this Nation I mean *Keppel*. . . . I have found since I sent them to Newcastle that my one is liked better than any yet out & have Sold better than I Expected therefore Success to Admiral Keppel & he'll bring Success to me Keppel for ever Huzza –.

Bewick admired the admiral even more after Pollard described his easy ways: 'a little Man tho Jolly Red fac'd & not so tall as my Father'.

The wartime slump in trade, combined with enclosures on the land and disputes in the growing industrial towns, brought riots and unrest, especially in the north. Speeches, pamphlets and books attacked government corruption and incompetence, often appealing to ancient models, as Bewick and his friends so often did. In 1779, John Cartwright had founded the Society for Constitutional Information, to 'prove' the legality of the Saxon constitution, and in June 1780 the Duke of Richmond introduced a bill for 'restoring' annual parliaments and universal male suffrage. But at the same time strict Protestants were rising in protest at proposals to give Catholics relief from the penal laws. Even as the Duke's bill was being debated, Lord George Gordon marched on Parliament carrying a Protestant petition, followed by a furious mob. After five days of violence, bringing many deaths and much destruction, the power of the people came to seem dark and dangerous. Moderate supporters of reform drew back and the 'epidemic democratick madness', as Elizabeth Montagu called it, was checked in its course.

From now on the Newcastle clubs were more subdued. James Murray had helped to organise the Protestant petition in Newcastle, signed by over seven thousand people and supported by Thomas Slack's *Chronicle*, but this cause was now tarnished by the riots. Bewick himself always turned his back on bigotry: he admired the persistence and good works of the Catholics even while he despaired of their lack of

reason and dominance by priests, and although he supported an extension of the franchise to all householders, he was no egalitarian: he could not, for example, agree with 'the philanthropic, well intentioned & honest Major Cartwright' in supporting universal suffrage, remaining hotly convinced that 'ignorant & wicked' men should never have a say in government. In religion he was tolerant, in politics a radical traditionalist – a mix very common at the time.

At last, in October 1781, the American war ended with Cornwallis's surrender at Yorktown: the rebels had won. The prime minister, Lord North, resigned and British power recoiled from the Atlantic shores, before stretching out again, north across Canada, east towards India.

That October Bewick moved to his new house at the Forth. He was proving himself at the workshop and making new friends. After work his long-legged stride often took him to Sam Alcock's pub, the Cannon, to get his 'pint of ale & a cake & to hear the News' and to meet friends who had formed a book group and kept their small library there – young tradesmen like Moses Marshall, a cashier at the bank, and the woollen drapers Joseph Hubbuck and Gilfred Ward 'of facetious memory'. He went to the club's annual dinner, not because he liked dinners, he said, but because he enjoyed the songs, particularly the Scottish airs of the carver and gilder Walter Cannaway, far sweeter than the singing of affected professionals.

Over the last few years the streets that once rang with music had become oddly quiet. The guild of 'Waits and Musicians' still operated in Newcastle – 'no fiddler, piper, dancer upon ropes, or others that went about with motions or shewes' could perform without a licence – and during the American war the Common Council cracked down on subversive ballad singers. In 1781 they even passed an order for-

bidding singing-clubs in public houses. Missing the street music, Bewick called on John Peacock, one of the most famous Northumbrian pipers, and asked him to play for him and his friends, 'and with his old tunes, his lilts, his pauses & his variations', Bewick wrote, 'I was always excessively pleased'.

A year or so later he joined yet another group, the Brotherly Society, which met at The Golden Lion, an old Elizabethan coaching inn in the Bigg Market: for this club he himself engraved the tickets, surrounding them with a border of flowers. Outside the clubs he now mixed with the older men who did business with Beilby, like the silversmiths John Robertson and John Langlands. Hospitable, cheery, full of stories, in his early seventies Langlands became a model for Bewick, who admired the way that he never forgot former colleagues and workmen: if age or illness brought them low, 'he then shook hands with them as he had done before, but now his own mostly concealed his token of respect – a half guinea'.

Slowly, Bewick was making his mark, taking warnings from disasters in his own and other trades. Martin Barber, for instance, had inherited his father Joseph's bookselling trade at Amen Corner in 1781, but sold it to his apprentice Joseph Green, who was bankrupt within a year. From London, Robert Pollard sent news of William Gray, who had failed in his bookbinding concern but had pulled himself up and won praise for repaying all his creditors. A businessman needed fortitude as much as riches, wrote Pollard seriously, 'but as its not in our Power to mend the Matter all that we can do is to endeavour to be as good Pilots as we can & shun if *Possible* the Rocks which others have Split upon'.

Wood-engraving was vital in saving Bewick and Beilby from these rocks. Although the workshop receipts dipped in the depression after the war, Bewick could now afford to follow Langlands' example and

be generous, whether handing out small charities, tracking a friend down on his luck, or appealing to the Corporation on behalf of an illiterate stonemason, who had not been paid for engraving a tidemark stone on the trackway up the Tyne: the tidestone is still there today, in a spot called Cathouse Plantation.

The mason's plea may have moved Bewick because he passed this stone on the way to Cherryburn, but it also reflected his own fascination with incised inscriptions. He often included these in his woodcuts and thought fancifully that the bare rocks he passed on his walks could also become monuments, inscribed with the names of states-men, patriots and philosophers. Why not engrave quotations from their works, lines from the Bible, or from poetry? Some contemporary landscape gardeners, like William Shenstone at the Leasowes in Staffordshire, were doing just this, but Bewick wanted to take words into the wild. While he was out fishing, he said, on 'a hot sunny day, which slackened my sport' he ran through suitable poems, like the stanza from John Cunningham, 'which I would, if I could have af-forded it, have *committed to the care of a Rock*':

'How smooth, that silent River glides
 Progressive to the deep
the poppies pendant o'er its sides
 have soothed the waves to sleep.

Pleasures intoxicated Sons! This is from
Ye indolent! ye gay! reflect! memory
for as the river runs, time wings
 his trackless way'

Bewick later showed what he meant in several vignettes, including one
of a great rock inscribed with Goldsmith's lines:

Ill fares the land, to hastening ills a prey,
Where wealth accumulates, and men decay:
Princes and lords may flourish, or may fade;
A breath can make them, as a breath has made;
But a bold peasantry, their country's pride,
When once destroyed, can never be supplied.

In his interest in sculptured rocks, Bewick was responding to a cur-
rent trend in his own individual way. There were many keen antiquar-
ians among the country vicars, squires, lawyers and teachers who
came to Amen Corner to have their umbrella handles engraved or to
order bookplates. One such – a good patron to Bewick in the future –
was George Allan, a wealthy Darlington solicitor who had collected a

mass of legal documents that he hoped to use in a history of County Durham, and had founded his own private press. In 1781 Allan gave his archives to his portly and prosperous friend, the lawyer William Hutchinson, who set about compiling the *History and Antiquities of the County Palatine of Durham*.

Bewick and Beilby worked on the illustrations for Hutchinson's first volume, Ralph doing the copperplates and Bewick the woodcuts of 'Roman arms and alters'. Hutchinson later produced a second volume on the bishops of Durham, only to find that his third was mysteriously 'undesired by the publisher'. After a court case, he published it himself, but sadly overestimated the market: two hundred copies were sold as waste paper, and the rest lost in a fire. (His other claims to fame were his daughters, 'known to their friends as Faith, Hope and Charity, and to their detractors as Plague, Pestilence and Ruin'.) Bewick wrote patiently to Hutchinson about armorial bearings and seals, skilfully steering him away towards scenes that were easier to engrave.

Alongside this scholarly antiquarianism a more popular version was gaining momentum. Many provincials resented the 'discovery' and rewriting of Celtic stories, northern ballads and west-country songs, taken up by writers like Thomson, Gray, Percy and Chatterton. One hostile critic was the diminutive and vehement Joseph Ritson, who published his poetry in Newcastle's *Literary Register* in the 1770s before moving to London. Over the next two decades, with his pen dipped in gall (as Gillray caricatured him), he attacked Wharton's *History of English Poetry* as plagiarism, Johnson's Shakespeare as a mockery, Pinkerton's *Caledonian Muse* as forgery and Percy's *Reliques of English Poetry* as inauthentic. In response he compiled his own regional collections, like the *Bishopric Garland, or, Durham Minstrel* and *The Northumbrian Garland, or, Newcastle Nightingale*, many with woodcuts from the workshop.

Such collecting was not always solemn. In 1780 Thomas Carnan published the first collection of nursery rhymes, *Mother Goose's Melody*, with many enduring favourites: 'See-saw Margery Daw', 'Ride a Cock Horse', 'This little pig went to Market' and 'Hey Diddle Diddle'.

Carnan said the manuscript had been found among his stepfather Newbery's old papers. If so, the compiler was probably Oliver Goldsmith, playfully treating this as an antiquarian 'find' and adding notes from 'learned authorities'. The introduction explains solemnly that the Druids were rocked in their cradles to such rhymes, and Henry V had been mocked for his ambition before Agincourt with 'There was an old woman, tossed in a blanket, seventeen times as high as the moon'. Bewick provided cuts, full of affection and humour. Even Ritson loved this little book, giving it to his nephew Frank, adding a general warning 'not to disfigure the cuts in your books, they are either too good to be spoiled, or too bad to be improved'. He doubtless enjoyed it all the more for its mockery of Percy's earnest annotations to *Reliques of Ancient Poetry*.

Everyone, it seemed, was delving into the past for different ends. In 1777 John Collier published a rambling survey of Newcastle charters, while Beilby's friend John Brand, a teacher at Newcastle Grammar School, revised Bourne's *Popular Antiquities*, with its description of

old festivals and customs. For years, Brand had been collecting material, and when he moved to London as chaplain to the Duke of Northumberland in 1784, he finally had time to work on the massive, meandering volumes of the *History and Antiquities of the Town and County of Newcastle*, published four years later. Beilby checked details for him, like the names of the lanes opening on to the quay, and he was grateful: 'yet on Mrs Beilby's account I am truly sorry that you have had occasion to visit those dark and suspicious lanes and be thrown in the way of the very dangerous, though not very tempting, females that inhabit them'.

Brand was a jovial man, as large and lumbering as his book. He loved to talk over his port and was an insatiable book collector, sinking to his knees on Sundays in front of the second-hand bookstalls 'to pay his devotions to the lower shelves in hopes of finding some precious morsel to stay his voracious appetite during the terrible time lost at Church' and stuffing his 'amazing pockets' with books, so that they dragged and flapped behind him. Over time the workshop printed more than two thousand bookplates for him, one showing an appropriate scene of ruins, with the lantern of St Nicholas behind.

Brand's antiquarianism may lie behind a puzzle in one of Bewick's vignettes of a snowman at Cherryburn. He had made an early sketch, supposedly showing himself as the boy on a stool adding finishing touches and Joe Liddell shivering nearby. When he cut this on the wood in the late 1780s he gave the snowman a pipe, cut a square for his own bedroom window and added a motto, 'Esto Perpetua': 'Let it endure for ever'. For Brand's *History*, Beilby had engraved a map of Newcastle, and under the elaborate coat of arms, at Brand's request, ran a ribbon inscribed *ESTO PERPETUA!* These were the defiant last words of the theologian and mathematician Pietro Sarpi, referring to the Republic of Venice, whose priests he had supported in their battles with the Pope.

Several defiant spirits in eighteenth-century Britain took up Sarpi's phrase. In 1782, for instance, Ireland was granted an independent parliament. It would last for only twenty years, but at its opening the Protestant leader Henry Grattan declared: 'Ireland is now a nation. In that character I hail her and, bowing in her august presence, I say *esto perpetua*.'

Esto perpetua.

As Bewick watched Beilby work on Brand's map he may have responded to the republican echo. But in his vignette he moved the motto about lasting forever to a sculpture in snow that would melt in a trice. It was a joke yet the undertones were serious. The childhood of the boys he drew, like the snowman, had now dissolved into adulthood: most of all, Bewick was suggesting that art, even a simple woodcut, was the only true magic that could hold lives from melting into time.

I I WALKING

Walking was Bewick's great escape, his own way of absorbing the history and life of his region. In July 1780, when Philip Gregson came up to see his family, Bewick arranged to walk back with him as far as York. 'P.G. a hungry chap,' Bewick scribbled in his notebook on their first day. This notebook was an old *Ladies Complete Pocket Book, or Memorandum Repository for the Year 1778*, with Northumbrian riddles, country dances and notes of sedan chair stands in Newcastle. He probably picked it up from its publisher, the bookseller Mr Vesey, who wrote a note of introduction in a sprawling hand on its first page, affirming that 'the bearer, Mr Bewick, is an ingenious, clever man, who is now upon a tour for his observation and improvement as an engraver'.

The 'tour' was work of a kind (he carefully wrote down his expenses), but it was also a holiday. After journeying south and calling on friends on the way, Bewick and Gregson reached York, where they spent a couple of days admiring the sights and enjoying 'an amazing fine view from the top of the Minster, 274 steps from ye bottom'. Gregson then took the London coach and Bewick set off alone. First he walked south to Boroughbridge, with its huge standing stones ('called I believe the Devils Arrows') and then across country to Ripon and to Studley Castle where the gardens with their moon-ponds and

follies curved up the valley to Fountains Abbey, its ruins straddling the river. In terrible weather, he passed the 'Hell Kettles' on the River Skerne, three great waterholes, said to be bottomless and inhabited by demons, and on to the crumbling castles of Barnard Castle and Bowes, guarding the ancient pass of Stainmore across the Pennines, where the Romans had marched. To the south was Greta Bridge, where Cotman painted his luminous study of the river Greta, flowing on to meet the Tees, but Bewick eschewed the rhapsodies of the Picturesque tourist. 'Excessive hungry,' he wrote; 'most stormy and disagreeable day'.

After a night in Darlington he crossed the pass, watching the larks fly up from the grassy moors and hearing the curlews call. As he reached the western slopes, he could see the twelfth-century keep of Brough, standing out against the sky above the Eden valley. Here he stayed, reluctantly, again 'on acct. of excessive hunger'. The little town did not appeal; not only did one of his guineas turn out to be clipped but, he wrote crossly, 'Bad Tabacco at Brough'. He was glad to leave, following the Eden north to Appleby, where he dined with old Mrs Gregson, the link between his mother's family and the Ovingham clan. Then he went on to Penrith to stay with Tom Collier, the brother of his radical friend John; against this visit he wrote a single word, 'Kindness'. Next morning the two men climbed Penrith Beacon and gazed

west towards Ullswater, where tourists were even now crowding on to barges, peering through their Claude glasses and listening in awe as cannons were fired and booming echoes bounced off the mountains across the lake.

Many families like the Colliers, Gregsons, Bewicks and Hodgsons straddled the North Pennines. Bewick passed through Kirkoswald, where his mother had been christened, and stopped at Ainstable, where he sauntered through fields and copses and stayed with his aunt and uncle Wilson, whom he had last seen when he set out for Scotland four years earlier. After a day or two's fishing, he rose at five and climbed on to the open plateau of Cross Fell, the highest point in the North Pennines, where snow can last until May. This moor has another name, 'Fiend's Fell', so-called from the hurricane winds that rush down to the valleys in the spring. On a clear day the view stretches west to the Lake District, north to the hills of the Scottish border and east to the slopes of the Cheviots. The rivers that flowed through Bewick's life rise near here, the South Tyne, the Tees and the Wear.

The high villages and lead-mining towns of the north Pennines were truly remote: even forty years later a teacher at Alston wrote that only five boys in his school had seen wheat growing and only three had beheld the sea. With the wind at his back Bewick walked on, down to the upper Tyne valley, where the river rushed over rapids between high banks, under weather-scarred rocks tufted with trees, past sheltered glades of foxgloves and ferns. He stopped with friends, met a girl he had once known at Haydon Bridge, by whom he was 'most kindly entertained', and strode on to Cherryburn. Next day, after calling on the Gregsons at Ovingham, he was back in Newcastle.

When he thought of this time, Bewick wrote: 'This is the short account of many years of great & uninterrupted health, bouyant spirits & of great happiness to me –'. There were shadows, however, over

these sunlit days. In 1782 Bewick's sixteen-year-old sister Sarah fell ill. Dr Bayles did all he could, but one November evening Bewick was scribbling an anxious letter, explaining that he could not ask the doctor to come out that night: Bayles was lame, and so was his horse, the dark fell early and the roads were bad. Sally did not need fresh medicines, Bayles said – the last batch had not agreed with her and her parents had stopped giving it – but 'want of strength is her greatest want & to remedy that, depends chiefly on the Nursing her properly'. They must try to make her eat and give her asses' milk twice a day.

Sally appears to have had tuberculosis, and the doctor's words acknowledged that the time for help was past; she was buried at Ovingham four days after Christmas. Soon afterwards Bewick faced another death, that of an old Ovingham schoolfriend, the printer Thomas Lawson, who had recently lived near him at the Forth. The funeral brought home his own mortality since Lawson was only thirty-one and Bewick himself was now thirty. Remembering how he and his friends followed the coffin to Ovingham, he wrote forty years later: 'This was the first time in my life that I felt poignant grief.'

On his long walks, however, Bewick ceased to brood. He tramped to Durham and Ripon, breakfasting in farmhouses and handing out 'Charity to a dum man' and 'Ditto to Fond David' as he met them on the road. In old age he described the rough public houses he knew in his youth, 'often partly dug out & built on the side of a hill or a brea – the gable end of which (formed the cool but scanty Cellar), scarcely appeared above ground, & which was, further, hidden by blossomed Whins, heather, ferns & Foxglove – which scented the Air with fragrant smells'. Knowing his love of walking, Robert Pollard even tried tempting him down to London with a hint that he had a week's holiday coming '& would be happy of Mr Bewick's Company to have a *Wander* where our inclinations might lead us too'.

Bewick preferred to stay in the north. Over Easter 1784, for exam-
ple, he persuaded Walter Cannaway to join him on a long walk up
the coast to Berwick on Tweed. He set a fierce pace and they
marched for miles before they stopped, for Bewick to down barley-
cake and cheese and Walter draughts of beer. A few miles further on
Walter sat down, declaring he could go no further. Next day they
went more slowly, idling through villages to Elwick, near the coast
close to Holy Island. Here they stayed at 'the hospitable Mansion of
my friend Thomas Younghusband', a landowner whose sons lived
next door to Bewick while they went to school in Newcastle, and on
whom Bewick kept a friendly eye. That evening local friends of the
Younghusbands came over, drinking led to singing, and the party
were so impressed by Walter's songs that they did not break up till
dawn.

Bleary-eyed, the friends visited Berwick, planning to return via Holy
Island, the site of Lindisfarne abbey and the Tudor castle on its
windswept rock, joined to the land by a narrow causeway that can be
crossed at low tide. Bewick and Cannaway left it too late and had to
run for most of the way, watching the sea rush in behind them and

wading ashore through rising waves. Poor Walter, 'being rather corpulent', was 'in a sad state of perspiration' but recovered in the inn, gulping gin. Night was falling and the abbey and castle were forgotten in their anxiety to return, but although they persuaded some boatmen to row them back, when they landed they had no idea where they were. Dripping and muddy, they struggled across ploughed fields back to Elwick, where Mrs Younghusband 'lost no time in fitting us up with dry clothes and making us comfortable'.

Bewick loved it all: the walking, the 'mansion', the adventure on the causeway, the dry clothes and the subsequent days with the Younghusbands. These included a trip to Berwick to a Freeholders Meeting at the Town Hall about the hotly contested 1784 election. Popular hopes were high since William Pitt the Younger was joining the administration 'and being the Son of the Great Chatham, most people hoped & expected that he would follow the bright, the patriotic example, that had been set him'. But one man, Bewick noted, spoke eloquently – and in his view prophetically – warning that he might turn out 'a quite different kind of Man'.

A walking tour, Bewick found, could embrace nature, history, adventure and politics. Yet the most precious walk was still his weekly round to Cherryburn. Some thought him mad, he said, to go out in all weathers – 'facing then the snow storms, the floods & the dark nights of so many Winters' – but he kept up his visits, their charm heightened by the thought that some day they must end. *The Seasons* 'by the inimitable Thomson had charmed me much', he wrote, 'but viewing them experimentally, much more so'. As he walked he felt the changing year course through his blood. The regular rhythm of seeing the same scenes forwards and backwards, over and over, gave them a clarity that was almost surreal: 'observing the weekly changes of the long

lengthened & varied year, which by being so measured out, appeared like living double ones time'.

Many of Bewick's vignettes show solitary travellers hunched against a storm, outlined against the sky, or marching on while the wind tosses the branches of trees overhead. He often stopped to talk to the people he met on the way. During one walk, old John Cowie who lived at Ovington, the sister village of Ovingham, higher up on the fell to the west, told him of the battle of Minden in 1759, and how, in the absence of their commander, Lord Sackville, the soldiers 'shook hands, the whole length of the line & vowing to stand by each other without flinching'. Cowie was still as vigorous as a young man, a comic contrast to his frail friend Ben Garlick from Prudhoe, who had served with him in Napier's Grenadiers. He wore his military coat until he died, '& after he died this coat, which had been shot at both at Minden & else where, was, at last hung up – on a Stake on the corn Rigs as a scare Crow'.

In the tailpieces that Bewick drew so carefully over the years, we meet travellers from all walks of life: showmen and pedlars, beggars and farm workers, and gentry in coaches and on horseback. The world is on the move. Life comes to seem like a perpetual journey

through changing landscapes and varying weather, sometimes benign, sometimes cruel. Each traveller has some longed-for goal: each has embarked on his or her own pilgrim's progress.

Bewick did not need to go to the Alps to find the Sublime, the awesome beauty born of terror:

To be placed in the midst of a Wood in the night, in whirlwinds of snow, while the tempest howled above my head, was sublimity itself & drew forth aspirations to Omnipotence such as had not warmed my imagination so highly before – but indeed without being supported by extacies of this kind, the spirits, so beset, would have flagged & I should have sunk down.

In these winter nights he came to feel a power in nature – the force that Wordsworth sensed in the mountains at night on the lake, that Turner found in sunsets on the ocean, that Samuel Palmer touched in great clouds swimming across the moon. Bewick's ecstasies gave him the vertiginous sense of being at once weak against the force of the storm, the rolling of earth and sky, and yet blessed to share in the great cycle of birth and life and death.

When the thaw came he watched the birds and noted the succession of wild flowers. Ignorant, still, he said, of the 'great and good Linnaeus', whose works were even then laying down our modern Latin names, Bewick knew the flowers only by their old English names – primroses, wild hyacinths, harebells, daisies and cowslips. As spring opened into summer he rose earlier each day, at last understanding his father's pleasure in the stillness of dawn, the song of the birds and the quietness of the animals in the pearly light. But for Bewick, to whom this countryside was still a working landscape, the best season was autumn, when the birds gathered before their great migration to the south, the leaves turned and 'the yellow harvest of the fields & the produce of the orchards are gathered in as the rewards of the labours of the Year'.

As he walked he also recaptured the lost licence of boyhood, recollecting his impressions in tranquillity, as Wordsworth put it, once he came home. Hundreds of his little drawings still survive, full of movement, swift outlines and hazy horizons. In one such drawing Bewick evoked the snowy hunting days of his youth, showing himself as a boy crouching beyond the hedge, while his ally Joe Liddell treads warily across the white field, carefully covering the stock of his gun with his coat to make sure the lock doesn't freeze. In the drawing, the strokes are rough, fast dashes to suggest the whip of the wind and the chill of the snow, the hedges dark streaks against the blank fields, the zigzagging hare a dot in the centre. He used this, folded over the block, to trace the outline for a vignette. Then when he actually cut the scene, he kept the flow of the wind and the chase but added more trees, refined the main figure, clarified the wintry horizon: it is crisper, stronger, firmer.

As he showed in his liking for Cunningham's verse about the river, Bewick was painfully aware of transience, and when he looked back on his walks out to Cherryburn he was seized with a keen nostalgia, seeing his parents in their home encircled by these shining journeys. Back in town, on the last day of May 1784, his sister and housekeeper, Ann, was married in St John's to Thomas Dobson, a cooper from the Close, and soon the couple moved back to Ovingham, where the bridegroom's father was the local dyer, a well-known character. (Robert Johnson provided a pencil and watercolour study for Bewick's engraving of 'The Dyers of Ovingham', old Dobson and his man, Geordy Carr, carrying a tub of 'chemmerly' or chamber lye – urine – to the dye house, with two men relieving themselves outside the inn behind, in case one did not guess the contents of the tub.)

Once Ann was gone, the house seemed emptier and there was a sense of threat, literally, in the air. June brought fierce electrical

'Joe Liddell tracking a hare'. Note the lines where the drawing
has been folded over the wood block.

storms with torrential rain and hailstones the size of pebbles, break-ing windows and clattering on the roofs. In July, Bewick and his apprentices sweated in the workshop through days of blazing heat, very different from the cool spring of his travels with Cannaway. The Tyne shimmered like rusty metal. And when the heat wave broke more thunderstorms crashed across the north, flattening crops and flooding the burns.

Bewick was not superstitious, and the autumn was calm and busy. But in Christmas week, as he amused himself with sliding on the ice between Ovingham and Eltringham, 'as smooth almost as a Seeing Glass', he felt a strange premonition: 'I know not what came over my mind, but something ominous haunted it, of a gloomy change, in the family taking place.' He had never felt this before, and once home he brushed it off as fancy: relations and friends of his parents came to dinner and John Bewick was his usual self, full of jokes and facetious anecdotes. Snow fell on Christmas Day, and for the next three weeks ice and floods stopped Bewick crossing to Cherryburn. In mid January, when he called on John Gilchrist, the Ovingham gardener in whose house the boys had always left their dinner when Bewick went to school:

He informed me, with looks of grief, that my mother was very unwell – I posted off in haste, along with him, & across the river to see her – upon my asking her earnestly how she was, she took me apart by myself, & told me it was nearly all over with her & described how she had 'got her death' – she had been called up, in a severe frosty night to see a young woman, in the Hamlet below, who was taken ill, & thinking the Bog she had to pass through at the nearest, might be frozen hard enough to bear her, she slumped deep into it & before she waded through it she got very wet & a perishment of cold, & in that state she went to give her advice about what was best to be done with her patient –

Once again Bewick called in Dr Bayles and ran up to Cherryburn with medicines, but Jane died, aged fifty-eight, on 20 February 1785.

The snow lay until April, with deep drifts around the farm. Bewick's pregnant sister, Hannah, who had left her new husband behind in London (he was the Ridleys' tailor, William Chambers) and had come to care for her mother, suffered a miscarriage from the strain and fell into a fever. Bewick rushed her back to his own house, 'my hitherto, happy little Cot at the Forth', but Hannah knew she would not recover. Shortly before she died she asked Bewick to see her buried at Ovingham, and when he promised, she 'proposed to sing me a song', he recalled: '– I thought this very singular, and at it, felt both sorrow & surprize – but she smiled at me & began her song of "all things have but a time".' Hannah was the nearest to himself in age, and had just reached thirty when she died, on 24 June.

The blows seemed relentless. At the age of seventy, his father, John, was also failing. All his life John had been a pattern of health, but he had been depressed since Jane's death, and when Bewick pressed him he confessed that he felt 'as if he were shot through from the breast to the shoulders'. The chest pain stopped him breathing, and once again Bewick thought of the doctor, but his father rejected help: he 'told me if I sent him any druggs, I might depend upon it he would throw them all behind the fire'. All summer and into the autumn John drifted in a kind of stupor, taking pleasure in nothing. He died on his birthday, 15 November, and was buried beside Jane at Ovingham. Later Bewick would engrave vignettes of two headstones, with their names upon them, and another with the commandment 'Honour thy Father and thy Mother'. The place he loved now held only pain. 'After this', he wrote, 'I left off my walks to Cherrybourn.'

12 BELL AND JOHN

One evening in that terrible autumn of 1785, Bewick was working in the glow of the candle. Before him a boxwood block sat on the well-worn leather-covered pad, and as his big hands pushed it around and curved the graver across the hard wood, an image slowly appeared – a dromedary. In his concentration on this exotic animal, set against the palm trees of a distant land, he lost sight of his grief for a moment. He remembered working on the dromedary on 15 November, the very evening that his father John died, although a couple of weeks passed before it was finished.

The loss of his parents knocked Bewick sharply back and left him, at thirty-two, as head of the family, with all the responsibilities that entailed. Yet their deaths also freed him to forge his own path. This little woodcut was a positive step toward the full-scale book on animals that had been in his mind for the last six years. And in 1785 he took another step towards a long debated plan: he decided to marry.

Bewick was tall, good-looking and loaded with prospects, but he was also shy and serious, an elusive catch. He shied away from any suggestion that he might be courting. When drinkers in the inn where he stopped on his walks to Cherryburn for a glass of brandy and water (a new discovery, 'the most delicious beverage in the World'), teased him for visiting 'Maggy Hay's bonney lasses', he hastily changed his

route. He bridled at all assumptions that he was heading for a sweet-heart up the river, and in Newcastle the girls even mocked him as a 'woman-hater'. When his concerned mother pointed out an attractive, well-off young girl in the neighbourhood, he dismissed her, deciding that though 'her character was innocence itself she was mentally one of the weakest of her Sex'. Then he ducked the issue by saying that he could not marry while his parents lived, so that he could give them his undivided attention. Now the excuse would work no longer and also, it has to be admitted, since Ann had left he had been lacking a house-keeper. With an almost audible intake of breath, he took the plunge.

Describing this moment in his memoir, his tone was suitably solemn. Convinced, he said, that matrimony was for life, he brooded on the step with 'utmost attention and anxiety'. Money should not enter into it but he felt (displaying a countryman's regard for good stock) that he needed a healthy woman for the sake of his children, and a sensible one for his own happiness and comfort. Here he slipped from prudence to romance, for he was sure, he said 'that love is the natural guide in this business, and much misery is attendant upon it, when this is awanting'. Fortunately, the right person was at hand.

One day when he went to visit Gilfred Ward, the Wards' house-keeper, Isabella Elliot, answered the door. 'Bell', as she was known to friends and family, had been one of the girls he tormented as a boy in Ovingham church when he crawled under the benches to tickle their legs, provoking her so much that she once jumped to her feet and appealed to the Vicar 'Oh! Sir, guide [punish] Thomas Bewick', thus winning him the inevitable beating. She had been born at Woodgate, on the south bank of the Tyne, opposite Newcastle, but her father, Robert Elliot, then became a tenant farmer in Ovingham. Her mother, too, came from a local farming family, about whom Bell told many stories – of family violence, errant stepsons and a grandfather who

stored his wealth in his coffin 'in the shape of crowns and half-crowns' until he died, and the coffin was needed, whereupon the coins were piled in heaps on the kitchen table and the family divided the spoils.

Bell had the kind of childhood Bewick knew well. She had grown up in the Brick House in Ovingham – the only building not made of local stone – but she had early memories of the Woodgate farm, surrounded by a common bright with gorse, 'the beauty of which', said their daughter Jane, 'my mother always spoke of with rapture'. Despite having to deal with a hard landlord, whose tall hat and gold-headed cane made a lasting impression on Bell, in her rose-tinted memories the family were healthy and contented. Some of the land was tilled but the rest left to pasture: they had poultry and sheep, and the women spun all the broadcloth and blankets, bed-hangings and linen, helped by an old Scotswoman who had lost her family in the turmoil of the Jacobite rebellion of 1745 and now toured the neighbouring farms to spin and card the wool, passing on her store of ghost stories as she worked.

When Bell's father died in 1777, 'being of a very active and enterprising and independent' turn of mind, she set off for Newcastle and found work as housekeeper to Gilfred Ward's wife, so that Mrs Ward could help her husband in their drapery shop in the Groat Market. Here Bewick met her and courted her slowly. She was no social superior, like Mary Beilby; she understood the country lore that Bewick loved and he knew from her life story that she could deal with hard times as well as good. 'In due time we were married,' he wrote in his memoir in 1821, 'and from that day to this, no cloud so far as concerned ourselves has passed over us to obscure a life time of uninterrupted happiness.' Their wedding took place at St John's on 20 April 1786, and Bewick gave Bell a ring, inscribed with more prudence than passion, 'Let Virtue be a Guide to you'.

As for cloudless skies, Jane, who sometimes had a difficult relation-
ship with her mother, might not have wholeheartedly agreed, but in
his own grave way Bewick undoubtedly loved his wife. They set up
home at the Forth and a little later Bell's sister, Esther Elliot, moved in
as their housekeeper. In the spring of the next year their first child,
Jane, was born. At her baptism, her godfather was Bewick's friend
Richard Oliphant, a curate and schoolteacher and fellow fisherman.
As the small house filled up, Bewick's apprentice Robert Johnson, now
a tall seventeen-year-old, moved out and went to lodge nearby with
the surveyor John Bell, although he was often in and out of the Forth
and stayed a family friend for years.

John Bewick, 'Infancy', from *The Progress of Man and Society,* 1791

At Cherryburn, the family was regrouping. Bewick's youngest
brother, William, took over the farm and the mine, and in May 1786,
a month after Bewick's wedding, William married his own Isabella,
from the numerous Johnson family. A few weeks before, the brothers
had entered into a new lease with their landlord, William Wrightson,
taking the colliery on the same terms and receiving assurances that as

long as the rent was promptly paid they need not fear they would lose it. The mine proved hard work: two years later the seam met a dike and could be worked no longer in that direction, so they looked for coal to the west, 'every Seam on the common & to the eastward being wrought out'. The agent agreed, a surveyor was called in and new shafts sunk, only to be stopped before they could work the pit because of damage to the farm above. In March 1789 Bewick had to plead directly to Wrightson before the matter was solved.

His ties with the neighbourhood stayed strong. His sister Agnes had been married for ten years now to John Harrison, a farmer up at Hedley, and their children ran on the fell as Bewick himself had done. Ann and Thomas Dobson had moved into the Brick House in Ovingham, where Bell's family had lived, and were now expecting their first child. Sally Dicker, who had shared their home at Cherryburn, made what seemed at first the best match of all: in April 1786, the same month as Tom and Bell, she married Fenwick Bewick of Stocksfield. Fenwick was not a direct relation and came from a wealthier family, and the marriage was not a success, at least according to Bewick's daughter Jane, who thought Fenwick 'as bad a fellow as could be, & a disgrace to the name of a man'. He and Sally had three sons and three daughters, but in years to come, before the sons grew up and redeemed the family name, they were almost destitute. Sally appealed often to Bewick '& my Father never refused her money when she asked for it – which was perpetually'.

Bewick took his family responsibilities very seriously and his letters are full of worries about his brothers and sisters and small financial arrangements for the wider family: 'any thing I can do further to serve you shall not be a wanting,' he promised his father's sister Ann when she was widowed. He made sure that the three brothers, for example, clubbed together in 1787 to help this aunt (confusingly called Nancy,

like their own sister Ann). 'I mean to pay Nancy for you Willy & Self 1/6p week,' he told John, 'so that she may not loss by her Lodger & if I can procure any thing in addition'. To his frustration, William still had not paid up months later: 'he seems very near, as well as very Queer', he grumbled.

As new families took shape, old households dissolved. In early August 1786, having served out his apprenticeship, John left for London. Unlike his older brother, John Bewick thrilled to the capital. From the moment he sailed, on a Sunday morning, in a flotilla of forty ships crowding down the Tyne, he felt that nothing could go wrong. 'It blow'd pretty fresh,' he told Bewick:

so that we were well heav'd a going over the barr but I did not get a puke, tho I was rather sick all the afternoon for I kept much upon Deck. – the remaining part of the voyage was quite calm & pleasant I was highly pleas'd with the beautifull Country on each side the river it being the hight of the Harvest & every thing so delightfull & pleasant but that I suppose you are no stranger to.

Even the Essex marshes and the flatlands of Kent seemed romantic, while an afternoon at Woolwich, where they were stopped by contrary winds, was 'delightfull'. He could not wait to see the city.

John's first stop was Bewick's old employer in Clerkenwell, Thomas Hodgson, who had arranged lodgings for him across the road, meals in his own house and a place in his workshop. A few days later John wrote breezily, 'I like London exceedingly well, I hardly dare go out in the streets for their is so much entertainment at the shop windows &c that I never can get Home in time to go to my Work.' He was welcomed by friends from home – the Gregson and Bulmer brothers – and went to supper regularly with Robert Pollard and his wife, Ann, and their small children. Pollard, who was now a respected copperplate engraver and was on the verge of setting up, with his typical concern

for the distressed, the first benefit society for 'Infirm, Sick and Disabled Engravers', took John to the Royal Academy exhibition, where he noted Stubbs's paintings of horses and his *Bulls Fighting*, 'which in my opinion', he wrote, 'were not very capital'.

For the Whitsun holiday of 1787, with Philip Gregson and another Northumbrian friend, he tramped across Kent and Sussex: 'we walked about 120 miles & got home fresh as dasys'. Familiar characters turned up out of the blue, like William Gray, whom Bewick had helped when his fortunes were low and who had since moved to Nottingham, and Thomas Spence, always broke, who called in for a meal and after a drink or two was 'as hearty as a Cracket & as full of his Coally Tyne Poetry as ever'. John acted as a reference and found him odd-job work with Charles Cooke, a patronising but entrepreneurial publisher in Paternoster Row.

Most of John's own work was for Elizabeth Newbery and her energetic and kindly manager, Abraham Badcock, who were keenly commissioning new books, having lost their stock in a fire. Within a year he was thriving, laughing at the children born to the flurry of Bewick marriages: 'It appears from the Prolific Proofs', he wrote to Bewick, 'that you new-married Couple's have not been idle, my word such a fry of fine little Nephews & Nieces make me begin to think myself an Old fellow.' But the news from home was not always so happy. On Christmas Day 1787 Bewick stood as godfather to their sister Agnes's fifth child, Hannah, telling John that she was a fine little girl, but adding that Agnes was very ill: Ann, who was the baby's godmother, had stayed to look after her. On 20 February, Agnes died. When the news reached London John was shocked, mourning her mild nature and generous ways. He grieved especially for the hard-working Jack Harrison, who had cared for her tirelessly and was now left with four young children.

The letters between the brothers were scattered with news of their family and friends, rumours of marriages, jokes and gossip, and songs. 'It will add one more to your collection,' wrote Bewick as he copied out a Geordie ballad, with a little sketch of a mother and child:

> Gan up the Toun, maw bonny Hinney,
> An' riyde on the Brum, a-u-a, Hinney
> Gan up an' doun, maw bonny Hinney,
> Thou's the Flower of the toun, ay-u-a.
> For shep and for culler, thou's leyke th'mother,
> A-u-a, hey-u-a, maw bonny Hinney;
> For shep and for culler, thou's leyke the mother,
> A-u-a, hey-u-a, maw bonny Bairn.

John sent Bewick his 'little books', and fulfilled his orders for tracing paper, and for boxwood from Turkey, which John hoped was good 'tho its like buying a Pig in a Poke their is two sticks which weigh, one Hundred weight & Twenty one Pound at £1. 4s. p. Cwt you'l let me know how it proves when cut'. They also sent each other proofs of their work, the difference becoming more marked as time passed. Bewick's vignettes showed more concern with naturalism and effects of space and distance, with an occasional undertone of the gothic and grotesque, while John's designs were more two dimensional and decorative, in tune with the fashion of the time, full of a sweetness and wit that made them perfect for children's books.

Hodgson was 'exceeding kind' to start with, but after a year or so John began to chafe at his religious fervour – he was a member of the Countess of Huntingdon's Connexion, an enthusiastic sect – and at his obsessive belief that men were out to filch his business, which made him look askance at all visitors. The worst offence, however, was that Hodgson kept his prices so low, paying only 6d. for each 'Fables' block. Bewick was furious, and made this clear when he wrote admiring John's

'Children often in danger', from *The Progress of Man and Society,* 1791

Holbein-inspired woodcuts for *Emblems of Mortality*, 'Representing, in upwards of Fifty Cuts, DEATH seizing all ranks and Degrees of People':

I am much pleased with the Cuts for Deaths Dance, & wish much to have the Book when it is done – I am surprized that you wo'd undertake to do them for 6*d.* each, you have been spending your Time & grinding out your Eyes to little purpose indeed – I woud not have done them for a farthing less than double that Sum.

John was sanguine and forgiving, blaming the London market as much as the meanness of Hodgson, but it was clear that he would fare better on his own. By now he had rented rooms from a sign painter on Clerkenwell Green, lamenting the expense, but optimistically sure that here he would be more comfortable and happier 'as I can work & sleep & do everything by my own fireside'. He piled up the usual stock-in-trade like handbills and trade cards, and a stream of work came his way from Elizabeth Newbery and later from John Stockdale, a Cumbrian who had reached the eminence of bookseller with a smart shop in Piccadilly via spells as a trainee blacksmith, valet and book porter.

A new patron was the zealously entrepreneurial Dr John Trusler, famous for his bowdlerised version of Hogarth, who was now pub lishing etiquette books, guides to economy and table manners, and collections of sermons for busy curates. John cut the diagrams for his *Honours of the Table* in 1788, drank port with him, taught his daughter drawing and struggled manfully with designs for his books. The most difficult was *Proverbs Exemplified*. Many of these, such as 'Out of the Frying Pan into the Fire', are familiar today but others are long gone, like 'Every herring must hang by his own Gill'. And how, John asked Bewick desperately, can you think up a picture for *'to forget a wrong is the best revenge* what's bred in the Bone will never come out of the flesh Custom is second nature &c . . . such mental ideas will hardly admit of a design unless being farr fetched'.

He found designs for almost all – including a witty wedding scene for 'Look Before you Leap' – but the work was hard. 'I do assure you', he told Bewick, 'I have not eat much Idle Bread.' Ann's husband, Tommy Dobson, took pity on the exile and sent rye bread, butter, wine and potatoes down by ship, and when John sent back musical instruments and a second-hand waistcoat in return, he wrote defensively that he had never been out of work and 'there is not a young fellow in twenty in London lives so frugal and saving as I do'. All he needed now, he said, was a wife and an apprentice. As he wrote, the Tyneside burr came back: 'PS you'll please to liver the enclosed as directed & put Brothr Willy's in the Hexham Post thou may give Robin Brocket the bit whip coard thas about the Box mind.'

Occasionally John needed finer waistcoats than the one he gave Dobson. Through his friendship with Robert Pollard, who was starting a short-lived 'Incorporated Society of Artists', he touched a wider world. In January 1789, he reported that he had been

to see all the Paintings in the Queens Pallace at Buckingham House which was a very great treet indeed to see the works of all the old Artists . . . I have been to hear the Lectures at the Royal Academy where I had the pleasure of seeing Sr Joshua Reynolds & all the Head Artists & have since been made a member of the Artists Club which meet once in a month –

Bewick's life seemed plain by contrast, although there were excitements. In the years after his marriage Newcastle saw a burst of town planning. Mosley Street was finished, driving across town from west to east, and the filthy Lort burn was covered over to make a new, wide street – Dean Street – running down from Mosley Street to join Side just before Sandhill. The twisting Side became a cobbled backwater and Low Bridge, where Bewick ran to take proofs to Thomas Saint in Pilgrim Street in his apprentice days, was now just another lane. Outside the town, the big coal mines had steam engines supplied by Boulton and Watt from Birmingham; the great 'glass-cone' of the Northumberland Glass Company rose to astonish all; and William Losh founded the region's first chemical works, producing alkali, particularly caustic soda.

The old fairs and travelling showmen were rivalled by modern entertainments. A month after John left, on Tuesday, 19 September 1786, crowds had surged through the streets to see Vincenzo Lunardi, hero of the new balloon age, make an ascent from the Spital Fields. Drama ensued. While they were filling the balloon, a rush of gas terrified the men holding the ropes on one side: as they let go, rushing to get away, the canopy stretched upward and the balloon soared skyward, carrying a young man called Ralph Heron, who had twisted a rope round one arm so that he had a hand free to eat some nuts. At five hundred feet, before a horrified crowd, he fell to his death in a nearby garden. Newcastle ended Lunardi's career and gave Britain its first fatal air accident.

The town's summer season, based around the Races in July, with concerts and balls at the Assembly Rooms, was well established, and in 1787 a bill received the Royal Assent for the licensing of a new playhouse, the Theatre Royal. But the papers still carried the old-style news: on 7 June that year the sensation in the *Newcastle Courant* was that 'two sparrows built a nest on the topmast of a ship lying at the Quay, & laid six eggs'. Novocastrians loved this kind of curiosity: one of the woodcuts from the workshop most in demand was of a nest that two crows built in the weathervane of the Exchange in 1783, intricately balanced so that it swung with the breeze, carrying brood after brood as the years went by. As the pace of change quickened people clung to such details, assurances of continuity as fragile as the nests in the wind.

Bewick walked to the workshop, returned home to Bell and baby Jane, and worked on his woodcuts in the evenings. Yet he missed his brother, and John missed him. John's book illustrations were peopled with children, lanky and plump, wicked and pious, but he longed to see the real nieces and nephews to whom he sent his small books. The feeling grew intense when Bewick and Bell had a second child, Robert, on 26 April 1788. 'My compl. to Bella & am happy to hear she & the little ones are well,' wrote John, adding warmly: 'I give you Joy of your little son.'

13 AMONG THE ANIMALS

As he ran the workshop, married and settled into life as a Newcastle craftsman, Bewick worked quietly on his long-planned book on animals. As early as November 1781, he had written to Squire Fenwick of Bywell, whose famous racehorse, Matchem, had died in February that year:

Sir

An anxious desire for Information has prompted me to take the Liberty of troubling you with these few Lines, in which I hope your goodness will excuse my Freedom – We intend, in a little time, to publish a Natural History of Quadrupeds and as the Horse, is the first which we shall begin with, we wish to relate as many authentic Anecdotes, as may be thought curious, *of that noble Animal*.

Could Fenwick send him particulars about Matchem, since they believed him 'to have been one of the most remarkable of his kind'? They would not write about his pedigree but stress his supremacy – how many races and Matches he had won, the number of mares he covered, the sums of money he earned.

Horses fascinated Bewick and his drawings of them often marked key moments. When he left for his apprenticeship, according to his daughter Jane, the last thing he drew was a horse tethered to a tree near Cherryburn. In his prime he cut forceful engravings of race-horses, carthorses, circus horses. When he was old and feared his

powers were failing, he drew a weary horse 'Waiting for Death'. His appeal to Fenwick thus reflected his own deep interest. But his letter, and the dignified title of their proposed book, suggests that he and Beilby had already changed their mind about its market: this was no longer only for children, but for everyone with an interest in animals and the natural world. And as many of these potential readers would come from the local gentry – keen on field sports, delighting in anecdotes, alert to new knowledge of bloodstock and breeding – the racehorse was an obvious place to start.

A century before horse racing had been about endurance rather than speed, but since then the Arab stallions that arrived in the Restoration had been bred with English mares to produce a smaller horse with an amazing turn of speed: 'a creature of mettle and elegance, a pasha of the Levant, a Bedouin of Arabia nourished upon English grass'. The old 'matches' that set one horse against another gave way to the great chases: the St Leger was first run in 1776, the Oaks in 1779, the Derby in 1780. Stubbs's racehorse portraits were now the craze of the sporting world.

R A C E - H O R S E

The idea of beginning *Quadrupeds* with horses followed the practice of current authorities on animals. It would be more than 'a little time' before the dreamed-of book appeared but Bewick was right to think that such a book would be popular. Studying natural history was now a fashionable pursuit. From the start of the century, among collectors, one fashion had succeeded another: for shells, then flowers, then fossils and minerals. Aristocrats and merchants assembled menageries of exotic beasts, duchesses took up botany, clergymen exchanged letters about insects. Fashion coincided with a shift in philosophical and religious approaches.

Since classical times animals and birds had been defined in terms of their symbolic value, the lion as a symbol of courage, the pelican as an emblem of parental love, but Renaissance scholars had begun to examine animals and plants for their own sake, and in the seventeenth century the vogue for collecting curiosities converged both with the discovery of new species in distant lands and with new methods of enquiry and experiment advocated by the founders of the Royal Society, with their emphasis on observation, dissection and experiment. Instead of accepting biblical, customary or literary traditions, they turned to nature itself, regarding all details as significant, however small – indeed, the new microscopes now revealed the smallest creatures in all their extraordinary variety.

The emotional response of 'wonder' was tempered by a respect for accurate description, the strange often being explained in comparison to the known. Voyaging to Australia on the *Endeavour* in 1769, Joseph Banks saw a strange, leaping creature, which he described as being 'as large as a grey hound, of a mouse colour and very swift': Captain Cook also searched for comparisons, deciding it looked more like a wild dog, 'but for its walking or running in which it jumped like a hare or a deer'. Words would not do: for people to understand what

a kangaroo was really like, they needed a picture, and artists now invariably accompanied the explorers on their expeditions.

Alongside curiosity and observation went the urge to classify, order and arrange this startling richness and diversity. In the 1670s, for example, the pioneering naturalist John Ray, building on his work with his late friend Francis Willughby, had arranged birds into two hundred species according to their habits, plumage and anatomical differences. In the course of his work Ray also developed a philosophy, which saw the natural world as a miracle of Providence, an intricate balance of need and provision for all species, a wondrous economy in which everything played a part – even a slug or a sea anemone. But in the next century the Royal Society became more concerned with status than science, dozing smugly in London and leaving the work to the amateurs who rode out into the country with their notebooks and butterfly nets. The galvanising impulse came from abroad.

In the 1750s, the Swedish naturalist Carl Linnaeus introduced the modern binomial system, for animals and birds as well as plants, classifying them by specific features, like teeth, hooves or beaks. But for Bewick and his peers the 'artificial' system of Linnaeus was less inspiring than the work of the great French naturalist, Georges Louis Leclerc, Comte de Buffon, Director of the Jardin du Roi in Paris. Dressed in full court costume, so the story goes, complete with medals and ribbons, Buffon sat in his study and wrote for eight hours a day, for forty years. The great volumes of his *Histoire Naturelle*, which appeared between 1749 and 1767, told the story of the earth in seven epochs, instead of the Bible's seven days, with animals emerging in the fifth, and man last of all.

Buffon had style and his great work read (and sold) like a novel, a rolling drama of creation. Soon admirers across the channel spread his ideas to the British public, including Goldsmith, whose eight-volume

History of the Earth and Animated Nature cannibalised the *Histoire* without shame. Six years later the Scots printer and naturalist William Smellie began publishing his translation, with line engravings by Alexander Bell, copied from Buffon's plates. 'Such Animals as I knew, I drew from memory upon the Wood,' wrote Bewick; 'others which I did not know were copied from "Dr Smellie's abridgement of Buffon" & from other naturalists, & also from the Animals which were, from time to time, exhibited in Shows.'

Among those 'other naturalists', the most important to Bewick was the antiquary, travel writer and natural historian Thomas Pennant, a landowner from North Wales (and a close friend of Bewick's patron George Allan), who had published the first volume of *British Zoology* in 1766, following this in 1771 with *Synopsis of Quadrupeds*, and in 1781 with an enlarged *History of Quadrupeds*. Pennant had corresponded with Linnaeus and drew greatly on Buffon, but he departed from them both in classifying his animals and birds on the old 'natural' principles of John Ray, whose reverential approach he greatly admired. From the late 1760s he was also corresponding with Gilbert White, and their letters would form a major part of White's *Natural History of Selborne*, which, like Bewick's own book, was so slow to be born and so long-lived in its popularity.

When Beilby was worrying whether the publication would pay for the time they spent on it, he had consulted Solomon Hodgson, who had married Sarah Slack and taken over her father's old Printing Press, including the *Newcastle Chronicle*. Hodgson encouraged the partners to go ahead, and when he saw Bewick's cuts 'he most ardently insisted upon our making our work assume a superiour character to that of the "Shabby Book" we had been only thinking of surpassing'. As soon as the format was settled Bewick began to draw the animals, compar-

ing them with illustrations in different sources, correcting them and finishing the drawings on the woodblocks. When he finally began to cut the blocks, he tackled the foreign animals first, beginning with his dromedary at the end of November 1785 and then completing the camel on 2 December, the elephant on the 10th, the 'Mufflon-Zebu' on the 12th, and – after Christmas intervened – the zebra on the 27th.

THE ARABIAN CAMEL, OR DROMEDARY

Meanwhile Ralph Beilby, 'being of a bookish, or reading turn, proposed, in his evenings at home, to write or compile the descriptions'. Over the next four years Bewick would read all his drafts, and although he did not quarrel with Beilby's descriptions of unfamiliar foreign beasts, he had the benefit of a life-long interest in the natural world and constantly corrected the entries on British animals. He also consulted the gentry who patronised the workshop, borrowed books from them, asked them questions, and often they sent him drawings, asked him round to see their own dogs or monkeys, or lent him stuffed specimens. When Fenwick Bewick, Sally Dicker's husband, sent a stuffed otter at

the end of 1785, Bewick made him a tobacco box as a New Year's gift, with the otter engraved on the lid. If treated carefully, he wrote with barely suppressed pride, 'it may perhaps be a Tobacco Box in the Hands of *your Children's Children*, a Century hence – and when nobody then living will know anything of either the Giver or the Receiver of it'. And he went on, with eager concern for his precious work:

I have drawn the likeness of the Foumart, for the purpose that I spoke of to you, and have cut several other Figs. Of Animals, the Proof prints of which I will shew you the next Time I am in the Country – I am rather suspicious that I have not represented the otter, upon your Box, so well and exactly as it ought to be, but as I never saw one alive, or any thing that could give me the true Idea of that Creature, but the stuffed Skin of yours – could not do it better –

The following year, he had an unexpected opportunity to see a very different animal, the reindeer, when the workshop engraved the copperplates for Sir Harry Liddell and Matthew Consett's *A Tour through Sweden, Swedish-Lapland, Finland and Denmark*. The nephew of the popular Baron Ravensworth, a coal owner and exemplary land-lord, Liddell 'possessed a warm and generous, though somewhat romantic disposition'. He had just returned from a trip to Lapland with two friends, undertaken in response to a wager, bringing back two Lapp women and five reindeer. The Revd John Brewster compiled the *Tour* from the party's rough notes, and Beilby and Bewick pro-vided illustrations: Sir Harry viewing the midnight sun, Lapland sledges, birds, women and the reindeer, which Bewick drew from the life. In *Quadrupeds* a long entry explained the reindeer's importance to the 'poor Laplander', and told how Liddell added another five to his herd in 1787. Their fate was sad: some were killed and the rest died from an illness resembling sheep-rot, put down to their unfamiliar diet of rich green grass: 'Want of knowledge or attention to minute particu-

lars, is sufficient to overturn the best-laid plans.' Twenty years later, when the Liddells' family seat was demolished, Bewick bought the antlers and hung them on his kitchen wall.

By 1787 Bewick also had plans for a book on birds, as he explained to William Hutchinson. But 'The 2 Curious old Books' which George Allan had lent him were not of immediate use, he confessed, 'as it will be some time before I can work thro' the Quadrupeds – they may be of service if I was begun with the Birds, but that will entirely depend upon the Encouragement in the Sales that the first meets with –'. As he worked on the illustrations, he took his blocks to Thomas Angus, who made up proofs on good paper, and sent copies to John, now established in London. 'I have not seen any thing in the Animal way that I like so well as your own drawing,' John wrote robustly in response in June 1787. He had now seen proofs of the wolf, bulldog, terrier and greyhound, but felt this was not enough, so Bewick sent more: on the back of his letter was a pencilled list of twenty-six animals. But he begged John to keep the proofs away from London booksellers until the work was done. There were already competitors: this year Thomas Rowlandson published a series of etchings called *Foreign and Domestic Animals*, and Bewick was driven to 'a pitch of anxious curiosity' when he heard that the London publisher Taylor was bringing out Catton's *Animals Drawn from Nature*, with thirty-six aquatint engravings.

Luckily, when he saw this work, he thought the plates feeble and the whole series far too highly priced, but its appearance undoubtedly made publication seem more urgent. John sent any animal prints he could find, visited the menagerie at Exeter Exchange in the Strand, and – as Bewick had asked – sketched the animals at the Tower. The kings of England had housed lions, leopards and other exotic animals here since the twelfth century, a token of their sovereignty and power over

the natural world and distant climes, and the menagerie was a favourite with visitors, a revelation of strange beauty: in 1720 John Strype described a leopard at the Tower as 'very beautiful and lovely to look upon; lying and playing and turning, and turning her back wantonly when I saw her'. When John Bewick went, however, he was rather disappointed. Of the two lions, the old one was hardly shaggy at all and neither had long hair at the end of their tails as they did in heraldic devices. There was no wolf here, and those at Bartholemew Fair looked more like tame dogs. Still, Bewick's own version was worse: 'I show'd yours to the man at the Tower, he say'd he was too much like a Bullock, I think myself he is clumsy & heavy & his ears are the one half two short.'

Bewick confessed he was puzzled by the wolf, since all drawings differed, but he showed John's sketch of the lion to Edward Edwards, the Royal Academician painting scenery for the new playhouse, who

THE LION

warmly approved. In the new year, Bewick told John that he was 'glad to find that a large Collection of Animals are now on their way to this Town', including 'various kinds of the Ape Tribe, Porcupine, Tiger Cat and Tiger, Greenland Bear & one of the finest Lions (very lately brought over) that ever made its appearance on this Island'. This touring menagerie spent the spring in the north, visiting Durham and Newcastle, Alnwick and Berwick, before appearing at Stagshawe Bank fair: their 'Royal Numibian Lion', the proprietor claimed, 'is the only Lion that travels this Kingdom, or has done for 20 years past'. Bewick had drawn a tiger the year before, and this time he drew the 'Pig-tailed Baboon' and the grand lion, which featured large in the show's poster as well as in *Quadrupeds*. A note at the end of Beilby's description states that the lion was 'exhibited at Newcastle in the year 1788. It was then young, exceedingly healthful, active, and in full condition.'

As Bewick worked on his cuts in the evenings, friends dropped in to watch and chat, among them Jane's godfather, the curate and schoolteacher Richard Oliphant, who tried out his sermons while Bewick wielded his graver. 'Curate' sounds too solemn for Oliphant, who was a lively, sweet-natured and emotional man. After he moved away, he took short-term jobs at great houses or distant villages, scribbling letters to Bewick about fishing while the schoolchildren milled around him. He was a cheerful correspondent, except when he found himself amid unfriendly people and poor labourers: 'This Country is dreary & desolate, nothing but herds & coaleys. Full of whigs & tyranny . . . They would wish for me to begin school, but have no heart to engage in it.' His brother Isaac Oliphant, an apothecary who later inoculated Jane against smallpox, became a good friend of John in London.

A second caller was Isabella's godfather, Thomas Hornby, curate of St John's, but 'he would not, like my friend Oliphant adjourn to a public house and join in a tankard of ale, but he had it sent for to us at my workplace'. With Hornby, Bewick had fierce arguments about religion – 'he being', wrote Bewick, 'as I thought an intolerant high Churchman' – but for a long time he forgave him his views for his kindliness and ever-open purse for charity.

In January 1788, Bewick was able to tell John cheerfully that the book was nearly ready: he should see it advertised soon in the Newcastle papers at the Hole-in-the-Wall. The great issue now was how to publish it: they decided on two sizes, a big print run of around 1,500 copies in demy octavo (the size of most hardback novels today, 23 x 14.3 cm) and a select, smart edition for wealthy subscribers of a hundred copies in royal (the modern standard size for non-fiction, biography and history, 24.8 x 15.2 cm). The smaller ones would cost 8s. and the larger 12s. This was a confident print run: 1,500 copies was regarded as the most economical by publishers in this period, when the pressures of the market and the costs of presswork encouraged them to aim at multiple printings of small editions, rather than one large one. (For most novels, the first printing seems to have been around 800 copies, and even Smollett's *History* had a first printing of only 1,000.)

The next task was to get orders from the booksellers, persuading them with proposals decorated with specimens of the cuts. To woo special subscribers, Thomas Angus printed twenty copies of ninety-two cuts, although as Bewick explained sadly in May, the printing suffered as Angus was now mortally ill and 'could hardly stand at the press'. When Angus died later that year and the partners had to find a new printer, they turned to Sol Hodgson, who had encouraged them from the start.

The proposals were designed to appeal to sensible manufacturers, lawyers and gentry, the kind of men who ordered bookplates and had their silver engraved for their table. The book, it promised, would give 'A concise Account of every Animal of that Kind hitherto known or described', with observations of their habits, faculties 'and Propensities', embellished by accurate engravings, drawn from the life, or copied from the best authors. While it might seem presumptuous to add to the many books already published, the modest advertisement continued, so far the smaller books had been 'mean and pitiful' while 'the great expense of the more Voluminous Works confines them to the Libraries of the Wealthy'. By appealing to the pocket of their purchasers, as well as to their desire to be informed and to give their children the best, Bewick and Beilby could not go wrong.

Six booksellers in Newcastle, as well as Hodgson, took subscriptions, and so did others in Durham, Sunderland, Stockton, York and Edinburgh. In Nottingham, William Gray, still grateful for Bewick's help in his hard times, had already got about thirty subscribers and wanted more proposals to show. In London he dropped in on John, who thought him 'the most industerous & active man, he is as sharp as a whitechapple Needle & runs about the Streets as if a Pack of Hounds were after him'. John himself obtained orders from the Newcastle Londoners and from his printing and bookselling contacts.

Although the partners were aiming chiefly at the northern book trade, Robert Pollard and John insisted that the venture would suffer if Bewick did not come down to London to push it himself ('I do assure you a sleeping Cat gets no Mice here'). But he stuck fast. To his friend, he pleaded too much work and too little cash. Surely the work could be stopped without injury, Pollard replied, offering a lift with his brother James and meals at his house: 'Make no ceremony, tell a few Friends where you are going & if not a Journey to Canterbury to expi-

ate yr Sins tell them yr coming to London for the Honour of *God yrself yr works yr friends & yr country.*' To his brother, Bewick confessed there would be domestic upsets if he came, but John was having none of it, writing firmly at the end of May 1788: 'as to your saying your Wife wou'd not hear of it, it is a poor cobweb boody-hoo kind of an excuse'.

John was particularly vehement since he had just seen the proposals with the accompanying cuts, some of which dismayed him. For once his tone was tart, rubbing in his complaint with a comparison to the rival that Bewick had derided:

I was exceeding sorry, & vext, to see your Hyena done without a tail, an Animal so particularly well known among the Curious, I should thout you might have seen Mr Cattons, which is a pretty good one, I was obliged to cut it from the Proposals as I could not show it to any Body.

He was right about the hyena, and Bewick cut and fixed a separate little piece to the block to give it a tail, but nothing could dent his confidence.

He sent the proposal and some of the special proof cuts to Samuel More at the Society of Arts, appealing to the Society's aims by suggesting that a cheaper edition might follow 'for the Use of Youth at School, with a View more widely to diffuse this Branch of Natural History, and also to awaken in the Contemplative Mind, an admiration of the Wonderful works of Nature'. When More responded warmly but cautiously, Bewick wrote again, stressing the unusual accuracy and quality of the cuts:

Considerable progress is now being made in the Work, in a Style, I think, not inferior to the choicest piece of typography. Its novelty (and I hope I may add without vanity its elegance and utility) cannot fail attracting the notice of the Curious – If I am not mistaken, it is, the first modern attempt in letter press

Printing, to unite with the description a decent Figure of the Animal described; a plan which while it lessens the price, will enable the publishers to introduce more abundant materials.

As Bewick piled up his proofs and checked and corrected Ralph Beilby's notes, unknown to him, at the other end of the country in a Hampshire village, the other great natural history book of this decade was taking shape. All this spring, Gilbert White was sending the last sections of his *Natural History and Antiquities of Selborne* to his niece Molly to mark up for the press, and while she corrected proofs, he began on his index, 'an occupation full as entertaining as that of darning stockings, though by no means so advantageous to society'. Just as Bewick's best drawings drew on knowledge gathered since boyhood, so White's observations had accumulated slowly over twenty years, expressed in journals and letters to Thomas Pennant and Daines Barrington. In future years, Bewick was to love, and use, White's book – a blend of empathy and feeling, sober observation and affection – but in 1788 neither author quite knew what to expect. Full of trepidation at launching his book, White felt, he said, 'like a school boy who has done some mischief and does not know whether he is to be flogged for it or not'.

The Natural History of Selborne was ready for Christmas 1788 and published at the start of the New Year. While White heaved sighs of relief, Bewick was still working. He was concerned for quality, buying fine wove paper, which could take ink more easily, instead of the usual laid paper. When he saw the proofs, John was thrilled: 'if your language & discription be equal to the cuts & Paper I think t'will be the most beautiful work'.

Many things intervened to take up precious time. In March, Bewick wrangled with the Wrightsons again over running the pit at Cherry-

burn, and made special prints of the 'Whitley Ox' for Richard Oliphant, who had moved to a curacy near Scarborough (where he got good fishing in the Derwent, full of trout and grayling). The following month George Allan passed on a request from the naturalist Marmaduke Tunstall, a Fellow of the Royal Society and Society of Antiquaries, asking Bewick if he would engrave the wild cattle belonging to Lord Tankerville at Chillingham Castle, about thirty miles north of Newcastle. Impressed by the engravings of birds in Consett's *Tour*, he first asked for a copperplate, but after he saw Bewick's woodcuts of the lion and the bear, this was altered to a large woodcut. On Easter Sunday 1789 Bewick set off with a companion to walk to Chillingham. The tramp took them north across the moors, first smoky with burning heather and then covered by 'immense old winter wreaths of frozen snow'. (The moor above Chillingham still sees snow at Easter, and winds so strong that snowflakes settle vertically on fence posts, and icicles stream out horizontally in the blast.)

The bailiff at the castle nestling in the lee of the moor was an old friend, John Bailey, and he showed Bewick the herd. These small white cattle with their black muzzles and tawny ears – which can still be seen at Chillingham today – are rare descendants of native wild cattle, penned in by the enclosure of the park in 1225. Now only a few remained, roaming large estates in Scotland and northern England. Tunstall's own family had once kept a herd, which had perished from fever, and being an ardent collector of natural history facts, Tunstall had made extensive notes on similar herds, living and extinct. As he explained in a long letter to Joseph Banks, President of the Royal Society, they were 'once the unlimited rangers of the great Caledonian and British forests', and still retained 'much of their native fierceness'. It would have done little good to point out that even domesticated cows reverted to such behaviour if left for a generation or so: these animals

were valued because they were 'Ancient Britons', aboriginal, dignified and 'noble'.

Although Bailey took Bewick to the herd, he found it was impossible to sketch them while they constantly wheeled round and confronted the intruders in their well-known way, forming menacing ranks before they charged 'looking wildly at the object of their surprize, but upon the least motion being made, they all again turn round, and fly off with equal speed'. (A few years later he told the antiquary Francis Douce that he had 'ventured myself more amongst them than I should like to do again'.) Although he was sorry not to show a young bull with shaggy neck and mane, he had to make the best of it, nervously seeking out a single bull, a defeated rival 'driven to seek shelter alone, in the Quarry holes in the Woods', and creeping downwind of him on hands and knees between the bushes, sketch book in hand.

The drawing was done, the block was cut and a few impressions on paper and vellum were made, and then came disaster. The cleaned block, left in a sunny spot at Hodgson's workshop over the weekend (entirely Bewick's fault, as he placed it there), split in two, and although it was clamped together it had to shed its elaborate border. But all was not lost: by many critics the large print has been regarded, at the time and since, as Bewick's masterpiece. It was his attempt to show that wood-engraving could match the fine copper engraving of a master like William Woollett, whose prints he owned and greatly admired. And to a historian like Simon Schama, Bewick's Chillingham bull, 'an image of massive power', still resonates as 'the great, perhaps the greatest, icon of British natural history, and one loaded with moral, national and historical sentiment as well as purely zoological fascination'.

*

'The Chillingham Bull'. With its border, the woodcut measured 7¹/₄ by 9¹/₄ inches

From Easter onwards the British held their breath at events in France. When news came of the fall of the Bastille on 14 July, dinners were held and speeches made, celebrating the end of despotism. It seemed that the French were following the 'rational' British model of the Glorious Revolution of 1688. Bewick, like many, felt that until now they had been slaves to an absolute monarch and a greedy, blind aristocracy. 'In this state of the public mind,' he wrote later, with undimmed approval, 'the French people rose simultaneously, as one man, and with unconquerable energy & bravery, like a whirlwind, swept off the advocates & the armies of despotism in heaps, or one after another, from the face of the earth.'

In Newcastle, the month of the Bastille triumph was wild and wet, with violent thunderstorms, and the surface of the Tyne was thick with hay from the fields cut upstream. Yet during the natural and political storms, Bewick's mind veered back to animals. And as he worked through the summer, his brother John was there to encourage him. The previous winter John had suffered a troubling cough, which he hoped to cure in the clear air of the north. In May, after nearly three years away, he sailed home. He spent the summer at Cherryburn, but when he returned to London in late September *The General History of Quadrupeds* was still taking shape. Nothing ever went straightforwardly at a local printing press, with all the constant interruptions of other work. Hodgson had a newspaper to print. Some sheets would be held up on account of a cracked or unfinished woodblock, or cold weather, or poorly dampened paper, or mouldy paper. It was never possible to print a book straight through from beginning to end. In some ways this was good, as Bewick could stop the presses to insert a new animal like the dingo, the 'New South Wales Wolf', which arrived in London that October on a ship from Botany Bay.

Gradually the end drew near: the agreements with two London booksellers, the Robinson brothers and Charles Dilly, were all in place. In the final anxious run-up to publication, feeling the need of his experience in publishing and bookselling, Beilby and Bewick offered Sol Hodgson a third share in the work, free from any payment for the woodcuts: on 10 April 1790 the agreement was signed. Soon all the proofs were corrected and the sheets were printed, but when he gave Hodgson the title page for the press Beilby wrote his own name in as author, as Bewick recorded:

on Mr Hodgson seeing this, without saying a word he stroked the name out with a pen, while Mr Beilby was looking on – I knew nothing about this trans-action for sometime afterwards, and it might have passed so, for any thing I

170

cared about the Authorship, or whose name was put on to it as such. – It was sufficient for me that I had the opportunity of giving vent to my feelings and gratifying my desires in doing my part of the work –

And that was how it appeared. On the title page the authorship of the text was not mentioned. *A General History of Quadrupeds* was published on 26 April with a single line in small capitals, 'THE FIGURES ENGRAVED ON WOOD BY T. BEWICK'. Below this, in smaller capitals, came the names of the 'projectors': 'PRINTED BY AND FOR S. HODGSON, R. BEILBY, & T. BEWICK, NEWCASTLE'.

14 QUADRUPEDS

Beilby and Bewick, like Gilbert White before them, did not quite know what to expect. This was a new venture for them, and in the concluding vignette of the two blind fiddlers, with its keen political edge, Bewick gave his own features to one of the musicians and Beilby's to the other. They were country entertainers venturing blindly past the enclosures and traps of gentlemanly authorities and critics. They need not have worried. As soon as it was published, the *History of Quadrupeds* was greeted with delight. People had in their hands a simple book, full of illustrations, with an index at the front where an animal they knew well, like the mole, was sandwiched between exotic-sounding creatures such as the Mexican Hog and the Monax, a rabbit-like marmot from North America. Just as the proposals had promised, the book was accurate and straightforward yet still in tune with the vignette on the title page: *Omne bonum de super. Opera dei mirifica*: 'All good comes from above. Wonderful are God's works.'

The first edition discussed 260 animals, from the 'Adive', a small jackal, to the 'Zorilla', described as a Mexican skunk with a black bushy tail and a stench so powerful that it could overwhelm a panther. But the useful alphabetical listing was actually a gesture of despair. One of the biggest puzzles Beilby and Bewick faced was how to arrange their animals. When they turned to the scholarly books

they found that arguments abounded between adherents of the 'systematic classification' of Linnaeus, the 'natural' system of John Ray and the looser arrangement of Buffon, who claimed that Nature's very variety and apparent randomness was what made it interesting and types should not be pinned down. The problem was made more difficult by Linnaeus's practice of changing his 'fixed' categories with new editions, and by the fact that so many other writers took different routes. Some divided animals into wild or domestic, native or foreign. Some used old categories like 'useful' or 'vermin': weasels, martins, polecats, rats and foxes fell into the latter. Other writers grouped them according to physical characteristics, like the kind of foot, or hoof. One critic of arbitrary rules even suggested that the dog should not be placed with foxes and wolves but should follow the horse, 'as it did in ordinary roads and farmyards'. Bizarre as this seems, it has its own logic: if God arranged the world, then our experience proved that he must indeed have intended the dog to 'follow' the horse.

Baffled by the arguments, Beilby and Bewick stepped back and left the whole problem to the scholars. But despite their acknowledged 'disregard of system', they settled on a loose system of their own,

dividing the animals into loose groups beginning with the most famil-
iar, especially 'those which so materially contribute to the strength, the
wealth, and the happiness of this kingdom; of these the Horse, the
Cow, and the Sheep, claim the first place'. With many earnest refer-
ences to George Culley's best-selling *Observations on Livestock* of
1786, to Robert Bakewell's breeding of sheep and cattle and to James
Anderson's essays on Scottish agriculture and the Western Isles,
Quadrupeds swerved cheerfully between a global survey of known
species and a handbook for a country livestock sale.

After the fine farm animals, the entries slid from one group to the
next, seizing on vague similarities of form or habitat as if a bewildered
Noah were puzzling over the procession into his ark. After the sheep
came goats, gazelles and antelopes, elks and reindeers and deer. Pigs
were followed by tapirs and then by a sudden flurry of exotics, who did
not fit in anywhere – rhinoceros, hippopotamus and elephant. With a
brave gesture, the book then leapt to 'Animals of the Cat kind', defined
boldly as 'a sanguinary and unrelenting tribe', running down from lions
and tigers to a polecat making raids and a well-fed pussy on a cottage
windowsill. Badgers gave way to bears; foxes and wolves to heroic
hunting dogs; hares and rabbits were followed by guinea pigs, mice and
squirrels; moles by monkeys, porcupines by hedgehogs. As it neared the
end, the book ended with a watery tail of otters, walruses and seals.

Beilby had done his reading earnestly, if erratically. His text was dot-
ted with references to Buffon, Linnaeus and Pennant, and to old
favourites, like John Caius's *On English Dogs* of 1576, and even, some-
times, to Aristotle. He looked up history books, quoting Camden and
Holinshed. He ploughed into travel books, citing Dr Johnson on red
deer in the Highlands, the Jesuit Father Jerome on Canada, and the
Anglican missionary Edward Parsons on Africa. But he had favourite
books by his elbow, which gave the vaunted 'general survey' some

strange geographical bulges, with many references to Siberia and Kamchatka and even more to the Cape of Good Hope, whose animals had been copiously described by Anders Sparrman when he accompanied Cook on the *Resolution* in 1772–6. (Sparrman's letters were translated from Swedish in 1785, so Beilby may have acquired them in his early enthusiasm, at the same time as Bewick was cutting the dromedary.)

Many entries featured weird, exciting-looking beasts, and dramas to entertain readers: an intrepid lady beating off a tiger with her umbrella; hunters selling beaver skins; lemmings pouring across country like a torrent, their course 'marked with ruin and desolation'. But this was also a distinctly regional book. Well-worn local anecdotes such as the 'noted old fox Cesar', who led the huntsman Charles Turner fifty miles across country, or Mr Ridley's dignified mastiff, who grabbed an annoying mongrel by its back 'and with great composure dropped it over the quay into the river, without doing any farther injury to an enemy so much his inferior'. This story was clearly an old favourite and so was the tale of the baboon shown in Newcastle in the

THE BABOON

late 1770s, a creature 'extremely fierce, libidinous and strong', which 'discovered marks of the most violent passion' at the sight of women, so that one rash girl who approached too near had to be forced from its grip by the keeper.

A few abstruse species trotted past without pictures, but Bewick provided 200 woodcuts of animals, and over a hundred tailpieces, scattered where space allowed. If the picture was copied he acknowledged his sources when he thought them good, like Buffon, and also where he thought them dubious, like Sparrman, whose hippo does indeed look strange until you realise it is a baby. Some exotics like the anteater, where his source was poor, are frankly hopeless, but those that he saw in the travelling menagerie are full of life, like the lordly tiger and sinuous, mischievous baboon. Indisputably, the best cuts were of the animals he knew, from the lumbering cows to the hare, leaping nervously across the page, its eyes glistening, the domestic rabbit, munching its recommended diet of 'sweet short hay, with a little clean oats', or the springer spaniel bounding through the reeds.

THE SPRINGER, OR COCKER

Readers could detect Bewick's presence in the text as well as in the woodcuts. We hear it in the common-sense rejection of gentlemanly experiments like Liddell's failure to give the reindeer the right habitat, or Buffon's deduction that foxes do not mate with dogs. This was nonsense: kept in captivity, their sexual drive failed just like their hunting instinct – chained foxes never pounced on a hen clucking near them, but if anyone deduced from this 'that Foxes have a natural aversion for poultry' he would be laughed at loudly. In the north of England, *Quadrupeds* asserted, cross-breeding was known for a fact and often exploited: farmers would tie up bitches in heat to lure a fox to mate with them. The puppies had their sire's sharp nose, prick ears and short legs, and were most useful for driving cattle: 'They bite keenly; are extremely active and playful; and are very expert at destroying weasels, rats and other vermin.'

Remembering such things, the boy from Cherryburn sprang back to life: the whole project made him look back at his own childhood, when he poked at the anthill, or watched the hares run across the

THE CUR FOX

fields in early mornings. He was there in his memories of the black-faced rams at Stagshawe fair; of the ferrets, left carelessly unmuzzled, who fall asleep down a rabbit hole once they have caught their prey; of the foumart, the polecat, running close to the ground, raiding the farmyard for poultry, eggs and milk. This 'has another mode of procuring subsistence, which has hitherto escaped the observation of the naturalist', we are told. During a blizzard, some tracks were found, mixed with other mysterious marks, leading from a burn to a burrow. The hole was dug out, the polecat taken, 'and eleven fine eels were discovered to be the fruits of its nocturnal excursions. The marks in the snow were found to have been made by the motion of the eels in the creature's mouth.' This was the creature Bewick showed.

THE FOUMART

Sometimes, especially with dogs, like the fine water spaniel belonging to John Blackett, Bewick drew individual portraits. On his way back from Chillingham at Easter 1789 he stopped at Sir Harry Liddell's estate in Eslington, where the agent was his 'kind and hearty

friend' John Bell, and drew the large Newfoundland dog belonging to John Vint of Whittingham. His woodcut showed it standing firmly with the owner's name on its collar, while a procession of smaller dogs scamper past to emphasise the Newfoundland's size, and four figures – Bewick, Bell, and the printers John Vint and William Preston – cross the bridge in the background. In *Quadrupeds* the text stressed the Newfoundland's love of swimming, its eager eating of trout out of the nets, and above all its cleverness and devotion to its master. When a Newcastle vessel was lost off Yarmouth, a Newfoundland swam ashore with the captain's pocketbook 'as if sensible of the importance of the charge'; on another occasion a dog rescued a child who fell into the Tyne, catching it in its mouth and delivering it safely ashore.

THE NEWFOUNDLAND DOG

Such stories, combined with the woodcuts, made irresistible reading. And local people liked to see their lives and animals immortalised.

Often Bewick copied from paintings and drawings belonging to local collectors, like the Revd Egerton of Durham (also the proud possessor of a 'squirrel-opossum' from New South Wales). Animals brought home by the sailors were popular pets, especially monkeys: one New castle surgeon had a small baboon, another man possessed a 'Green Monkey' and a third a 'Varied Monkey, or Mona', a gentle creature, remarkably tame and fond of those it lived with. Bewick drew them all. Native wild animals were also made pets. Several people had tame otters, and the one belonging to William Collins, who came from Kimmerston, near Wooler, followed him everywhere. When it was lost for a few days, he went down to the river and called it by name: 'to his inexpressible joy, it came creeping to his feet, and shewed many genuine marks of affection and firm attachment. – Its food, exclusive of fish, consisted chiefly of milk and hasty-pudding.'

Beilby's text, backed by Bewick's affectionate drawings, often focused on the animals' usefulness to humans, their provision of meat, milk, wool and leather, their role as beasts of burden, their skill in hunting or herding. But all the accounts and many of the pictures added moral judgements too. The weasel has 'patience, assiduity, and cunning'; the goat is a 'short lived animal, full of ardour but soon enervated: his appetite for the female is excessive, so that one buck is sufficient for one hundred and fifty females' – a statement followed by a vignette of a lad riding off on an understandably cheery billy goat. By contrast with these delinquents, the dog is lauded as virtually responsible for the rise of civilised nations: a true history of the dog, we are told, would show the 'gradual advancement of that order which placed man at the head of the animal world, and gave him a manifest superiority over every part of the brute creation'.

Man is at the head of the chain of being (and Britain, in this book, is undoubtedly at the head of the nations, in farming, hunting and

breeding dogs and horses). But all the animals, with the possible exception of the rat, command a degree of respect. Beilby's text and Bewick's woodcuts also often attributed human qualities to their subjects: loyalty, dignity, pride or determination. Bewick, in particular, seemed to think that animals' intuition and instincts could make them wiser than complacent humans. Thus a horse and a dog pull back while their master, out hunting, stares at the flock of birds overhead and tries to drive them straight over the riverbank.

These suggestions of animal intelligence linked the book to current debates. A century before, British law, as well as the Church, had accepted that animals had souls and must take moral responsibility for their actions: animals were publicly hanged for their crimes. When this notion was discarded, domestic animals were diminished to the status of property, like tables and chairs, to be used and abused at the owner's will. But the new sciences of anatomy and natural history had emphasised how much they shared in physical terms with humans, in the structure of bones and blood and nerves. In this case, if an animal had no soul, asked Julien de la Mettrie, was it a biological machine? It was a short step from there to the conclusion that if so, man must be a machine too.

The idea of the animal as a soulless, if living, mechanism, went against the grain with country people. They gave the birds names like their own – Jackdaw, Tom Tit, Robin Redbreast, Jenny Wren, Willy Wagtail. They knew that dogs had different dispositions, that pigs had cunning, cows had their own slow kind of reason. They knew, too, that men could be just as devious and cruel as foxes and quite as filthy as swine. In a different way, men and women of 'sensibility', who believed that true humanity rested less in reason than in an open emotional response to the world, from delight in a piece of music to sympathy with the poverty of a child, had no doubt that animals felt pain and could suffer. *Quadrupeds* certainly took this stance.

Beilby and Bewick did not criticise hunting, since so many readers would be country squires, to whom this was sacrosanct, but they spoke out firmly against the cruelty of badger baiting, 'an inhuman diversion', thankfully 'confined to the idle and the vicious', who enjoyed seeing this harmless animal defend itself against a pack of dogs 'with astonishing agility and success'. Their fiercest attack was on the training of brown bears, captured young in the forests of northern Europe and subjected to cruelties 'such as make sensibility shudder' to make them stand upright. Often blinded when young, a bear had an iron ring put through its nose, was starved and beaten and made to dance upon hot plates before being trailed around the country to dance at the fairs. The book's impassioned description ended with a direct appeal to the magistrates: to 'prevent every exhibition of this kind, that, in England at least, we might not be reproached with tolerating practices disgraceful to humanity'.

The sense that we are all 'fellow mortals', as one contemporary tract put it, made Bewick suffer for animals and argue for their protection. In this he was like his contemporary Burns, feeling for the field mouse,

'Wee, sleekit, cowrin', tim'rous beastie', turned up in her nest by the plough, or Christopher Smart comically, but with utmost seriousness, praising the beetle 'whose life is precious in the sight of God, tho' his appearance is against him', or John Clare in the next generation. But acceptance of closeness also made Bewick even more fearful of the collapsing of this animal/human boundary in himself and other men. On the one hand this fed into his politics, fuelling his anger at how the poor, the vagrants, the mad, the downtrodden workers were all compared to 'brutes'. On the other, he sometimes came near to panic at the thought that loss of moral control in himself, or in others, would lead to precisely this 'brute' state, the loss of the precious human soul, the light of reason, the essence of difference.

To drive home the point, Bewick cut a tailpiece of a wandering showman leading his poor old bear with a monkey on its back: round the corner in the distance stands a gallows. He placed the same dread warning in the background of his scene of two boys coolly hanging a dog from a tree, one standing with folded arms, the other sitting back on the bank to watch its agonies. If such boys could torture and kill animals for pleasure, what was to stop them progressing to humans?

This was the question Hogarth had posed in his *Four Stages of Cruelty* in 1751 forty years before, and still relevant in Bewick's day. The lives of people, as well as animals, are the subject of this book.

The first readers of *Quadrupeds* were particularly struck by the way that the native animals were so carefully placed in fields and farm-yards, forests and hills. They liked the sketched lives in the back-ground: the tinker on his ass with his family trailing behind, the Scottish herdsman in his kilt and bonnet, the milkmaid balancing her pail. The whole life of the countryside seemed to pass before them. The vignettes amplified their enjoyment. These had a practical pur-pose, filling the empty space when an entry was too short to allow another on the page, and some of them were simply copy-book designs of rococo ornaments and masks. Most of them, however, were also, to use Bewick's own pun, tale-pieces; they added a story, a joke, a moral. Most unusual of all, they showed ordinary people that read-ers might recognise. Bewick thoroughly enjoyed creating such scenes, finding them a relaxation from the carefully accurate animals. He delved into his store of old cuts and sketches, always offering some astute observation, the amused glimpse of a moment, like the way a

small dog delicately raises its paws when venturing on to slippery ice, or a piglet dashing across the grass suddenly starts back when it sees its reflection in the bell jar covering a tender plant.

Although the placing of the tailpieces was dictated by practical needs, filling empty spaces at the end of pages, they often made an oblique comment on the ways of men and animals. One scene showed a pedlar's horse, up to its withers in the water as it carries its master across while the dog barks on the bank. (In the next edition, in comic contrast, Bewick also showed a pampered horse being ferried across a river surrounded by a family all in their Sunday best.) And thinking of beasts of burden, elsewhere Bewick showed an elderly countryman, perhaps a tinker, carrying his wife across the stream, while she balances a basket on her head and a baby on her back.

The moral might be to show a foolish marriage between age and youth – December and May – but the detail made it real. To keep his head warm, the old man is wearing a clergyman's cast off wig and beaver hat: his legs are spread wide to steady him on the slippery river-bottom. The young wife clutches her husband's shoulders with one hand, but with the other she carefully supports the heavy basket teetering on her broad straw hat as she slips down his bony back, sticking out her feet for balance, with her heels peeping though her

stripy stockings. The baby, meanwhile, looks snug and secure, peering over the sling made out of an old sack, perkily unconcerned.

The marks of Bewick's graver are so delicate they might almost be drawn with a needle, yet a whole life is there, framed in the curling foliage, with a skein of birds soaring over the parish church beyond. The scene draws you in, and tiny as it is, it can be looked at over and over again. This made people value their copies of *Quadrupeds*, both the adults who knew the country ways and the children who looked first at the animals, and then laughed at the pictures beneath. As a boy, the novelist Maria Edgeworth's brother Frank had a copy, inscribed: 'This book was given to Frank Oct 27th 1798 by his Father'. As one correspondent told Bewick's daughter Jane in 1865, this copy was 'still in existence after 70 years wear & greatly treasured'.

III FLOOD

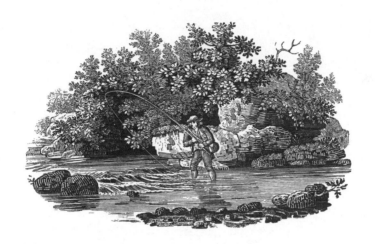

15 FROM FUR TO FEATHERS

'We have never heard of Mr Bewick or his history, yet perhaps both deserve to be better known,' declared the *Critical Review*. In the past few months Bewick had shot like a firework from the obscurity of Amen Corner into the glare of national fame. To his embarrassment, a poem by the 'lively and animated' schoolteacher George Byles appeared in the *Newcastle Advertiser*, in praise of 'his excellent Engravings on Wood, in the HISTORY OF QUADRUPEDS, published at Newcastle':

> Go on, great Artist in thy pleasing way,
> And learn us Nature as the rising day:
> Thy just Creator's wondrous beings show.
> And teach us from thy art – his boundless pow'r to know:
> Thy charming pencil claims our warm applause,
> And leads us on to study Nature's laws.

This was a vindication of Bewick's own aim, but as soon as the poem appeared, he said, 'I felt obliged on its account to shun Swarley's club, of which Geo. Byles was a member, to avoid the warm & sincere compliments that awaited me there.' When a Glasgow lawyer called at the workshop to compliment him, he remembered, 'I blushed over the ears & left him talking to Mr Beilby.'

He would have to get used to celebrity. Readers near and far praised the book to their friends. Beilby's brother William, now a Pall Mall bookseller, took over thirty copies; in Birmingham, his other brother Thomas distributed another fourteen. In London Sutton Sharpe showed it to James Barry, 'which pleases him so much', reported John in June, 'that he wishes to have a dozen copies more'. Southern readers were alerted by an advertisement in *The Times* on 26 July and by delighted articles in major periodicals. Within a few months every copy had gone and London booksellers were eager for a second edition: Charles Dilly was particularly keen, reported John: 'he wishes much to have a hand in the Pye'.

Bewick's laziness – as John saw it – in not puffing his book personally in London was turned to his credit, since people were delighted to seize on something untrumpeted, like finding a treasure on a junk stall. Instead of a mere notice, they gave this 'entertaining and judicious work' full-length articles, including extracts intended to persuade parents to buy it for their children. All declared, too, that the woodcuts, rather than the text, made it stand out. The real excitement for critics was not in having a new book on animals, but in discovering an unknown artist who was working in a medium long overlooked. Bewick's woodcuts had a delicacy and clarity that had previously seemed unattainable: they were lively, spirited and original – 'peculiar' in a positive sense.

John passed on an enquiry from some connoisseurs, who wondered if they could have 'the Animals printed in a copy without the letterpress with the names only'. 'I could sell a great many in London,' he added. One such request, immensely flattering, came from Sir Joseph Banks. About a dozen to eighteen sets were printed. One went to Matthew Gregson, a Liverpool upholsterer and collector who was a member of a local 'Print Society', who found the cuts, he said, 'much

superior to any thing that has lately been seen in this way and what I had given up all hopes of ever seeing . . . The general Effect, the Distances are excellent.' Another set went to Samuel More of the Society of Arts. 'The work has met with such a reception from the World', Bewick told them both, 'as I had never lookd for nor expected.' (At the time of the first printing, four sets were printed on 'Whatman's fine wove atlas vellum paper': Bewick gave one to Bell, and later wished that she would let him sell it to the 'bibliomanists' to whom he owed obligations, but she would not part with it.)

The sales of *Quadrupeds* more than doubled the workshop profits in 1790. At the same time, brooding on how the watchmaking business had distracted his partner from the workshop, Bewick began to feel he might work more efficiently by himself. He discussed this with his brother, who had not a sliver of doubt that he should break away. A great deal could be said pro and con, John said, but all those who wished him well would strongly encourage it, and 'as to its appearing to you like beginning the world again, it might be so, tho' not without some knowledge of it'. He also pointed out that the 'intricate matrimonial accounts' of a partnership could only get more complicated. The longer Bewick waited, the harder it would be. Nevertheless, it was a big decision. At thirty-seven, Bewick had real matrimonial accounts to worry about: he was currently supporting Bell, her sister Esther and three children under four – the Bewicks' third child, Isabella, was born in January 1790. It had been a difficult time, as Bell had a breast abscess, with a violent fever, but all was well by the time Isabella was baptised in St John's. Thomas Hornby stood as godfather and little Jane remembered the christening all her life, 'being drest in white with a blue sash & red morocco shoes – which made me very proud'.

Bewick thought hard about his family when he reviewed his relationship with Beilby. In one oblique reference, John made it sound as

though Bell was completely behind the move, or might even have pro-
posed it herself, folding her arms and declaring that she could bring
the family up perfectly well on less money, even if they had to eat
crowdy, the local porridge. 'I cannot help admiring the intrepid pro-
posal of your faithful Helpmate,' John commented:

she seems to have enter'd on the Business with some degree of spirit, I am
perfectly of her way of thinking & should do the same myself on such an
occasion, tho' to be sure Crowdy here wou'd be esteemed a dish of some
novelty, but I could live in a hollow Tree on Bread & Cheese which might
be equally cheap.

But Bewick dithered, partly out of caution and partly out of loyalty to
Ralph. 'I acknowledge', John wrote, 'to do as we would be done by is
the grand Motto, & ought to be before the Eyes of every man whether
in Business or not, but cannot help thinking at the same time that Mr
Beilby (in his various persuits) has lost sight of it.'

The partnership unbroken, Bewick and Beilby began to plan ahead.
The extra profits meant that they could finally move from their
cramped rooms at Amen Corner. Nathaniel Bayles, who was ill with
gallstones and had given up his practice, agreed to sell them the lease
of his house in the south-east corner of the churchyard, with steps
beside it down to the new Dean Street. On 2 September, when Bewick
was staying at Tynemouth in the end-of-summer calm, Ralph dashed
off a note to him about orders to be collected, adding 'NB They have
begun to lay our Foundation *this Day*'. Builders stripped the old house
and laid new foundations, strong enough to carry a copperplate press.
Carpenters fitted stairs, floorboards and cupboards, upholsterers
brought new furniture, and painters gave the walls a fresh lick of
whitewash. Both partners were in an extravagant mood, but Beilby's
proposal to make metal buttons here as well as running an engraving

shop made Bewick despair. 'I never thought the difference between *I* & *we* had been so great till the other day when we were speaking of the new business of dealing in Buttons,' he groaned. 'The more I think upon it the worse I like it.' It made him think again of all the time Ralph devoted to his other business and to feel even more unsettled and exploited.

In these months they had also both been working on a second edition of the *Quadrupeds*, adding eleven new animals, including the Arabian horse, the Kyloe ox and the seal, and fourteen different bats. Excited letters from readers brought corrections to existing entries and suggestions for new ones. Friends were eager to help. Richard Oliphant, now teaching in 'a bit blind country school', sent long ramblings on sheep, wolves and African goats. Once again John scoured the capital for prints, this time of 'Truffle Dogs'. After issuing proposals quoting the glowing reviews, the second edition was published in July 1791, and a third would appear for Christmas the following year.

From now on, many orders were accompanied by enquiries about Bewick's next project. He began to correspond with Thomas Pennant, who corrected his names and praised his prints: 'they are much admired, are they cut on box? Pray call yr Bear a new Species of Bradypus or Sloth: it is very faithful: I have seen the animal & have closely examined it . . . Do not forget the Seal tribe in yr next Edition.' Other requests were less helpful and more peremptory. John Mackenzie of Morpeth, on learning that he had also illustrated Gay and the *Fables*, ordered both, as well as two copies of the second edition of *Quadrupeds*, a royal for himself and demy for his children, 'as I consider natural history as one of the most interesting subjects of attention to Children when they begin to read'. Was Bewick planning to work on any other branches of natural history?

This, of course, was exactly what he was planning. Having finished one mammoth ten-year project, he immediately embarked on another. He had been dropping hints about a book on birds for the last three years, since mentioning it to Hutchinson and George Allan in 1786. The trigger for his new burst of activity came in the autumn of 1790, when Marmaduke Tunstall gave Beilby a letter from Sir Joseph Banks, urging them to go on with their *History of Birds*. 'I believe we must think of it seriously', wrote Ralph: could Bewick get any 'Aquatics' while he was in Tynemouth? As Christmas approached, John had to field eager questions from booksellers which, since he knew nothing about a planned book on birds at that point, vexed him considerably, but now that the idea was in the open Bewick consulted both him and Robert Pollard. He was worried about taking money in advance from keen subscribers, but Pollard insisted that everyone did it, even the Lord Mayor of London – he should get going as soon as possible.

Working on birds, especially the British birds he knew, gave him a deep, intense pleasure: 'with these I had long been greatly charmed, paid great attention to, and busied myself very much in reading various descriptions or accounts of them'. Reading would become a passion in the next two years. He started with the recently published general 'Natural Histories' of Richard Brookes and John Miller and, once again, with Smellie's abridgement of Buffon. Then he moved on to Pennant's writings and other books lent by friends and enthusiasts, particularly George Allan, who gave him Eleazar Albin's three-volume book with its beautiful watercolours, as well as Pierre Belon's 'very old Book', *L'Historie de la Nature des Oyseaux* of 1555, and Francis Willughby's *Ornithology*, edited by John Ray in 1678. 'With some of these', Bewick wrote, 'I was in raptures – Willughby & Ray struck me as having led the way to truth and to British Ornithology.'

Bewick had, however, been determined to work from nature if he could, and the first real chance for this came in the summer of 1791. Marmaduke Tunstall had died suddenly the year before, and his heir asked Bewick if he would like to draw the unique collection of stuffed birds at Tunstall's house at Wycliffe, in County Durham, before it was sold. Without hesitating, on 16 July he set off. He intended to travel to Darlington with a brief stop in Durham, but once there he was way-laid by a friend, missed the coach, stayed the night and went on the next day. From Darlington he continued on foot through a summer storm, jotting down a reminder in his notebook: 'Walked to Wycliff – ½ fryed wth Heat – Thunder & lightning – Exps 6d.' Later he told Bell that his luggage had been left behind, so that he had to wear his sweat-soaked shirt during the first few days working in the grand Hall.

He stayed near the churchyard, down by the river Tees, in a cottage belonging to John Goundry, a joiner who had done taxidermy work for Tunstall, and ate his meals with John's father George, a retired miller. It was an idyll of tolerance as well as work. During Sunday lunches at the Rectory, George Goundry and the elderly vicar, Thomas Zouch, both reminisced warmly about their late landlord. Tunstall had been a Roman Catholic with a private chapel, Zouch was a Church of England minister and Goundry a Deist, 'and yet these three

uncommonly good men, as neighbours lived in constant charity and good will towards each other'. Zouch acknowledged that old Goundry could beat him in argument, but although he shook his head over his unorthodox beliefs, 'as to his moral conduct, he was one of the best Christians he knew'.

Tunstall had written his own *Ornithologia Britannica*, published privately in 1771. He had enlarged the old fortified farmhouse at Wycliffe, building a special room to house his 'Museum' and bringing his whole collection from London in 1783: over eight hundred birds, as well as reptiles, fishes and insects. Collecting stuffed birds had been a fashionable pursuit since the mid century. In 1763 the *Annual Register* had announced proudly 'A New Method of Preserving Birds, with their Elegant Plumes, Unhurt', which involved dousing the bird with a mixture of salt, ground pepper and powdered alum, hanging it for two days and drying it for a month in a frame, where it was braced with threads into a natural pose. Collectors were the prime purchasers for lavish illustrated books, which enhanced their status as experts, and Bewick was entranced by Tunstall's fabulous library, a treasure chest of all the books he needed. 'I arrived at this remote corner of the Earth on Monday night last,' he wrote excitedly to Beilby and since then he had been 'looking thro *part* of the very rare and curious Books on natural Hist'y'. Surely this library was the best stocked in the kingdom? Tunstall's own work also amazed him: he had corresponded with all the leading naturalists and had left a mass of notes and anecdotes, with quotations from every conceivable authority: 'he has not even forgot *Beilby & Bewicks* Quads'. The notes alone would furnish a history of birds, if they could borrow them.

Almost dizzy with delight, Bewick powered into his research. He looked at works by all the well-known names and listed what he found in his notebook – 200 descriptions of birds in Pennant's multi-

volume *British Zoology* (carefully annotated by Tunstall); 365 in George Edwards's *Natural History of Uncommon Birds*, which had appeared in seven parts between 1743 and 1764 with large and detailed plates; 900 birds in Linnaeus and 1,000 in John Latham's more recent three-volume *General Synopsis of Birds*, published between 1781 and 1785, for which Latham had drawn, etched and coloured his own plates, showing many new species. There were Swedish and German authorities and elegant French volumes, including Brisson's six-volume *Ornithologie* from the 1760s. Reeling after three days' immersion, Bewick had already decided that Edwards and Buffon were the only ones really useful to them:

I mean for the figures, which are generally extreemely well done, & indeed I think them better to copy than the stuff'd Birds here. I can only pay attention to the Beak & plumage – they are so distorted and unnaturaley stuck up that, as faithfull representations of them as I can do, appear stiff as a poker.

Bewick planned to draw as many of the rarest British birds as he could – 'I think we cannot in one Volume do more'. This passing comment marks the moment when he decided to restrict himself to Britain. *Quadrupeds* had demonstrated the difficulty of dealing with strange species, and Bewick was stunned by the vast numbers recorded by Linnaeus and Latham. But while he was at Wycliffe Bewick noted Edwards's descriptions of summer migrants from India, like the 'Greater Redstart' (the modern rock thrush), 'Whitwal' (golden oriole) and small green wren, and made watercolour sketches of several foreign birds.

In this small village by the Tees, with good friends and a wealth of material, he was blissfully happy, even though there were a few snags:

I am rather inconveniently situated I lodge at one house – victual at another & have to go backwards & forwards to the Hall – they are strickt Roman

Catholics & have prayers twice a day – during which all the doors are lock'd – & those who are out must stay till they are done – this is the soberest corner in the world. I am quite weaned & find Milk & water a middling good beverage – at least for the present I am obliged to think so –

A far greater worry was the health of his son Robert, now four. After variolation against smallpox, his eyes were inflamed – perhaps from rubbing the spot on his arm or leg that had been deliberately infected with smallpox matter, and then touching his eyes. When Bewick left, Bell took the children to Tynemouth for the fresh sea air.

In early August her first letter arrived: 'I never opened a letter with more anxiety nor read one with more pleasure in my life, than I did my Bells,' Bewick told her; 'my dear little Boy is hardly ever out of my mind . . . if upon my return I find him recovered – I think I shall be frantick with joy – indeed, if upon my return I find you all well I shall look upon my fireside at the Forth like a little heaven.' He planned to stay another three weeks until the new heir to Wycliffe arrived, but was already weary from packing so much into such a short time. 'I have dulled myself with sticking too close to it,' he admitted; 'I am tired out already & wish it was over.' Signing off as 'My Bells loving husband', he finished in his best domestic vein. They must take care to make sure the beds were aired when they went back, he warned her, and 'tell Jane & Robert that if they behave well I will let them see a vast of little pictures of Birds when I come home – I hope my little Bell will be able to say more than *dadda* when I see her again.'

August was a sweltering month and his fears for Robert did not lessen: 'Let him lie cool & take him often to play at the seaside,' he fretted. But he kept his nose in the books. The household became used to him working quietly on his own while they were at prayers; the steward and housekeeper were kind to him and he learned to live without more than the odd glass of wine. In the absence of barbers, he also

learned to shave himself ('this puts me sadly about'). Altogether he spent two months 'at that little earthly paradise'. Back home in the autumn he sent presents via John Goundry including a new razor for old George, much needed in that barberless desert. But, he added with a flourish, no razor could ever be sharp enough to cut the thread of their friendship. Writing to Goundry, he sent greetings to the whole family, seeing the village as if it was before him: 'I can imagine that I hear Robin singing in the Mill, old John Baylis riding upon the Poakes & poor old Kitty Wycliffe talking about Clocks and Sun Dials &c.'

In early September he traipsed home through pouring rain, calling in for a couple of days to dry off at the home of John Forster, an Ovingham schoolfriend. Back in Newcastle he began cutting blocks of the birds he had drawn, but almost at once, as he had foreseen, he became impatient with the stiff stuffed forms, finding a

very great difference between preserved Specimens & those from nature, no regard having been paid at that time to place the former in their proper attitudes nor to place the different series of the feathers, so as to fall properly upon each other. This has always given me a great deal of trouble to get at the markings of the dishevelled plumage & when done with every pains, I never felt satisfied with them.

There was nothing for it but to wait for birds newly shot or brought to him alive. Friends were already inundating him with pheasants, owls and sandpipers found by the river. 'This place abounds with Jays, thrushes, black-birds & other small birds,' wrote the ever helpful Oliphant, 'but these I suppose are so common that it would be no compliment to procure you one of each.' He was right: the common birds posed no difficulty, but for the rarer species Bewick just had to be patient. 'I cannot hope to get half of the cuts done for the birds the ensuing winter,' he confessed to a London bookseller in July. 'I cannot

help it if other History's of the same kind come out before ours with a view to foredate the market to clash with & rival it – I shall do my utmost to give faithful representations from nature – to be able to succeed in that is the first wish with me.'

Although progress was slow, Wycliffe was a wonderful beginning. As good luck would have it, the Museum was sold to George Allan, who carted every case of birds, insects and reptiles over to Blackwell Grange near Darlington. The great books from the library were sold, and in June 1792, when he received a catalogue from a York bookseller and recognised the titles, Bewick wrote quickly in hopes that the Buffon that he had so admired had not gone. He had missed it, but paid a fortune – nine guineas – for Brisson's six volumes. The carriage alone, for these heavy quarto volumes, was costly. Bewick entered the sum in a new account book:

1792	Apr 4	Wm Charnley Whites Voyages	£1–11–6
	May	Pennants Arctic Zoology 2vols 4to	16s. 6d.
	June 23rd	Carr of Brisson works from York	2s. 8d.
	28	Brissons Ornithy	£9–9–0
		Carr. Of Bird from Yarmouth	6d.
		Sea Gull from Tynemouth	2d.
	July 26	F[reight] of Buffon by Sea	3s. 0d.

Slowly, very slowly, over the coming years, he began to put together *A History of British Birds*.

16 'YOUR LADS'

We jump, skip, forget the daily round, the trivial things like the broken nights that Bewick suffered when Isabella's teeth came through in the spring of 1791: 'Teething is an unavoidable trial Children have to undergo, therefore must expect some disagreeables to attend it,' wrote Richard Oliphant blithely. He had cut down on his clubs and social evenings: 'I am seldom at Swarleys or in Public Company,' he wrote to one friend; 'I cannot rise *clear headed* in the Morning when I Spend my Evenings out of the Company of my Wife and Bairns.' This was partly due to Bell. In their early days together he often stayed out until two or three in the morning, but Bell, he reported late in life, 'got him broken of these habits, and in cases of occasional transgression, used to rate him pretty severely':

for instance, she commenced one morning a pretty lively tirade upon the impropriety of such rakish conduct, reminding him how unbecoming it was in a married man, and the father of a family &c, and concluded by some slight cut at his untidy, slovenly habits before marriage: all this he endured for some time with much philosophy, till seeing no immediate prospect of a cessation, he began with an enormously long and curiously intoned ejaculation, something like the following 'A–h what a wind there's in our house this morning! Why before I knew you I was a nice, canny, tidy lad – but now I gang about with my coat out at elbows, and taties in my stocking heels! A–h!' this,

uttered in a tone of undisturbed good humour and so comic, that his good lady was compelled to desist.

Every morning the sober married man stepped out of the door and walked the brisk five minutes to the new workshop. It seemed busier than ever. Many people who had bought the *Quadrupeds* now wanted bookplates or business cards by Bewick – 'I have quite set my heart upon having a Card cutt by you,' wrote Matthew Gregson in August 1791. He was still hoping eight months later, and when the card eventually arrived, displaying the shop's name on a crest against a swirl of drapery, with a river and fort behind, he showed it to everyone he knew. The result was that still more orders arrived – and still less leisure for Bewick. Several times he had to turn work away. He declined, for instance, to do four cuts for Thomson's *Seasons* 'being already engaged in more undertakings than (I doubt) I shall ever be able to perform' (although he begged to be put down as a subscriber to his favourite poet).

On big illustrative commissions like *Poems by Goldsmith and Parnell*, he roped in the apprentices. This was a lavish project undertaken by William Bulmer, now acknowledged as the finest printer of the day. He had established his Shakspeare Press in 1790 to print the folio edition of the plays, using a new typeface designed by William Martin, one of Baskerville's pupils, and embarked on the quarto volume of *Goldsmith and Parnell* at his own expense, specifically to show that British printing, type-founding, engraving, and paper-making could compete with the best Continental work. It should have been a fine showcase for Bewick, and Bulmer was hurt that he was so slow with the cuts: 'Your delay in the execution of them, has entirely defeated my original intentions of the publication,' he complained. He exaggerated, but his irritation was understandable.

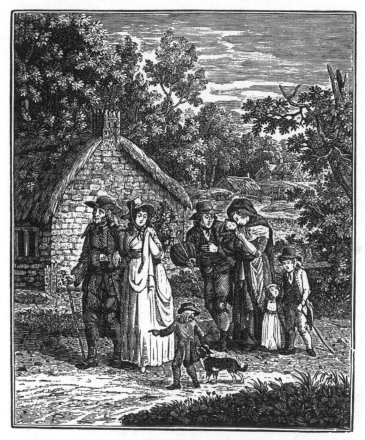

'The Departure', from *Poems by Goldsmith and Parnell*, 1795

To make things worse, Bewick charged the maximum for the cuts despite a clear agreement in advance about prices. Originally they had agreed on four guineas for cutting the large blocks, like 'The Departure', with the smaller vignettes at two guineas each, but when Bewick sent in his bill in January 1793, six months after the work

was started, he charged five guineas for all the large cuts except one. Even John was surprised, reminding Bewick that Bulmer was a good honest friend: 'I cannot help thinking you have behaved extreemly quere.' For the final cut, 'The Sad Historian', Bulmer commissioned John directly, at a cheaper three guineas. But he appreciated Bewick's talent (and he made a thousand pounds from sales of *Goldsmith and Parnell*, which made the £36 that he paid Bewick for the woodcuts look very meagre), and he soon approached him again.

In 1794 John reported that Bulmer planned a new work 'in Latin from some old author'. Their earlier spat forgotten, he had asked John to tell Bewick '(if you wish to immortalize your name) to do a few head or tail Pieces for it which he will Print in such a manner as has never been done before, the work will be presented to *the King* & all the society's of arts & sciences'. Too busy with the birds, Bewick let this pass.

For some large projects, like the copperplates for a new edition of *Ostervald's Bible* (a popular English edition of a Bible translation by a Swiss protestant preacher), the workshop farmed out work to outside engravers and even to Pollard's men in London. This could cause problems. With his mind on his own books, Bewick was rushing and cutting corners, and he enraged Pollard when he sent some designs by other engravers for his men to copy. Using these would be a flagrant breach of copyright, and even if, Pollard suggested sarcastically, Bewick and his client did not know the current copyright law, such plates were 'liable to severe Penalty beside the disgrace in Assisting in an unjust & impolitic attack on the Rights of a Brother Tradesman'. He would set his young men to work only if they were provided with proper drawings.

Matters calmed. Pollard bought out-of-copyright prints on Bewick's account and by March 1791 his men were working on the first twelve

engravings, beginning, appropriately, with Genesis. But he smarted again when he had to chase Bewick for payments: 'Your acceding to this request will oblige Yr (tho almost out of Humour) & somewhat Dissappointed / Robert Pollard.' The start of the following year brought him more disappointment. For some time Pollard had been working on an ambitious two-volume work, *The Peerage of Great Britain and Ireland*, aimed at the nobility, to demonstrate the high standard of copperplate and wood-engraving. He asked Bewick for cuts, yet when they arrived they were so crude that he could not use them. His normally fast writing sloped furiously across the page, heavily underlined. If Bewick could not do the cuts himself, Pollard fumed, he should have said so and returned the designs, 'as I cd of got yr brother to have done them instead of giving them to yr lads'.

Pollard was right: Bewick did rely too much on his lads. Although he complained that the apprentices were more trouble than help, without their work he could never have spent time on his own books or on his correspondence with naturalists. A succession of boys filled the premises and as they grew in height, years and skill, so new ones arrived to take their place. In 1789 John Laws ended his time and after a spell as a journeyman set up as a silver engraver, while also managing the family farm. The account book noted his step to independence, and the celebration that marked it:

> Mar 18 John Laws first wages 18s. 0d.
> Exps upon the occasion 6s. 0d.

Jack Johnson stayed on after his apprenticeship ended. In 1790 he and his cousin Robert engraved copperplates for *Captain Cook's Voyages*, and two years later Jack designed 'The Hermit at his Morning Devotions' and Robert 'The Departure', which Bewick then cut for *Poems by Goldsmith and Parnell*. Always concerned about the John-

son family's welfare, Bewick obtained the post of Keeper of St John's Poor House for Jack's father, and his parents moved into the city from Weardale – Jane Bewick remembered going down the dark lanes to the Poor House to see them as a child. Meanwhile Jack's cousin Robert lodged nearby with the surveyor John Bell, and often called in at the Forth, bringing flowers from a relative's garden each Sunday, playing with Jane and Robert and carrying baby Isabella in his arms.

Gradually the team expanded. The talented Charlton Nesbit, a keelman's son, was apprenticed at fourteen in 1789; in 1791 Henry Barnes began a three-year stint before suddenly disappearing, possibly to America, and the following September the seventeen-year-old John Anderson arrived. His father, Dr James Anderson, was an admired figure in Edinburgh who had provided information on Scottish agriculture for *Quadrupeds*, but he was always short of cash, not only because he had thirteen children, of whom nine survived, but because he poured his money into his periodical the *Bee*, for which the workshop provided cuts. He paid a substantial £60 for John's indentures, but his restless son provoked such tension that in March 1795 the partners appealed to the magistrates, accusing him of irregular attendance, rudeness, influencing the other apprentices and deliberately finishing his work badly 'to the great injury as well as the discredit of the said masters', and finally stopping work altogether. John was arrested, and a few weeks later, after a panel of arbitrators sorted out the dispute, his father took him home to Edinburgh. He missed his friends, writing sadly that he wished Robert Johnson would answer his letters. Later he worked as an engraver in London, ending a chequered career with a final flight – either, it was said, to Rio or to Botany Bay.

In the mid 1790s Beilby and Bewick took on another wave of apprentices. The first to arrive, in 1794, was the splendidly named Henry Fulke Plantaganet Wollocombe Hole, son of a feckless soldier

disinherited for marrying a Newcastle butcher's daughter. He was followed a year later by Charles Hickson, whose father, a London musician, had died and whose indentures were paid by the charitable Yorkshire squire Sir John Lawson. The third of this group, and by far the most brilliant, was Luke Clennell, a sturdy but knock-kneed sixteen-year-old, who thought of nothing but drawing and painting. One of nine children of poor parents, Luke had been apprenticed to his uncle, a grocer, who generously set him free to follow his heart's desire, and Bewick looked after him well, paying for clothes and for mending his shoes, and lending him money. Two quieter apprentices soon followed, Mark Lambert, from a village near Hexham, and Edward Willis, grandson of old Geordie Carr, who had worked for the dyer Thomas Dobson in Ovingham.

Bewick found it hard to see the boys he had cared for grow up and form their own opinions, as his brother John had done and Robert Johnson was beginning to do in the early 1790s. Bewick had often passed his preliminary drawings for woodcuts to Johnson, who turned them into careful watercolour studies. In addition, the partners sent him out to paint topographical scenes for distinguished clients, including views of Charles Clavering's castle at Widdrington and Lord Delaval's Ford Castle. They paid him well, but always took the view that these were workshop commissions and thus belonged to them – just as Josiah Wedgwood felt he owned the work of his designers, and would not let them sign designs or models that they made for his cameos and vases. But this was a delicate matter and views were beginning to change: increasingly, craftsmen were redefining themselves as 'artists' and laying claim to their own work.

After Robert ended his apprenticeship in late August 1794, his parents moved into town to live with him and he set up as a drawing teacher in Mosley Street. He caused much amusement with his local

satires, such as 'Isaac Dixon, spirit merchant, finding Timothy Dobson, Keeper of the Shakespeare Tavern, Mosely Street, Playing with False Dice', but he found it hard to earn a living. Seeing him short of cash, friends reminded him of the time in 1793 when the Earl of Bute, passing through Newcastle, had bought some of his watercolours at the workshop for a handsome £30, and persuaded him to claim for the payment. When Bewick and Beilby refused, he took them to court. The case, which was heard in 1795, hung on the assertion that lessons in drawing and watercolours were not part of the apprentices' training. Technically this was correct, and when Charlton Nesbit gave evidence to back up Johnson's argument, much to the surprise of all those involved, he won the case.

Bewick was aghast. He could not bear to blame Robert and instead turned his rage on his 'friends' and on the jury. He still felt the hurt when he came to write his memoirs. He had taken a boy, he wrote, and treated him with the kindness of a father or a brother, taught him 'with every pains in my power', been generous to him with money, called in doctors when he was ill, paid him whether he was at work or not, tried to advance him in the world, '& when all this was done, he shewed not a particle of gratitude, but observed that any "cart man would take care of his Horse"'.

It was an unhappy story. The court decreed that the partners should pay Johnson by the end of 1796, but he never saw his money. In October that year he was in Scotland copying paintings at Taymouth House, Kenmore, for Pinkerton's *Scottish Portraits*. Alone, but for a few servants, in the empty, freezing mansion, he caught cold, became feverish and fell into a delirium that led local people to judge him 'a madman'. With a ferocity that harked back to the treatment of insanity in an earlier age, the villagers bound him and beat him to drive out the devils that possessed him. A passing doctor stopped the beating

and treated him, but although the fever passed, Johnson's frail body was shocked beyond recovery by the assault. He died the next day, at the age of twenty-five.

Even closer to Bewick's heart than Robert Johnson was his first apprentice, his own brother John, to whom he confided all his plans. John had seemed better when he left Cherryburn in the autumn of 1789, and he was planning for the future, drafting love-letters to a Newcastle girl: trying to 'smother & suppress', he wrote, 'that ardent Passion which in my Breast seemd only to glow in vain, but alas the more I have endeavoured to forget you the more I am inclined to Love'. By now he had moved from Clerkenwell to a cottage at Mount Pleasant in Hornsey. It was only an hour's walk from London, he told her, and 'you may in one Day unite all the Pleasures & Conveniences & the Bustle of the Great City with the sweet retirement of the Rural Village'.

At first he planned only to take these lodgings for the summer but he felt so well there – 'perfectly recovered, thank God' – that he decided to stay. The countryside around lured him out. Unlike Bewick, he had never given up hunting. 'I have wished much for my Gun ever since I have been at Mount Pleasant,' he wrote, and 'shou'd be glad if you could send her, and an old favourite tinn Powder flask with my name upon it, the first opportunity'. Their sister Jane was in London (perhaps following Hannah in working for the Ridley family), and John saw her before she went back to the north. He met acquaintances from the art world, like Thomas Stothard, and had plenty of work: Trusler wanted cuts for his part-work *The Progress of Man and Society*; Elizabeth Newbery for *The Visits of Tommy Lovebook*, and especially for Arnaud Berquin's *The Looking-Glass for the Mind*. This was John's liveliest and most often copied book, a collection of little

stories, adventures, discoveries, warnings against cruelty to animals, with beguiling cuts seen from a child's-eye view.

'Nancy and the boy who sold the birds',
from *The Looking-Glass for the Mind*, 1792

Commissions also came in for handbills and cards, puzzles and games, and twice a week John taught drawing to the boys at Crouch End Academy, the old weather-boarded school ruled by the benign headmaster, Nathaniel Norton. In March 1791, Robert Pollard told Bewick, 'Yr Brother John dined with us yesterday & was Present when your Parcel came – *He is very Well.*' But the following spring, 1792, brought a relapse. It was clear now that John had consumption.

The summer heat was unusually fierce and the country was on edge. In July, France declared war against Prussia and in September, after the storming of the Tuileries and the terrible prison massacres in Paris, the new French Republic was proclaimed. The Bewicks' old cronies like Thomas Spence reacted with passion, responding to Thomas Paine's call, in the second part of the *Rights of Man*, for British society, too, to be transformed: Bewick kept his own copy of Paine's book until his

death. New societies sprang up, such as the London Corresponding Society, founded by the Scottish shoemaker Thomas Hardy. The government and conservatives bristled in reaction: Paine fled to France, but in December he was tried *in absentia* and outlawed. Rumour spread like mist, with tremors of coming war.

But while Bewick's radical friends were caught up in the turmoil, his own main preoccupation was with John. Realising his concern, John assured him in late October that he was daily getting better:

& am at Present thank God, perfectly well, excepting a little Cough, which I cannot persuade myself that all the smels of Mickley Bank, or Benwell Hills, will ever eradicate, or have any better effect than the sweet & wholesome Air that I here enjoy, yet at the same time must again return you my most sincere & affectionate thanks for your kind & Friendly offers to accommodate me in the North; your reasoning respecting Lifes slender thread is perfectly good, & your argument equally forcible, to be with ones Friends in time of sickness is, or at least was my most earnest wish, But I ever here hope for the best.

It was true, he admitted, that 'the Kitchen the Nurse and the Doctor' had swallowed most of his earnings, yet the same was true of Bewick himself. At this point, very briefly, John acknowledged a slight regret that he had not been given the opportunity to sell the *Quadrupeds*, instead of the bookseller Robinson. Later he apologised for this mild rebuke, afraid that he had seemed to criticise his brother:

Your advice & utmost endeavours to serve me, I may say from my infancy, when Ill able to judge or serve myself, must to my last day with gratitude be remember'd, which I am afraid will be the only (tho poor) recompence that may ever be in my power to make – my very poor state of health at present crouds with grief on my memory all these past obligations.

John wrote this in March 1793, a low point. He was now in cheaper lodgings in Crouch End, a damper, mistier spot, and he had been

spitting blood, which he confessed alarmed him. By contrast, the Bewicks' family life at the Forth seemed, as their sister Hannah had said, a little paradise. Their fourth child, Elizabeth, had just been born. 'I sometimes wish to be with you in the North,' John wrote sadly. Isaac Oliphant, Robert's brother, now an apothecary in London, was urging him to go abroad, somewhere warmer, but France was now out of the question since on 1 February the new Republic had declared war against Britain. Any other foreign trip would be too costly, and in April John took the boat back to Tyneside. Ill as he was, Jane Bewick remembered her uncle, with his green coat and presents of little books, as one of the funniest, gayest men she ever knew.

He enjoyed his stay, working on the tailpieces for Robert Pollard's *Peerage* and the cuts for Joseph Ritson's *Robin Hood*, the most outstanding of the many popular antiquarian collections. John gave Bewick several cuts to finish at the workshop, and their joint work imparted a lyrical beauty to Ritson's democratic greenwood, 'the forest of English fellowship where English class magically dissolved into the moss'. By the time he went south again in August, travelling by coach to avoid a rough passage, he seemed stronger. The boat with his chests took two weeks, in terrible weather. When it finally docked he discovered that the seaweed he and Bewick had collected (a favourite, health-giving addition to the diet) was lost, and the pickled Tyneside salmon had gone bad on the voyage. Such setbacks, small as they were, were hard to take.

Shortness of breath stopped him walking, but riding seemed to help, although keeping his pony was expensive and he thought with envy of the straw stacks at Eltringham. The brothers discussed plans and passed on gossip: John told Bewick, for example, about old Thomas Hodgson's will, his legacies left largely to charities with a few bequests to friends in the north: 'consequently the chicks about Bladon & the

Lang-raw will be sporting a dashing figure this summer'. But by the summer of 1794 John himself cut a pathetic figure. From Easter he had a tube in his side to discharge the fluid, and the disease spread to his joints, causing excruciating pains in his back and groin, reminding him of their sister Sally's long and painful illness.

This was a strange, dark time. Press gangs were ranging along the coasts, picking up sailors to fight the French – there were fights in the Newcastle streets, deputations, cries of women whose men were snatched. In the district of All Saints behind the quay the parish rate doubled as the wives and families of seamen turned to the parish for help. The clubs that Bewick enjoyed were silenced by fear of government spies. Deaths and departures seemed to leave him stranded on an unfamiliar shore. John wrote calmingly about how well he was feeling, but when he sent his print for the frontispiece of *A General State of the London Hospital* to Charles Brown, his doctor at Hornsey, he added a rhyme:

> Dear Charles, I here send you an impression from wood
> Of that grand institution which tends to do good.
> Whère the poor, sick and feeble, the lame and the dejected,
> May here find relief, and again be respected.
> But this trifle of trifles, nay trifling its worth,
> Yet when I'm dead and gone and laid in the earth,
> If you e'er for me had the smallest regard,
> In that same proportion you'll value this card.

This sombre note was new, but with the optimism characteristic of tuberculosis patients, John also clung to his plans. He had been talking to their brother Willy about living in a cottage near Eltringham. All he wished, he said – if Squire Fenwick would let him – was to build 'between the west end of the water Banks & the Boat hill a House, containing a small Kitchen & parler & two Rooms above small', with

a bit of a stable. William Johnson, who manned the sporadic Eltring-ham ferry, was happy to give up a piece of ground, and 'to attend the Boat which has always been a plague to them woud be a kind of amusement to me, I am always best in health when sauntering about the Fields &c'.

As John was writing these words, in early September, Bewick's work-shop book bore a blunt entry: 'J. Johnson badly'. A week later, young Jack Johnson died of fever, aged twenty-five. Poignantly, Bewick endorsed the back of his brother's letter, full of longing for saunters through Eltringham fields, 'Answer'd 15 Septr / the day on which Poor John Johnson was buried'. Although he was less talented than his cousin Robert, in his *Memoir* Bewick remembered that Jack died 'when only beginning to give great promise of his future excellence'. Then in late 1794 Bewick's brother-in-law Thomas Dobson died at Ovingham. Dobson had made Ann's married life hard, but now it seemed that she and the children would be homeless, a prospect that appalled John when he remembered how 'she (poor Soul) had been a slave and a Nurse in the family for Years', caring for her parents, her sisters, her husband. Bewick thought she could stay on at the Brick House and take lodgers, although John blanched at the thought of being one of them, and having to deal with her elderly father-in-law, the dyer:

I wou'd with the greatest pleasure contribute any thing that might add to the comfort or happiness of sister Nancy, yet respecting my transportation to Ovingham to be shut up in that large House with perhaps a Drunken Brewer in one apartment, a Drayman in another, with a parcel of ruid and noisey Children, together with an Obstanate Old Dyer coming home Drunk at an unseasonable hour wou'd appear me a compleat picture of Bedlam.

Yet London was no place for him. That winter the ground there was frozen so hard that bodies lay unburied in the churchyards. At New-

castle Quay, ice draped the rigging of the ships. In Flanders British troops shivered without greatcoats, protected only by flannel waistcoats paid for by their officers. In the bitter days of drifts and driving winds and on into the long cold spring and the start of summer, John thought of Eltringham. In his imagination, he wrote, 'I pland my Garden, planted Trees, & made walks, nay in short it was my Morning prayer and Evening hymn.'

Finally, in June, he accepted that he must leave, telling his fellow Tynesider, Matthew Williamson, 'I hope to have the pleasure of a shake of the Hand (perhaps for the last time) with my old Friend.' A month later his luggage was delivered by mistake to the Forth, and Bewick sent it out to him at Cherryburn. There he worked slowly on elegant cuts for books for Bulmer: *Fabliaux, or Tales by Le Grand*, translated by Gregory Lewis Way, and William Somervile's hunting poem, *The Chase*. In the hazy summer months everything seemed beautiful. The golden light stretched on into September, when John urged Bewick to take a long-planned walk up the Tyne: a week or fortnight more would rob it 'of its richest beauty the *Harvest*': 'I think the Corn is all cut & standing in the Fields which throws over the whole face of the Country that pleasing Picture of abundance and plenty.'

John saw the harvest home, but by October he was unable to eat and being cared for by Nancy at Ovingham, despite her noisy children and drunken father-in-law. John reported the old man's stubbornness to Bewick. But his letter also showed he had little time left: 'with respect to myself I can only say that it is with pain that I can now whisper out my wants, I think a few Days more will relieve me from all my Pains & Troubles here'. He lingered on as the days shortened, until on Wednesday 5 December a note from Ann brought the news Bewick dreaded.

Dr Brother

I make no doubt by you'r waiting with the greatest ankciety for this unpleasant intelligence, my Dear Brother is now no more he Died at 5 oClock this morning, his sufferings was great but still patiant & sensible to his last Moments his Goodness is more that I am able to express.

The funeral would be on Tuesday. Could Bewick please send Esther her black gown, plain muslin apron and white handkerchief, arrange the lock and handles for the coffin and engrave the plate: 'you know his Age 35 I nead not tell you what more'. The sweetest and boldest of all Bewick's lads was gone.

17 'RED NIGHTCAP DAYS'

After John was buried in Ovingham in December 1795, Bewick collected his books, his tools and his unfinished work and carried them back to Newcastle. There he lovingly cut the intricate blocks for Somervile's *Chase* according to the designs that John had already drawn on the wood, giving the last scene to Charlton Nesbit as the cuts were late. In his preface Bulmer noted that John had completed all the drawings except one, and 'they may therefore be considered as the last efforts of this ingenious and much to be lamented Artist. In executing the Engravings, his Brother, Mr Thomas Bewick, has bestowed every possible care.' Bewick and Nesbit also finished the prints for the *Fabliaux*, and the lads helped with Newbery's *Blossoms of Morality*. When this appeared in 1796, it too contained a note explaining that the delay was due to John's illness: 'And sorry, very sorry, are we compelled to state that this is the last effort of his incomparable genius.'

Bewick kept all the vivid letters from London, bundled up and inscribed 'My brother's letters'. He answered notes of condolence from Abraham Badcock of Newbery and kindly Nathaniel Norton, headmaster of the school at Crouch End, and sorted out unfinished tasks and payments due, including a quickly resolved muddle with Robert Pollard who had paid John in prints rather than cash. In the week after John's death he carefully wrote down a 'Schedule of Sundry

Effects left to me by Bror. John'. He listed his books – Goldsmith's *Essays*, the grammar he had used in his French lessons, the works for Trusler and others, his copies of Ovid's *Metamorphoses* and More's *Utopia*, his folios of Rowlandson prints and precious copy of Dürer's woodcuts of the Passion, of 1510. But he also noted John's boxwood, his designs, his box of Reeves' colours, camel-hair brushes and black lead pencils, his crayons and file and, last of all, 'A Fiddle for Rob'.

At the New Year of 1796 Robert Bewick was nearly eight and already showing a flair for music. Jane would be nine in April, Isabella six in January, and Bessy was a fat and healthy two-year-old. The cottage at the Forth was loud with children's voices, a simple household with an orderly routine. Bewick and Bell rose at six and got the children dressed – as old ladies Jane and Isabella remembered how sometimes they longed to stay in bed, giving way reluctantly to their father calling from downstairs, 'Come down and get dressed.'

Their clothes were always neatly folded by their beds and on summer mornings they came down, pulled on their things and went straight out with Bewick, walking up Summerhill to Elswick Lane where they drank whey and buttermilk and looked down on the smoke of the town, across to the windmills of Gateshead and east down the Tyne, snaking towards the sea. Then they walked through the meadows to the river, where Bell came to meet them. Breakfast was hasty pudding – a sweet porridge of flour, oatmeal and milk – eaten with their own wooden spoons, carved with their initials. Instead of sweets and treats, Jane remembered, 'we had good store of little nice gilt backed books – such as Robinson Crusoe, Little Turk, Goody Two Shoes, The History of a Fly'. Her favourite was *The Looking-Glass for the Mind*: even at eighty she wished it might be reprinted.

The three older children attended Miss Stevenson's seminary, a little

school nearby attached to a house that belonged to their own landlady, Sarah Laidler. Bewick was the agent and collected the rent for all her properties, and also looked after the orchard and the huge conservatory in the school garden. This great glasshouse was Isabella's favourite retreat when she had to learn her lessons, and she was often startled by hearing the large apples fall from the trees. The school room was in a converted hayloft, reached by a wooden staircase outside.

In summer they went on holiday to Tynemouth, but in July 1796 Jane went with her aunt Esther in July to stay in South Shields. On 2 July Bewick was touched and proud to receive her first letter with her account of bathing in the sea and coming back to hot breakfasts, drinking tea with friends and eating 'the best spice cake that I ever tasted in my life', adding, 'please to send my slip for I cannot get my muslin frock on'. They despatched their servant Molly Hencles ('who is in high Tift at the prospect of such a Voyage or Journey') to take down a few things that had been left behind. It was the moment for a bit of fatherly advice:

I hope you will treat her, while she remains with you, with great kindness, remembering, that 'tho she is but simple, yet she is our honest Servant at command – we hope you will see her safely into the Wherry on her return, for shou'd she miss them, she will run herself of[f] her Foot in returning home again, & poor Soul, a little matter in that way may lay her up for some time.

A month later they had changed places. Jane and Elizabeth remained with Esther at the Forth while Bewick went down to join his wife, Robert and Isabella, in what he thought were the pleasantest lodgings he had ever had, the address being 'Willm Deans, bank top facing the Sea Tynmouth'. The house was just outside the town, with the sea in front and the fields behind; all they needed – if Esther could send them down – were some biscuits and some more eggs. 'I hope to hear from

my little Jane,' he ended. 'I hope you will take care of my little Bess 'till we return again to the Forth, & in the mean time / I am / your loving father / Thomas Bewick.'

Bewick heard his children's lessons, listened to their songs and drew their games and their walks and small incidents that amused them, like a schoolmate stealing the school tongs to get hold of an apple out of reach. He took the role of benign father and left discipline to Bell, so that in the children's memories, perhaps unfairly, she was the tough one. Since his own first schooldays at Mickley, Bewick had a horror of physical punishment, but Bell had no such qualms; Jane felt it was impossible to hide anything from her mother, for her eye was always on them. She allowed no disrespect: 'and as she always thought my father way too indulgent to his children she considered it the more incumbent upon her part to freely use the rod'. By contrast Bewick's worst weapon, a terrible one, was the simple withdrawal of warmth: 'The severest punishment he ever inflicted upon me, was taking no kind of notice of me for a whole fortnight – a miserable time it was.' Jane's crime was to pass a person she 'thought very meanly of' without speaking.

A countrywoman in the town, Bell held to the old ways. She 'manufactured every winter a web of most excellent linen', and she was not alone in this – the daughters remembered an old woman in a gipsy hat, sitting on a basket in St John's Lane every Saturday when they went with Bewick to the workshop, selling bands for spinning wheels and calling out, 'Now then lasses, don't forget your wheelbands.' Each Sunday Bell chivvied the children 'all clean & neat' to church at St John's, where they sat in their own pew (actually the Slacks' family pew, lent to them by Sarah). But when the rest of the family trouped off to church Bewick stayed at home, reminding Jane later that he used to call this a '"*Red nightcap day*" – because it was set apart for contemplation & for this purpose, I walked undisturbed in the Garden

alone – & thus employed it was always a welcome & happy 'tho a short day to me'. His excuse was that he could not sit hatless in the cold church without catching a chill – he often wished that this convention was dropped and people would adopt the sensible ways of the Quakers, who kept their hats and coats on if they wished. But the real reasons were his dislike of dogma and creeds, his irritation with sermons and his resistance to any fundamentalism that denied 'a knowledge of nature, on which science is founded'.

To Bewick, the Old Testament was a horrifying fusion of violent history and fevered allegory. In later life, when his friend John Dovaston described an encounter with a fundamentalist, Bewick wrote a passionate letter, which he then echoed closely in his memoir. He could not accept, for example, that people believed that the sun and moon literally stood still until Joshua was avenged on his enemies: not only would this throw the measured workings of nature out of joint, but it gave a licence for 'cruel butcheries' at odds with a benign deity. The doctrine of original sin and damnation seemed to him merely a ploy for controlling people through fear. That thousands of generations should be condemned for an imaginary fault of Adam and Eve, which they could not possibly help, 'does not seem in my humble opinion to come within the scope of either rationallity or justice'.

The story of Noah and the Ark was also absurd. He did, however, concede that at some time a devastating flood might have occurred: 'Geologists at this day feel convinced of this, from the changes which they see matter has undergone.' Fossils also suggested that the sea had once covered much of the earth, and since geology and mining were closely linked, such ideas were often discussed among interested Newcastle men. At the Bewicks' colliery at Mickley Bank, perfect mussels were found about two hundred feet below ground, embedded in ironstone. Bewick and William conducted their own experiments, finding

that the surface pattern of the shells effervesced in acid but that the fossils were still stone through and through.

Writing to Robert Pollard in later years, he wrote that much might be said on religion and morality but of one thing he was sure:

when the vital spark leaves this frame, it shall depart to the *unknowable God* who gave it . . . To suppose the Soul was given to us for no good purpose, is folly – and if we reflect for one moment, it will surely appear to us that there is no more of a miracle in its living to all eternity than there is in our being placed here – Thou'ts of this kind I have long turned over in my mind . . . They are productive of continual happiness & I find I am never more in company than when I am alone – it is then that I hold converse with the being of infinite wisdom and goodness – and of truth justice & mercy and the mind is filled with raptures – The reward, is indeed, perpetual cheerfullness.

Bewick was essentially a Deist, accepting that everything was made by design and prepared to believe in a transcendent Creator and a life ever after, but not in the mysteries of the Holy Trinity. Christ 'was a Deist', he alleged: 'he could be no other'. In terms of ethics, he admired the 'sublime & yet simple plain doctrines & truly charitable principles which Christ laid down & informed by his own example – His life was a continued scene of active benevolence'. His Jesus, like the Christ of the Unitarians, of Thomas Paine and many others of the day, was a good man rather than a divine being – a model late-eighteenth-century philanthropist.

He argued about such matters with Hornby and Oliphant, but his views were closer to those of another clergyman friend, William Turner, minister of the Unitarian congregation at Hanover Square. Like Gilbert Gray, Turner was passionate about education: he had his own school in Percy Street and started the first Sunday school in the north of England in 1784, and he was the prime mover of the Literary and Philosophical Society, founded in 1793. The 'Lit and Phil', as it soon

became known, drew its members from the gentry, the manufacturing and professional classes, and combined investigation into such things as the dangerous gas and 'damps' in the coal mines, with studies of local antiquities. Bewick respected Turner as a master of both the sciences and the arts, but he admired his humanity more: 'I know not how I can say more or less of him than that his character was composed of every thing great, good, amiable and praise worthy.' A gentle, eccentric man, Turner had to be forcibly stopped by his daughter Ann from giving away all he had: the doors of their small house in Cumberland Terrace were left open wide on to the street so that anyone in need could call in. When Elizabeth Gaskell's cousin Henry Holland stayed here in the late 1790s, he remembered the time fondly: 'there was very little constraint upon me, quiet instruction and a cheerful home'.

Bewick too was known for his generosity, and like Turner's daughter, Bell sometimes felt this made unreasonable inroads into their budget. His cash books are full of small donations, often clustering together, some for business, some to individuals: 'Gave Hodgson's lads £1 / Trinity House Beadle 6s. / Henry Richardson in distress 5s. / Charity to Betty 6s. / Barber Boy for running errands 1s.' (A year later even Bewick gave up: 'paid old Richardson 6d., *forbid him the shop*'.) These small sums were acceptable, but Bell's keen antennae could always smell out pretence. When a friend, who had given an ostentatiously extravagant party for local families and their children, asked Bewick to guarantee a huge bond of £1,400, he was ready to agree but, as Jane remembered it: 'My mother, horror struck, said you have not got the money Oh said my father "I can work as well in gaol as anywhere" . . . It may easily be supposed that if my Father slept that night my poor mother never had a wink.' As soon as day broke, Bell went straight to Beilby who added his voice, rousing visions of ruin for the business and the family. Bewick subsided, crushed. This was one of

many incidents to worry Bell, who 'used every argument that the wit of woman could suggest to open his eyes and to prevent him *lending*':

She wd. say no one ever asks me to lend – no he wd. reply because they know thou wd. not do it – My mother for a long period was his banker – & I believe he never had a secret from her: he wd say – such a one wants £30 to borrow & away she had to go to her store, & hand it out – & I well remember how unhappy it made her.

From then on, Bewick often asked her advice about financial risks, on which she had decided views. In later years, when he was pondering over whether to take a doctor as a tenant, Jane reported Bell's objections. She had two: 'the first is his habit of frequenting Public Houses the second and most weighty is his character of a bad payer, this she has frequently heard from good authority and should the cash be bad to come at, there will be nothing in him but Phials & Galipots'. Sometimes, however, Bell's prudence could be upsetting. When Bewick's nephew John died in 1809, he was prevented from going to the funeral by a paper merchant coming for payment of his bill 'and (Mother having the cash lock'd up) I was obliged on the spur of the occasion to borrow the Cash of the Bank'.

Bell could be kind in her own way, with actions rather than cash, but she saw, as Jane said, that the 'candle must not be lighted at both ends', whereas Bewick would just have let it flame. As his views on the New Testament imply, he had a strong sense of humanitarian obligations. From the early days of Spence's debating society he spoke out about conditions in Newcastle gaols, especially the plight of debtors, and when the town became caught up in the anti-slavery movement in the late 1780s, and presented a petition to Parliament for the abolition of the slave trade in 1792, he immediately subscribed. All his life he admired William Wilberforce, making Bell raise her eyebrows, as their daughters remem-

bered: 'Mrs Bewick used to say, "Why, what can you do to help him?" and he would reply by saying that he considered it to be the duty of every honest man to afford Wilberforce all the support in his power.'

In 1795, Bewick was forty-two, feeling slightly overwhelmed by the responsibilities of juggling family and business. His friends in London were also having to cope with the successes and setbacks of middle age. Robert Pollard's *Peerage* had not been the triumph he had longed for, and he dropped his plans for a second volume, and although Christopher Gregson was doing well at the Society of Apothecaries and invested shrewdly in navy stock – a good investment in time of almost constant war – his wife was 'derainged in her mind', shaken far more than Bell by the spectre of imminent poverty. However secure one's situation, the 1790s were a nervous time. The war took its toll. Bewick saw no glamour in battle, no heroic return, just weary soldiers, often disabled, forced to search for work.

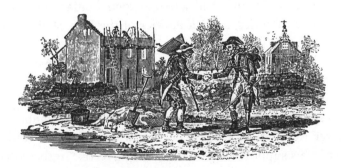

Thomas Spence and Bewick's fellow apprentice David Martin were both in the heart of the maelstrom. In Sheffield in 1792 Martin became chairman of the Society for Constitutional Information, supporting Paine, alienating customers and drawing the unfriendly attention of the magistrates. In London, Spence was now a well-known

radical bookseller and pampleteer and his land plan lecture was republished in 1793 as *The Real Rights of Man*. The '12 Division', the most vocal section of the London Corresponding Society, met at his shop, the Hive of Liberty in Holborn, and a militant troop drilled in the big room above. In 1793, a year when the Edinburgh lawyer Thomas Muir was sentenced to fourteen years' transportation after arguing for parliamentary reform, Spence was briefly imprisoned three times. Then in May 1794, when habeas corpus was suspended, he was one of twelve London radicals arrested, with Thomas Hardy, the old warhorse John Horne Tooke and the propagandist and lecturer John Thelwall. Charged with 'treasonable practices', he lingered in Newgate for seven months without trial. So alarmed were the respectable members of the Newcastle Lit and Phil that they sent a statement to the *Annual Register* and the *Gentleman's Magazine* disclaiming any connection with the original Philosophical Society where Spence had given his notorious lecture, and stated as their fundamental rule 'that Religion, *British* Politics, and *all* Politics of the Day, shall be deemed prohibited Subjects of Discussion'.

Bewick, however, still admired Spence, and his views were well known. In July 1794, when ten Manchester men were charged with sedition, including the manufacturer Thomas Walker, Chairman of the town's anti-slavery committee and a leading member of the Manchester Revolution Society, Bewick was sent thirty copies of a pamphlet in his support to distribute and advertise in the Newcastle papers. Walker's politics had irritated the Manchester authorities for years and the trial collapsed when it was revealed that they had bribed the main prosecution witness. And when the London cases came to court in November, Hardy and Tooke were acquitted and the others dismissed, to the intense delight of their supporters. But in the fevered atmosphere, many radicals fled abroad. Even Bewick

briefly considered emigrating. In October 1794 he wrote to one correspondent:

Before I get the Birds done, I have no doubt of matters being brought to such a crisis as will enable me to see clearly what course to steer. My fears are not what you think will happen in America: it is my own much-loved country that I fear will be involved in the anarchy you speak of . . . A reform of abuses, in my opinion, is wanted, and I wish that could be done with justice and moderation; but it is because I do not hope or expect that it will take place in the way I wish it that makes me bend my mind towards America.

In late 1795 David Martin left Sheffield for New York, where he died of brain fever a year later. Spence chose to stay but in 1798 was imprisoned again for a year for his 'seditious' publication, *The Restorer of Society to its Natural State*.

The harvests of 1794 and 1795 had been terrible, and famine now threatened country districts. Bewick was horrified by the profiteering in grain and land, and his workshop engraved a design for the Cheap Flour Company, founded to help the poor. During the French revolution and the long Napoleonic wars – 'A lifetime of blood & slaughter' – Bewick took refuge in his friends:

I frequently, by way of unbending the mind after the labours of the day, spent my Evenings (chiefly at the Blue Bell) in Company with a set of staunch

advocates for the liberties of Mankind, who discussed the passing events mostly with the cool sensible & deliberate attention, which the importance of the subject drew forth –

These men, filling their long tobacco pipes and settling down to put the world to rights, were shoemakers, builders, iron founders and tradesmen. An added attraction was the landlord, William Cant, formerly the piper to the Northumberland militia, an excellent performer on the fiddle and the pipes, who 'kept up the ancient tunes, with all their charming lits and pauses'. Another favourite watering hole was the Unicorn, run by Jane Elliott, popular both with tradesmen and actors from the old Turk's Head rooms and the new Royal Theatre. Bewick described Jane Elliott as 'sensible, spirited, clever & obliging', and from this, he said, and 'her handsome & majestic appearance, was called the Queen of Landladies'. Nevertheless, 'in her House & indeed in every house, Politics formed the topic of conversation'.

Bewick's view was straightforward. He detested war and found the current French wars in particular were 'superlatively wicked'. When the people of France had looked for help from Britain, a free country, they found none. Instead Pitt and his ministers had sided with despotism, determined to 'put an extinguisher upon the rights of man'. They had imposed taxes from which they lined their own pockets, passed arbitrary laws and established 'a system of espionage spread over the whole kingdom, to keep the people down'. Bewick was particularly hurt by the apathy of the country gentlemen and by those who shrugged and ended all arguments with 'if you do not *like your Country* leave it'.

The loss of life in the wars seemed terrible to him. As he looked at his children wielding their wooden spoons, walked through waving grasses to the field called 'Paradise' by the Tyne, and made woodcuts of the thrushes and cuckoos of the English hedgerows, Bewick grieved for the slain and their kin.

18 DAILY BREAD

Bewick honed his art with every cut he made, but his private passion was submerged beneath the workshop round that flowed on its relentless, repetitive rhythm. Every day saw a stream of small orders. Messenger boys, servants and local traders came in with orders, written on little slips of paper and usually – but not always – entered in the engraving and work books. Less often, people called to settle their accounts, like Walter Trevelyan, leaving a note and enclosing two five-pound Newcastle Bank notes. The apprentices strolled up the steps, or rushed in late, scraping their stools up to the long table under the window. In winter mornings and evenings the lamps were lit; in summer the long windows were open on the noise of the streets. The mail coaches clattered up Dean Street bringing orders from London and Liverpool, Edinburgh and Durham. There were bills to be paid for fire insurance and poor rates and a mass of stores to be bought: 'Frankfurt black' ink for copperplate printing, boxwood and gravers for the woodcuts, coal, candles and lamp wicks, spirit of wine for cleaning.

There was a lot to manage, and the accounting was complex. In theory at least, the orders that arrived were entered in the Day Book, and at the end of each week all the work done by apprentices and journeymen was noted in the Weekly Engraving Books. All receipts and payments of cash were entered separately in Cash Books and the

copperplate printing was recorded in the Press Books, while regular customers, such as the gold and silversmiths Langlands and Robertson, had separate accounts in the Ledgers. Bewick often made little sketches in the cash books and ledgers as a kind of visual shorthand: pairs of scales to show a long-existing balance, a beating for late payers, gallows for a bad debt, a fish to mark payment of the poor rate, which was collected by a Mr Fish, a snake when they paid 'to see the rattlesnake', a cart and horses for a trip to Tynemouth.

There were still plenty of commissions for silver engraving. A powerful landowner like Charles Clavering thought nothing of placing a mammoth order and demanding that someone be sent out to his house, partly for security reasons:

It would be inconvenient to me to send the plate to Ncastle as being so much of it now unpacked. The principal thing to be engraved is my Crest. 8 Doz knives and Forks Spoons, – Cruets – & 2 Salvers with Arms, Tea Pots &c which would take a man no more than a Fortnight, & as I would pay his Journey here and Back – I cannot see the objection to his Working here, as well as at N Castle . . .

Although the apprentices worked on the basic jobs, from christening mugs to coffin plates, Bewick helped out. Well into his sixties, he worked on the lettering of bottle moulds for the glass manufacturers, for example, 'sitting late at work by candle light':

The doing of these Jobs, such as bottle moulds is very hard work . . . there is more labour & exertion used in them than there is in breaking stones for a Turnpike Road & the Work is full as stupid – but they are jobs from friends & coarse as they are I think nobody except Mr Beilby & myself can do them.

As far as woodcuts and copper engraving were concerned, the workshop provided a visual commentary on Newcastle life. Orders came in from many public bodies and societies: the seal of the Clerk of

the Peace in Durham; a medal for Gateshead parish; coats of arms for the Freemasons; the figure of Mercury for the Lottery Office; fire engines for the Tyne Fire Office; a view of rough seas off Tynemouth for the Northumberland Life Boat.

Drink also brought much work to the engravers. They supplied bar bills for taverns across the North, from the Swan of Kendal to the Red Lion of North Shields and the Half-Moon of York, whose bill showed the moon floating drunkenly but serenely on its side, the corners ornamented with grapes, bottle and glass, punchbowl and lemons and pipe. Shops and businesses, too, asked constantly for trade cards and bill heads. Some traders plumped for the exotic, like a feather-crowned Indian from Virginia for a tobacco merchant or a Chinese tea-drinking scene for Davidsons the grocers. Sometimes they just went for boldness: 'Cheap Clothes. Hats. Stockings'. The wax-chandler chose a beautiful beehive under a festoon of flowers; the wool-stapler a lamb on a sack of wool; the florist an orange tree growing in a pot; the shoemaker a foot; the upholsterer a man in an easy chair.

Some customers sent precise demands with much underlining, or enclosed little sketches. William Stevenson, a Sunderland sadler, wanted a bill head of the Sadler's Arm but instead of the sadlers' motto in the book of heraldy, 'Our Trust in God', he asked for the more comprehensible 'Hold fast sit Sure'. A printer writing on behalf of an Association for Prosecution of Thieves left the design to Bewick: 'only I should not wish the *Devil* introduced'. Often the requests were more personal: 'Please to engrave the above Dog on Wood,' wrote Charles Brown of Pontefract sending on an order for a bar bill with a small sketch: 'you will attend to the features as the Dog is a likeness of one now living in possession of the man who wants it.'

To save time, designs were changed and adapted, re-drawn and re-cut, and some old favourites reappeared, year after year, like the ships on stormy seas above notices of ship auctions and voyages, or the horse and groom on posters for horse sales. A little devil leaping up on a horse behind the rider announced the lists of 'Lost, Stolen or Strayed', and fighting cocks and racing cuts headed columns in local newspapers from York to the border.

The boxwood blocks were astonishingly hard and durable. One tiny cut of St Nicholas church spire and the castle and the roofs between was used in the *Chronicle* for years. When Solomon Hodgson came round with a visitor one day and mentioned this, Bewick got out his ledger to see when it was first cut. Sol was amazed: 'He at first startled & said "it must have printed a million"! – he however sat down & calculated exactly, and found it had printed above 900,000.' It was used for many years more, until the columns were changed. Bewick felt its long life was due to it being surrounded with a border within which the surface was lowered before the view was cut, and when he came across it much later, 'except being somewhat damaged by being tossed about in a drawer among other cast away cuts', he knew that after a little repair it could still print many thousands of impressions.

As well as mastheads and column headings, the newspapers carried cuts advertising particular events, like the 'Descent of Sadler's Balloon'. James Sadler, an Oxford chemist and designer, began ballooning in the first craze of the late 1780s, and took up the sport again in 1810, aged fifty-seven. He visited Newcastle several times and also sold his balloon trademark to promote another new fashion, for soda water. For entertainers and promoters, Bewick's workshop was the first place to call when they arrived in town and needed broadsides and leaflets to advertise their shows. These stretched from 'Performances on the tight rope and of learned dogs at North Shields' in

August 1786, to the splendid 'Madame Girardelli, the Fire-Proof Phenomenon', appearing at the Joiner's Hall in 1818. Hosts of performers passed through, from ventriloquists to 'Thomas Denton's Mechanical Exhibiton' with its striking automata, 'The Writing Boy' and 'The Speaking Boy'.

The Theatre in North Shields and the Theatre Royal in Mosley Street both called on Bewick for playbills and tickets. One anxious letter from the actor Robert Payne asked for cards to be sent to York by coach: '*Don't fail* as my benefit *is next week* & I shall be greatly in want of Tickets.' Bewick knew all the great actors and actresses, including the massively fat Stephen Kemble, manager of the Newcastle theatre from 1791 to 1806, the only man, it was said, who could play Falstaff without stuffing. The workshop engraved tickets for benefit concerts for grand causes, such as the widows and children of seamen, and for smaller ones, like 'the Family of the Late Mr Claggett', a poor musician.

Bewick's favourite subject was undoubtedly the circus, which at this date was a purely equestrian event. In 1789 a permanent 'Circus and Riding School' was built near the Forth Walks, and the lane where the

Bewick house stood was re-named 'Circus Lane'. A fine advertisement with a Bewick cut appeared in the *Chronicle*. 'A Grand Display of TRAMPOLINE TRICKS over Men, Horses etc, by Mr Parker. Likewise his astounding SOMERSET over a Garter Ten feet High.' Other delights included a ballet and a tambourine dance, and rope dancing by the 'Celebrated Mr Spinicuta'. Bewick often drew the balletic riders in their gay spotted clothes, turning somersaults, balancing on one foot and wielding a sword or hanging from the saddle. Many cuts of broadsides for the partners Jones and Parker still survive, as well as benefit tickets for individual performers, a lovely Merry Andrew for 'Mr Swan's Night', a horse and rider for Mr Humphreys, a special banner for 'Miss Bannister'. The building remained a venue for shows. In 1799 a London troupe displayed a panorama 'of the British Grand Fleet, consisting of 40 Sail of the Line, under every possible Point of View, and on different tacks, getting under Weigh at Spit head, off the Isle of Wight'. It was painted in oil and was 120 feet long, 'but appears to the spectator to be several miles in length'.

In all these ephemeral works Bewick made the little scenes come alive, and his work delighted his customers: 'the Stags Heads are Gold', wrote Ann Hunter of Hexham, on receiving a design for her husband's bookplate. Often the orders had an intimate touch. A mother who sent her little girl's pony to Newcastle to be painted reminded Bewick that he had promised he would give the artist some 'hints about the outlines of it'. A countrywoman from Carlisle, the mother of his late friend Robert Batey, asked poignantly if Bewick would see about his headstone 'as we have been in such a loo way ever sens we Lostt him that every thing has been at a stan'.

The more serious copperplate engraving and printing was largely Beilby's province, but in the late 1790s both partners were working on plans for a new canal from Newcastle to the Solway Firth, taking Tyne

coal to the west and opening the route to America. The major towns from Hull to Liverpool, Bristol to London, had been slowly linked since the first canal mania in the 1770s, but routes across the Pennines had been left because of the harsh terrain and the many locks required. The first suggested route in 1794 ran along the north bank of the Tyne, but in 1796 a competing group – which Bewick and Beilby joined – proposed a different line to Hexham on the south bank. It looked like a good investment and Bewick subscribed for two shares at £200. The summer was peppered with committee meetings, at Ovingham boathouse or the Black Bull at Hexham, and since every canal had to have a separate Act of Parliament, and all promoters and opponents needed plans, work on these now filled the workshop.

To add to the many tasks, requests arrived all the time for woodcuts to illustrate 'a Book of Proverbs Jests Maxims &c' or 'a Small Book for the Amusement & Instruction for Children'. Bewick accepted a few new commissions, like the *Poems of the Rev. Josiah Relph*, but he found it hard to meet deadlines. He was very late, for example, with the cuts he had promised David Walker of Hereford for *The Poetical Works of Goldsmith* in 1794. The following March, acknowledging that Walker had treated him generously, he regretfully turned down a second request for seven designs for *The Vicar of Wakefield* (although he relented a year later). He knew, he said, that Walker would want the cuts done well and it would not do to entrust them 'to any of our young men they can do commoner work very well but none of them are equal to the task of such designs'. But his main reason for saying no was his desperate sense of urgency with regard to the *History of British Birds*. Sometimes, he told Walker, he regretted the way this ate into his time, forcing him to turn down work and upset friends: 'and has often made me wish I had never begun upon so heavy an undertaking'.

*

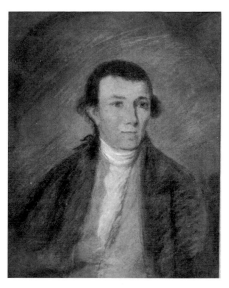

1. The disputed portrait of Thomas Bewick, painted by George Gray in the 1780s

2. John Bewick, pastel sketch by George Gray

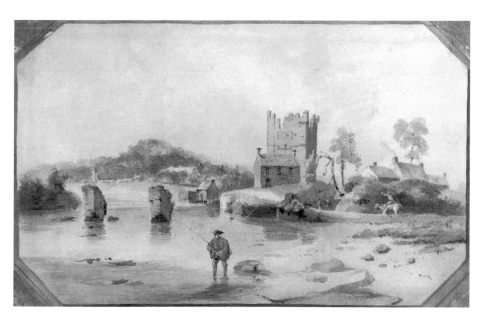

3. *The Tyne at Bywell*, watercolour by Luke Clennell, c. 1800

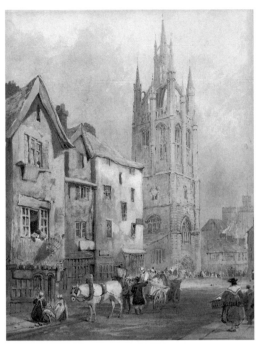

4. *St Nicholas Cathedral and the Groat Market*, around 1827, by Thomas Miles Richardson

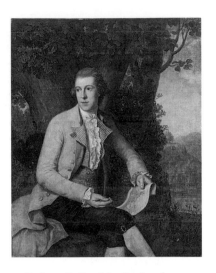

5. Robert Pollard by Richard Samuel, 1784

6. The gold 'Freedom Box' for Admiral Keppel, 1779

7. William Bulmer, from the *Gentleman's Magazine*, 1830

8. A children's Lottery book of the 1780s

9. Illustrations from *Memoirs of a Peg Top* and *Tommy Trip's Book of Beasts and Birds*

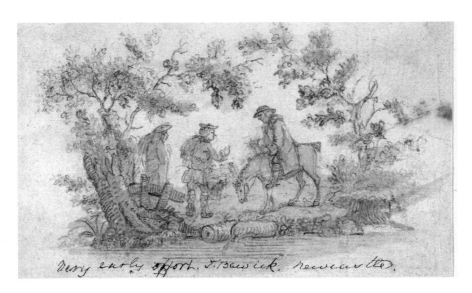

very early effort. T. Bewick. newcastle.

10. Bewick's early drawing of Highlanders from his Scottish trip in 1776

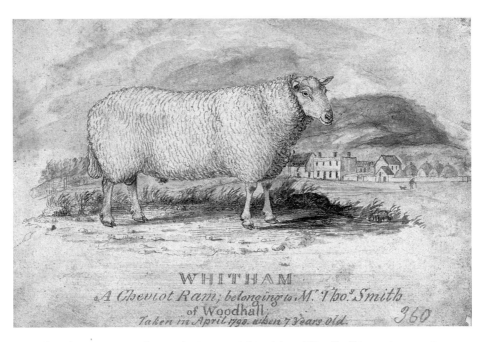

WHITHAM
A Cheviot Ram; belonging to Mr. Thos. Smith
of Woodhall,
Taken in April 1798, when 7 Years old. 360

11. 'The Cheviot Ram', drawn during Bewick's visit to Woodhall in spring 1798

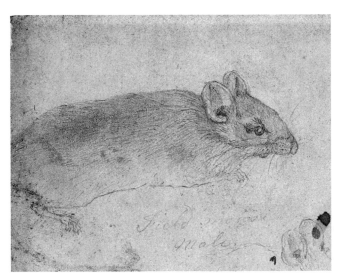

12. (ABOVE) Bewick's sketch of 'The Long-tailed Field Mouse', engraved in *Quadrupeds*, 1790

13. A pen and wash design for an advertisement for Jones and Parker's Circus, which was held at the Forth near Bewick's house

15. Robert Bewick, painted as a
boy by his friend John Bell

14. Thomas Bewick, painted by James Ramsay
in 1816, when Bewick was sixty-three, and
presented to Bewick's wife Isabella by the artist

16. Jane Bewick, aged around sixty-
five, by an unknown artist

17. The workshop in St Nicholas
Churchyard, a late-nineteenth-century
photograph discovered in a scrapbook

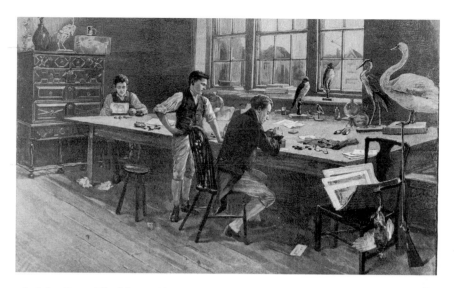

18. John Eyre, *The Master Engraver*, 1896. An imagined scene in Bewick's workshop, with one apprentice holding a transfer drawing and another watching Bewick work on a wood block

19. A page of John Dovaston's scrapbook showing the specially coloured impressions of birds and vignettes, given to him on his visit to the Bewick family in Gateshead in 1826

20. 'A Man crossing a Stream'. A typical workshop collaboration: drawing by Bewick, watercolour by Johnson, and engraving by Clennell. The man has thrown his bundle and stick across and crawls along the rotting branch while his dog, sensibly, waits anxiously behind.

Def. & Engr. by T. Bewick.

Title page cut for *The Vicar of Wakefield*

Bewick's own *Quadrupeds* and *History of British Birds* were only a tiny part of the workshop's vast and varied output, and these had to be crammed into his leisure hours. In the evenings, placing two double-wicked candles carefully to get the most light, Bewick worked on his woodcuts of the birds, focusing minutely on their form, their stance and plumage, trying to convey the softness of down, the flutter of feathers, the point of a beak. After looking again at the preliminary drawing – often made several years before – he sometimes made new sketches, altering the position and adding background. He also made watercolour studies, perhaps to help him instil the variations of shade in his mind, producing lively portraits of birds like the wren and the cuckoo. Luke Clennell, like Robert Johnson before him, also painted watercolours from Bewick's drawings, particularly of the tailpieces.

When Bewick transferred these to the wood, he often added little details, like the snowman's pipe and 'Esto perpetua!' or the proud peacock on the wall behind a hungry beggar.

If he was going to engrave the block himself, he just blackened the back of the drawing in his old manner, placed it over the block lightly dusted with white chalk, and traced the outline before cutting the fine detail straight on to the wood. Later, when he was giving the work to an apprentice, he drew the whole scene on the block 'with miniature like minutiae, otherwise my Boys cou'd not cut them'. He made all his tools himself (the American artist James Audubon noted how delicate they were), and used them with his own direct, expressive style. The shapes and names are just the same today. Every tool is a single piece of steel set in a wooden handle, with a shape adapted to a special function. Some, called the scorpers, are quite large and are used to clear the white spaces. Others are extremely fine, their names reflecting the varying width: graver, spitsticker, bullsticker. The cutting edge, or face, is ground off at an angle and the lower edge is very sharp, while the mushroom-shaped handle is flattened on one side so that it clears the surface of the block. An equally indispensable part of the equipment is a stone to sharpen the points and blades: when he sent the enthusiastic Revd Bache Thornhill a set of tools in the 1820s, Bewick added: 'A good Turkey oil Stone may be got at any of the Hardware Shops – but I fear it will require a good deal of practice before you are able to sharpen your Tools properly.'

Every beginner has first to learn simply how to hold the tools: the handle rests in the hollow of the palm, fingers bent along one side and the thumb on the other – the thrust comes from the palm, and the guidance not from the fingers, but the thumb. All the time, with the other hand, the engraver holds the block – gripping it carefully lower than the surface in case the graver slips – and rotates the pad. The

movement that creates the line thus often comes from moving the wood against the point, rather than pushing the tool.

Bewick experimented all the time, and at one point was frustrated that he could never achieve the neat cross-hatching he saw on a Dürer print that George Allan showed him, wondering if two blocks had been used. But he found he could get a similar effect with plain parallel lines, almost approaching 'colour'. The basic surface of the block would always print black

and it may easily be seen that the thinest strokes cut upon the plain surface will throw *some light* on the subject or design – and if these strokes are made wider & deeper, it will receive more light & if these strokes again are made, still wider, or of equal thickness to the black lines, the colour these produce, will be a grey – & the more the white strokes are thick'ned, the nearer will they, in their varied shadings, approach to white – and if quite taken away, then a perfect white is obtained.

If you look carefully at details of Bewick's engravings, particularly with a magnifying glass, you can see how his skill matured. In his early trees, for example, the leaves are cut with a single wedged stroke, but by the 1790s constant practice meant that he could move the soft pad beneath the block without thinking, to make the finest cuts, showing detail within the leaves themselves and varying their form in tiny, subtle ways. The same was true of feathers and fur, his lines suggesting the direction of growth as well as the tone: long hairs are cut with a continuous fine line, short ones in little flicks or short lines. On smooth-coated animals he concentrated on the ripple of light on muscle to display the form beneath. Playing with the different ways of using a particular tool, he worked out the best technique to convey the textures of everything he showed – the blades of grass, the bark on a branch, the creases in clothes, the ruggedness of stone. The only

exception was water, where he was happy to use a simple series of fine lines, conveying the liquid smoothness in contrast to the roughness of the bank. In cutting his designs, every stroke played its part in the whole: no line was superfluous.

He lavished as much care on the plainest of birds and beasts as upon the most exotic, like the 'Old Teeswater sheep, the unimproved breed', with its subtle contrasts between the spiky windblown grass and the leaves of the hedge, the heavy rock and the equally 'unimproved' shaky fence, its willow strands woven round rough wooden posts. Iain Bain calls this 'a wonderful piece of Bewick at his best – the head of the ram is perfection. All instinctive cutting from a hand long trained.' The texture of the coat is rendered by long parallel cutting, with lighter cutting crossing at an angle to evoke its shaggy feel, but all on a lowered surface to give a softer impression.

Bewick appears to have had a faultless sense of exactly what line was needed, and above all where to stop, as if there were no pause for analysis or reflection between the image in the mind and the hand on the wood. This skill, which has made later generations of engravers pause in awe, could be explained as an innate talent, the je-ne-sais-quoi of 'genius'. But it also came from the constant habit of drawing as a child, the painstaking learning of technique as an apprentice and the long, long years of bottle moulds and trade cuts and seals, the 'ordinary work' that earned Bewick his daily bread.

19 *LAND BIRDS*

As Bewick looked back, he counted the time it had taken to collect the specimens, study the books, and draw and engrave the birds one by one. From the start, many people had been keen to help. William Turner, for example, put Bewick in touch with Unitarians in Manchester who had a collection of drawings of American birds. But he soon decided on two things: to concentrate on the British Isles, and to draw from life wherever he could. Drawings and engravings were useful guides but could not be relied on. He confessed that he could not even trust the engravings in Pennant's works: 'so far as I know his Birds they are incorrect both as to position & plumage & I wish as far as I am able to be faithful in both'.

When word got round that Bewick needed birds, packages and crates arrived at the Forth and the workshop, some with their contents putrid and maggotty, others containing specimens as glossy as if they were still alive. In the eighteenth century, as one historian has put it, 'the first impulse of many naturalists on seeing a rare bird was to shoot it'. Local gentry donated prize specimens from their collections and aviaries, and country landowners and clergymen, whose interest in birds had grown from a love of hunting, kept an eye out for odd species. The Revd Brocklebank of Corbridge sent a pied flycatcher and a pair of woodpeckers, adding notes on their habits, songs, and varied appearance.

Bewick responded warmly, carrying out his own dissection of the woodpecker to confirm the Reverend's points: 'I find you are right as to its food passing like the Cuckoo's, immediately to its Gizzard, which I examined & found full of Ants.' Another Anglican vicar, Henry Cotes – a keen angler and follower of the hunt – sent a hoopoe that he had shot near his parish of Bedlington. This was an uncommon find in the north-east and it obligingly stayed alive long enough to walk about 'erecting its tail and crest in a very pleasing manner', before it expired. It too then went under the knife, revealing a stomach full of the claws and indigestible parts of 'insects of the beetle tribe' (an interesting instance of Bewick's knowledge, since some expertise would be needed to identify all the bits and pieces as coming from beetles).

THE HOOPOE

The Revd Carlyle, vicar of Newcastle, told him how he kept a lapwing in his garden, which became so tame that it cried '*pee-wit*' to

come into the back kitchen, where it settled by the fire with the household cat and dog. Even William Turner once came round with a ring pheasant, although this was probably a gift from a member of his congregation rather than the fruit of a day's shooting.

Soldiers, idling in barracks while they waited for orders, also contributed to the work. Lieutenant Gibson, of the 4th Dragoons, gave Bewick 'a fine Ash-coloured Shrike', 'the Murdering Pie or Butcher Bird', as well as a corncrake – a summer visitor that has now almost disappeared from the British Isles – which became a family pet. (As years went by, Lieutenant Gibson climbed the ranks, becoming 'Major H.F. Gibson' by the sixth edition in 1826.) An even more impressive military birdwatcher was George Montagu. As Lieutenant Colonel of the Wiltshire militia, Montagu filled the empty hours when he was stationed in different parts of Britain with hunting and shooting, gradually becoming more interested in local wildlife than in the size of his bag. His eager curiosity and meticulous observations bore fruit in his detailed *Ornithological Dictionary* of 1802, which transformed the whole subject and led some to call him 'the father of British ornithology'. He lent Bewick drawings and books, and Bewick referred to his dictionary frequently in later editions.

By the mid 1790s the *Birds* had become a local project, taken up with zest by the northern gentry. Among Bewick's most enthusiastic helpers were the Trevelyans, a large family whose members often shared two names, Walter and John. The senior members were Sir John Trevelyan, MP for Newcastle until 1780 and owner of a large estate at Wallington, and his brother Walter, a hero to progressive farmers for his showpiece estate at Netherwitton. Old Sir John, a keen naturalist, retired to Somerset in 1796 to take the waters at Bath, leaving his Northumbrian estate to be managed by his son. The second John sent Bewick several birds, carefully noting where each was shot:

two owls in Roadley Park, a duck on Whodley lake, and a buzzard, shot while devouring a partridge it had just killed, having carefully picked the flesh from the bones and wings. Special birds, like the horned owl, arrived with a note asking for them to be stuffed and returned to him when Bewick had finished, while an 'old Black Cock' should be despatched to a friend as soon as the drawing was done.

Meanwhile, Walter's son, Walter Blackett Trevelyan, who was currently at Cambridge, also began sending birds. In 1796 he posted a pintail duck and a female shoveler, adding jovially, 'As the birds are good to eat – I hope you will make a hearty meal on them,' and asking Bewick to save the wings and feathers for his father. Soon he sent a redshank ('at present it does not smell very sweet'); and then a godwit and a ruff, a bustard and two 'white Sparrows – whatever they may be'. These arrived too late for the book, and Bewick had to pay for their carriage, meriting a terse entry and exclamation mark in the cash book. Walter Blackett's younger brother Raleigh also sent game, and their clergyman cousin, yet another Walter, sent birds from his parish. The whole family came to act as Bewick's patrons, whipping up subscriptions and orders for the book from their acquaintance.

It was difficult to find species that did not usually frequent the north-eastern moors and rivers. Sometimes there were sudden strokes of luck, as when a Plymouth clergyman offered drawings of west-country birds, but Bewick often had to rely on books or stuffed specimens. His lordly eagle owl, for example, was based on two sources: a living bird seen in a show and a badly stuffed one caught off the coast of Norway, lent by the ship's captain.

The discussion of a single bird, the swallow, shows how intricate the exchange of information could be. Writing from Somerset, Sir John Trevelyan told Bewick of two swallows that had flown through a broken window pane into Camerton Hall near Bath and nested for three

years in succession on top of a picture frame above the mantelpiece. They would probably have continued, he thought, 'if the room had not been put into repair, which prevented their access to it'. Such a story was useful evidence to Bewick and Beilby of their fixed habits (and to us, of the devotion of the bird-loving house owner, content to live so long with a broken pane and bird-messed fireplace). Next, when the book was almost in the press, Sir John forwarded a letter from James Pearson of London, describing his efforts to keep swallows over the winter, protecting their perches with flannel 'to guard their feet from the bad effects of damp and cold'.

Mr Pearson's strange tale went straight into the text, as this was a subject of immense interest: arguments had long raged over whether swallows could survive British winters. Were they birds of passage, or did they disappear into bushes, or even into ponds and rivers, during cooler months? In 1800 Revd Walter Trevelyan described how a baby swallow had flown down the chimney and his children had tried to rear it, letting it fly free around the room until it fed from their hands and roosted on their heads until they were sent to bed. Bewick then added his own experience, explaining that the swallow he had illustrated was a bird whose wing was slightly wounded – not deliberately – which prevented it flying away. 'It sat on the bench while the cut was engraved, and from its having been fed by the hand with flies, when sitting for its portrait, watched every motion, and at every look of the eye, when pointedly directed towards it, ran close up to the graver, in expectation of a fresh supply of food.'

This close attention made his woodcuts live. 'I have, all my life busied myself with feeding Birds,' he told a friend, and in this he was unusual, even eccentric, as feeding wild birds did not become popular until the mid Victorian age. At the workshop he also kept a reed bunting in a cage, noting '25 Jan 1794 – Bird seed for the Reed Spar-

THE SWALLOW

row 1*d*.'. The payments continued until May, suggesting that the bird was freed when once Bewick had drawn it in its fine spring plumage. His 'Black-headed Bunting' is a fine healthy specimen, and the text notes that it 'is a watchful, timorous bird, and very easily alarmed; in captivity it sings but little, and only when perfectly undisturbed . . . That from which the foregoing figure was taken, was caught during a severe storm in the middle of winter.'

At the Forth, Bewick kept a 'Swan Goose' (a domestic Chinese goose), which splashed about in a tub of water sunk into the ground, as well as Gibson's corncrake. The family got used to the corncrake's grating, monotonous cry, loud enough to be heard a mile away – well evoked by its Latin name *Crex crex* – and the corncrake got used to Newcastle winters instead of African sun. In defiance of its usual classification as a wading bird, the authors put it next to the quail, which it so resembled (although Bewick later moved it to *Water Birds*). He must have watched it often, dashing for cover, and he well understood the frustration of hunters:

Its well known cry is first heard as soon as the grass becomes long enough to afford it shelter, and continues till the grass is cut; but the bird is seldom seen, for it constantly skulks among the thickest part of the herbage, and runs so nimbly through it, winding and doubling in every direction, that is difficult to come near it: when hard pushed by the dog, it sometimes stops short and squats down, by which means its too eager pursuer overshoots the spot, and loses the scent. It seldom springs but when driven to extremity, and generally flies with its legs hanging down, but never to a great distance: as soon as it alights, it runs off, and before the fowler has reached the spot, the bird is at a considerable distance.

There were corncrakes around the Tyne until the 1960s. Now they have vanished, with the meadows that rang to their call – perhaps some day they will return.

THE CORN-CRAKE

Whether he was on the beach at Tynemouth or up on the Cumberland hills watching flocks of mountain finches, Bewick noted the birds' behaviour: he had an up-to-date pocket telescope, marked with the date, 1794. Even in town, he looked out for unusual birds. On one morning walk with the children, he climbed the wall of his friend John Hodgson's

garden at Elswick Hall to sketch the guinea fowl, 'much annoyed in his clandestine entrance by the house dog'. Guinea fowl were carefully protected; Hodgson was fierce towards poachers and often advertised in the *Courant* and *Chronicle*, offering rewards for information, and threatening to prosecute for trespass.

Just as they had with the *Quadrupeds*, Beilby and Bewick faced difficulties in arranging their material. Everything was fraught with complications, even the apparently obvious division into land and water birds. Where did the waders belong? 'Systems have been formed and exploded, and new ones have appeared in their stead,' declared the Preface, but 'like skeletons injudiciously put together', they gave little idea of the order and symmetry they were supposed to represent. Their own solution was rather haphazard. As guides to the arrangement and general descriptions, they used Pennant and Latham, but they made their own changes, beginning with the birds of prey and then dealing with the hard-billed birds, which live on seeds, before moving on to the soft-billed worm and insect eaters. Within these divisions they mustered loose families – 'the Falcon Tribe', the owls, woodpeckers, buntings, finches, flycatchers, larks, wagtails, warblers, titmice, swallows, doves, grouse, bustards, plovers – although some of these clans included odd houseguests: 'Birds of the Pie Kind' took in the chatterer (waxwing), while 'Of the Swallow' found room for the unrelated nightjar.

One of their correspondents had suggested that in the *Birds*, and in new editions of the *Quadrupeds*, they should give the modern Linnaean names. They agreed, but they were reluctant to lose the common names and included these too, and cited Buffon's French names as well. Since then, with better identification, many Latin names have changed: the hen harrier – *Falco Cyaneus* to Bewick and Beilby – is

now *Circus cyaneus*; the tawny owl, their *Strix Stridula,* is *Strix aluco*; the house martin, their *Hirundo Urbica,* is *Delichon urbica,* and so forth. The names paint the time and the place, since many popular names belong to the north country: 'Gowk' for the cuckoo; 'Stone-smith', 'Moor-titling', for the stonechat; and 'Woodspite, High-hoe, Hew-hole, or Pick-a-tree' for the green woodpecker. Readers then added their own variations and many well-scuffed copies of early editions are annotated with names from the owner's home area.

The mix of Latin nomenclature with graphic local names conjures a moment of balance, when the study of nature was passing from the country people who lived intimately with plants and animals and birds, to the scholars who studied them in their libraries. Early naturalists had often gleaned information from shepherds, bird-catchers, mole-catchers, bee-keepers, farmers and gamekeepers. Bewick firmly believed that knowledge could only be gained in the field, an idea latent in his tailpiece to the Preface. This shows an old shepherd with his collie, sheltering under a wall, with Rimside Moor and Cheviot in the distance. The well-dressed man with the gun is apparently asking the way 'under the impression that he will get a plain practical truthful answer from this stalwart Son of Northumbria . . . He does not disdain to gather his information from men of observation, whoever they may be & this old fellow & the young one are no "Garret Naturalists".'

In their descriptions the authors plumped for a familiar format. First came the physical description of the bird, its size, shape, and distinctive features – the length of its bill, feet, claws and especially its plumage, including the difference between male and female, or summer and winter feathers. Bewick obsessively corrected these details to match the actual specimens he was drawing and felt frustrated that even such a bald description was inevitably subjective: what was 'brilliant red' to one writer might be scarlet or even orange to another – why could not there be a standard rule for colours? But his woodcuts, black and white as they are, convey all the subtlety, intricacy and variety that he saw in feathers and form. His technique of lowering the block to get shades of grey gave beautiful results, managing to suggest texture – the softness of down, the sharpness of claw – as well as shading and shape. He made sure that each bird stood out against the background so that readers could check it against those they saw. A modern book describes the grasshopper warbler, for example, as 'anonymous streaky grey-brown'. Bewick's woodcut shows how rich this dullness is, how the dark streak passes from the bill to the eye and a dusky tone shines in the middle of the upper feathers, how the wing feathers are edged with pale brown and the yellowish white of the breast is speckled with deeper touches.

From appearance, the text moved to habitat, habit and song, from the nightingale's liquid trill to the screech owl's scream, loud and frightful in the still of the night. It noted the grasshopper warbler's sibilant call, which Gilbert White thought sounded like a whisper close at hand, although it might be a hundred yards away, adding, 'The country people laugh when you tell them that it is the note of a bird.' To illustrate its shyness, in a later edition Bewick told how the young taxidermist Richard Wingate once fought his way through a gorse bush to reach a warbler's nest, buried in a ditch overhung by

THE GRASSHOPPER WARBLER

prickly branches and dense with matted grass – and there in the middle lay five white eggs, freckled with carnation spots.

In the finished woodcuts, Bewick managed to convey precisely the characteristics of the species, while apparently showing an individual, living bird. In some cuts he showed his birds in profile, often standing on a branch against a white background, like the blackcap on an ash twig. In others he places the bird in its habitat: a hooded crow on a pebbly riverbank; a lark among waving grasses. Often, too, the cuts hint at the birds' relationship with men, like the rooks wheeling over an old house with a scarecrow in the field, or the blue tit eyeing the cottage orchard. 'This busy little bird', ran the text, 'is seen frequently in our gardens and orchards, where its operations are much dreaded by the over-anxious gardener' who fears it will destroy the tender buds but ignores its role in destroying caterpillars.

'Usefulness' was a much praised virtue. As Bewick suggested in the

THE BLUE TITMOUSE

woodcut of the farmyard above the Introduction, the relationship of birds and men ranged from awe at the freewheeling skein of geese, to downright war on the pestiferous crows and magpies and fish-eating heron, all nailed to the barn – 'the countryman's museum', as Gilbert White called it. The yard itself is full of useful poultry, ruled by 'Our gallant Chanticleer', and in other cuts and tailpieces Bewick showed the cocks strutting or stretching out their necks to fight, the hen defending her chicks against a prowling dog or squawking in distress when a polecat stole her eggs. The description of hens mixed long familiarity with the interest in instinctive behaviour analysed by Ray, Buffon and others:

A sitting hen is a lively emblem of the most affectionate solicitude; she covers her eggs with her wings and body, fosters them with a genial warmth, and changes them gently, that all parts may be properly heated: she seems to perceive the importance of her employment, on which she is so intent, that she apparently neglects, in some measure, the necessary supplies of food and drink . . .

253

When once the young have escaped from the shell, her whole nature seems to undergo a transformation. From being the most insensible and timid of birds, she becomes impatient, anxious, and fearless, attacking every animal, however fierce or powerful, that but seems to threaten her brood.

If the foolish hen wins respect, the book also spoke out in defence of birds such as rooks, jays and sparrows, usually considered vermin. In many places 'sparrow clubs' competed to see who could shoot the most: in one Bedfordshire village, between 1764 and 1774, nearly 14,000 sparrows were destroyed, and 3,500 eggs. Beilby admitted that the house sparrow was unusual in preferring the dwellings of humanity to woods and fields: 'it follows its society, and lives at its expence: granaries, barns, court-yards, pigeon-houses', indeed anywhere that grain was stored. But although even Buffon damned it as destructive, dull to look at, no good to eat, its song grating to the ear 'and its

familiarity and petulance disgusting', *Land Birds* disagreed, following the line of Ray and Tennant. Instead, the authors proposed that we should not condemn a whole species just because some individuals annoy us: 'the great table of nature is spread out alike to all'.

The sympathy for nuisance birds was matched by attacks on cruel sports like cock fighting, although with so many hunters among their readers Bewick and Beilby trod gently around the subject of shooting, only sounding an occasional warning, as with the ring pheasant: 'this beautiful bird is likely soon to be destroyed, by those who pursue every species of game with an avaricious and indiscriminating rapacity'. Bewick's own views were complicated by his anger at the way current laws favoured the sporting rich rather than the starving poor. Writing of the black grouse in a later edition, he argued that more birds should be introduced to stock the unproductive moors and wastes with a rich source of food, 'but till the legislature shall alter or abrogate our very unequal and injudicious game laws, there hardly remains a single hope for the preservation of such birds of this species as we now have'. (In fact both the pheasant and the grouse would probably have vanished without the protection of the shooting fraternity.)

The partners were not out-and-out protectionists. For Bewick, as for Blake, the wild birds' freedom of the skies mirrored the liberties that rightly belonged to the people: 'A Robin Red breast in a Cage / Puts all Heaven in a Rage.' Yet Bewick did not, for instance, edit the entry on the goldfinch, the most popular of caged singing-birds. Goldfinches, argued Beilby, are happy in captivity. They sing for most of the year, longer than in the wild, and in confinement 'they are much attached to their keepers, and will learn a variety of little tricks, such as to draw up small buckets containing their water and food, to fire a cracker, and such like'.

He also wrote cheerfully of how good particular wild birds were to eat, quoting Buffon's verdict on the honey buzzard, 'frequently caught in the winter, when it is fat and delicious eating'. And although he agreed with most British naturalists in their horror at the mass slaughter of small birds on the Continent, he followed Pennant in reminding readers that it was not sensibility but prosperity that saved them – the British diet was now so substantial that such bony mouthfuls were hardly worth cooking. Yellowhammers might be eaten in Italy, 'where small birds of almost every description are made of use for the table', but in Britain, where people were used 'to grosser kinds of food, they are considered too insignificant to form any part of our repasts'. Yet in the 1790s thousands of larks were still sold in the London markets, and in later editions Bewick added a note deploring the very idea of eating 'these tiny creatures, the ornament of our fields, our gardens and groves'.

History and science, as well as gastronomy, found a place. Sometimes Beilby added historical background, such as a brief account of falconry, noting that in the reign of Edward III it was a felony to steal a hawk, while taking its eggs, even on your own land, could land you in prison for a year and a day. Elsewhere he noted striking new findings like Edward Jenner's brilliant paper on the cuckoo, published in the Royal Society's *Transactions* in 1787. He also drew on local sources, such as Wallis's *Natural History of Northumberland*, which told of hen harriers breeding in the Cheviots and on shady precipices under Hadrian's wall, and he referred to events near to home, like the rooks who built their nest on the Exchange, or the migrating redwing that had crashed into the lighthouse at Tynemouth one November morning in 1785.

On the whole, Beilby and Bewick tried hard to be objective and scientific, men of an enlightened age, but their descriptions often slipped

towards the anthropomorphic, reflecting older folklore and country experience. The magpie was 'crafty and familiar', starlings were 'frolicsome', the linnet had gentle manners and the pied wagtail was ferociously tidy, even clearing up the paper and straw that naturalists put down to mark its nest. Partridges, too, were models of domesticity, mating for life:

The affection of the Partridge for her young is peculiarly strong and lively; she is greatly assisted in the care of rearing them by her mate: they lead them out in common, call them together, gather for them their proper food, and assist in finding it by scratching the ground with their feet; they frequently sit close by each other, covering the chickens with their wing, like the Hen.

Rooks, by contrast, were gregarious and quarrelsome – they stole each other's food and tore newcomers' nests to pieces.

THE ROOK

By the late summer of 1796 the partners had enough material to think seriously about sending the book to the press, and Beilby – accompanied by his wife, Ellen, and travelling with Robert Pollard, who had come up to see his family – took the coach to London to find good paper and to set up deals with the booksellers. 'We arrived in this great city safe & sound last night,' he told Bewick, reporting that he had stopped in York and taken orders, and asking him to send tailpieces so that he could show them to the booksellers with cuts of the birds. A fortnight later he sent samples of papers and reported jubilantly on orders. He also passed on rumours that a minister was to go to France to negotiate a peace: 'may it prove successful is the universal wish'.

The king, he told Bewick, was to go to Parliament the next day, 5 October, a testing moment since angry crowds had mobbed his carriage at the opening of Parliament the year before. A stone had broken the carriage window and Pitt's government had seized on this to force through even harsher laws, banning public meetings and making it an offence to incite hatred of the king. Many people were disillusioned and longed for the war to end, and in 1797 conditions worsened: coin was so short that the Bank of England introduced the first £1 note, there were mutinies of seamen at Spithead and the Nore, and constant threats of invasion. The only bright news was of Nelson's victory at the Battle of the Nile (for which there was another Panorama at the Forth, showing French ships blazing).

Yet when Beilby wrote of the war and the king, with that switch of focus characteristic of us all even in terrible times, he turned in a single paragraph from great matters to the smaller, more immediate, subject uppermost on his mind. The paper was ordered, he said. Soon two large deal cases containing a ream of imperial size for the fine editions and forty-one reams of royal were hoisted on to Newcastle Quay. By

now the order book was full of the names of booksellers and sub-scribers: rich landowners from the area; well-wishers like Thomas Pennant; Newcastle doctors, lawyers and merchants; print collectors and artists. Several customers had put their names down for multiple copies, and there were even some orders for coloured copies, although only a very few sets were ever finished.

All looked set but, as with the *Quadrupeds*, the publication date receded week by week. Christmas came and went. 'Beilby & I have been both harrassed in such a way, as we never were before', Bewick lamented to Pollard in February 1797, apologising for his hasty scrawl. For weeks he and Ralph had been 'closely & with the utmost exertion' working on five large plates of plans of estates to oppose the North Canal: 'we have had whipping work of it & have been obliged to lay everything else aside – We are at Press with the Birds at last & I shall be kept as busy in filling up the *gaps*, wanted in order to keep the Press agoing.' Even the invoice for the paper had a small plan of the Tyne between Bywell and Ovingham scribbled on the back. All through the summer they worked on, and every day Bewick went down to Hodgson's shop to supervise the printing of the cuts, confer-ring with his favourite pressman, George Simpson – he explained later that woodcuts would print an immense number if they were in the hands of a good pressman, 'for on his assiduity & care every thing depends'.

At last, in September 1797, all the text was finished. Only the Pref-ace and Introduction remained to be added. Now came a last minute hitch. When Bewick read Beilby's introduction, he noted that it thanked him for his 'assistance'. Then Thomas Hornby had supper with Ralph Beilby, who mentioned that he intended to put his name on the title page as 'author'. After a sleepless night, Hornby rushed indig-nantly to Bewick. This was what Beilby had tried to do with the

Quadrupeds, and to Bewick it seemed unjust: he was the creator of the cuts that everyone requested and the one to whom people sent their birds, and he knew that the unique, truly new value of the book to naturalists lay in the accuracy of his illustrations. Moreover, he had virtually rewritten Beilby's text.

He tried to write to Beilby, laying aside draft after draft, each one displaying his hurt. Would the declaration of Beilby as author help the sales, he asked, or 'Is it meant to *surprize* and *undeceive* the World & to make our friends exclaim to each other – oh we find Bewick is only the second hand man in this business – Mr Beilby is the Man?' When he finally raised the matter, Ralph and Ellen left town for a fortnight. On their return, Beilby was still adamant that his name should appear, and Bewick challenged him: 'Then Sir said I, if you can point out any single sentance, from one end of this Volume of the History of Birds to the other, of original matter as your own, I shall be glad to see it – at this he hesitated.' As with their dispute over the *Quadrupeds*, they turned to an informal panel (an interesting, and constant, feature of trade disputes in Newcastle at this date), consisting of the venerable printer and bookseller William Charnley, Solomon Hodgson, William Turner and Robert Doubleday, Secretary of the Lit and Phil.

Work was at a stand in the press room, so they met at once, and since Charnley was elderly and very deaf – he was often mocked for his conspicuous ear trumpet – both men made written submissions. Beilby's statement was handed round first and then Bewick's, which Beilby refused to read. In it Bewick explained angrily that he did not in the least want to conceal his partner's role, but objected to him 'taking upon himself the Parade of Authorship and representing me merely employ'd as a Workman to engrave Figures to embellish a Work of his composing', warming to his theme when he added that Beilby had not furnished one anecdote of his own, 'nor from himself described

one Property of a Bird'. Indeed, he fumed, Beilby's knowledge was so trifling that when he copied earlier authors 'who have published the most glaring falsities and absurdities he never cou'd discriminate between Truth and Falsehood, I have been obliged to cross out a great quantity of trash as can be seen by the Manuscript copy'.

Both men left the room, and while they waited impatiently outside, the panel agreed on a form of words, which eventually appeared as the last paragraph of their Preface:

It may be proper to observe, that while one of the editors of this work was engaged in preparing the Engravings, the compilation of the descriptions was undertaken by the other, subject, however, to the corrections of his friend, whose habits led him to a more intimate acquaintance with this branch of Natural History.

The book was the product, the Preface added, of hours spared from laborious employment and on that grounds the editors hoped it would be received with indulgence. The matter was settled, and on 14 October 1797 *Land Birds* was published – without Beilby's name on the title page.

20 ON HIS OWN

As soon as *Land Birds* appeared, readers responded eagerly to the way that Bewick's woodcuts showed the distinct 'personalities' of different birds, especially those they knew. A Captain Stuart wrote from Ipswich barracks to thank Bewick for the many pleasant moments the book had given him, assuring him: 'I never before saw the *character* & *attitude* of the birds so admirably drawn.' In the 1820s, his young friend George Clayton Atkinson waxed lyrical about Bewick's art in conveying their 'dispositions'. As a naturalist he knew that this was a dubious, anthropomorphic word, yet no other would do, since Bewick based his studies on such precise observation – the stern-eyed eagle, the restless magpie, the complacent sparrow, the lark caught in the moment when it is 'just going to rise carolling to the sky – till this moment it has cowered down to escape your notice; and now it is startled and looks round it preparatory to flight':

Then the Jay – is he not a saucy impertinent fellow? Fancy him in a semi-domesticated state, slily approaching you with a sidelong hop, endeavouring to assume a kind of conscious rectitude air, and trying to look innocent, at the same time with such a degree of unconcealable roguery and cunning in his face that you cannot help suspecting the purity of his intentions.

When the jay flies off, with his furious scream, you laugh at his knavery, continued Atkinson, but 'can hardly refrain from sending at him

the first convenient missile you can lay your hands on. In fact he is just the fellow that would bully you if he could.' And Bewick displayed him to perfection.

Later generations agreed. As John Rayner wrote, 'Bewick so often conveys the *character* of birds . . . the clownishness and self-confidence of the starling, the self-consciousness of the yellow-hammer, the alert aggressiveness of the robin, the modesty of the wren, the apprehension of the quail.' The active 'Kitty Wren', singing until dark and sometimes even in a fall of snow, and the robin, tapping at the window in frosty weather, were the birds he had watched as a child from the sill of the byre at Cherryburn. In his woodcuts, affectionate and accurate at once, he recaptured his youthful fascination with the whole airy tribe.

The book was an instant success. By mid 1798 this whole first edition was 'as good as disposed of': 1,000 copies of the small demy size, 850 of the royal and a final 24 of the grand imperial size. Subscribers were delighted. 'I am in more raptures than I can possibly express,' cried old George Allan, offering to lend any book Bewick needed for the next volume. The engraver John Landseer, whom Bewick much admired, wrote from London to express his admiration. A Doncaster artist sketched his portrait, feeling honoured to draw 'a Man who has taken the lead in his peculiar Profession'.

It was pleasing, yet he felt oddly alone. There was no John to share Bewick's delight, as he had after *Quadrupeds*, when he urged him to break with Beilby and set out on his own. This time the break had come suddenly, without his expecting it. During the dispute over the authorship William Turner had tried to pacify Beilby, who agreed that the whole affair had been foolish. Vividly, he described the pattern of such rows: a misapprehension perceived as an insult, retaliation, loss of temper on both sides, 'and the breach is widened beyond the power of any party to close of themselves'. But although he declared himself

happy with the compromise over the Preface and grateful for Turner's intervention, beneath his urbane manner Beilby was stung to the quick. His private response to Bewick had been passionate. 'Why am *I* to be rudely cast aside', he burst out, '& set in a corner as your Amanuensis . . . ? You seem to have forgot your own principles & have committed an act of the purest *despotism*, you have dragged me before a tribunal of your own erecting, where you have judged me to Death, & were to be your own executioner.' It was time, he felt, to go their different ways. And so it was. *Land Birds* was the last major work that Beilby and Bewick would undertake together.

Bewick found it hard to calm his tumultuous feelings. He was raw, clumsy, easily hurt and never seemed to learn from experience: matters that could have been quietly resolved often turned into long-blowing tempests. At the end of 1797 Sol Hodgson, overfond of the bottle and now rapidly succumbing to consumption, inflamed him further against Ellen and Ralph Beilby. 'My dear Tommy,' he wrote:

Since you left me the Subject you mentioned has occupied my Mind in an extraordinary Degree so as to fret my Disposition beyond Endurance . . . it has always as you know been the ardent desire of my Heart to promote Conciliation, but on the recent Occasions which now crowd on my Mind I think that you are sacrificing your own Abilities & the Interest of your Family to the Ostentation of two People who I shall not describe . . . That a Separation has now become advisable I have no Doubt.

Knowing Bewick might quail at the thought of another tribunal, Hodgson offered stout support: 'You are always *wavering* I am *uniform!*'

Even at forty-four Bewick found it hard to shake off the feeling that Beilby was somehow still his master. He was grateful for his good training and remembered the times they had stood together in a crisis,

but his thoughts circled back to the way he had been left to mind the shop while Beilby ran his other business. Writing to him one Saturday night in December 1797, working out the value of the stock, the desk, tables and shelves at the workshop, he signed his letter: 'I am / your injured 'tho / constant Friend / Thomas Bewick.' At the end of the year it was all over. 'Finis to Beilby & Bewick's Partnership', he wrote in the weekly engraving book, on 31 December. In inner turmoil, Bewick tried to run the workshop and to carry out, temporarily at least, the demanding duty of Parish Overseer of the Poor. The separation was expensive as well as distressing. The lawyers' bills alone were £20 and Bewick paid over £21 more for Ralph's share in the presses and books, tables and benches, 'Paper, Copper, Seals, Seal Handles, Box Wood, Copper Plates, Cutts, Drawings, Designs, Work Tools and other Effects'. Although the profits from *Land Birds* covered this expense, the rest of the workshop income slumped. It was hard shouldering the burden alone on such a slippery basis.

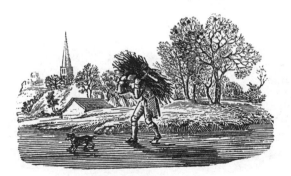

To begin with it seemed almost impossible to juggle the demands: first there were the books, then the ups and downs of the workshop, and finally the new tasks and challenges that came from taking full respon-

sibility for the copper engraving, previously Beilby's domain. Things were not even simple as far as his own books were concerned, since just as he was settling down to work on the second volume on water birds he had to think of animals again: in the spring of 1798 he travelled to Durham and Brampton to draw 'improved' sheep and cattle.

Stockbreeding had been a craze since the 1760s – even George III, 'Farmer' George, ran model farms – and selective breeding, combined with winter feeding on new crops such as turnips, clover and potatoes, had led to far greater yields of beef and mutton and pork. On the new enclosed fields, the farmers also needed more powerful horses for ploughing: Thomas Coke of Holkham bred the powerful Suffolk Punch, Robert Bakewell developed the Shire horse and the Duke of Hamilton reared the Clydesdale. Bewick had already engraved these new horses in *Quadrupeds*, as well as Robert Bakewell's Leicestershire Ram, and had made separate copperplates of 'The Whitley Large Ox' in 1789 and 'The remarkable Kyloe Ox' in 1790, with a smaller woodcut version for his book.

THE KYLOE OX

As the years went on, farmers called on him increasingly. When the price of wheat soared during the war, millions of acres were turned over to cultivation, the value of land rose, and in the short-lived boom the farmers made huge profits. Bewick, like William Cobbett, noted how this created more rigid class divides in the countryside:

The Gentry whirled about in aristocratic pomposity, they forgot what their demeanour & good, kind, behaviour, used to be, to those of inferiour stations in life & seemed now, far too often, to look upon them like dirt. – The character of the farmers, were also *totally* altered, from what it used to be, and they now acted the Gentleman very awkwardly – they could not, in these times, drink any thing but wine, & even that was called 'humble Port' & they were to have such kinds as bore a higher price – when they left the market, they were fitted to ride over all they met, or overtook, on the way.

In the interests of 'improvement' and anxiety about provisions during the war, the Board of Agriculture had been founded in 1793. One of the Board's first moves, under its tireless secretary Arthur Young, was to commission surveys of each county: soil and climate, landholdings and stock and crops, the state of cottages and conditions of workers. When Bewick's friend John Bailey produced the survey of Northumberland with George Culley, one stockbreeder, Mr Smith of Woodhall, objected to Bailey's poor image of a Cheviot ram and summoned Bewick to draw one of his own rams, to show how the breed had changed.

This was an enjoyable trip, but others, to Darlington and to Brampton, where the Colling brothers were breeding improved sheep and Shorthorn cattle for the Duke of Northumberland, were less fun: his drawings were dismissed as too lifelike compared with the popular paintings of stout owners standing by barrel-chested beasts. As he put it disdainfully, the trip to 'these fat Cattle makers, ended in nothing – I would not put lumps of fat here & there to please them where I could not see it.' He watched wryly as agricultural societies sprang up, giv-

ing prizes and premiums. 'I cannot help thinking', he wrote, 'that they often suffered their whimsies to overshoot the mark & in many instances, to lead them on to the *ridiculous*.' Yet in the fourth edition of *Quadrupeds* in 1800, the fatter, fuller breeds were there in force: the 'Improved Holstein or Dutch Breed', the Cheviot ram and Teeswater sheep and a fine 'Sow of the Improved Breed'.

Animals brought delight as well as frustration. In 1799 Bewick produced a superb series of cuts for Gilbert Pidcock, owner of the famous travelling menagerie. Pidcock had been travelling the country for twenty years, and John Bewick might well have seen him in the mid 1780s in London, exhibiting 'a tiger, a porcupine, an orangoutan' and a 'wonderful little Fairy' from Madagascar, perhaps a monkey, since 'he eats, drinks, likewise smoaks his pipe, and sleeps in the human way'. The show toured the fairs, claiming to be the largest collection ever exhibited, starring 'A most Stupendous Elephant, brought here on the East Indiaman *Rose*'. 'Pidcock's Grand Assemblage of Curious Foreign Animals and Birds' arrived in Newcastle in July 1799, and Bewick's great lion stalked snarling across the poster, a wonder of energy held in the bars of type. He made large cuts of the Lion, Tiger, Elephant and Zebra, taking a couple of hundred impressions on fine drawing paper for collectors, some of which were then beautifully coloured in, probably by Luke Clennell. When Pidcock settled his account for the show bills, he added a PS: 'Mr Bewick I have purchased a fine Rhinocerous there for I think I shall want a Cut for that but I will give you further Intelligence. Hope you and the Family are well.'

The drawers in the workshop desk and in the chest at the Forth were full of proofs of animals: the fourth edition of *Quadrupeds* was nearly finished, ready to be published in February 1800. There were startling new entries including 'two nondescript animals' of which

drawings and descriptions were sent to the Lit and Phil in late 1799 by John Hunter, the Governor of New South Wales: the animals themselves later arrived in Newcastle, pickled in spirits. Bewick received permission to include them, the first being a wombat, and the second a curious beast, still lacking its name – the duck-billed platypus. To enhance the book's status, Bewick added the new Linnaean names and printed a large imperial size, priced at one guinea, as well as the normal royal and smaller demy copies, costing 15s. and 10s. 6d. respectively. His reputation had spread to Europe and he sent copies of the new edition to Germany at the request of Messrs Hulsinbeck & Co. of Hamburg, enclosing prints of the Pidcock wild animals. Hulsinbeck placed an order and sold all he was sent.

Bewick ran off special sets of some cuts for the *Quadrupeds*, printed in light brown ink, which he thought more sympathetic to colour, and he then coloured these carefully and gave them to the children for presents on New Year's Day, 1800. He began to feel more confident, renewing the lease on the workshop and converting the attic into an office, where he could get away from the boys and look out over the rooftops. He dealt with his correspondence here, responding to numerous appeals, from letters soliciting donations to a Christmas feast for printers to pleas from the indigent teacher John Marshall, down on his luck after release from a French gaol, who inundated Bewick with letters begging for help in buying clothes, finding jobs and liberating his German flute from the pawnbrokers.

As the new year opened Bewick and Beilby were tentatively reconciled. Beilby engraved silver for the workshop, advised Bewick helpfully about prices and sent proofs coloured by Clennell and the large prints of the Pidcock Lion to his special customers. Bewick also corresponded with the other Beilby brothers, William and Thomas, and in

the summer of 1800 he and Ralph jointly published *Figures of British Land Birds*, which included a few of the foreign birds that Bewick had drawn long ago in his happy weeks at Wycliffe: Beilby shared the profits even though it was a collection of the woodcuts alone.

Bewick was also hot in Beilby's defence when an attack appeared from an unexpected quarter. A supplement to the third edition of the *Encyclopaedia Britannica*, published in Edinburgh in 1801, contained an entry on wood engraving, which heaped praise on Bewick and also noted the fine work of John Bewick and Charlton Nesbit. Beilby, however, was passed over as 'an engraver of the very lowest order, who was seldom employed in anything more difficult than the cutting of the face of a clock'. William Turner wrote a stout rebuttal for the *Monthly Magazine* but the contributor evidently knew the workshop well and suspicion points to James Anderson, a member of the Edinburgh literati, who could have picked up details from his son John. Whatever the source, Bewick was furious at the slur.

The partners were further linked in a dispute with Sarah Hodgson, who had run the press since Sol's death from consumption in 1800 and continued the close links with the workshop. Sarah knew the value of Bewick's work: she once playfully ordered a crest with the note, 'I must have TB in the corner, you may as well set about it, for I will tease your life out till it be done.' But in doing his accounts at the end of 1801 Bewick made a fatal mistake. He concluded that Sol had charged for printing 246 copies of *Land Birds* that they never received, and deducted the amount, just under £9, from a payment to Sarah. Outraged, she sent a long account of the printing and paper charges to old William Charnley and Edward Walker, proving that the shortfall was a clerical error by Beilby.

Sarah's ferocity was understandable. Widows often took over their husbands' businesses, but this was still a man's world, and at forty she

had five children aged between one and fifteen. Her first response was to pull in all her assets – even evicting her brother-in-law John Bell from the shop that he rented from her. One of these assets was, of course, Sol's third share in *Quadrupeds*. In April 1802, when Beilby and Bewick offered to buy this, she refused, saying that she had planned to buy *them* out: she would always keep Sol's share, as '*he* was the original projector of the Work'. Moreover, she claimed the exclusive right to reprint and proposed to do so at once.

Bewick, who had plenty of stock, threw up his hands. He did not know before this, he wrote, how much the birth and rearing of the Quads was obliged to the 'skilful operation & fostering care' of his old friend Mr Hodgson, 'but, in my Opinion, at this day, it is not much matter how the Bastard was brot forth, or which of his Parents his features may most resemble, if they do not suffer him to continue his efforts to serve them'. Letters flew backwards and forwards, full of martial language. Eventually, seeing no end to the wrangling, Beilby sold his share to Bewick, who took advice on copyright from Richard Phillips of London. 'I am not surprised that you cannot agree with that Tartar Mrs Hodgson,' Phillips wrote. '*I* have some curious letters of hers!'

This row would rumble on for the next decade, but for the moment the issue was set aside, and with the help of the apprentices the workshop almost ran itself. Although Bewick grumbled, he appreciated their work and the cash books recorded their jaunts:

1799	Jan	Harry & Luke to Fishers Benefit	2s. 0d.
	Mar 1	Luke to see the Wild Beasts	
	June 20	Harry & Luke to see the Panorama	
	Aug 1st	Luke to the play last night.	

But his valuable 'understrappers', as one Edinburgh bookseller called them, could also cause trouble. In 1800 he had to vouch for Hole, who was suddenly arrested under the Bastardy Act, as the father of an illegitimate child. This may have been a false accusation to get funds for the child's support since nothing more was heard, but it was awkward nonetheless. Bewick was fond of Hole, and when his indentures ended in October 1801 and he left for Liverpool, he asked the Merseyside book and picture dealer Thomas Vernon to look out for him, as he was 'of a poetic and romantic turn of mind, is unsettled, and does not know where to cast Anchor and moor in Safety'. He was worried that Hole was being cast adrift without a pilot, 'and indeed (although I shall not show it to him) I shall be inwardly much grieved at bidding him farewell, for I think I shall never see him again'. His fears were groundless: after early anxieties Hole did well as an engraver, and even gave advice to his old employer about a particular double-dealing client. Later he inherited his grandfather's estate and lived the cheerful life of a Devon squire.

The slim, crop-headed Charlie Hickson was more of a problem. He cut work as much as he could, usually with a hangover, and in September 1800 he vanished for weeks. News came at last from Richard Oliphant, now settled in the parish of Long Horsley near Morpeth, where his wife ran a girls' boarding school, that Hickson had been harassing a young woman whom he thought was an heiress. To Mrs Oliphant's warnings, 'His minced reply was "Mr Bewick was a good sort of man, & would not be angry with him".' He was wrong: Bewick put a note in the papers under 'Apprentice Absconded', and when Hickson turned up his indentures were cancelled. In the engraving book, Bewick scribbled briskly, 'Farewell to Charles!'

Workshop life was demanding, and at the start of 1801, when Thomas Vernon sent him three blank volumes to fill with loose cuts

and suggested he might illustrate Burns's 'Tam o'Shanter', Bewick confessed he was exhausted:

I hardly know what to say to you about doing Tam o'Chantur on wood. I cannot undertake to do it untill I have got quite done with the Second Vol: of Birds. – every thing that causes a delay in the publication I consider as taking a liberty with an indulgent public, who have a right to expect it as soon as I can – & yet it is not in my power to keep closely upon the Birds while I keep a Shop in the manner I do; and indeed, to tell you the truth – I am almost wrought to death – the [small drawing of a bent bow] is kept continually bent & I find myself not very well.

The stress took its toll. This tall, strong man, so proud of his tough regime, was ill for much of that year, with dizzy spells and faintness. It was not until December that he sent Vernon his cuts, apologising because he had never bothered to keep fine impressions. But Robert was now taking charge of them: 'my little Boy is now very careful of them, & you may be assured that I will pull out his Stores (such as they are) for you'. (When another batch was sent two years later, Vernon sent Robert a present of a silver cup, which made him blush with pleasure.)

Part of the rush was due to Bewick's new obsession: bank notes. In the past, Beilby had done most of the copper engraving, and Bewick felt that he was learning all over again. Bank notes and coal certificates were a staple of their trade and the workshop now had rivals: the previous year John Andrews Kidd, Abraham Hunter's old apprentice, had set up nearby, advertising copper engraving of 'Portraits, Views &c. Bills of Parcels; Bankers Notes, Bill and Check plates; Pottery Plates for either Blue or Black Printing; and every other Branch of Engraving, neatly executed'. Soon another competitor would challenge him, when his ex-apprentice Mark Lambert opened a shop in Dean Street in 1804.

M.ʳ Culley's Beagles

—— will Hunt at ——

PLACE	DAY	HOUR
	Monday	o'Clock
	Tuesday	Dº
	Wednesday	Dº
	Thursday	Dº
	Friday	Dº
	Saturday	Dº

With copperplates the graver, called the burin, was usually used directly on the plate. Bewick's later notes to his nephew John Harrison, who was learning the art of 'writing engraving', illustrate the detail and care this required. John needed polishing stones of his own, Bewick said, to polish and re-use old plates; he should see that the edges of the plate were square so that he could keep his lines straight, make the long strokes of his letters slightly shorter so that the long tops and tails did not crowd the space between the lines and be very exact in his measurements; 'make the letters rather deep & bold, but not much larger than the printed letters & so as to come in & not take up more room – The letters may be engraved in either small Roman or in a stump hand & the different ones placed in the middle, between the dry point lines I have ruled.' Because he cared for John, who was epileptic, these notes provide a rare glimpse of Bewick at work, for example in cutting flat letters on a seal:

I first of all (after the Letters are accurately drawn out) cut all the hair strokes of the Tops & botoms of the letters with a Spitsticker, of the depths they ought to be, & then with a flat tool, sharpened exactly to the width of the letters, I cut out the thick strokes or body of the letters at one or two strokes with this flat tool, without any outlining about them – you will find this an easy as well as a correct way & a very little practice will enable you to do the Letters well.

Once the engraving was done, the cleaned plate was inked in the usual way, with heavy dabbers. For the best work the printers mixed Frankfort black (made from the burning of vine twigs) with oil and other vehicles to give a denser pigment, as opposed to the common lampblack. The ink had to be thick, almost like a soft cheese, so that it could be pressed into the lines of the plate, which was then polished and skimmed with the ball of the hand, so that not a trace remained on the surface. The whole technique was different from that used for letterpress and woodcuts. The copperplate printers used a rolling

press, rather like an old-fashioned mangle. The plate was laid on the press bed and covered with blankets, and then the pressmen pulled on the long wooden handles of the star-wheel to grip and pull it under the heavy top roller. Beilby had bought their first press in the late 1770s and invested in a second in 1789.

The printers were usually itinerant journeymen and the cash books showed how passing men were given sixpence if there was no work, according to custom. Some printers worked regularly for Bewick for years, or irregularly, in the case of George Barber, whose early work books are crammed with entries, and later ones with Bewick's doodles of empty tankards and George flat on his back in the road. Drunkenness was an occupational hazard with a job that was long, repetitive and thirsty-making. Eventually, after sixteen years, Bewick had to sack George, but the references for his new pressmen made them sound much the same. 'He is a harum-scarum rattle scull,' went one; 'he often goes on the ramble – & when in his cups he is exceedingly ill tongued & insolent – but with all these exceptions he is by no means to be ranked amongst the most licentious of Copperplate Printers . . . upon the whole I do not think you could get a better.'

George Barber's work in the year that Bewick set up on his own included watch papers, name cards, coal certificates and '500 Notes Durham Bank'. Bewick knew that the notes issued by country banks were alarmingly easy to copy and was intrigued when George Losh asked him to engrave a £5 note for the Carlisle Bank, designed to deter forgers. With this in mind he created an elaborate panel, decorated with flowers, so dense that it looked like a woodcut. Through contacts in London this found its way to a government official, who showed it to the king 'and also to many other mighty personages'. In March 1801 it was seen by Joseph Banks, President of the Royal Society, and eventually Bewick received a letter from the Governor of the Bank of

England, Samuel Thornton, asking how the impression was made. After this hint of interest he spent months working on a plate, only to be told that though this 'would do well enough for country banks, it would not do for the great number wanted for the Bank of England'.

The business came to nothing, although later it would invade his time again. In his sixties, from 1813 to 1820, he experimented in anti-forgery techniques, encouraged by John Bailey, by now a director of the Berwick Bank – Bewick's note for this bank is among his most beautiful designs. To solve the forgery problem he tried to combine etching and engraving, and printing in blue and red. This was hard, he told Bailey: 'whether the fault lies in your hard gum'd paper, or in my oil being badly boiled, or the ink not properly mixt or ground up I am in doubt about'. (The biggest problem lay in his printer – not Barber but a later workman – 'my Botcher' as Bewick called him, who disliked working in colour and was often drunk.) Bewick also tried cutting the main device on brass or steel before stamping it into a copperplate.

When a Parliamentary Commission was set up, he suggested to his MP, Sir Matthew White Ridley, that country banks be supplied with special paper already printed with elaborate borders. This, he was told, was not in the Commission's remit, but Bewick showed the method to the Grand Duke Nicholas, who visited his workshop in 1816, and whose entourage included Sir William Congreve, a member of the Commission. To Bewick's rage, Congreve put forward an almost identical method and was loudly applauded as its inventor. He was left feeling sore about the whole affair.

While he was in his first flush of enthusiasm for bank notes, the new century dawned – taken as starting on 1 January 1801, not 1800 – and Bewick pronounced a four-day holiday for his pressmen on letterpress and copper, George Simpson and George Barber. To announce it he drew a PROCLAMATION for a Jubilee, with a mock coat of arms

and crest – a ragged, armless coat and an old wig. The two Georges were the 'Sup-porters', waving tankards of porter. Almanacs and cobwebs, prints and scored-out tasks, pinned behind them on the wall, stood as mottoes and embellishments. The proclamation announced a 'Grant' of a four-day holiday, provided they kept to the following rules: moisten their bodies with wholesome malt liquor, lay in a foundation of good beef and mutton, and above all stay friends – since life was so short, there was no time for 'Broils & Strife'. As an afterthought, taking account of the effects of all this indulgence, Bewick added a note: 'This Jubilee may continue a *little* longer.' It was not so bad after all, he decided, running the business on his own.

21 HOME AND FRIENDS

On 12 October 1801 the news arrived that the Peace Treaty of Amiens, which had been under negotiation for months, was finally signed. In Newcastle bells were rung and guns fired. All the ships on the river were decorated with flags and lamps, and in the cool moonlit night the whole town came out to see the transparencies in the windows, lit by candles behind. Langlands the goldsmiths displayed large designs of 'Peace and Plenty', while Dr Pearson made everyone laugh by showing a real skeleton in one window, under the banner 'Effects of War', and in the other a large Cheshire cheese and a loaf, 'The Blessings of Peace'.

The Bewick family, like the rest of the nation, rejoiced in the peace, little knowing that it would last a mere fourteen months. They were happy and settled in the house at the Forth, with many friends living nearby. Ralph and Ellen Beilby were at the Spital Tower, John Hodgson the banker lived up the hill at Elswick Hall and the young taxidermist Richard Wingate in an old Elizabethan house just round the corner. Another near neighbour was the wealthy John Waldie, a colliery owner and partner in the Northumberland Crown Glass Company. In 1803 he built a country seat, Hendersdyke Park, near Kelso across the Scottish border, but he spent several months of the year at Forth House, where all his children were born, and was a member of the Lit and Phil, building up a fine library and collection of works of art.

Bewick had become a member of the Lit and Phil himself in 1799, but he put on no airs, either with his neighbours or with his customers. When the Quaker banker Joseph Gurney brought his family to Newcastle in 1802 and called in at the workshop, his fifteen-year-old daughter Hannah found Bewick rather disappointing:

He is a large, fat, dark man pitted with the small pox, very ordinary, & what does not serve to embellish his person, chewed tobacco. He was in his workshop which is no more than a dirty hole. He was very civil & shewed us a great number of his vignettes which entertained us very much.

Bewick was content to be 'very ordinary'. His friends included saddlers and hardwaremen, painters and china dealers, brush manufacturers and builders. They ranged from the hard-working doctor Samuel Pearson, to William Harvey, a hired gardener on the estate at Summerhill with a large family and little money. Bewick met Harvey on Sunday evenings at the house of old William Gill, the former colliery agent to Lord Windsor, 'a neat nice old Gentleman with a ruddy complexion & a very benevolent heart', according to Jane. Gill was devoted to his servant's little son, William Ord, and Bewick was outraged when he decided to leave all his estate to Ord, cutting out an impoverished brother in Yorkshire, but 'Mr G. said he had made his money by his own industry & wd leave it whomsoever he chose'.

These friends formed a network of support. William Gill, for example, set Harvey's wife up in business making cakes, while Bewick took one of Harvey's sons, also William, as an apprentice – later the most successful of all his pupils. Almost all his friends, like Gill, were independent, opinionated and generous. Edmund Robson, a saddler, once called Bewick out of the club room at Swarleys, worried that he might be out of pocket by having to find funds for his books, and offered a loan of £200 whenever he needed it. Bewick himself stuck to his

friends in bad times as well as good, lending a sympathetic ear – and probably money – to John Bell when he suffered setbacks in his business, and supporting David Sivright when he finally succumbed to alcoholism, women and lonely wanderings. 'You are the only person who has ever shown any interest in my welfare,' wrote Sivright, 'who visited me when sick, who forgave my foibles, and who would have given sixpence to have saved me from Death.' Bewick became the conduit for his Edinburgh funds, paying for board and lodging, drink and debts. Just before his death in 1819, Sivright was still pleading 'for Godsake do not abandon me'.

Bewick had a soft spot for eccentrics, like the local inventor John Rastrick, a mechanical genius who talked constantly about all his ideas, with the result that they were constantly pirated, and George Gray, Gilbert's talented and wayward son. George had been apprenticed to a still-life painter, but his real love was for botany, mineralogy and chemistry, and in 1787 he had sailed from Whitehaven on a 'botanizing expedition' to America, travelling far into the interior. On his return Prince Poniatowsky hired him to lead a geological survey of Poland, but he found his colleagues so extravagant and so rude about his own untidy ways that he abandoned them in Krakow and stormed home, to open a shop in Dean Street as a 'portrait, fruit, house & sign painter'. At his lodgings in Pudding Chare

in a Room, never cleaned nor swept out he pursued his business – surrounded with models, Crucibles, galley pots, brushes & paints – pallets – bottles, Jars, retorts & Distills, in such a chaos of confusion as no words can describe – from this sanctum Sanctorum, he corresponded with Gentlemen of science in London & other parts.

'Few men were better liked,' wrote Bewick, 'as well for his knowledge as for his honesty & the genuine simplicity of his manners.' One of

Gray's ventures was an attempt to start a local industry weaving stockings out of nettle fibres: the stocking he gave to Bewick still survives, silky grey and green, despite its mottled patches. In 1815 he startled everyone by suddenly marrying. 'Pray how is our old friend George Gray doing since he became a Married Man?!!!' asked Pollard, to which Bewick replied that he had 'a decent canny woman for his Wife, who keeps poor George tidy & in good order'. Their only problem was money, since she had opened a shop that did not do well, but all Gray's friends had subscribed to his fruit pictures '& I think they will not stop 'till his loss is made up'.

Bewick's ties with friends from his youth, such as George and William Gray, always stayed strong. In 1802 William Bulmer asked him again if he had thought of a poem that he might like to engrave cuts for (we have no record of his answer), and Robert Pollard was in constant touch. 'My Old Friend Bewick,' wrote the latter, 'at first glimpse I recognized your handwriting when my daughter laid your Letter upon the Table before me.' Pollard's elderly mother was a good friend of Bewick's wife, Bell, and when he came north to see her and his brothers he called in at the Forth. 'Tell your Eldest Daughter', he wrote when he was back in London, 'I have not forgot how happy we all were when she danced with my Brothr. Joseph while Your Son Playd the Bagpipe.' This was one of Bewick's own favourite scenes. 'There they go,' he would say as he watched his daughters twirl, 'Queens of England! Queens of England!'

The girls had been taking dancing lessons with Mr Kinloch and Robert was now improving his piping with a real master, John Peacock: Bewick recorded his first lesson in the office cash book, with a sketch of him playing in the margin. Robert learned fast, exchanging tunes with his friend John, the son of the house decorator and portrait painter

283

M^R KINLOCH'S BALL.

Joseph Bell. When the Bewick children went to play with John and Mary Bell above the artist's shop in the High Bridge, full of colours for the trade, they marvelled at their house, with large landscapes on the walls surrounded by borders of flowers and a sitting room ceiling of deepest blue, scattered with gold stars. Young John Bell later painted Robert, serious and wide-eyed, while his father, Joseph, apparently painted a now lost portrait of Bewick. So did the artist William Bell, allegedly painting Bewick 'in the style of Rembrandt', in the brown silk cap he wore to keep his head warm. The Bells were a large family with many branches: Bewick was also friendly with Thomas Bell, an Alnwick lawyer who supplied him with birds in the early 1790s, and with two more John Bells, the land agent at Eslington who was now a merchant at Alnmouth, and the dynamic young bookseller on the quay.

Though far from well-off, the Bewicks now mingled with the quality. In church the girls admired the ladies from Charlotte Square, wielding large fans during services in summer, and spilling out to walk up the

lime walks in the shade, wearing large leghorn bonnets and 'Rosina' hats, decorated with wreaths of flowers, and low-heeled shoes in red, pink and yellow, with silk stockings. At St John's they met the family of Admiral Collingwood, later the hero of Trafalgar, but they were equally intrigued by 'Peter Waggy', old Lieutenant Hamilton with his stiff neck, cocked hat and red and white plaid, whose wounds made him walk lopsided, to the amusement of local children.

Their own life was simple, even frugal, its high points being trips up to Eltringham, picnics in the fields and visits to the sea. In the summer of 1801 Jane was fourteen, Robert thirteen and Isabella eleven, while eight-year-old Bessy was the baby, and her father's darling. As they grew, the girls moved to a smarter school run by Miss Smith at the foot of Westgate Street. Often they walked to work with their father, but what should have been a five-minute stroll was far longer, since Bewick constantly stopped to talk over politics and the progress of the war, especially with Mr Leadbitter the saddler, next door to the Crown and Thistle. Isabella, tapping her feet in impatience, was 'wearied and tired out in listening to them'.

Bewick was still an indulgent parent. 'I was never more delighted in my life', wrote John Bell from Alnmouth, 'than at our house to see the four Children run about you & strive each to attract your notice.' By contrast, Bell was still strict, and often unwell. Three years before, in the heat of July 1798, when Jane was staying with her aunt, the wife of a boat builder at South Shields, Bewick wrote apologetically that her mother had been 'very poorly since Sunday last and has wanted your help as her Little Maiden very much'.

The Bewick family were great believers in bathing as a route to health and the following June, Jane was back at '*Merry Shields*'. 'When you bathe', added Bewick, echoing Bell's strictures, it was their anxious wish that, 'it may be along with some steady person, & not any of the

giglet giddy Girls – we hope you will endeavour to be a steady good Girl while you are from home.' In the summer everyone fled the town, to the sea or to the country. In 1799 when Jane was at South Shields, Robert and Isabella went to Ovingham, while Esther Elliot – who remained their housekeeper until she died – took the wherry to Newburn, a short way up the Tyne. Only Bewick, Isabella and little Bessy were left at home. 'I think the Forth solitary', Bewick wrote, 'for want of some little *Lads & Lasses*, & think the time long 'till their return.'

A week later, Robert told Jane, all in a rush, of his time at Ovingham and Eltringham:

Where I met with the finest fun that Ever I had in my life I have learned to walk upon stilts and can almost cross the Tyne upon them I expect a pair at the Forth soon Where I expect plenty of plodging with them when wet weather comes. my word Jane I have got some nice new tunes from Jemmy Maffin my father likes the one called *What would a Lassie de we an auld Man* the best of any of them and I have jingled them up since I came home.

He would have been glad to go down to Shields, he added plaintively, 'to play at Betty Skipsey's Birth Day but my father dare not trust me

out of his sight'. One can imagine Bewick chuckling at 'What would a Lassie do with an old man'. Sometimes he did feel old, and in late June 1801, when Newcastle was thronging with crowds for Race Week, Jane brought his youth back to mind when she described her journey out to Ovingham, through Heddon-on-the-Wall and Wylam, with her cousins and Bessy, who laughed all the time at the jolting of the cart, while the carter stopped at every public house so that by the time they reached Ovingham he was drunk.

Jane went to the church where Bewick had climbed the pillars to dodge Revd Gregson: 'a very canny Country Church I think', she decided, like a true town girl. At Eltringham she walked round the fell and the pit and the pond, noticing how the fields were parched, the potatoes, corn and meadows looked singed and the fruit had failed to ripen in the drought. Her uncle William, she reported, kept up his father John's ways, getting up at two or three o'clock: 'He says it would delight one to see how sweet every thing appears the Birds singing so sweetly and every thing so still and quiet.' Bewick annotated her letter, as if to fix it in his mind, re-writing 'delight' in his own clear hand above her childish script. When the boatman ferrying Jane across to Ovingham found out that she was his daughter, he would hardly take payment.

This was still his country. In 1803 he asked his old friend Christopher Gregson why he didn't leave the metropolis to come home to the banks of the Tyne, where he and his family were so respected. How could Gregson, he wondered, let slip the chance of contemplating at his ease 'the beauties of Nature spread out to enlighten, to captivate, & to *chear* the *heart of man* – for my Part, I am still of the same mind that I was when in London, & that is, I would rather be herding sheep upon Mickley bank top, than remain in London although for doing so, I was to be made the Premier of England.' He was in Ovingham a few weeks after Jane's visit, when his daughter Isabella wrote from Tynemouth, demanding his presence and his gossip: 'We expect to see you on Sunday mind don't forget the Newspapers and the Forth news and hunt if there is any . . . there are numbers Bathing close under the bank, we are much amused with Peggy and her mother edging in and out so guilty like . . . we are all in high Glee and as happy as Queans so no more at this time.'

Bewick loved his late summer holidays. The family often stayed in Tynemouth into September and October while he went back and forth to the workshop. When he was there in 1802, he relied on the sensible advice of the Newcastle doctor George Davidson: he should go bathing, walking, forget about business and do nothing hastily 'except Laughing', which was allowed with total freedom. He was supposed to drink warm salt water as well as swim, telling Davidson that he had drunk 'one pot after another until I was *full* . . . I only feel rather over loaded, heavy and dull – I think I shall not try it again.'

But even here he was pursued by work. The plates for bank notes were so precious that the copperplates were kept under lock and key, and only George Barber could tell which was needed. On the night of 13 October, responding to a request from Luke Clennell, Bewick sent a vivid, hasty note to Esther at the Forth:

Dear Aunty

I have just now received a Letter from Luke informing me that the Newcastle Bank wants a number of Bills printed immediately, therefore as soon as you receive this Letter you must go along to the Shop with the key of the Desk, which you will find in my Pocket Book in my Night Cap Drawer – it is the largest key of the bunch – and when you have opened the Shop Desk with it, you must desire George to get the Bill Plate wanted, which he will find in the book hole . . . Luke does not know the Plate . . .

When you are out if convenient, you may call at Mr Bell's. we are very anxious to know how he is – also you may tell John that Robert received his Letter at which he was both pleased & disappointed – he longs much to have his company among the Rocks at Tynemouth & we think it a pity he should let the opportunity & the fine season pass away, without reaping the full benefit from it – Little Rob is (while I am writing this) playing John's new tunes of peace & plenty &c to old Willy Dean in the Kitchen – Jane desires her compl. to Mary & hopes she is very well since her return to NCastle – Jane has met with a misfortune to day her bathing dress was stolen from off old Willy's garden dike & the Thief has escaped –

By the end of this year, Bewick's new book was almost finished. Nearing fifty, he was a modestly successful businessman and an admired artist. And however tired he became, his friends and family nourished him. At the Forth, on the longest day, 21 June 1802, he found a small parcel on his table:

Mr Bewick

I am happy to have it in my Power to present you with a Strawberry, so early this year, it is out of my Strawberry Bed – I hope in a short time to be able to give you some more

I remain your / Dutiful Daughter / Jane Bewick.

IV TIDE

22 WATER BIRDS

All this time, Bewick had been working on the second volume of his *History of British Birds*. The publication of *Land Birds* had brought shoals of letters, and Bewick was now considered one of the leaders among the new wave of naturalists. In 1798, in return for *Land Birds*, Thomas Pennant sent him a copy of his *History of London*. Bewick gave this treasured volume to Bell, who had it bound in morocco and bequeathed it at her death to their daughter Elizabeth. Pennant was ill – he died at the end of this year – and he felt a sense of hurry, a need for a successor. He sent Bewick his portrait and urged him: 'If possible, introduce into your book all the birds omitted in mine, which will make yours a perfect work.'

Yet Bewick was always aware that his work was far from perfect. Lacking Beilby's notes on the specimens that had arrived in the early years, he struggled with precise descriptions of plumage and colouring, and in December 1799, working in the long winter evenings, he begged Ralph to look out his notes when convenient. Time was pressing. In January 1801 the Hull apothecary Edward Oxley sent a comic appeal for the second volume: '*by all Means, & at all events* get it out this summer – the Amateurs here are out of all patience, pray put them in a good Humour again – several of them positively aver to my face that you was *dead*, until I produced one of your Letters'.

One of the problems – although it was also a pleasure – was that instead of receiving information, he was now often called upon to give it. Even Pennant had sent queries at the same time as congratulations. Did Bewick know of a small linnet, he asked, darker than usual and called the Thorny Linnet in Yorkshire? Was it 'the *Twite*'? George Silvertop of Minsteracres sent him 'a small bird which I shot in a turnip field about two days ago & as no person here ever saw such a Bird, it may perhaps be uncommon in this country'. While naturalists were respectful, the local gentry sometimes treated him as brusquely in his role as bird expert as when they were sending orders for engraving:

Jn Surtees Compts to Mr Bewick and has sent him a Non-descript which he believes to belong to the Anas (apud Anseres) tribe of Birds and requests its specific name by ye return of Bearer.

He did his best to respond, trying to be tactful when writers sent a bird they thought rare which he knew was nothing of the sort, but the correspondence seemed endless: 'and many a letter I have written, after being so wearied out with the labours of the day, that I often forgot how to spell the commonest words'.

Letters came from old correspondents like Revd Brocklebank from Corbridge. Now getting on in years, and unable to walk out into the country – he had been dramatically stabbed in the stomach in 1799, which may have impaired his health – the hunting-shooting parson was delighted to spot an apparently new species of tit, right at his back door:

It runs with great Facility up or down the underside of Branches of Apple Trees or Pear Trees, with its Back downwards. Its Note is loud and singular, resembling the Sound excited by the sharpening of a large Saw with a File, and this note it repeats, invariably, three times – Te-Gai –Te-Gai –Te-Gai – within twenty yards of my Door, a few days ago, when I shot it –

This was entertaining, but also infuriating, as Bewick wanted water birds, not a tit or, as it turned out, a pied fly-catcher. Once again, he appealed for help in finding difficult specimens. And once again, the Trevelyan family responded with zeal (although sometimes their parcel contained a bird he did not need, or not even a bird at all: 'Mr Walter Trevelyan sends Mr Bewick an uncommon coloured Hare killed at Long Witton to day – if Mr Bewick do not think it worthy a place in his Museum, it may be consigned to his Larder').

Friends rallied to the cause. John Bell sent a spotted redshank in perfect plumage from Alnmouth, even though his mind was on lost cargoes of corn and looming debts. Lt Colonel John Dalton sent a spotted rail, 'the Rallus Rorzana – or spotted Gallinule', while his officers scoured the Farne islands, scaling the rocky nesting places of guillemots and shags, kittiwakes and terns and puffins. Despite his pleas people often sent common birds: thus Colonel Dalton later sent a duck, adding: 'I have in vain exerted myself to procure the different Birds you enumerated in your Letter, but as I am rather an Enthusiastic kind of Naturalist I by no means despair of success.' (The enthusiastic Dalton once asked Bewick to be careful 'as I have only *borrowed* the bird'.)

Bewick sometimes had to point out gently that one or two specimens were so long on the road that they arrived in no fit state to be stuffed, or that the quantity could be overwhelming: parcels of curlews arrived 'sometimes a dozen or eighteen at once'. There were unforeseen hazards: a puffin, sent in a box covered with netting, caught hold of a workman's finger with its razor-sharp beak and ripped the flesh as if it had been cut with a knife. It was rather a relief when George Strickland of Ripon, who had a superb collection and whose observations Bewick often quoted, sent drawings and descriptions instead of actual specimens, dead or alive. When he went to stay

at Redcar, on the coast, he listed the birds he had seen – cormorant, herring gull, curlew, dunlin, greater and lesser tern, peewit – and promised to look out for more in 'the fenny part of the East Riding'.

With the birds came the stories. Sir John Trevelyan reported an early experiment in ringing on a Dorset estate, to prove that woodcock return to the same place every year. Bewick's own illustration of the woodcock showed its plumage marked with different shades so that it blended perfectly, as he wrote in his description, into the 'ferns, sticks, moss and grasses . . . by which it is sheltered in its moist and solitary retreats'. In the opinion of his apprentice, John Jackson, this was 'the most perfect likeness of the bird that was ever engraved', an example of the way Bewick used all the potential of his medium, managing light and shade to gain a softness and subtlety that a copper engraver could never have achieved.

THE WOODCOCK

In this volume, as in his first, Bewick considered birds in relation to men, and the experience of sportsmen and farmers underpinned his text. He noted, for example, how certain birds, such as geese or gulls, have leaders who call the alarm when a hunter is near, and described the many ways of catching mallards, even giving instructions on building decoys or using funnel nets. Describing domestic geese, he incorporated Pennant's account of their rearing in Lincolnshire. When they were incubating their eggs, he noted, wicker pens were placed in rows, tier upon tier, 'often under the same roof as their owner', and the birds were fed, driven to the water and replaced on their nests until the eggs hatched – a month's hard work for a gooseherd. In contrast to this intensive rearing, the ordinary farm ducks, 'picking up the waste about the barn door', took Bewick back to heather-thatched farms like his father's and to the verse of Allan Ramsay:

> A snug thack house, before the door a green;
> Hens on the midding, Ducks in dubs are seen:
> On this side stands a barn, on that a byre;
> A peat-stack joins, and forms a rural square.

Soon after this rhyme, a small boy stands in for his remembered self, watching the ducklings adopted by an anxious hen:

The village school boy witnesses with delight the antic movements of the busy shapeless little brood, sometimes under the charge of a foster mother, who with anxious fears paddles by the brink, and utters her unavailing cries, while the Ducklings, regardless of her warnings, and rejoicing in the element so well adapted to their nature, are splashing over each other beneath the pendent foliage; or in eager pursuit, snap at their insect prey on the surface, or plunge after them to the bottom: some meanwhile are seen perpendicularly suspended, with the tail only above water, engaged in the general search after food.

THE TAME GOOSE

These birds were for eating, as well as watching. Geese and ducks were standard fare but the ruff was a delicacy, and some enjoyed the coot, 'with a strong *marshy* taste'. The most daunting was the common seagull:

Some persons who live near the sea commonly eat this, as well as various other kinds of Gulls, which they describe as being good food, when they have undergone a certain sweetening process before cooking, such as burying them in fresh mould for a day, or washing them in vinegar.

Many descriptions evoke moments in Bewick's life, from his childhood on the farm and his angling in moorland streams to recent holidays by the sea, where some birds, he thought, 'like little boats, keep within bays and creeks, near the shores; others, meanwhile, adventure into the ocean and sport amidst its waves'. When the family were staying in Tynemouth in late September 1801, Bewick caught a guillemot,

stranded among the rocks on flat sand, 'from which it could not raise itself to take flight':

While the drawing was making, it sat under a table trimming its feathers, and appeared perfectly at ease, and not the least alarmed at the peeping curiosity of the children who surrounded it. When this business was finished, it was taken and set down upon an open part of the shore, where it immediately began to waddle towards the water, with the whole leg and foot extended on the ground; and as soon as it reached its beloved element, it flapped its wings, darted through the surge, dived, and appeared in the place no more.

THE FOOLISH GUILLEMOT

He made rough sketches of details, of heads and feet, and then careful pencil drawings and watercolours. He went back to some of his Wycliffe sketches of 1791, but sometimes chose a slightly different stance, setting his subject among the rushes of a stream or on a rocky

shore. Occasionally he gave the drawings for cutting to Henry Hole or Luke Clennell.

Entries in the workshop books chart his progress. In March 1798 he used a Wycliffe drawing for the cut of the garganey duck; in the week ending 2 November 1799 he engraved the greylag goose, charging the business a guinea; in mid December that year he worked on the great auk, showing the big bird almost slipping off its small rock. In January 1800 he finished the black guillemot; in May he engraved the eider duck from a drawing of 'a perfect bird, in full plumage, shot in April, near Holy Island'. So it went on, month by month, each bird drawn and cut with care, like the fulmar, arching its neck and pluming its feathers while floating on a small scrap of board, finished in May 1802.

Bewick was punctilious in noting which specimen he had made his drawing from, like the spotted sandpiper 'shot in the month of August, on the bleak moors above Bellingham, in Northumberland'. He was equally meticulous in citing his authorities – from Willughby, Buffon, Pennant and Latham to Captain Cook's *Voyages* – and for the first time he was able to refer to Montagu's new encyclopedia of 1802. The respect was mutual: later Colonel Montagu proposed the name *Tringa Bewickii* for a bird that Bewick had been the first to describe as a 'Red-legged Sandpiper' in 1804. (Bewick modestly noted that this was probably not a sandpiper at all but a ruff in one of its many varied states of plumage.)

In his descriptions, as he selected his copy from previous writers and mingled their words with his own, Bewick seemed to *see* the birds, as if he were standing silently nearby. The water crake, or spotted rail, sits on its floating nest, moored to a reed to avoid being swept away, rising and falling on the current; the stormy petrel skims over the heavy rolling swell of tempestuous seas, seeming to foresee a coming storm long before any

THE HERON

sailor. The heron, 'a bird of a melancholy deportment', silent and patient, waits for its prey as if fixed to the spot like the stump of a tree.

Few waterfowl escaped his admiration, except the cormorants:

This tribe seems possessed of energies not of an ordinary kind. They are of a stern, sullen character, with a remarkably keen penetrating eye, and a vigorous body, and their whole deportment carries along with the appearance of the wary circumspect plunderer, the unrelenting tyrant, and the greedy insatiate glutton, rendered lazy only when the appetite is palled, and then they sit puffing forth the fetid fumes of a gorged stomach, vented occasionally in the disagreeable croakings of its hoarse hollow voice.

Milton, Bewick thought, put the finishing touch when he made Satan, spying jealously on Paradise, the evil archangel who

. . . on the Tree of Life,
The middle tree and highest there that grew
Sat like a cormorant; yet not true life
Thereby regained, but sat devising death.

THE CORMORANT

Bewick enjoyed working on the descriptions and woodcuts, where he felt confident of his own knowledge and mastery, but he did turn for help in editing his prose. His main editor was the Revd Henry Cotes, who sent several specimens including stints and a supposed wigeon, which Bewick firmly corrected to 'scaup duck'. Cotes was a well-

known character, who buried his hunter, Wheatley, in a field by the church, with a tombstone and elegy, and wrote pious poetry and rumbustious verse, while being caricatured himself for his long sermons:

> I pray, Mr Vicar, do try to be quicker,
> In teaching us miserable sinners.
> Our beliefs are croaking, and its truly provoking
> To be kept so long from our dinners.

Despite his oddities, Cotes efficiently pruned Bewick's overlong flourishes, at least in the Introduction. Grateful for his help, Bewick cut a bookplate for him, later used as a vignette in the *Water Birds*.

At last the descriptions and cuts were finished. But the book still had to be printed, and now that Sol Hodgson was dead and matters were so tense with Sarah, Bewick felt that he needed to find a new printer. First he turned to Matthew Brown, the publisher of *Cook's Voyages*, for which Beilby and Bewick had provided some of the copperplates in 1790. Brown accepted with pleasure, but when he died suddenly in 1803 Bewick found himself dealing with another distraught widow. Mrs Brown was not as confident as Sarah Hodgson and in her grief she found it difficult to manage. Very gently, as he wanted to help and to show his gratitude to her late husband, Bewick wrote in late April 1803, asking if she thought it was in her power 'to undertake a job of such magnitude'. He was ready to print, telling Thomas Vernon that he was 'in the midst of anxiety and bustle', preparing to go to press with the second volume, 'the paper for which is now *all at Sea – I fear at a bad time –* but however I must hope it will arrive in safety'. It was indeed a bad time: on 18 May, the day that Bewick wrote this letter, the war with France resumed.

The paper arrived and was stacked safely in the warehouse, but he could see that the job was too much for Mrs Brown and he withdrew

the book, assuring her he would repay her for any expenses, including the ink and the new types, even if they had proved wrong for the task, 'for I will not suffer you to sustain any loss on my account'. Instead he gave the job to Edward Walker. George Simpson came over from Hodgson's to teach Walker's man, George Barlow, how to temper the preparation of each cut to get Bewick's special effect of distance. The printing took almost a year, sharing the presses with the *Courant* and Walker's daily work. 'First edition of the Second Volume of Water Birds – put to Press on 13 July 1803,' Bewick later recorded in his notebook; 'Finished at press the 2nd and 5th July 1804.' The work was often interrupted, but at last the *Water Birds* was finished. The sheets were gathered and sewn and pressed and sent to the binders, and soon the first copies were sent to Bewick's many subscribers.

As they opened their books, some readers may have been surprised by the intense tone of Bewick's introduction. He was leaving behind the birds of the hedges and moors, he explained, for those of the streams, estuaries and seas, and journeying into new landscapes. 'In exploring the track which leads us, step by step, to an acquaintance with them,' he wrote, 'we must travel through reeds and rushes, with doubtful feet, over the moss-covered faithless quagmire, amidst oozing rills, and stagnant pools.' In his mind's eye he followed the birds to the lakes and swamps of the tundra, where nothing was heard except the wind's howl and their own cries, or hurtled across the seas, guided among solitary rocks by the grating cries of the great sea birds:

There a barrier is put to further enquiry, beyond which the prying eye of man must not look, and there his imagination only must take the view, to supply the place of reality. In these forlorn regions of *unknowable* dreary space, this reservoir of frost and snow, where firm fields of ice, the accumulation of centuries of winters, glazed in Alpine heights above heights, surround the pole, and concentre the multiplied rigours of extreme cold; even here, so far as

human intelligence has been able to penetrate, there appears to subsist an abundance of animals, in the air, and in the waters.

In such a universe, man could no longer be placed at the centre and it made no sense to rank animals, birds, insects, reptiles and fishes according to how useful or destructive they were to humans. Above all it was clear that every region, however hostile or benign, teemed with abundant life, in myriad forms. His response resembled that of Coleridge's Ancient Mariner – the poem was included in the *Lyrical Ballads* in 1798, just when Bewick was turning from the land to the sea – as he watched the fiery trails of the water-snakes in the shadow of the ship and 'blessed them unaware', feeling the weight of the slain albatross fall from his neck. Bewick felt a similar instinctive sympathy and astonished awe at the beauty of living things. Nature was undoubtedly cruel, with each species preying on another, he wrote at the end of his introduction, but the 'philosophic mind' could only bow in awed silence at the way the void was constantly replenished, in an endless cycle of destruction and reproduction.

Like naturalists before and since, Bewick thrilled to the mystery of migration, about which little was then known, although more evidence was being collected all the time. 'Let the imagination', he wrote, 'picture to itself countless multitudes of birds, wafted, like the clouds, around the globe', itself turning ceaselessly around the sun in a perpetual succession of day and night, summer and winter, 'and these migrators will be seen to follow its course, and to traverse both hemispheres from pole to pole.' In his vision, all the dead birds – the subjects of the drawings and the gorgeously coloured plates, the stuffed specimens on their stiff, bent wires – stretched their wings and took to the skies.

23 'WITH BEWICK, I WAS THEN HAPPY'

Bewick's books were like folk-tale tasks, needing seven-league boots. But his stride got quicker: nine years of planning and work for the *Quadrupeds*, seven for the *Land Birds*, five for the *Water Birds*. Already, in the view of many people, he had brought nature to life, and revived the 'nearly forgotten art' of woodcuts. Thomas Stothard, working away from home in 1803, asked his wife to bring him the volumes of a new edition of Addison's *Spectator*, which he had illustrated himself, 'and Bewick's History of Quadrupeds'. In the same year, the young James Akin wrote from Philadelphia to tell Bewick that his animal cuts had 'long ago ravished' his eyes and inspired him to become an engraver – and in 1804 a pirated edition of *Quadrupeds* by the pioneering American wood engraver Alexander Anderson was published in New York.

Water Birds crowned Bewick's achievement. It was superfluous, wrote the *British Critic* in 1805, 'to expatiate much on the merits of a work' that appealed to so many different audiences, 'by the aptness of its descriptions, the accuracy of its figures, the spirit of its wood engravings, and the ingenious variety of its vignettes'. For countless readers who loved the country, wrote William Howitt, opening one of Bewick's books was the beginning of a new era in their life. In the 1820s John Bowman, a Shropshire naturalist, explained that he had begun to study

birds as a boy after being given *Land Birds*. Forty years later, in 1867, Charles Kingsley told Jane Bewick that he had always been her father's 'loving & reverent pupil', as was his father before him:

When your father's book on birds first came out, my father, then a young hunting squire in the New Forest, Hampshire, saw the book in London, & bought at once the beautiful old Copy which was the text book of my boyhood. He, a sportsman & field-naturalist, loved the book, & carried it with him up & down, in days when no scientific knowledge could be got – from 1805–1820; & when he was laughed at in the New Forest for having bought a book about 'dicky-birds' – till his fellow Squires, borrowing the book of him – agreed that it was the most clever book they had ever seen, & a revelation to them – who had had these phenomena under their eyes all their lives, & never noticed them.

When Kingsley came to write *The Water Babies*, he asked his readers to imagine a river, broad and gleaming, like one that 'dear old Bewick' would have drawn.

Kingsley was not alone in this delighted boyhood response. Writing of Tennyson, his brother Arthur noted, 'I remember his excitement when he got hold of Bewick for the first time: how he paced up & down the lawn for hours studying him & how he kept rushing in to the schoolroom to show us some of the marvellous woodcuts.' This phrase 'for hours' often recurs, as if Bewick could entirely take over a child's imaginative vision. Future decorative artists like William de Morgan also seized on his work. As a child, de Morgan was fascinated by Bewick's woodcuts: 'from four or five hours a day', his mother wrote, 'the little fellow looks through the book, and can now tell the name of almost every bird'. In the 1870s Beatrix Potter copied the birds and animals into tiny home-made books, and when she and her brother found an old printing press in the attic they made their own ink from soot, 'a sticky black mess, always too thick or too thin . . . so

messy it was confiscated'. Potter, like Bewick, drew the wary red squir-
rel guarding its acorn, whiskers flaring and ears pointed, its long
bushy tail laid along its back – a balancing rudder when leaping
between trees or a sail to help it cross a lake on a piece of bark, a myth
long loved by naturalists.

THE SQUIRREL

Bewick's work was timely, since it coincided not only with the grow-
ing interest in natural history but also with a thirst for fresh images of the
countryside. The 1790s was the decade of the picturesque, of Gilpin's
Tours, Cotman's watercolours of distant vistas and rushing rivers, and
the moralised scenes of rural poverty in George Morland's prints of cot-
tagers. But a new mood, at once more precise and more mystical, was
already spreading. In 1798, Turner exhibited his scenes of Yorkshire, the
Lake District and Northumberland at the Royal Academy, and in the
same year Constable set out for art school in London: three years later
Constable would write that while the Old Masters had much to teach,
'still Nature is the fountain's head, the source from whence all original-
ity must spring'. Bewick would have agreed. Like Constable, he had the

utmost respect for the eminent artists of the past but, he wrote, 'Had I been a painter, I never would have copied the Works of "Old Masters" or others, however highly they may be esteemed – I would have gone to nature for all my patterns, for she exhibits an endless variety – not possible to be surpassed & scarcely ever to be equalled.'

Bewick's small black-and-white woodcuts, however, were never meant to hang on walls. They were designed to appear in books and belonged with the letterpress that ran alongside them – they were meant to be 'read'. It is perhaps not surprising, then, that the most fruitful comparisons are not with other artists, but with writers. In the world of fashionable literature, the greatest vogue at the time was for the 'peasant poets'. Burns had been the rage of the last decade, and the best-selling poetry of 1800 was not the *Lyrical Ballads* of Wordsworth and Coleridge, which barely reached 1,000 sales, but *The Farmer's Boy* by the Suffolk shoemaker and former labourer Robert Bloomfield, which eventually sold forty thousand copies. Bewick's devotees also liked to think of him as an innocent, directly in touch with nature. John James Audubon, who met Bewick in his last years, and must have seen the fine prints and substantial library in his house, still stressed his 'natural', untutored talent:

My opinion of this remarkable man is, that he was purely a son of nature, to whom alone he owed nearly all that characterized him as an artist and a man. Warm in his affections, of deep feeling, and possessed of a vigorous imagination, with correct and penetrating observation, he needed little extraneous aid to make him what he became, the first engraver on wood that England has produced. Look at his tail-pieces, reader, and say if you ever saw so much life represented before . . .

Considering him in this guise of peasant artist, George Atkinson was among the first to draw a comparison with Burns, remarking that 'the same strength of understanding, keenness of observation, and

simple originality of thought and expression, seemed peculiar to both', as did their humanity and tenderness, quick perception of the ridiculous and profound regard for nature. Atkinson's comparison was carefully qualified, but once made it stuck. In 1838, William Howitt described Bewick as 'the very Burns of woodcutting', and later Ruskin used almost the same phrase. Ignoring his education, his long years in a town workshop, his collecting of fine books and prints, and the dynamic complexity of provincial culture, Ruskin and his followers placed Bewick as a country clod or a 'printer's lad'. Because he was uneducated and not a gentleman, he could draw the poor but not the rich, 'a pig but not an Aphrodite'. Yet Ruskin saw Bewick's limitations as, paradoxically, his greatest strength. The reason 'that however failing in grace and scholarship, he should never fail in truth or vitality', he declared, in his respectful yet condescending tone, 'and that the precision of his unerring hand – his inevitable eye – and his rightly judging heart – should place him in the first rank of the great artists not of England only, but of all the world and of all time: – that this was possible to him, was simply because he lived a *country* life'.

In 1805, the *British Critic* had already emphasised this country background. The review noted Bewick's tailpieces, which it praised for taking 'subjects of common and familiar life, such as have not been touched by other artists, but full of characteristic truth, and frequently of original humour'. This judgement also suggests why his work appealed to Wordsworth, whose principal aim, as he explained in the Preface to the *Lyrical Ballads* in 1800, was to choose

incidents and situations from common life, and to relate or describe them, throughout, as far as was possible in a selection of language really used by men, and, at the same time, to throw over them a certain colouring of imagination, whereby ordinary things should be presented to the mind in an unusual aspect.

Wordsworth looked to rustic life in the belief that here the passions were less restrained, spoke a plainer and more emphatic language, and were linked to the forms and rhythms of nature. He paid tribute to Bewick in the jingling rhyme of 'The Two Thieves' in the year after *Land Birds* was published:

> Oh now that the genius of Bewick were mine
> And the skill which he learn'd on the banks of the Tyne
> Then the Muses might deal with me just as they chose
> For I'd take my last leave both of verse and of prose.
>
> What feats would I work with my magical hand!
> Book-learning and books should be banish'd the land
> And for hunger and thirst and such troublesome calls
> Every ale-house should then have a feast on its walls.

In an extra verse in the manuscript version Wordsworth suggested that Bewick, too, was using the common language, contrasting his cheap woodcuts to the high art of Sir Joshua Reynolds's Royal Academy. But he was also making a sharper point, suggesting that Bewick's naturalist's eye for detail produced a finer, more valuable art than the quest for a generalised, ideal beauty advocated by Reynolds and his followers.

> Oh! Now that the boxwood and graver were mine
> Of the Poet who lives on the banks of the Tyne
> Who has plied his rude tools with more fortunate toil
> Than Reynolds e'er brought to his canvas and oil

Wordsworth and Bewick grew up in similar northern landscapes and cultures and depicted similar subjects: pedlars and shepherds, idiot boys and beggars. Wordsworth's Cumberland beggar, a 'solitary man', sharing his bread with the birds, could almost be a text for a Bewick cut:

I saw an aged Beggar in my walk;
And he was seated, by the highway side,
On a low structure of rude masonry
Built at the foot of a huge hill, that they
Who lead their horses down the steep rough road
May thence remount at ease . . .

The two men never met, and Bewick never mentioned Wordsworth's poetry – his favourites were Shakespeare, Milton, Thomson and Burns. But the affinity between poet and engraver went deeper than subject matter. In the workshop amid the noisy markets and alleys of Newcastle, Bewick turned in memory to the streams, fells and woods in much the same way that Wordsworth recollected the mountains of his boyhood in *Tintern Abbey*:

. . . 'mid the din
Of towns and cities, I have owed to them
In hours of weariness, sensations sweet,
Felt in the blood, and felt along the heart.

Bewick's closeness to the young Wordsworth of this poem, written in July 1798, reflects a shared way of thinking about nature. Bewick's response to 'the brilliantly studded canopy of Suns & Worlds . . . the

equally wonderfull Globe, of this earth & Sea', and the ecstatic sense of being close to God that he experienced on his walks to Cherryburn, have much in common with Wordsworth's intense physical sense of an all-enveloping presence:

> . . . a sense sublime
> Of something far more deeply interfused,
> Whose dwelling is the light of setting suns,
> And the round ocean and the living air,
> And the blue sky, and in the mind of man;
> A motion and a spirit, that impels
> All thinking things, all objects of all thought,
> And rolls through all things.

In his memoirs, Bewick spoke as a man of the enlightenment, determined to illuminate the dark corners of superstition through the findings of scientists, geologists, fossil hunters. Yet his language belonged to the Romantic age. How, he asks, could one accept the Mosaic story of 'the time that God took to make this World, with the whirling floating Universe of which it is comparatively a small part, a speck – a mote'?

No, no, this sublime, this amazing, this mighty work of Suns & Worlds innumerable is too much for the vision, of a finite purblind proud *little* atom of the creation, strutting about in the shape of Man . . . the powers of the mind would soon become bewildered & lost, in attempting even to form any conception by figures of what is meant by *unnumberable* Millions of centuries – here on this subject we must rest !

The introduction to *Water Birds* had displayed a rhapsodic response to a unifying force 'beyond the reach of thought and human knowledge'. Acclaimed as an observant and accurate naturalist, an artist of skill, originality and humour, Bewick also found that the more facts he learned, the more he was intrigued by the numinous, the flickering promise beyond the horizon.

Despite the mystical undertones, Bewick's approach to his material of 'humble life' – as opposed to his engravings of nature – was stubbornly down to earth. He showed his country folk as cruel, foolish and crude as well as hard-working and long-suffering. He shared the scatological humour of the day, which so often explodes, literally, in the sketches of Rowlandson and Gillray. The country might be beautiful but it also stank: in his vignettes men relieve themselves in hedges and ruins, a woman holds her nose as she walks between the cowpats, and a farmyard privy shows that men are as filthy as the pigs they despise. In the respectable atmosphere that settled like a cloud during the Napoleonic Wars, such scenes disconcerted his readers: an article appeared suggesting 'that the fair sex, pass *over-leef* on seeing them'. With much grumbling, he bowed to pressure and reworked 'The Pigstye Netty', covering the man's bare backside with a plank: but his vignettes still unsettled later Victorian readers. Even his admirer Ruskin lamented that he shared 'the fixed love of *ugliness* which is in the English soul', also to be found in Hogarth and Cruikshank, making their work 'totally unfit for the sight of women and children'.

Bewick had not meant to offend, but to amuse, and to be truthful. In this he was like John Clare, who also upset friendly readers with his affectionate description of Mary, embracing a baby to please its mother: 'when the baby's all be[shit] / . . . kisses it / and vows no rose on earth's so sweet'. Clare was a generation younger than Bewick, born on the edges of the Fens rather than the northern moors, but they are often understandably bracketed together. Clare's poems and Bewick's woodcuts both contain loving, intensely observed depictions of birds and animals, of the passing seasons and the farming year, the flickering of light through hedgerows, the wheeling of crows over a bare field. In the 1820s Clare planned to write a 'History of Birds'. His natural history notes and poems show the keen eye, direct approach and profound sympathy that also characterise Bewick, as in the sonnet 'Hares at play', which opens at dusk when the 'sheep lie panting on each old mole-hill', and

> The timid hares throw daylight fears away
> On the lane's road to dust and dance and play,
> Then dabble in the grain by naught deterred
> To lick the dew fall from the barley's beard;
> Then out they sturt again and round the hill
> Like happy thoughts dance, squat and loiter still,
> Till milking maidens in the early morn
> Jingle their yokes and sturt them in the corn;
> Through well-known beaten paths each nibbling hare
> Sturts quick as fear, and seeks its hidden lair.

Both Clare and Bewick felt their thoughts dance and loiter as they walked the country paths they knew, and looked back on their country childhood as a lost Eden. Both acknowledged Thomson's *Seasons* as their inspiration, but set the artifice of Thomson's pastoral against their lived experience and found it wanting. Both collected local sto-

315

ries and ballads and spoke out against oppression of the poor by harsh landlords, devious officials and above all, by the soul-diminishing acts of enclosure:

> Like mighty giants of their limbs bereft,
> The skybound wastes in mangled garbs are left,
> Fence meeting fence in owner's little bounds
> Of field and meadow, large as garden-grounds,
> In little parcels little minds to please
> With men and flocks imprisoned, ill at ease.

A passionate empathy with nature and sensitivity to the pain of living creatures often coincided at this period with oppositional politics – with sympathy for the poor, for the outcast and downtrodden. William Blake, who could rarely be thought 'typical' of anything, encapsulates the combination of wonder and rage in 'Auguries of Innocence'. The well-known opening – 'To see a World in a Grain of Sand / And a Heaven in a Wild Flower / Hold Infinity in the palm of your hand / And Eternity in an hour' – appears startlingly fresh when set beside Bewick's woodcuts and writings. And the thorny necklace of opposites is very similar to the contrasts in Bewick's work:

> A Robin Red breast in a Cage
> Puts all Heaven in a Rage . . .
> A dog starv'd at his Master's Gate
> Predicts the ruin of the State.
> A Horse misus'd upon the Road
> Calls to Heaven for Human blood.
> Each outcry of the hunted Hare
> A fibre from the Brain does tear.
> A Skylark wounded in the wing,
> A Cherubim does cease to sing.
> The Game Cock clipp'd and arm'd for fight

Does the Rising Sun affright . . .
The Beggar's Rags, fluttering in Air,
Does to Rags the Heavens tear.
The Soldier arm'd with Sword & Gun,
Palsied strikes the Summer's Sun.
The poor Man's Farthing is worth more
Than all the Gold on Afric's Shore.

*

Bewick never went mad, like Clare, or soared to the visionary heights of Blake. There was, however, terror and loneliness as well as humour in his art, and this too had a powerful appeal.

After Charlotte Brontë was brought home from school at Cowan Bridge, where her two older sisters had died, she and her sisters were taught at Haworth by their father, Patrick: they had copies of Dyche's *Spelling Book*, and Aesop's *Fables*, both of which Bewick illustrated. As a girl, Charlotte longed to become an artist, and – perhaps because she was so shortsighted – according to a friend would examine engravings minutely 'with her eyes close to the paper, looking so long that we used to ask her what she saw in it'. In the *History of British Birds*, which arrived in the parsonage when she was twelve, she saw a great deal.

317

The Brontë children passed the volumes around, dating the engravings they liked or copied, waiting for their turn. Emily – who kept two pet geese – copied the whinchat and ring ouzel, and a vignette of an old woman beating off geese. Charlotte, who fed wild birds in winter, drew the tree sparrow that visits humans in hard times, the cormorant on a rocky shore – Bewick's Miltonic bird of death – and the lonely man fishing in the rain. Brought up, as Bewick had been, on ghost stories told by country people and servants, Charlotte also responded to his eerie scenes of night and demons, and after he died she wrote a poem in his honour, imagining his traveller on the dreary moor and his chill picture of the surf crashing at sea:

> There rises some lone rock all wet with surge
> And dashing billows glimmering in the light
> Of a wan moon, whose silent rays emerge
> From clouds that veil their lustre, cold and bright.

Years later, she gave this vision to her heroine in *Jane Eyre*, published in 1847. When we first meet Jane, she is a small girl taking refuge in the window seat at Gateshead Hall, clutching a copy of Bewick's *Birds*. With the curtains screening her from the bully who torments her, and the windows behind her shut against the rain, she can escape, at least in her mind: 'With Bewick on my knee, I was then happy.' Ignoring the text, Jane goes straight to the pictures, to the arctic seas that are Bewick's 'unknowable places', to the broken boat on the shore and the phantoms of the night:

I cannot tell what sentiment haunted the quite solitary churchyard, with its inscribed headstone; its gate, its two trees, its low horizon, girdled by a broken wall, and its newly risen crescent, attesting the hour of even-tide.

The two ships becalmed on a torpid sea, I believed to be marine phantoms.

The fiend pinning down the thief's pack behind him, I passed over quickly: it was an object of terror.

318

So was the black, horned thing seated aloof on a rock, surveying a distant crowd surrounding a gallows.

Each picture told a story; mysterious often to my yet undeveloped understanding and imperfect feelings, yet ever profoundly interesting: as interesting as the tales Bessie sometimes narrated on winter evenings.

The icy seas, devils and gravestones were, as Brontë said, the stuff of folk tales, but they also suggest some of Bewick's own demons. As well as suffering from sudden flarings of anger, at times he fell into dark moods that made him feel set apart, like an exile far from home. Three times, as with blows of an axe, he felt cut from his moorings: when he left home to become an apprentice, when he sailed for London and when his parents died. Like Brontë, he was also at times surrounded by death. After his parents died, and he stopped his walks to Cherryburn, he often visited churchyards on Sunday afternoons, brooding over the graves of those he loved. He forced himself to stop, since, he said, the generations of the dead, 'appeared to me so immense, that to estimate them, seemed impossible & like attempting to count the grains of sand on the sea beach, which had been tossed to & fro & then left by the Waves'.

In his later years he continued to brood on mortality. In 1816 Christopher Gregson died, and was buried at Ovingham in the same grave as his father, Revd Gregson – it was a common practice to open up family plots for new burials. 'To have the scull of my old preceptor pointed out to me', he told Robert Pollard, 'raked up such a croud of reflections, as greatly overfilled my mind – but indeed the Scull of my own Father, only a few months before, was turned out of his grave & gave rise in my mind to a similar glut of reflections – in the latter case I had some hours to spare to examine it & to turn it over & over & talk to it, all alone, I knew it so well that I cou'd pick it out from among 10,000.' There is no reason to doubt this dryly recorded conversation with the skull, with its echoes of Hamlet and Yorick.

In a similar mood, on holidays in Tynemouth in his seventies, Bewick would work on his woodcuts until dusk, and then walk through the burial ground and past the ruined priory on its rocky promontory, finding that 'the roaring of the dashing surge below – this on one side & the frail memorials of the silent dead on the other – disposed the mind to contemp[l]ation & solemn meditation'. But he was always brought sharply back to earth: 'after this I was sure to meet with what I *call a scold at home* "now Thomas what can you mean by walking among grave stones in the dark night alone", "I'm sure it is an odd fancy" &c'. Each time he fell into depression – 'gloomy days' he called it – Bewick pulled himself back. He drew strength from Bell's scolding, from his family and friends, and from his art and the natural world.

24 BACK TO BUSINESS

On 26 May 1804, when Robert was sixteen – two years older than the normal age – his indentures were signed and he became his father's apprentice. Robert remained a worry. He was excruciatingly shy, to the point where, today, he might be seen as suffering a mild form of autism. He could function well only within the circle of his family and close friends, where he was open and sweet-natured, enjoying treats, shows and outings. In the workshop he could cope when tasks were explained in detail, or when he focused on minutely detailed drawings, and slowly he became a precise and careful draughtsman.

Over the next ten years, the workshop began to feel like a family concern: Agnes's son, John Harrison, already worked there, and soon William's son John joined. But Bewick made no difference between the boys, whatever their background: when one better-off apprentice refused to take the workshop pitcher to the pant (the well at the head of Side known as the 'Two Sisters' from its double spout), considering this a menial task, Bewick grabbed the jug and fetched it himself, surrounded by an amused crowd. 'Bewick carrying the jug' became a local joke.

Other new apprentices were Isaac Nicholson, George Armstrong and Henry White. However hard they worked, they were lucky in that they were exempt from being called up to fight. In 1804 Britain was

facing new threats of invasion, and in January John Harrison was enrolled in the Newcastle Loyal Armed Association, a kind of home guard: the workshop paid for a uniform of blue jacket and white breeches. This may have been a move to save John from the press gang, against which local feeling ran high: in South Shields, pilots and women attacked the gang's Regulating Officer with brickbats and stones, threatening to murder him with their spades if he came back. Many Tyneside employers had to plead for the release of employees, and six years later Bewick wrote himself when his sister Ann's son, Thomas Dobson, was impressed. He feared more and more for his lads.

In the workshop, there was plenty for them to do. In the stress of getting the *Water Birds* to press Bewick had let many commissions slip, including thirty cuts for Sarah Hodgson for *The Hive of Ancient and Modern Literature*. Bewick's rows with Sarah, a doughty opponent, show how deeply embedded his life was in the intimate Newcastle community. Sarah was impatient at being fobbed off with apprentice cuts, and it was not long before the old dispute over the *Quadrupeds* reared its head again. An article in the *Annual Review* for 1804 credited Bewick with the idea for the book and mentioned the ending of the partnership with Beilby and hinted that because of a disagreement with 'the other partner' the book was out of print and unlikely to be republished. Sarah at once wrote a letter to the *Monthly Magazine*, denying Bewick this role and claiming that he was hired 'merely as the engraver or woodcutter', and that she was now the owner and had tried to get the book reprinted. Furious, Bewick responded with a detailed account of the book's gestation and birth.

In May 1805, when he realised that *Quadrupeds* did indeed need reprinting, he offered to sell Sarah his share, fearing they could not easily work together (although, as he told William Bulmer, it was hard

Title page cut for *The Hive*, 1799

'to part with this Bantling of my own rearing'). Sarah declined, and when she did not respond to his proposals about printing he abruptly promised the job to Edward Walker. It was a typical Bewick muddle, a hot-headed gesture of wrath, later regretted. The following February, when Walker was about to go to press, Bewick was so nervous that he scribbled five drafts of an appeasing letter. But by now, despite her declaration that she would never sell, Sarah was talking to Longmans in London: by the time of the following edition in 1811, Longmans were Bewick's new partners.

Their mutual friend Robert Pollard heard both sides of the story and tried to mediate, but always in vain. At one point, in her fury, Sarah asked her manager, William Preston, to get her books back from Bewick: 'desire him likewise to send me the Key of my Pew which his Family have sat in for several years – because tho' I dont go to Church myself I can at least have the pleasure of obliging a Friend with it'. The

dispute was very public, and the rows were the more painful because they were so personal. Bewick had been fond of Sol, for whom he designed a touching memorial. When he realised that he had charged Sarah for this in error, he quickly returned the money. He had never meant her to pay:

in charging you with the scabey expence of it I have done wrong – I have forgot myself – I have done an injury to my own feelings, and I cannot now in passing by – the silent Grave, speak to his remains as was always usual with me before – I have only now to beg that you will accept the return of the inclosed, & then commit this paper to the flames.

Sarah did neither. After he had made the charge, she said, no apology would wipe it out.

Bewick often found himself in muddles of his own making, acting hastily or making bad judgements. He was like the farmer in his vignette, who decides to walk his cow across the river rather than paying the toll for the bridge, loses his hat (worth more than the toll fee) and finds himself in deep water while his cow swims placidly on. Far from being alienated, Bewick's exasperated friends remained

fond of him, merely folding their arms and waiting for him to cool down.

Requests still poured in from individuals, each with their own demands, like a bookplate for Robert Southey's brother in Keswick, 'The shield to be grouped with such things as Mr Bewick may think will suit a studious man – living in the country & not attached to any field sports'. Much time was taken up by the shipowner Sir Cuthbert Sharp who was writing a *History of Hartlepool*. The artist Thomas Busby etched the copperplates while the workshop added the lettering and Robert engraved a precisely drawn map and a few unexciting woodcuts. Everyone was intrigued by Sharp. His knighthood is a puzzle, but one suggestion is that he received it for his work in the secret service. If so, he would have been a curious spy. He was conspicuously tall, frizzy-haired and absent-minded: he forgot his money, his blocks of boxwood, and his new 'mud boots', and lost his portmanteau containing all his new book plates. Luckily Bewick had kept the original plate, 'a good thing', beamed Sir Cuthbert, 'as I never heard anything more abt. my portmanteau'.

Despite his frequent rejections, booksellers were now even keener to have Bewick's name on their title page. Over the next few years the workshop despatched woodcuts to every corner of Britain, from fine editions of poetry to 'Fenning's Spelling'. The flow of orders would continue until Bewick's death, and it has been estimated that around 750 books published between 1770 and 1830 are illustrated with cuts from the workshop and its pupils, ranging from children's books and poetry to religious tracts and large commissions, like Thornton's *New Family Herbal*, with over a hundred cuts.

Bewick's popularity had boosted the demand for wood engravings, but the rush had an adverse effect, since publishers now hired artists to make drawings that engravers then simply reproduced, becoming

mechanical copiers rather than original artists. Increasingly, in the first two decades of the new century, Bewick was asked to work on books with outside artists, and he agreed, although not with any great enthusiasm. He collaborated, for example, on several different projects with John Thurston, a Yorkshire-born artist who had spent much of his childhood in Newcastle. The joint work was complex and slow, with woodblocks being sent by sea up and down to London, or more hastily by coach when a bookseller panicked.

One of many such commissions was for John Poole of Taunton, who wanted illustrations to his new *Pilgrim's Progress*. Thurston asked Bewick to send down some good blocks, for him to draw on and return, and: 'When you have executed 2 or 3 of ye cuts, be so good as to send me proofs of them pr post – that I may touch upon them.' He then returned the proofs via Poole, marking them with black ink to show the printer where pressure would be needed and 'white touches' to show Bewick where lines should be lightened. Poole waited anxiously and also fiddled with designs himself, like that of Christiana passing the ruin:

The upper part of the Group of Angels is rather naked, and that of the Trumpeter not well designed – but I hope you will improve it a little – Some little objection has been made to the Testicles of Apollyon being so much in view, but this cannot now be altered – it is certainly descriptive of the creature – Pardon my remarks.

As far as the actual woodcutting was concerned, during his later years, Bewick concentrated on his own books and passed most of the workshop commissions to his apprentices. But he found that being a manager could be tricky, involving correspondence with so many different clients and – not least – chasing them to pay the money that they owed. Sometimes, particularly with private clients, it took years to

recover the debt. In London, Robert Pollard tackled slow-paying booksellers and occasionally managed to obtain substantial sums: 'but not without much trouble & 2 or 3 Attorney's letters – I took it in 10s. – in 4s. & 6s. – or as I could get it his case is like many other Honest Mens put about by cramps losses & bad pay'. To help his hard-up friend, Bewick let him keep the money until times looked better. 'It more than obliged me it really *served me essentially*,' Pollard wrote gratefully. He also sent Bewick boxwood, ornament books and other supplies and tried – unsuccessfully since Bewick could not offer a big enough discount – to get London bookshops to buy the *Quadrupeds* and *Birds* directly rather than through big booksellers like Longmans.

As the years went by, the two friends confided in each other about the strains and worries of middle age. When Bewick responded slowly to a letter, for example, Pollard excused him:

As you observe you are 'not quite so alert as you used to be' which by the by I can fully credit from a fellow feeling in these matters myself & I daresay either of us would make but a sorry figure in a Walk from Ncastle to Eltring-ham now & a very different from what we did 34 years ago when you Mr Gray & myself went there a nutting &c.

They also shared news of their families. Pollard described his daughters giggling round the table as he wrote, and described his increasing reliance on his son James, who would later become a well-known painter of sporting scenes. In return Bewick wrote of Robert helping in the workshop, and of Jane and Isabella and Bessy, who was now at school at Southwick near Sunderland. Bessy was a quiet soul, like Robert. Bewick took anxious care of her, writing tactfully one January to her teacher about the infected chilblains that had tormented her at school, which led to a dull Christmas with her leg laid up on a pillow. Would Miss Watson look at these, he asked 'for we all know her silent

disposition & also her aversion to complain – and we believe it may be owing to this her peculiar temper that you might not know anything was the matter with her when she left'.

In 1807, when Jane and Isabella were at Tynemouth, they missed a ball at Bessy's school, much to their annoyance. That year, Bewick stayed at the Forth, sending down the newspapers to Jane and hastening 'to drop these few lines to supply the place of a bit chat by the fire side' including the news the 'Aunty is seized with a fit of carefillity & is brewing treacle Beer'. In return Jane sent seaside gossip, asking him to tell Esther that Robert 'has been a most excellent *protector* which will no doubt give her great satisfaction'. They were up at six to go bathing before breakfast, except for Isabella: 'We cannot prevail with her to go above her ancle though she daily sees what a good effect it has on us aquatics, particularly Robert who enjoys it as much as any of us as I am afraid he drinks too much salt water.'

Bewick quite liked being on his own. He set off on a jaunt with the wealthy builder Thomas Maddison to his country estate at Birtley, where the orchards and hothouses produced apples, pears, peaches, apricots, nectarines and a much-prized pineapple. Maddison, now in his late sixties, was a hospitable man, another good friend who sent many specimens for the later editions of *Birds*. Bewick printed bookplates for him, making no charge, while Maddison gave him an engraved silver box in which to keep his tobacco. In winter, he 'spent many a social evening' at Maddison's town house in Dean Street, and in summer he and Robert passed pleasant lazy days on his country estate. Bewick enjoyed these days out with Robert and made plans for the years to come. He looked forward, in particular, to seeing 'Bewick and Son' over the workshop door.

25 SHIFTING GROUND

The regular routine of these years was shortly to be broken – there was a creaking and a shuddering as if underlying strata in their lives were moving. In August 1808 Bewick and his Eltringham neighbours, John Laws of Prudhoe and Johnny Johnson from the boathouse, were summoned across country, all expenses paid, as witnesses in a complicated case at Lancaster Assizes. They travelled the last thirty miles on a canal barge, a novel experience that Bewick thought 'the pleasantest mode of travelling I ever knew'. Their case was delayed because the court calendar was packed by trials of people caught up in riots following peace petitions from workers in the cotton industry in Manchester, Bolton, Burnley and Rochdale. The whole country was suffering from the war. The collier ships from Shields were almost destitute of men, as a result of impressments and raids: one of Bewick's charitable donations was for local men held prisoner in France. Over the next two years, banks failed and poor harvests brought widespread hunger, and a new wave of petitions heralded the Luddite outbreaks of the next decade.

Bewick thundered at the corruption of the government and signed petitions with the rest, but tried to concentrate on the workshop, his books and his family. In 1808 Pollard urged him to let Robert come down to London, particularly if he wished to concentrate on copper

engraving. Both he and John Scott would be happy to help him and even take him on as an apprentice for a year or two. With his deep dislike of London and strong love of his only son, Bewick was reluctant, but in July 1809 he did send Robert and Jane to the capital, convincing himself that the sea voyage – on a modern steam packet – would be good for Robert's health. After they left he confessed to Jane that he walked backward and forward in the garden all day listening to the howling wind and fearing for them 'amidst the rolling Waves of a disturbed sea': 'I wish you to be careful not to over fatigue yourself & Robert, in your excursion to see the fine sights of London & I charge you anxiously, if possible, get soon to bed.'

In town, the two young Bewicks saw all his old friends, but after only a week or so they came home. Tactfully, Pollard suggested to Bewick that a repeat of the visit, and a longer stay next time, might be good for Robert:

An excursion from home – now & then is beneficial to young People it opens their minds renders them familiar & easy in Company & comfortable to themselves . . . & as an Artist he should possess a good share of address & what the world call some thing of the Gentleman. He seems a nice young fellow & deserving of every encouragement.

This would have been a good idea, and a shrewd investment, but Bewick knew that Robert would never survive on his own, without his family.

Yet the visit was a step towards the day when his son might, Bewick hoped, take over the business: Robert was called up to serve in the militia in 1810 and ended his apprenticeship in May, a year earlier than the normal term. Bewick had already confessed to one friend that if he were richer he would think of retiring: 'I may then, indeed, in the down hill of life, have it in my power to attain to the summit of my

wishes, in retiring to a cottage, by a burn side, surrounded with woods and wilds, such as I was dragged from when young to exhibit myself upon the stage of the busy world.' He even drew a sketch map of the area around Guest-burn, where a house stood by a ford on a bend of the wooded Stocksfield Burn, near the land that his grandparents had farmed. Nothing came of this, but a wistful passage in his memoir suggests his dream. The artist, he muses,

ought if possible to have his dwelling in the country where he could follow his business undisturbed, surrounded by pleasing rural scenery & the fresh air and as 'all work & no play, makes Jack a dull Boy,' he ought not to sit at it, too long at a time, but to unbend his mind with some variety of employment – for which purpose, it is desireable, that Artists, with their *little Cots*, should also have each a Garden attached in which they might find both exercise & amusement – and only occasionally visit the City or the smokey Town & that chiefly for the purpose of meetings with their Brother Artists.

Bewick did not have his cottage, but he was still the head of the Eltringham family, to whom they turned in times of trouble; he wrote letters to William's landlord, for example, asking for a long lease to enable him to sink a new pit. Dealing with such problems, Bewick remembered his father working at the pit long ago, the ballad singing in the evening, the gossip at the pit lodge and the miners who turned up at his door in Newcastle after drinking all their wages. It seemed a long time ago.

The year 1809 was also marked by the death of Revd Christopher Gregson, his old teacher. As soon as the news came that he was ill, Bewick rushed to Ovingham and into Gregson's room, where his niece, Dinah Bell, was caring for him. 'Knowing Dinah well,' he said, 'I used no ceremony, but pulled the curtain aside & then beheld my friend in his last moments – he gave me his last look but could not speak – multitudinous reflections of things that were passed away hur-

ried on my mind, & these overpowered me – I knew not what to say – except – farewell for ever – farewell!' Letters were sent to Gregson's sons Christopher and Philip in London: Bewick later realised that he must have sent these notes himself but was so distracted that he could not even remember writing them. 'Few men have passed away their time on Tyne side', he wrote, 'so much respected as Mr Gregson.'

At the same time as this break with the past, which 'enwarped & dwelt on' his mind, Bewick was anxious about the present. The previous year his landlady, Sarah Laidler, had died. Bewick was one of her executors, an onerous task since she had inherited property from her husband as well as the profitable Barras Mills. He collected the rents and began corresponding with John Bowman, a Cumberland boy distantly related to Bewick's mother, who had been brought up by the Laidlers. Jane and Robert made the Bowmans' Hackney home their base in London, but over the next few years Bowman experienced setbacks and depression: in 1815 he left his wife and four children in Brighton, returned home and put a pistol in his mouth. Bewick administered his Newcastle properties for his widow, rewarded by silk gowns for Jane and fulsome tributes to himself: 'Words are inadequate to convey the feelings of the Widow & fatherless for those who espouse their cause.' In return Mrs Bowman's brother, James Soppitt, collected money owed to Bewick in the capital.

The Bowmans were not the only ones concerned for their interests in 1808. Mrs Laidler had been only a tenant for life: behind her stood a freeholder, Mrs Oliver, who had died a few years before and whose heirs now wanted to reclaim their property in the increasingly desirable residential area of the Forth. Bewick loved his house and garden, with its fruit bushes and laden pear trees and roses – in a postscript to Jane he wrote, 'We are all well at the Forth & the Garden beautifull &

full with Blow Roses blow.' He could not bear the thought of leaving. Digging in his heels, he stayed on, paying a far higher rent. His neighbours, rejecting the advice of the solicitor Thomas Carr, joined him in fighting the threatened evictions but the owners did not budge and the only result was a heavy bill for costs. In July 1811 the cottage that had been Bewick's home for thirty years was sold. At the last minute he offered to buy, but his bid was topped by a grocer, Mr Featherstone, while the garden went as a separate lot. Bewick had to move.

For his new home, he chose the site that he had gazed at for years from the Forth, the western edge of Gateshead across the Tyne. New houses were being built here for the professional classes but the little town was still Newcastle's poor neighbour, with its bottle factories by the riverbank and the lonely fell behind. For years this fell had been common land, covered with gorse and briars and cluttered with turf-roofed cottages, where the tinkers and gypsy 'muggers', who sold pots, pans and candlesticks, kept their donkeys, and where parish foster-nurses allegedly reared all the illegitimate children of Newcastle. In 1809 an Enclosure Act ended this vagabond culture but Gateshead still had a distinctive character, the wildness of the fell offset by nursery gardens and estates.

Tipped off by his friend John Hancock (a saddler on the Close and the father of the future naturalists John and Albany), Bewick opened negotiations for a house in Mirk Lane – sometimes called Mirk Place – that was still being built. A solid three-storey affair, its windows looked west towards Cherryburn and the sunset, across the fields to the Windmill Hills and the trees of Axwell Park. Carr advised him to wait until he had a proper Article of Purchase, but in his anxiety Bewick again ignored his solicitor's wisdom. In spring 1812 he took possession and began building an extra back kitchen. His haste cost him dearly when the vendor, Joseph Dixon, died suddenly; the heir

was a boy of seven and an order from the Court of Chancery was needed. The lawyers found many complications, and it was two years before the sale was completed.

The house in Mirk Lane, later West Street, drawn by Joan Holding

In April, in the middle of buying the house, Bewick fell seriously ill. The doctors thought that it was typhoid, although Jane described it as severe pleurisy that led to a terrible abscess, discharging a mass of fluid from his lungs. His bulky frame, he said, 'pined to a Skeleton, without any hopes of recovery being entertained either by myself, or any one else – I became, as it were, all mind and memory.' Reviewing his life and contemplating his death, he decided that he should be buried at Ovingham 'and when this was settled, I became quite resigned to the will of omnipotence and felt happy'. He was indeed lucky to live, but his constitution was strong and his will power fierce, and over the summer he gradually pulled through. That January, he had taken

Robert into the partnership and from mid April he ran the workshop, helped by Isaac Nicholson, who had stayed on after his apprenticeship ended.

Bewick was away from the workshop for months, and his slow recovery was made worse by severe pains, loosely labelled as gout, which attacked his knees and his feet, and worst of all his hands, so that he was unable to draw or work on the woodblocks. According to his daughters, when he moved into the Forth in 1781 his mother had said he would not stay there long, and Bewick retorted that he would stay until he was carried out. In August 1812, weak and frail, he was indeed carried from his house. First he was taken to convalesce at Carr's Hill, on the outskirts of Gateshead, with the family of his friend Matthew Atkinson, and then took a holiday at Tynemouth. In November the family finally moved all their possessions over to the new house, and surrendered the key to the cottage at the Forth.

26 FAME, FABLES AND APPRENTICES

In November 1812, when he finally moved house, Bewick still felt crippled and unable to attend to business 'otherwise than scrawling a few Letters to friends & customers'. He was also worried about money. As soon as he began to recover, he told David Sivright, the first thing that pressed on his spirits was the injustice he had done to his family by lending large sums to friends. The winter was long and grim. To recover fully Bewick needed to get out of Newcastle, into the country. Yet even as he lay ill, the countryside he knew was changing: this year an Act was passed to enclose a large part of Mickley Fell.

But the countryside did heal him. The following spring he went to stay at Chillingham, where he was treated 'like a *petted Bairn*' by his old friend John Bailey and his son and daughter. From the turrets of the castle, Bewick circled round to drink in the view. Looking north, he saw farms and villages backed by distant blue mountains; to the west the long line of the Cheviots stood out against the sky; to the east lay the castle woods and to the south stretched the park with its deer and hares and wild cattle. In the foreground was a deep dean overhung with trees, where Bewick listened to the cooing of wood pigeons, 'the Songs of thrushes & Blackbirds & the cawings of Rooks chattering of Magpies, the crowing and cackling of pheasants, and the various notes of numberless small Birds and all the

336

concert crowned by the continual Murmur of Waterfals from below'.

There were visits from local friends and a 'frothy Duchess' (Bewick was tickled to think what Bell would make of her and how Robert would be at a loss 'what to say to her clack'), and a dinner with '50 or more Gentlemen at Mr Thompson's Tup Show'. At the Chillingham Feast, as at the fairs at Ovingham, there were gingerbread stalls, jumping competitions, foot races and a night of dancing, with neat, bonny girls in their best and many young men wearing tartan. Bewick joined a trip to Berwick along the coast, past Bamburgh Castle and Lindisfarne, the site of his adventure with Walter Cannaway nearly thirty years before. He rode across the moors and went fishing with a 'little footman' who delighted him with his knowledge of local game and his Border accent. His spirits rose. 'I am not now afraid of a little Wet if I were to happen to get it while I am fishing, but you conjecture right when you fear Dinner parties,' he told Jane, since dinners set him back, while 'with fishing I am always well & hungry & return from it Sun burnt or Weather beaten indeed & much disposed to go soon to Bed'.

But still, he missed his family and his sheepdog, Cheviot, and looked forward to returning to Mirk Place, an unpromising name (although probably derived from St Mark) soon changed to West Street:

Notwithstanding the absence of some of our Canny Neighbours, Mirk Place would not be Mirk to me & I shou'd think myself very happy to be at it again, I could with great pleasure pop into the Kitchen to see Aunty spin – Nanny skewing about – call in Cheviot, see the Hens & then the Garden to see the mighty Works performed there by Mother & Jane . . . I would like to see Mr Bell, at my House, from Mill Green – I think we would have a good dish of Gossip.

337

From now on his letters were full of business, tenants, taxes, orders – he was ready to get back to work.

For the next two summers Chillingham was Bewick's great escape. He waited impatiently to set out in the coach with John Bailey across country alight with gorse, heading for the hills. In 1814 they stopped at Morpeth on the way, where the shepherds who had come for the market next day were penning their sheep until midnight and the militia began drilling at six in the morning before marching to Alnwick to be formally disbanded. At last, peace had come. In April Wellington's triumph at Vitoria had ended the Peninsular War, and on 30 May the Treaty of Paris was signed: Bewick entreated Jane to make sure they contributed generously to the Gateshead illuminations, but she was more prudent than he and made excuses. Across the river in Newcastle every house was lit, the favourite display being a transparency of John Bull swigging stout, with Bonaparte on a gibbet in the background. On a column at the side, notices of taxes were crossed out and replaced by a list of beer, beef, flour and sugar under the heading 'Good Old Times Revived'.

The peace did not last. After Napoleon's escape from Elba, the armies were forced to drill again and many more lives were lost before the final victory at Waterloo. But in Chillingham battles felt far away. To Bewick, it seemed that time stood still, as if he had gone to sleep and woken to find that a year had passed and all was still the same. He could wander about the wood from six in the morning until six at night and never think the time long, and when he sat on a stone and looked at the view he imagined that someone might sit there, thinking the same thoughts, a thousand years hence. Early one morning, he walked alone through the woods and found a young fawn, hidden by its dam in the deep grass, coiled up under a hawthorn. It eyed him timidly '& I dare say was very glad when I left it alone'.

When he was away Jane kept him informed of life at work and at home:

Robert is at his usual study, perspective, in the Kitchen & my Mother fast asleep resting her elbow, on the Book which helped her to the land of Nod, Nanny in full blow is gone to a Christening; Bell & Bessy are above stairs railing at the bad weather. Old Aunty I'll venture to assert is shaking her foot & winking in the Arm Chair in the Kitchen. A rainy Sunday is surely one of the miseries of life.

Bewick could bear rainy Sundays, but not the image of Robert 'stupefying' his mind over the rules of perspective. He thought such theory was irrelevant and damaging: Robert should simply draw, all the time. This was how he had learned: 'he ought never to have the pencil out of his hand & ought to be almost continually sketching or making finished drawings,' he fumed, since only constant practice would 'enable him to glide pleasantly with his business thro' life & to make engraving the greatest pleasure to him'.

But he could not make his son in his own image. Robert was now a large, gentle man who found pleasure in careful studies of buildings and spent his allowance not on pencils but on books of music, new chanters and ribbons for his pipes, and on trips to the theatre and the races. He went to William Turner's lectures, escorted his sisters and friends to Mr Kinloch's ball and to fireworks in the Spital, and his biggest expense was his tailor, especially scarlet silk for making a cravat. It was a different form of pleasure from spying a fawn beneath a hawthorn at dawn.

At Chillingham Bewick became very fond of John Bailey's good-natured daughter Mary, who acted as his hostess there until her marriage. In December 1814 he wrote her a lively and intimate letter, dashing aside her teasing compliments about his honours and fame but accepting her

scolding about his health, since he had caught cold sitting up late work-ing on bottle moulds and other 'coarse jobs'. If his new vigour kept up, he said, he would '*go a fishing* also'. His spirits were high, life seemed good again and he was looking forward to Christmas:

my Lasses have promised me that they will get soon up at Christmas Day in the Morning & sing their Mother & me a Christmas Carol – & 'God rest you merry Gentlemen let nothing you dismay' &c is now in rehearsal & I expect we shall hear it in the good old way, before we get out of Bed.

Despite this modest scene, Mary Bailey was, of course, right about honours and fame. Bewick had already sat for his portrait by William Nicholson, who painted him in 1814, rosy-cheeked against a regal swag of curtain with trees behind, his books at his side and a fine dog looking up by his knee (the model was Emerson Charnley's 'fine dog Don', as Cheviot would not pose, and in the only painting of him he hides his head behind Bewick's leg). His friends did not like the 'grand portrait', but when Bewick heard that it was to be engraved by Thomas Fryer Ranson, he thought briefly of using it as a frontispiece for his

works. He had a similar idea about John Summerfield's engraving of the earlier miniature by Murphy, but both plans came to nothing.

In 1815 a new portrait, Bewick's favourite, was painted by James Ramsay whom Bewick thought 'a very agreeable, kind, good man, as well as a first rate painter'. Jane and her friends pronounced it to be 'you exactly'. Pollard went to see both pictures at the Royal Academy show in May 1816, feeling pleased and rather overwhelmed by his old friend's eminence, although the portraits were hung too high for him to judge them properly. 'When we were apprentices trudging by the Tyne 44 or 45 Years ago', he wrote wonderingly, 'making our observations on Nature its Objects & Scenery &c we never dream'd of what was to be our future fate.' (Bewick scribbled a little sum at the foot of the page: '1816–1770 = 46'.)

Bewick enjoyed the fuss and the portraits – he was pleased, for example, when Edward Jenner told a friend, 'his peculiar humour has often brought a flash of sunshine from behind those black Clouds that sometimes envelop me' – but even his detractors acknowledged that he had no vanity. Fame did not make any difference to the way he treated people. When the young Grand Duke Nicholas of Russia called on him in 1816, Bewick showed him his woodcuts and presented him with a set of *British Birds*. He still worked with his hat on, and if a high-ranking patron arrived he just doffed it for a moment when they entered and turned round on his seat saying 'How do you do, sir? And are ye quite well? Sit down – sit down – how's your father?' When less exalted guests called he worked on, keeping his quid of tobacco in his under lip; when he got excited he put it on the table and simply 'resumed it when his fervour was abated'.

Yet if he was modest, he was also confident in his own knowledge and aware of his status. One of his favourite haunts was Mavings the brushmakers, where his friend Richard Wingate worked. Maving,

apparently, was a 'political, weather observing kind of man', who used to call his little shop 'the chamber of science' and make fun of Bewick and his followers: one day he brought someone to see Bewick, whom he knew well, and was

in spite of his ridicule, not a little proud of; and introduced him in the following homely language: 'here's auld Tommy – if ye bring him an auld geuse [goose] wing or an auld crows leg, he'll tell ye what genus it's of'. Bewick turned on him, a look of considerable dignity, and turning his quid calmly in his lip, said in his slow impressive way, 'you know nothing about those things Mr Maving'.

Visitors always found him cordial, but in an argument, all agreed, he was formidable, and as he passed his sixtieth birthday he hardly mellowed. First he got into a justifiable rage with Isaac Nicholson, who was working on cuts for Buffon's *System of Natural History* for Davison of Alnwick and had filched one of the apprentices to moonlight for him. Then came a sudden flare-up with Ralph Beilby, who saw a print of the Chillingham bull in a window and wrote to remind Bewick that this had been done under their partnership and he should therefore share any profits. Bewick pointed out brusquely that it belonged to neither of them (the block may have been sold), but Beilby defused his anger with a gentle, dignified reply.

Beilby had been seriously ill for some time and they saw little of each other in these years, as Bewick told Miss Bailey: 'He sometimes calls in – but I think – at least I cannot divest myself of a suspicion, that he comes by a kind of stealth, to see me – he does not know that my respect for him is unabated & that I wou'd not have deserted him even had he gone blind.' The stealth was needed since Ellen remained so set against him: in Beilby's last illness in 1816, Bewick called to see him and was shown the door although he could hear Ralph on the stairs begging for him to be let in. When he died early the following year, Bewick was not invited to his funeral.

*

Bewick also confided to Miss Bailey his progress on a new project, dear to his heart. When he was lying ill in 1812 the one thing that he had regretted, he said, was 'that I had not published a Book, similar to "Croxalls Esops Fables", as I had always intended to do – I was always extremely fond of that Book, & as it had afforded me such pleasure, I thought with better executed designs, it would impart the same kind of delight to others.' This was an old plan, he explained, one that he had long intended to carry out, 'indeed ever since I *intended anything*', and he had in fact started before he collapsed.

His interest had been spurred by a new telling of Aesop by Brooke Boothby, published in 1809, which included an essay on the history of the genre. He felt a new respect for this ancient form, and for the vignette at the head of the Introduction he drew a rock inscribed with the names of the 'Fabulists' from Phaedrus and Aesop to La Fontaine and their eighteenth-century followers Dodsley, Gay and Boothby. The illustrations, as well as the text, had a recognisable lineage: with his reverence for the history of his craft, Bewick could look back and see similar designs, copied and reversed and copied again, handed down since the fifteenth century.

Many of the basic designs for Bewick's *Aesop* followed age-old formulae, and Bewick himself had drawn and redrawn them over the years. Returning to fables was partly an act of nostalgia. Sir Cuthbert Sharp acknowledged as much when he said that he was glad to hear Bewick was 'occupied with a work which gives such good scope for originality & humour – Aesops fables like Robinson Crusoe will amuse as well in old age as in infancy & under your pencil I shall return to the happy days of childhood with encreased relish.' The writing of the stories and the earnest 'Applications' harked back to Bewick's schooldays and later self-education at the side of Gilbert

Gray. His tailpieces in particular were often a farewell to places and people. Two separate small cuts of gravestones in a country church-yard are marked, very faintly, with the death dates of his parents.

It was a mammoth task. Bewick chose 165 fables, knowing that each would need a picture and probably a tailpiece. In late 1814 Bewick told Miss Bailey that he had got 'well forward' with them: he was spending his afternoons and evenings on the writing and drawing finished designs on the wood in the mornings. 'This to me is a delight-full employment', he added; 'indeed I think I pursue it with an ardour & enthusiasm that borders upon being *Crazey*.' He roped in Robert to help and his apprentices William Harvey and William Temple. He needed their assistance because his hands were stiff after his illness and he found it hard to get the effects that he had once achieved so easily. His aging eyes also suffered, and for a time he had to set the work aside until he 'somewhat recovered the proper tone of memory & sight again'. He found more difficulties with this book, he confessed, than any of his earlier ones, yet nearly all the designs – like 'The Cat and the Mice' – retain his peculiar sharpness and humour.

The cuts were engraved from Bewick's drawings by his apprentices, and the title page acknowledged this by saying simply 'Designs on Wood by Thomas Bewick'. For some scenes he drew a rough sketch and left the work to the boys, but for others he made very precise drawings, often copying them in detail on to the wood and later taking the blocks back to add finishing touches. When William Harvey finished his apprenticeship and left for London in 1817, Bewick told Pollard that he gave him some designs: 'which I had, on his acct drawn on the wood with a finish and accuracy of fine miniature paintings, and flattered myself that I cou'd put a finishing hand to them when he returned them'. A few months later Harvey had sent none back, 'and I fear,' Bewick told John Bailey, unfairly, 'he only intends to make a *blaze* about the Fables being of his doing, at my expense, in London'.

All his admirers were anxious to see the new work: the influential local lawyer James Losh even brought his dinner guests to see the Aesop cuts, and heartily approved. In July 1818 Bewick told Sir John Trevelyan that the fables had been stopped at press for three months past, but he hoped to start work on them again in ten days, and then there should be nothing to stop them. A few days' fishing 'or rambling about at Wallington wou'd indeed give me new life & "*unbend the Bow*"', he agreed, 'but I cannot at the time be spared from home & when the Fables are at press I must attend the printers every day'. A month later he pleaded with Harvey for the last two cuts, apologising for pressing him but 'delay is terrible to us at this time, when we are so teased by our tired out subscribers'.

Harvey's problem was time: in London the Darlington portraitist William Bewick (no relation, although he liked to claim to be one) had enrolled him in Benjamin Haydon's school and introduced him to his fellow pupils Edwin Landseer and his two brothers. Haydon was a demanding teacher and patron. When Jane and Isabella were in town

that summer, enjoying themselves thoroughly in steaming heat, visiting the British Museum and the Royal Academy exhibition and going to Drury Lane and Covent Garden (where they saw 'Rob Roy in high style'), they thought Harvey looked tired. Eventually, however, he completed the cuts and by 30 September *The Fables of Aesop* was at the binders.

Soon the books were despatched to subscribers and booksellers. It had been discovered that printers sometimes took copies from the run to sell for themselves, so this time Bewick certified each one as a genuine sale by pasting in a receipt, a woodcut of a moonlight scene, with a design of seaweed stamped upon it in red, plus the mark of his thumb – an early instance of fingerprints as a sign of identity, as well as the ingenuity of woodcutting. Several people had put their names down for up to a dozen copies and had waited impatiently for them to arrive.

When they received their books most purchasers were respectful and some were delighted, requesting more copies at once, but others were rather disappointed. Bewick's text offered plenty of good sense but little that was new, while his return to the oval format of early fable cuts made them look rather old-fashioned. Some cuts were too elaborate – 'more minute and more studied, less certain of stroke, less sparing of line' – and their relative fussiness had made them hard to print clearly. Although Bewick went down to supervise the pressmen every day, the printing was not good. Bewick knew this and was mortified. Edward Walker had gone to great pains to do the work well, he told Bulmer, but his men were not used to the ink '& consequently they have failed, for the Impressions instead of being smooth & soft, are *clagged* broken & grey'.

Feeling so disappointed, Bewick was ruffled to hear that Emerson Charnley, whom he considered a friend, like his father before him, was

planning to reissue the *Select Fables* of 1784. After Thomas Saint's death the blocks from this book, which Bewick and John had cut, had been sold to a firm in Hull and then to Wilson and Spence of York, who used them in countless potboilers and school books. Finally, they passed to Charnley, who saw the reissue as a sensible way of using them and exploiting Bewick's fame. But to Bewick, it seemed an embarrassing return to his crude beginnings and a gross exploitation of the collector's market, 'a Bait to hook the poor Bibliomanist!'

In a letter drafted for Walker's *Newcastle Courant*, he protested that the 1784 *Fables* was a mere school book (in fact it had been relatively expensive), and said revealingly that he dated the *Quadrupeds* to be his 'commencement of Wood Engraving worthy of attention': 'Before that period I was engaged in the general work of a Country Engraver's Shop; one hour employed on copper, another on wood, another on silver, another on brass, and another on steel – indeed, ready and willing to undertake any description of work.' Charnley quickly made his peace, assuring Bewick that part of his intention had been to show his early promise. In 1820 he issued a different *Select Fables*, including work by the Bewick brothers and many imitations by Isaac Nicholson. Printed by Sarah Hodgson, it carried a frontispiece – William Nicholson's portrait of Bewick engraved by Charlton Nesbit – and its preface gave a brief biographical sketch of the two brothers.

The next edition of Bewick's own *Aesop*, in 1823, was better printed, and the cuts were touched up by Bewick himself, making them sharper and clearer, but it did not sell so well. It was not until the late Victorian era that people began to value the delicacy of the designs and evocative background scenes, some of the finest Bewick ever achieved in this minuscule form. The book was also original in its use of a new technique noted as 'pen & ink facsim', copying loose pen drawings, a

style that nudged it gently into the nineteenth century, towards the era of Cruikshank and Phiz.

These have nothing of Bewick's poetry but they show the scenes he remembered, the groups around the fire and the prints pinned on cottage walls, the fiddlers in the street and the fisherwomen on the shore. He never stopped experimenting, and returned, for example, to his quest for a mode of cross-hatching by using three blocks printed over each other, to create the effect of rain slanting across a rider on horseback: this trial cost Edward Walker's pressman his job, since Bewick persuaded him to get the key off Walker's housemaid when he was away, so that they could sneak in through the back door of the press and try out their ideas in secret.

Not all the experiments in *Aesop* succeeded, or were so drastic. But the book spurred other illustrators to start looking at fables afresh, including Bewick's own pupils. When William Harvey designed the superb illustrations for Northcote's *One Hundred Fables* in 1828, Bewick was wholeheartedly delighted, especially as most of the engraving was done by other ex-apprentices: Charlton Nesbit, Harry White and John Jackson. He declared it 'a brilliant book – the Cuts finely engraved & wonderfully clear & well printed'. Writing to the

publisher, George Lawford, he confessed, 'little did I think while I was sitting whistling at my workbench that wood engraving would be brought so conspicuously forward & that I should have pupils to take the lead in that branch in the great Metropolis'.

This pride was heartfelt. In 1815, when John Chambers asked him to send an account of his career for a planned work on living British artists, he sent a plain outline, stressing not his own work but that of his brother John and his other apprentices, Robert Johnson, Nesbit, Hole, Clennell and Willis. 'I know nothing beside that makes me so proud or vain,' he wrote, 'and I still hope to bring up others to surpass even them.' By the end of this decade he had new apprentices, among them eighteen-year-old John Jackson, the son of an Ovingham cottager, who later provided much of the information on the workshop for the *Treatise of Wood Engraving*, which he published with his co-author, the Newcastle-born William Chatto. Jackson's relationship with Bewick was fraught, since there were disputes over terms, and he left after a short time, returning briefly for a spell when he was twenty-one. Even so, he had no doubt that Bewick was the greatest wood engraver of the age.

When Jackson knew him Bewick was getting on, a sturdy but stiff figure who made the long haul down from Gateshead, 'over the water' (as he always put it) and up the steep hill of Dean Street to the workshop every day, braving the summer dust and the icy gusts of winter, before settling down in his top floor garret 'cheerfully pursuing the labour that he loved'. He never had a watch, and governed his time by the chimes of St Nicholas. Jackson recorded his regular and methodical ways, arriving on time each morning and 'lapping up at night, as if he were a workman employed by the day, and subject to loss by being absent a single hour', and his smaller habits, like the way he always

carried the walking stick that had long ago belonged to John. (In later life he often said that John would have outshone him if he had lived.)

As the apprentice watched the master, so Bewick looked back at his apprentices, a branching tree of names, lives and deaths. Towards the end of their time, most of them had felt strongly that they could do better on their own – as Bewick himself had felt when he was young – keeping the payment for their work instead of seeing two-thirds of it swallowed by the workshop. Some had stayed nearby. Mark Lambert was now running a profitable business in Newcastle and Isaac Nicholson had also set up here in 1814, imitating Bewick and charging half his prices. Emerson Charnley used his Bewick-style fishing vignettes to decorate the annual collections of poems called *Fisher's Garlands*, including one vignette in 1826 copied so directly from the *Birds* that Bewick not surprisingly exploded.

Most apprentices, however, moved to London. Charlton Nesbit was well known for his reproductive engravings from artists's drawings, while Edward Willis, who came back to work for Bewick from 1814 to 1817, was now in Clerkenwell, working on the cuts for *Mayday with the Muses*, by Robert Bloomfield: eventually, when trade declined, he and his wife became servants at the grand town house of his cousin – old Geordie Carr's other grandson – the railway hero, George Stephenson. Henry White was providing cuts for Hone's satires and *Every-Day Book* and for the 1824 edition of *Walton's Angler*, which pleased Bewick greatly. Meanwhile, William Harvey became the most called-for designer of his day after John Thurston's death in 1822. All his life he generously acknowledged Bewick's achievement.

Bewick rejoiced in the successes but he grieved for the lost talent: of his brother and Robert Johnson and now of Luke Clennell, whose work – like the woman hanging out her washing – had always shown

such a distinctive charm and fluency. In 1804, Clennell had left for London. A whirlwind of energy, bold and versatile, he showed great promise as a painter, providing romantic, luminous watercolours for Scott's *Border Antiquities* and winning a prize for his painting of the Charge of the Life-guards at Waterloo. He and his wife, Elizabeth, had three children and looked set for life. But a commission to celebrate the peace of 1814 with a vast painting of the *Banquet for the Allied Sovereigns*, including over four hundred individual portraits, proved too much.

In 1817 Clennell collapsed into depression and delusions, intensified after Elizabeth also suffered a breakdown before dying of fever. He was sent to a Salisbury asylum, where the Artists' Fund, which Pollard had founded long ago, paid his expenses. A Committee – including Benjamin West and Clennell's close friend, Thomas Stothard – published an engraving of the Waterloo painting to support his children, who were looked after by relatives. Bewick wrote a moving letter for the proposals. In the mid 1820s he recovered enough to live with his brother on Newcastle Quay, straggling up to Bewick's workshop and begging for boxwood to engrave. But in 1831 he was con-

351

fined once again and a few years later William Chatto described his plight:

Poor Clennell, though dead to the world, is still living in a lunatic asylum in Newcastle, where though all recollection of his former self be lost, he still retains his fondness for drawing, and sketches those objects which he has an opportunity of observing; such as the labourers whom he sees riddling the walks, and the peacocks, in the garden; the keeper who locks him up; the tom-cat which disturbs his rest at night, and the bird which sings to him in the morning.

Clennell died in 1840, still in the asylum, the art he had learned at Bewick's hands his only consolation in his dark final years.

27 TAKING STOCK

In Bewick's sixties the workshop swung along in its old routine. The only threat seemed to be the draining of copperplate work away to his ex-apprentice Mark Lambert: 'you must be tender with the Burdon Main folk,' Bewick had advised Robert in 1816, in connection with coal-certificates; 'I believe Lambert has made great progress in supplanting us in that office.' He suffered occasional illnesses, when the doctors confined him to the house and forbade him to work, but he was soon up again, defying their orders, experimenting with his bank notes, taking charge in the workshop and holding forth down at the Blue Bell. By now he and his friends had formed their own small 'lunar society' to take advantage of the greater light in the dark streets. The full moon, he wrote, 'was generally the signal for our assembling – when we gave full vent to whatever was uppermost in our minds – this was called "getting the froth off our stomachs"'.

Bewick was still a fierce critic of the government. Through the later years of the war he had supported the opposition line of Cobbett's *Political Register*. (His views were known, and when Gillray – paid by the Tory camp – produced a satirical cartoon in 1809 of 'The Life of William Cobbett', he used recognisable Bewick motifs, like the pigstye netty, washing line, barn and cans hung on the dog's tail.) Cobbett lambasted 'Old Corruption', the vast web of patronage, a 'Demi Oli-

garchy', in Bewick's view, 'cemented together by the same fellow feeling of rapacious interests'. So great was the propaganda, Bewick fumed, 'that I think if Mr Pitt had proposed to make a law to transport all men who had Pug noses, & to hang all men above 60 years of age', the people would have supported it as 'a brilliant thought & a wise measure'. The vital connections between classes, between government and subject, had been broken. If Pitt was as brilliant as people said, why could he not have avoided war, saving the lives of a million men? These lives could have been spent in the improving of Britain, in building canals and harbours and gardens, instead of ending in the mud of battlefields or on the shattered decks of British vessels.

In 1809 Bewick had contributed to the expenses of Colonel Wardle, the MP who secured the resignation of Frederick, Duke of York, as Commander in Chief by exposing his mistress's influence on the awarding of army contracts. This scandal had led to new cries for reform, during which the independent MP Sir Francis Burdett put forward the first real bill to extend the franchise, and when Burdett was imprisoned in the Tower in April 1810, his Newcastle supporters were outraged. They decided to present a piece of plate to 'the distinguished Patriot' and Bewick attended the meeting to raise a subscription. The start was delayed so they waited in the bar and the chairman for the evening, John Kirkup, got thoroughly drunk. As soon as the meeting started, rows broke out, Kirkup was dethroned and the first man to be asked to stand in his place was Bewick. He demurred: he 'never had been in a chair in his life', he said, but he was voted on to the committee of 'partizans of Sir Francis and his Cause'. In the end they sent a thirty-pound salmon instead of silver plate, followed up by a respectful address, which was briefly lost and sadly crumpled.

The end of the war had proved far from the end of repression. The country reeled under a huge national debt, while 300,000 servicemen

returned to find no work. The iron-works and the collieries which sup-
plied them were hard hit and 8,000 miners lost their jobs; on Tyneside
a seamen's strike paralysed the coast, and returned sailors turned vio-
lently on neighbours they suspected of informing on them to the press
gangs during the war. The return of 'The Good Old Times' began to
seem a lie. As one song put it:

> You say that Bonyparty he's been the spoil of all,
> And that we have got reason to pay for his downfall;
> Well Bonyparty's dead and gone, and it is plainly shown
> That we have bigger tyrants in Boneys of our own.

Bewick responded fiercely to such events as the suspension of
habeas corpus in 1817, prompted by a stone thrown at the Prince
Regent's carriage, and to the trials for blasphemy of the journalist
William Hone, who had penned a mock Te Deum for the Regent's
escape. Hone defended himself brilliantly, each acquittal rousing
shouts of 'Long live an honest jury! An honest jury for ever!' Bewick
subscribed his guinea for Hone's support. It was appalling, he
thought, to see the authorities resort again to spying and imprison-
ment 'under the pretence of preserving the constitution'. (Edward
Walker had apparently persuaded him to leave one story out of *Aesop*,
'The Alarm', accompanied by a cut showing the world with legions of
devils hurled about in the vortex, 'intended as a satire on the ministe-
rial politics of the time'.)

The events of the next few years hardly cheered him. The 'gagging
acts' continued and prosecutions for seditious libel mounted. In 1819
came the outrage of Peterloo, when the magistrates ordered the yeo-
manry to break up a huge reform meeting in Manchester: eleven peo-
ple were killed and over four hundred wounded. The government
congratulated the magistrate and passed the notorious 'Six Acts', pro-

hibiting meetings, limiting the rights of the accused, and increasing stamp duty on newspapers to subdue the radical press. The public outcry was followed the next year by widespread fury when the Prince Regent brought charges of adultery against his wife, Caroline of Brunswick, to prevent her being crowned Queen. When the government dropped the bill to allow the Regent's divorce, Newcastle debtors illuminated their prison windows, and tradesmen showed a 'neat and appropriate device' of 'Innocence Triumphant'. Robert Pollard, sending on an invitation from William Bulmer (whose brother Fenwick had just been knighted), warned Bewick that if he ever went to Bulmer's house he should hold his tongue: 'He is not a Queen's Man & if you can keep off Politics you may be happy there.'

But it was hard to keep off politics. During the furore over Caroline's 'trial', his friend John Ambrose Williams, editor of the *Durham Chron-*

icle, was arrested for having 'spoken freely' in his paper of the Durham clergy's attitude to the Queen. Out on bail in October 1822, he called on Bewick at Tynemouth (much to the alarm of Jane and Robert, who feared their father would offer to be bound for his expenses). Writing to Thomas Ranson, Bewick said, 'I fear that this wicked *persecution* has unsettled his mind & we are unhappy lest this is the case & long to see him again.' His fears were justified. The gentle, scholarly Ambrose was found guilty of denigrating the 'clergy of Durham and its vicinity' and although never sentenced he was a broken man.

Anger at the high-handed ways of Westminster and the Church intensified the radicals' determination to preserve regional, popular cultures. Despite his fame, for example, Bewick proudly maintained his accent. In his last years John Dovaston caught his voice, and while the Northumbrian colour gained a Scots tinge in his transcription, he had a musical ear and captured the mix of educated and local, as in Bewick's anecdote of fighting off a mastiff, which he caught by the hind legs and gave 'such a hell o' a thwacker owre the lumbar verte-brae, that sent him howling into a hovel'. Bewick himself was inter-ested in dialect forms, and one of his close friends (despite a brief, almost inevitable, falling out) was John Trotter Brockett, compiler of the pioneering *Glossary of North Country Words*. He also wrote two dialect pieces of his own, 'The Upgetting' and 'The Howdy'. The latter tells how a midwife is summoned by young Andrew Carr, running up through wet mud in the howling winter wind, with his wild, 'tahiti' hair standing up through the crown of his hat. The broad speech – which just makes sense if read phonetically – was that of Bewick's childhood, fifty years earlier.

Ae-hy, Ae-he, kih she, yeh may say what yeh leyke, but Aze suer aws reet, aw ken weel enough when he was bwoarn, fir aw meynd, aw was up at the Mis-trisses suon ee mworning, ith th' howl oh wounter, when in cam little Jenny

running – Muther! Muther! sez she, here comes little Andra Karr, plishplash throw the clarts, thockin and blowin, wiv his heels poppin oot ov his Clogs every step, leyke twe little reed tatees – wiv a Hares bum on his Hat and the crown of his head and teheyteed hair stannin up throwt . . .

As he wrote such stories, looking back to his past and to the friends who had died – Ralph Beilby, Kit Gregson, John Bell, William and George Gray – Bewick began to feel like a survivor. He made sure to visit Pollard's brothers and have 'a good bit of crack together': they were all, he realised, getting old. When he cleaned old wood blocks to take good impressions for collectors, he found the detailed work hard on his eyes and printing on a hand-press slow and tedious. He told Pollard that he 'would not know what to make of myself, were it not that I find means *when able to work*, to keep filling up the gaps in my own publications – My lads are worth little, & I have only Robert B to look to, to keep the Pot boiling.'

In theory Bewick had turned the day-to-day running of the business over to Robert, who, he said, was 'very diligent'. In practice Jane dealt with most of the correspondence, chased the debts and ordered the boxwood and paper: 'she is now completely my *Man of Business*,' he told Pollard. If Jane had been the official partner, 'Bewick and Daughter' would probably have flourished. For one thing, she could stand up to her father. She was horrified to hear that he had opened one of her letters to Eliza, wittily turning his own rhetoric against him: 'It is *perfectly inexcusable* – if that system is to be pursued, away goes all *freedom* of *debate* – tell him in this particular at least there must be a *radical* reform.'

Robert had no such strength. Now thirty-three, he was ill for several months in 1821 with severe stomach pains – perhaps another sign of stress – and his account books for a stay in Tynemouth show entries for strawberries and tobacco and taking 'warm baths'. After nursing

him at home, Jane and Isabella took him to Edinburgh and then to London to see a succession of doctors. As soon as he sailed, Bewick sent medicine after him, begging him not to tire himself and ending his letter with kisses and drawings of hearts. As it happened, everyone was seasick except Robert, who also managed to get a bed when they landed at Berwick, while Jane, feeling very queasy, 'was glad to lie upon the Floor, with a coil of ropes for a pillow'. Next morning, she made sure they took the coach instead.

In Edinburgh they saw the doctors but they also saw the sights and called on booksellers and engravers, who gave Robert letters of introduction to London patrons. Back home in Gateshead the anxious family seized on their letters, passed them around and read them aloud, in the parlour and the kitchen. Significantly, once he was away from the workshop and his father's eye, Robert was immediately better, although Jane kept a watchful eye on him: 'Isabella and I have determined never to leave our charge without a guard – or to accept of any Invitations.' In London, after another buffeting at sea, a Scottish merchant they met on the boat found them lodgings with a 'pleasant intelligent Scotch woman' where the boarders, Jane reported, joined 'your blooming Son, & pale faced daughters' at breakfast.

Jane took Robert to London again in 1822, when he went to exhibitions and took trips on the river to Kew, and she shook with nerves before visiting Longman and Dickinson, their paper suppliers, parried queries from booksellers and collected debts 'after a great deal of screwing (in which I succeeded to admiration, having come off with flying colours, from two of the Trade)'. She also went shopping, buying ribbed silk stockings and sending back fashion news to Isabella: 'Waterloo is the genteelest colour, sleaves *are now worn to the Elbo*w with long Gloves for walking dress!!! The necks are still as long as ever, & the Bonnetts small . . . I purchased to day a nice brown silk

Umbrella for a better time – indeed like the Bee I generally come in loaded with Honey.' On their return, although Robert seemed well, Bewick was still anxious. When he looked after the workshop while his parents were in Tynemouth that autumn, Bewick warned him to get funnels for their new gaslights to take all the fumes away in case it made him ill again.

That summer, convalescing at home, Robert made an inventory of the books in the drawing room at Gateshead, and at Christmas he made a second list – a remarkable survey of the reading of a master craftsman and his family, ranging from poetry and history to travel and politics and natural science. There were treasures among the jumbled books, like Gerard's *Herbal* of 1597 and Topsell's *Foure-footed Beastes* of 1607, but also favourite works such as Walton's *Angler* and Sterne's *Sentimental Journey*, and much-read volumes of Shakespeare. And among the serious tomes and carefully collected copies of Bewick's own work were scuffed copies of the many fables and children's books that he and John had illustrated long ago.

As Robert listed the library that autumn, Bewick began to take stock of his own life. People had often asked for details of his career with a view to writing a life, and it was partly to avoid later distortions that in November 1822 Jane persuaded him to write it himself. 'My dear Jane,' his memoir opens, as if at the start of a long letter: 'It is in compliance with your wishes, that I have after much hesitation and delay, made up my mind to give you some account of my life, as it may at a future day amuse you & your Brother & Sisters in your passage through its crooked, as well as its pleasant paths.' He plunged first into details about his grandparents and parents and then into memories of Cherryburn, cold days on the fell, his rebellion at school, neighbours on the common, his days with Mr Gregson at Ovingham and his

early love of animals and birds and drawing. His pen ran easily across the pages, recalling his sobbing at the Earl of Derwentwater's lament, his fear at the ghosts, his anger at the beatings.

At Tynemouth in November and December 1822 he wrote fast, hardly correcting a word. As he told the engraver Thomas Ranson, 'I feel it to be quite an easy job – I have no author to consult on the business – & it flows upon me.' As the memories rose up, he recalled the distant years far more vividly than the past week. He saw himself in outline, a small figure, as if looking down the wrong end of a telescope, backward through time; the stories stay clear, sharp, vivid in their detail. Like his woodcuts, his stories persuade through the particular: the names and clothes and oddities of people, the details of animals and plants and places, like Colliers-close-wood, his refuge from Mickley school or 'Ned's hole', where the ice-sheet was trapped beneath the bank.

After the first fast weeks of writing at Tynemouth in 1822, he set his book aside until the following May and June, when a fit of gout kept him at home and he wrote another long section at a gallop. In October, back at Tynemouth, he spent the days on his engravings and the evenings on his memoir. The time seemed to fly, he told Pollard. He rose early in the morning and walked in the castle yard, watching the sun rise out of the sea, then went to breakfast and took 'a ramble among the rocks & after washing my Arms or ducking my head in a pool of salt water – I sat down to work where, excepting a short turn out before dinner, I sat closely upon my Wood Cuts till the Dusk'. It was now that he took his long walks to the burial ground and was met on his return by Bell's scolding. In the autumn he added a further twenty pages, covering his journey to Scotland and London, his early days as a master and his great walks with his friends, or alone with his dog by his side.

By mid November he had reached the great break in his life, the death of his parents in 1785, when, he wrote, 'I left off my walks to Cherryburn.' With that wrench, on the page as in life, his mood changed. In Bewick's life, that was when he married, began the *Quadrupeds* and stepped into the limelight; in his memoir, this is the point at which he begins to speak as a commentator, a 'philosopher'. By now, he had begun to think of the memoir not solely as a record for his children but as something that might be published, although, as he explained to John Dovaston, the manuscript belonged to Jane and 'she seems very unwilling that I should publish it, *in my life time* – I think her wrong in this, for several reasons – but as I feel indifferent about it I can easily be put off.' Pollard agreed with her. 'Your daughter Janes Idea is a good one as to writing your on Life provided it is *by No means published till You are no more* . . . & unfeigned friendship will not flatter – !!!' he wrote, with heavy underlining. Jane was doubtless worried about affronts to living people (including a libellous passage about Sir William Congreve and the bank notes), but she was also nervous about her father's politics and attacks on organised religion.

Once he saw the book as having a public life, the *Memoir* became yet another attempt – like the *Quadrupeds*, *Birds* and *Aesop* – to guide the ways of youth. It is apt that Bewick's final page is a plea for 'little Colleges' where teachers would put individual children before rote learn-

ing and discover their talents and longings, 'so as to be inabled to advise or direct, their inexperienced youth as to what might best suit their several capacities'. The key incidents of his own childhood – when he holds the wounded hare, or stares at the bullfinch brought down by his stone – are typical of many autobiographies, which often highlight defining moments that authors see as marking them out as different from those around them. However trifling such incidents may seem, they form a hinge in the narrative, confirming the person they will become, their 'true self'. No plan for Bewick's memoir has survived and it is doubtful if he made one, but in his idiosyncratic way, consciously or unconsciously, he was following a familiar model of the confessional autobiography popular among dissenting sects, where a mis-spent youth is suddenly reformed in a flash. This helps to explain why the later chapters spin into passionate disquisitions on politics and religion, nature and morality – and also why so many of his friends who had a fondness for the bottle or women are glumly said to die 'of dissipation'.

The effect, however, might not have been quite what he expected. In confessional autobiographies the wild lad or girl often proves more interesting than the reformed citizen, and in Bewick's case his truancies and scrapes were haloed by nostalgia and by his Rousseauian belief in the value of the primitive, open-air life. The model of sudden enlightenment was undermined by the new view of childhood, not as a state of ignorance and sin but of innocence unsullied by the world, as Wordsworth's 'Intimations of Immortality' bears witness. Furthermore, Bewick's moments of revelation do not run counter to his errant life, but spring from it. It is not the Bible but nature that opens his eyes. It is not prayer but the trembling of the hare that makes him renounce hunting, not 'waggon loads of sermons' but the people of the common who alert him to social wrongs.

Bewick was no trained philosopher and he was a man of wayward passions. In the later chapters, 'committed to paper in fits and starts' over the next three years, he stepped back into old controversies and rows, praised the apprentices he had admired and stormed at the laziness of others, and poured out all his views, haphazardly, often when something had happened that day to remind him of, say, his views on religion or his fury with Pitt's government. Many sections echo his arguments at Swarley's Club and the Blue Bell. Dr Robert Blakey, reminiscing about Bewick, remembered that he was fond of porter and could sit in the pub from seven until eleven each evening 'sipping his favourite beverage to the tune of five or six pints'. Blakey thought that perhaps long habit had inured Bewick, as drink did not produce 'any muddling or stupefying effect upon him whatever. He was always clear, collected, humourous, and pleasant.'

One can't help feeling that some of the fits and starts of writing followed straight on his return from such a session, but even at his fiercest Bewick's writing on political leadership, war and exploitation blazes with an energy and compassion that still rings true today:

One would think that the gaining of Worlds, would not compensate the misery & horrid waste of human life, which are the certain attendants of War, and one would wonder, what kind of materials men are made of or what kind of *minds & souls* direct the actions of the Authors of it – were they to reflect, it may fairly be concluded, they could not bear their own thoughts & that they would after taking a cool survey of the wretchedness they have occasion'd, go immediately and hang themselves . . .

All wars, except defensive ones are detestable and if Governments admitted morality into their institutions and were governed by its precepts, all wars, would in all probability grow into disuse & cease – but hitherto that treasure of inestimable value I think has been discarded from their councils – And I cannot discover much difference between them & the lesser Banditti of old – for in the former as well as the latter they were guided by the strong disposi-

tion to rob as soon as they thought themselves able successfully to do so & to shew that they thought *'might was right'*.

The *Memoir* is full of Bewick's loves as well as his hates: his great walks across the country, his sunny days of fishing, his delight in the pipes and ballads and, above all, his dedication to his craft. It remains outstanding among British autobiographies for its pictures of a workshop life and a country childhood, which Bewick knew had given him the substance of his art, and whose beauties and freedoms – running on the moors, wading and splashing in the burns – he believed would benefit us all. It was, in its way, a testament to Bewick's particular religious vision, and to his own mission, with the book of Nature bearing witness to a guiding Providence:

In all the varied ways, by which Naturalists and Artists are befitted to enlighten, to charm & to embellish civilized society, as they advance through life – if they entertain the true feeling that every production they behold is created not by chance, but by design – [they] will find an encreasing & endless pleasure in the exhaustless stores which *nature has provided*, to attract the attention & promote the happiness of her votaries during the term of their sojourning here.

28 SALMON AND SWALLOWS

One of Bewick's worries about Robert was his slowness in working on the new project close to his heart, *A History of Fishes*. Matthew Gregson and other collectors had urged him to work on this for years, and back in 1813 a forceful nudge had come from Charles Snart of Newark, who was then finishing the second edition of a book on angling and wondered if he might use some of Bewick's vignettes, adding that his admirers had 'long entertained the hope that you would favour the Public with a History of British Fresh Water Fishes accompanied by Cuts in your usual stile of Excellence'. Bewick responded quickly and Snart, who suffered from gout and was confined to his room, was delighted to find a brother angler.

Snart acknowledged that Bewick's fishing in rapid rocky rivers was very different from his own sedate style on the slow-flowing Trent. However, the Trent, he claimed proudly, was 'abundantly supplied with Pike, Barbel, Chub, Bream, Grayling, Roach, Rud, Perch, Flounders, carp, Tench, Eels, Ruff, Dace, Bleak, Gudgeons, Loach, Bullheads, Minnows, and Pricklebacks . . .' Both men could see endless possibilities for tailpieces in the details and disasters of fishing, including 'the unlucky but very common Accident of a Line fastened to a branch of a Tree'. Both also insisted that the true pleasure was not in feeling the tug on your line and playing and landing the catch, but in the dreamily alert

concentration on the water and the charm of 'seclusion from the busy Scenes of a crouded Town, which few Men (except Anglers) have an Idea of'.

That summer Bewick was fishing at Chillingham, making quick studies in his notebook. John Bailey's son Nicholas watched him draw the head of a pike twelve times, each sketch apparently perfect but all discarded until a lucky pencil stroke caught the pike's true ferocity, when 'his whole countenance gleamed with a satisfaction that can be felt only by the true lover of Nature'. His correspondence with Snart brought them both great pleasure. Bewick was at his most relaxed, and the two aging anglers swapped anecdotes like addicts. 'I shall not forget to notice what you say respecting the 2 Carps which were taken with a Night line baited with Loaches,' wrote Bewick. 'Fish are very whimsical creatures and often gobble up substances that seem quite unnatural for them to take & they all seem fond of catching at every glittering substance.' This he confirmed with the 'well authenticated' Newcastle story of the salmon that swallowed a ring that fell off an Alderman's finger while he was leaning over Tyne bridge.

Soon other keen fishermen joined the conversation, like the man from North Wales who sent stories of a glut of eels and the Manchester naturalists who promised 'information *quite new* on the Art of Angling'. Fish, instead of birds, now flopped on Bewick's desk, however much he tried to forestall offerings by saying he could get the common species in the fish market on the quay. George Townsend Fox, currently helping Bewick with the new edition of the *Birds*, asked for a lumpfish he had sent to be stuffed: 'The Scales must be preserved, & the Fins set up, & no false colouring used in the Varnishing. It might be well to expose the Teeth.' By 1820 booksellers were asking Bewick for a prospectus, but he put them off, explaining that he must finish the Supplement to the *Birds* first.

Having decided that he must not write on fresh water fishes alone as 'this would make it like a Book of Angling', he followed his old practice of looking for reliable authorities. His own library now contained the fine Heidelberg publication of Conrad Gesner's *Nomenclator Aquatilum* of 1606, and Edward Donovan's *Natural History of British Fishes*, although some years later he held back from purchasing the beautifully illustrated work by the German expert Bloch, which James Ramsay told him in a cheery Christmas letter 'is the *small sum of £45 with the Plates*'. Revd Robert Tweddell in Manchester lent him priceless works from the sixteenth and seventeenth centuries, but not all the material that came his way was so welcome. When the young expert Jonathan Couch sent him a manuscript plus drawings, Bewick expressed delight but set aside his sketches.

Work ground to a halt while Robert was ill in 1821. Bewick was longing to begin writing: 'With all these bright prospects before me', he told Couch, 'I am quite bouyant & wish to be driven forward in full sail.' This was the year that he began his memoir, dashing his pen across the pages. 'I have so much before me to do', he told Snart, 'that I fear I may not be *spared* to make a finish of it. I am however struggling & striving to do it. You must not suppose that I feel any either mental or bodily weaknesses – and I am executing work that might put about some youths to do it at 20 or 30 . . . but yet I still consider that old time has a *heavy* score against me & that I am only a *tenant at will*.' The same urgency coloured his letters to Pollard: 'I have a vast deal before me to get through . . . but I will never give up.'

Fishing was present in the memoir from the early pages where Bewick looked back on his boyhood evenings by the river while his father whistled for him in the dusk, to the last chapter, where he recalled the tingling anticipation that always spread through him, 'from mounting the last stile, which gave the first peep of the curling or

the rapid stream'. He saw again the grassy banks studded with daisies, the hedges white with sloe and blackthorn blossom, and heard the song that filled the air – lark, blackbird, thrush and blackcap. He remembered, too, the streams further up on the heathery moors, tumbling between lichen-covered rocks, where the only music was that of the burn itself, the whistling cry of the curlew or the whirring wing of the moor game. The birdsong, he admitted, 'altogether charmed, but *perhaps retarded* the march to the brink of the scene of action'.

Yet politics entered even this nostalgic account. Prompted by the decision of the Northumberland MP, Charles Brandling, to give evidence to a Parliamentary committee on falling salmon stocks in the Tyne, Bewick wrote a vehement letter, repeated almost exactly in his memoir. He could not stand the game laws, which he saw as 'severe and even cruel', a wretched cause of tension, widening the gulf between rich and poor: 'To convince the intelligent poor man that the fowls of the air were created only for the rich is impossible, & will for ever remain so.' He felt the same with regard to the fish of the rivers and lakes and suggested that local 'Waltonian societies' could protect the waters against the worst practices of poachers, like the piling of thorn bushes into a mill race to stop the salmon fry swimming through or the liming of burns to kill a few trout, which poisoned everything downstream. He lived in dread of fishing being checked in the same

way as shooting, 'the disposition which sets up claims of this kind, is the same which wou'd if it could, sell the Sea, & the use of the Sun & the rain'. The laws governing fishing rights were, he thought, a remnant of feudal tyranny, when aristocrats won huge grants of land and the rights of the community were set at nought. Fish should belong to everyone, just as the rivers they swam in flowed freely to the ocean.

In Bewick's suggestions we hear the voice of an early conservationist as well as a democrat – up to a point. Rivers should belong to the public, with access through a payment to the justice of the peace: a fishing licence, in effect. Commercial over-fishing should be stopped. When he was a boy, his parents had sent him down to Eltringham ford to buy salmon at three halfpence a pound – the Tyne teemed with them – but stocks had dropped because commercial weirs and dams prevented them swimming upstream to spawn. All these should be pulled down. Thirdly, something must be done about the 'filth from the Manufactories', the sewage from the town and rubbish from the streets, and the excess of lime and manure on the land, which sullied the waters. These points would win applause today, but Bewick might lose it all by his final argument. Most salmon were lost, he pointed out, not to pollution or over-fishing but to their 'most conspicuously destructive enemy' – the porpoise. Could not these rapacious beasts be caught, pickled, eaten, used for oil, their skins tanned? The angler overturns the naturalist.

I have seen a shoal of porpoises, off Tynemouth, swimming abreast of each other & thus occupying a space for more than a hundred yards from the shore & crossing the mouth of the River, so that no Salmon could enter it – they went backwards & forward for more than a mile, along shore & with such surprizing rapidity, that in their course they caused a foam to arise like the breakers of the Sea, in a storm. Might not a couple of steam packets, with strong nets sweep on shore hundreds at a time?

Who knows what mixture of precise observation and eloquent rage would have gone into the *History of British Fishes*, if the book had ever been finished? Or what poetry. Even the humblest fish, the herring that filled the nets of the North Sea fishermen and glistened in baskets on Newcastle Quay, filled Bewick with awe. In the introduction to *Water Birds*, before describing the seabirds that preyed on them, he wrote of their beautiful, perilous journey south from the icy arctic seas:

Closely embodied in resplendent columns of many miles in length and breadth, and in depth from the surface to the bottom of the sea, the shoals of this tribe peacefully glide along, and glittering like a huge reflected rainbow, or Aurora Borealis, attract the eyes of all their attendant foes.

In the early 1820s Bewick worked away on the text and the vignettes and Robert provided several fine watercolours, despite warnings from Pollard and Bulmer of a similar book already under way in London. 'My Son is busy in drawing such fishes, as we can meet with', he reported to John Dovaston in June 1824, 'and I am very happy to find he finishes them with *inimitable accuracy* – so it appears to me – I also trust he is *going* to be a keen naturallist – I only at present help & inspect – & am furnishing Vignettes as fast as I can, my *dear Jane* tells me I have finished above seventy – but to me this is an endless field. I cannot do these things half so fast as I can think of them.'

The Dace or Dare, by Robert Bewick

Later that year proposals were printed announcing that the book should be ready in 1826. Emerson Charnley hung the notice in his shop for two years, although subscribers were wary, suspecting, rightly, that the book might never appear. Friends agreed with Bewick about Robert's accuracy: his forte, wrote George Atkinson, was 'minute and proportional copying. I have measured fish of his execution, and found them true to the most extraordinary degree.' But in 1825, Robert decided that he must concentrate on the workshop rather than the fish. Reluctantly, Bewick finally retired and handed over to his son. He turned his back on his garret and set up his workbench in the parlour window at Gateshead, going back to St Nicholas churchyard from time to time. To would-be purchasers he confessed that 'little progress has been made towards the completion of the Histy. of Fishes', and that Robert's drawings were 'much retarded by reason of his having to attend to other avocations'. Two years later he admitted that the book was 'at a stand'.

Robert's preoccupation with the shop was not the only reason for the delay: Bewick himself had other projects on hand. One was organising fine quarto editions for collectors of the main figures and vignettes, without text, of the *Quadrupeds* and *Birds*. When he sent William Blackwood the figures of the *Birds* in June 1825 in gratitude for a warm article in *Blackwood's Magazine*, Bewick said that they had printed a hundred special copies. The greatest obstacle to completion of the *Fishes*, however, was Bewick's determination to bring the *History of British Birds* up to date and to make it as complete and accurate as he could. This involved long negotiations with Longmans, his main distributor. Both sides drove hard bargains – at one point, in 1817, when a number of sets of the 1816 edition were lost on the Goodwin Sands in a gale, a disaster that ruined Bewick's Christmas and New Year, Longmans politely resisted his attempt to charge for

them and merely requested him to send 'a fresh supply by another vessel, which we hope will be more fortunate in her Voyage'.

Bewick was doing more in these years than merely filling in gaps. In 1821 he had published a *Supplement to the History of British Birds*, with thirty-eight new cuts: one of the last birds to be included was a mountain linnet sent by his ex-apprentice John Laws, who was now running the family farm. The following year he issued a slightly enlarged edition of the *Supplement* and then set to work straight away on a totally revised and updated edition of both volumes. He worked on, organising his material, correcting old entries and adding new cuts. During the terrible early months of 1823, when Newcastle was completely cut off, and on Gateshead Fell snowdrifts reached the height of a two-storey house, Bewick worked by the fireside, conjuring up the birds of the summer hedgerows and streams, like the little willow wren.

THE WILLOW WREN

373

In May 1823, when he sent a list of thirty-five new cuts to George Townsend Fox, he added, 'I still want the Chiff Chaff & perhaps one or two more to complete the British Birds.' A Tyneside ropemaker and merchant, Fox gave invaluable help: Bewick thanked him in his memoir for 'rummaging the stores of the Metropolis, for specimens, and also as being equally desirous to see the Books appear in perfection'. To achieve this, Bewick revised almost every page, adding and deleting, amending the names and reclassifying birds under the most recently defined groups. Yet he told Fox that he still felt the arrangement could be improved, 'for I find it extremely difficult to place the different species so as that they may glide into – or approach & rescede from & to each other in a perfectly natural way'. He saw his book as a work of art as well as a reference guide, a bird-filled sky within binding and boards.

New contacts included George Leadbitter, who stuffed birds for the British Museum, and the naturalist William Yarrell, who had recently begun to observe rare birds and who proved, as Fox said, 'an excellent friend'. Another knowledgeable expert was Prideaux John Selby, High Sheriff of Northumberland in 1823, who lent Bewick specimens from his great collection of stuffed birds (preserved with the assistance of his butler) and sent copious notes. With the young Sir William Jardine, Selby was now working on his *Illustrations of British Ornithology*, published in nineteen parts between 1821 and 1833. These men – Yarrell, Selby and Jardine – would be among the great naturalists of the Victorian age. Selby's book contained over two hundred and twenty copperplates etched by Selby himself, with the help of his brother-in-law, Captain (later Admiral) Robert Mitford. Mitford came to the Bewick workshop to learn the skill: 'He was an excellent Man & always kind', wrote Jane forty years later, '& now while I write Jan 2 1861 we dine off Game which he sent us.'

The letters piled up as they had always done and many old connections sprang back to life. The Revd Cornish from Devon told him once again of keeping swallows over the winter and of his pet whitethroats, one of which was 'warbling his song very sweetly' as he wrote. H.T. Liddell, the son of the man whose reindeer he had drawn forty years before, suggested he come over to Ravensworth to see some rare books. 'I feel proud', Liddell wrote 'of rendering any assistance in my power to a man who has so much contributed to the extension of knowledge, the diffusion of science throughout *all Europe* – For I believe no book is so universally & deservedly valued as "Bewick's Natural History".' (Since no such book existed this was a compliment, perhaps, to Bewick's larger project.)

Bewick sent birds to Richard Wingate to be stuffed and did his best to answer the queries, like that from Francis Hawkesworth, who had been collecting the feathers of every bird in his Bewick books and was not at all sure now which ones they came from. Or Samuel Thompson from North Shields, who sent the chick of an eider duck in July 1821 and asked Bewick's advice on feeding the rest of the brood: 'The birds seem extremely lively & much attached to the hen – they already delight in the water & boiled pot barley.' They had been tried with scrapings of fresh fish, he explained, 'but do not appear to care for it'.

At last, in July 1825, the two volumes of the new edition of *A History of British Birds* were sent to the press, although he continued to make additions and changes: he must have been a nightmare to the pressmen, since his proofs are always heavily corrected, the changes involving movement of tailpieces to fit the altered pages. 'The new Edition of the Birds is going on their flight,' he wrote cheerfully that September. After delays, disappointments and muddles (the paper was sent to Newcastle under Lyme, instead of 'upon Tyne'), and a final

flurry over the Preface, the books would appear in July the following year. Bewick believed that this would be his last word on the subject, because he genuinely thought he had covered every possible bird ever to alight in the British Isles. But this was not so – new birds would hover around him until the end.

29 SORE TIRED

As Bewick worked on the final edition of the *Birds*, his friends and daughters urged him – as John had done so many years before – to go to London to talk to distributors and puff his books. Sheepishly he confessed to Robert Pollard, 'My lasses are baiting me about accompanying them in the Steam packet to London – how I shall get decently off refusing them, to whom I owe so very much, I know not – they are quite *Men* of business & hold out to me the good they could do to our publications, if I were with them – & they are perhaps right in this – but I have the greatest aversion to moving from home and I should feel bewildered in London.' Yet in 1823, to everyone's surprise, Bewick did at last venture from home. His destination was not London but Edinburgh.

Not having seen the city since August 1776, he wrote in the memoir, 'I longed to see it again.' His children's reports of their visit in 1822 had intrigued him and the following August, on the day before his seventieth birthday, he and Jane headed north. The splendid Georgian New Town with its squares and crescents had been built since his first visit, but this 'city of palaces', he thought, was nothing compared to 'the mass of intellect and science which had taken root and had been nurtured and grown up to such a height as to rival, and perhaps outstrip, every other city in the world'. In a rainy fortnight, Bewick saw many old cronies and made new friends.

Edinburgh society was an eccentric blend of the lavish and informal. There was a baffling tea at which a footman and a small maid handed round fruit cake and unbuttered bread on silver platters, followed by a soirée that lasted until midnight, where Jane was cornered by a woman in black satin whose father was allegedly '*King* of one of the Orkneys'. The only disappointment was that everyone sang Italian songs, since the Scottish music that Bewick loved was not considered 'genteel', but to his delight he was presented with a rare volume of Scottish airs, which he had been hunting for everywhere, to give to Robert.

'My father never tires,' reported Jane. He did a deal with the publisher Archibald Constable (whose huge publishing concern would crash three years later, bringing ruin to Walter Scott), and visited engravers and painters, but his most exciting moment occurred at the end of the stay. He had been fascinated by the efforts of a 'very ingenious' and eccentric painter called Stowe, 'who had been labouring in vain like thousands, perhaps, of other painters to give a representation of motion in Animals' and had got into an intense discussion in which Bewick tried to convince him that however fast it ran, a horse 'could not throw its fore-feet forward beyond its nose'. Bewick confessed too, that he was never content with his own studies of motion. When he visited the lithographic printers Ballantyne and Robertson, he was pressed to make a drawing on the stone, something he had never tried, and he seized on the subject of a horse in motion to prove his point. Quickly, as they were about to leave, Bewick drew a sketch before breakfast and the proofs were taken the same day – this was 'The Cadger's Trot', his only lithograph, a vivid, atmospheric study of a horseman riding fast through the rain.

Bewick sat for several portraits this year, perhaps because he was approaching his seventieth birthday, and, as George Clayton Atkinson

put it, 'his father and grandfather had both died about the age of 70, and he had a kind of presentiment that the same period would be fatal to him also'. From now on, he often told friends that he felt he was living on borrowed time. But by 1823 he was a well-known character, who drew admirers from across the country: this September, shortly after his return from Edinburgh, the Shropshire naturalists John Dovaston and John Bowman came to Newcastle after a walking tour in the Cumbrian fells, deliberately to see him. They found him reading the newspaper at the Blue Bell, as he did most evenings. 'For my part, so warm was my enthusiasm', wrote Dovaston later, 'that I could have rushed into his arms, as into those of a parent or benefactor':

He was sitting by the fire in a large elbow-chair, smoking. He received us most kindly, and in a very few minutes we felt as old friends. He appeared a very large athletic man, then in his seventy-first year, with thick, bushy, black hair, retaining his sight so completely as to read aloud rapidly the smallest type of

a newspaper. He was dressed in very plain brown clothes, but of good quality, with large flaps to his waistcoat, grey woollen stockings, and large buckles. In his underlip he had a prodigious large quid of tobacco, and he leaned on a very thick oaken cudgel, which, I afterwards learned, he cut in the woods of Hawthornden. His broad, bright and benevolent countenance at one glance bespoke powerful intellect and unbounded goodwill, with a very visible sparkle of merry wit.

From politics, on which Bewick declared himself 'a warm whig', the talk turned to natural history and Bewick saw them back to their hotel: 'where we renewed our libations even to "sangs and clatter"'.

Bewick at seventy, engraved by F. Bacon after the portrait by
James Ramsay in his group painting *The Lost Child*, 1823

Despite his effervescent prose, Dovaston was intelligent and warm-hearted and became one of Bewick's closest friends in his last decade. A qualified barrister, educated at Shrewsbury and Cambridge, he was rich enough not to practise and lived in rural ease at 'The Nursery', his villa outside Shrewsbury, collecting Welsh songs and writing poetry in the style of Scott's *Marmion*. As an ornithologist Dovaston was a real innovator, trapping and marking birds to discover if they had distinct territories, inventing a feeding device for wild birds – his 'ornithotrope' – and putting up nesting holes and boxes. He even ringed migrants, 'utilizing his cello wire for the purpose', and tried to translate bird songs into musical notation. For the new edition of the *Birds*, he and his Shropshire naturalist friends plied Bewick with notes – not many of which he used.

Dovaston and Bowman came to Gateshead again in August 1825 after a tour of the Highlands, arriving on Bewick's seventy-second birthday. This time Dovaston stayed with the family for almost a week, watching Bewick cut woodblocks and testing his claims about his whistling by playing intricate Highland tunes, which Bewick repeated straight off. He also found that with his fine ear Bewick could identify faint birdsong far quicker than he could. Birds, music and Scotland were shared interests: Dovaston borrowed Robert's rare book of Highland airs, while Jane and Isabella pored over his tour journal and copied the tunes he had transcribed. In the evenings they sang Scottish airs around the piano and listened to Robert piping. Sometimes Jane read Shakespeare aloud, or the novels of Walter Scott (a liking typical of their class: across the country Marian Evans, later George Eliot, was also reading Scott to her father).

Dovaston and Bowman both subscribed to the marble bust commissioned by the members of the Lit and Phil from Edward Hodges Baily – the man who sculpted Nelson for Trafalgar Square. The idea

was to honour Bewick's 'uncommon Genius and extraordinary Talents', but he stoutly refused to be portrayed in a toga. Instead he wore his ordinary coat and waistcoat with neckcloth and ruffled shirt, and even asked for some of his smallpox scars to be shown. Although he hated the plaster cast being taken from his face as he lay on the couch 'with small pieces of quill in his nostrils, as usual, to enable him to breathe', the resulting bust was a fine likeness. Other tributes came Bewick's way. He was an honorary member of the Newcastle Society of Antiquaries, and the Dilettanti Society of Edinburgh, and since 1822 he and Robert had been on the Committee of the new Northumberland Institution for the Promotion of Fine Arts. Bewick showed some work in their first exhibition – the only time in his life he exhibited anywhere – and later shows included work by Robert Pollard and his son James.

If Dovaston saw Bewick feted by the intelligentsia, he also saw him in the streets where the ragged children followed him for halfpence while he growled 'Get awa' bairns, get awa'; I hae none for ye the day', and then handed out sixpence, whacking out with an imaginary cudgel: 'There, chields, fit yourself wi' ballats, and gae hame singing to your mammies.' Many people noticed, as Dovaston did, that Bewick was extremely, but unsentimentally, fond of children. After years with apprentices of different ages, he was good, too, with growing boys, especially if they shared his interests.

In the 1820s a carpenter's apprentice, William Proctor, trudged sixteen miles into Newcastle on his days off 'just to look into a bird-stuffer's window'. In that window (doubtless that of Richard Wingate) was a copy of the *Birds*. When Proctor went in to ask the price Bewick was there, and told him bluntly they were 13s. a volume. Since this was all the money Proctor had, he asked if he could pay for one and call for the other when he had saved enough. Bewick, 'in his broad

Northumberland dialect, said he did not do business that way, and at first declined the offer; but afterwards perceiving, from the blank face of the young man, the keenness of the disappointment that he felt, he handed him the two books, and told him he could take them away and pay for them when he got the "brass"'. Proctor took his books and once out of town he sat on the grass verge of the road and read until dark. Six weeks later, when he had enough to pay, he came again. 'Well, my lad, I trusted thee when I did not know thee, there's thy money back,' said Bewick and gave him the books as a present.

Bewick spoke out roundly on his behalf when George Townsend Fox sent him a rare bird, the 'Cursorious', the cream-coloured courser, a distant relative of the plover and a rare vagrant to Britain from North Africa and the Middle East. Fox took the credit for identifying it in the Revd Gisborne's collection, but Bewick knew that Proctor was the one who had spotted it and arranged for him to make a drawing, commenting tartly that Fox 'sucked Proctors brains for his information'. Their friendship lasted until Bewick's death, and Proctor became a 'bird preserver' in Durham and eventually Curator of the Durham Museum.

His closest naturalist friends of these years were undoubtedly John Laws and Richard Wingate, but another young protégé was George Clayton Atkinson, the son of Bewick's friend at Carr's Hill. In the summer of 1825, when George was seventeen, his younger brother Richard, on holiday near Penrith, found the eggs of a bird he could not identify: when he got home he consulted Bewick's *Birds* and immediately realised that it was a pied flycatcher. Seeing from the text that Bewick was unsure about the eggs and nest, the brothers decided to call on him. Bewick was delighted, 'questioned Dick repeatedly on the manner and habits of the bird and expressed himself highly gratified by his remarks, making memoranda from his answers on the margin

of a copy of the birds, scrawled almost full of notes for the correction of the next edition'.

After that George saw him two or three times a week. He was fascinated by Bewick's mobile face and the power of his glance: 'when animated in conversation, and he was seldom otherwise, his eye was particularly fine, and imparted a vivacity to his countenance very difficult to describe or forget'. Trying to describe it, he found words like 'candour', 'animation', 'intelligent benevolence' – and 'severity' when displeased. Like Dovaston, Atkinson noticed Bewick's dialect, and his simple but expressive language. He was struck, too, by Bewick's dismissal of praise for his work as a naturalist:

The Idea of Socrates 'that the summit of our knowledge is only to perceive our own ignorance,' was a great favourite with him: he had it (whence I know not) on a poetic form, thus –

> What is discovered only serves to shew,
> That nothing's known, to what is yet to know.

He used to quote it with great emphasis and solemnity, and often added some such remark as 'Why sir, it would take a man a lifetime to write the history of a spider'.

*

While Bewick seemed to thrive, enjoying the visits of these young naturalists, his wife of fifty years was ailing. For some time past Bell had been ill, almost certainly with cancer, and by September 1825 she was in great pain, 'very low & sad'. She found it hard to sleep but revived during the day 'so as to make us hope she is getting better', wrote Bewick, 'so that we are kept thus between hope & dispair'. Her daughters took turns to watch with her at night. This year there were no Christmas Carols on the stairs and on 1 February 1826 Bell died.

Bewick was distraught. 'The last pitious appeal to me with the voice of distress for my help, entered into the heart, and there it will remain,' he wrote. Although her death had been expected, he was utterly bereft and within a month of Bell's death he had collapsed with 'gout of the stomach', sudden agonising cramps. 'A little longer time under its terrible *devastating* influence', he told Dovaston, 'would have extinguished the vital spark – this I felt was quite sensible of it and wished it might go out.' Work helped him to recover, and after scrubbing out the inaccurate changes that one of his doctors had added to the *Birds* in an effort to be helpful ('you would be surprised to see the *blarney* his brain & his pen has produced'), he was packed off with Jane and Isabella to convalesce at Buxton in Derbyshire. 'I am sore tired,' he wrote on 27 May.

They stayed in smart lodgings in the Crescent, where Bewick teased the maid about her sweetheart and gave her picture books and prints, puffed his pipe through the open windows and drew sketches of passers-by on the windowsills, ledges and shutters. No one seems to have complained. In June Dovaston came to visit and discovered that he was keeping his identity secret to avoid being pestered, insisting on being called only 'the old gentleman'. 'We dined occasionally at the public table', remembered Dovaston,

and one day, over the wine, a dispute arose between two gentlemen about a bird; but was soon terminated by the one affirming he had compared it with the figure and description of Bewick, to which the other replied that Bewick was next to Nature. Here the old gentleman seized me by the thigh with his very hand-vice of a grasp; and I contrived to keep up the shuttlecock of conversation playfully to his highest satisfaction, though they who praised him so ardently, little imagined whose ears imbibed all their honest incense.

Bewick was not the only focus of Dovaston's interest. One of the reasons he visited and wrote so often was his increasing attraction to

Jane. He was now forty and she thirty-nine and he thought her fine looking ('graceful and fascinating; her features lovely, and brilliantly animated with intelligence') and was impressed by her open manner and the way she ran the house and much of the business. Jane seems to have turned down suitors, serious or facetious: a letter from a young solicitor (which one biographer unkindly thought must have been dated 1 April), survives in the family files:

Dear Sir,

Permit me to ask you two or three questions. 1st, Whether you think Miss Jane Bewick would have any objection to marry me? 2ndly – If you think she would not object, – whether there would be any objection on your part? and 3rdly, what Fortune will you give her?

Yours truly

John A. Pybus

Mr Pybus witnessed Bewick's will, but he did not join the family. Yet despite her independence, for a while Jane was drawn to Dovaston and wrote to him in tones that were eager, even flirtatious.

On this holiday she and Isabella toured the Peak District in an open carriage with Bewick and Dovaston, sitting high up, two by two. They went to Castleton, where Peveril Castle sits above the huge cave, which Bewick called by its old name of the Devil's Arse (to the dismay of his Victorian admirers) and was amused to find a girls' boarding school next door. After their picnic the women looked for wild flowers and fossils while Dovaston lit his pipe. Two ring ouzels settled among the wallflowers on the castle wall and Bewick caught his friend's arm to silence him, muttering as they flew off, 'Pretty darlings! pretty darlings! pretty darlings!' He had never seen them before, but had recognised the habitat as suitable and told Dovaston they might spot them – and there they were, another tribute to his acuteness as a naturalist.

Birds were still on his mind. Before he came away, he had made his final changes to the new edition, which had now been at press for almost a year. The only thing left to do was to check the proofs of the Preface, which he had corrected with Walker the night before he left. Once he felt stronger, he sent peremptory notes to Robert and a fierce letter to Walker about his incompetence and '*soul sickening delays*'. Walker knew him well, and wrote the right reply:

I am glad you are alive & well enough to scold . . . A lady at Yarmouth has applied to me for an autograph of yours, & I cannot show the Natural Philosopher in a more animated view, than by giving her the letter written in a passion; though if it become matter of future history it will remind the reader of Dr Johnson knocking down his Bookseller, & I shall cut a poor fallen figure in the scene.

The Preface was on its way, he said, with some suggestions 'to which you can apply the Ink or India Rubber as you please'. When it arrived Bewick consulted the emotional Dovaston, who hated the suggested changes, ripped up the proofs and stamped on them. As the startled Jane and Isabella picked up the torn pages, Bewick swept them to the floor again and challenged Dovaston to write it himself, throwing down the stump of a pen he had been using as a pipe cleaner. Meekly, Dovaston wrote a draft, which Bewick eventually followed almost to the letter.

Bewick was grateful to the ninety-year-old 'Dr Buxton' who shared his name with the Spa and had seen him through this difficult time. (Jane reported that he saw him at least twice daily.) Buxton had done the old man good, thought his nephew William Bewick, but he did not come down to the churchyard workshop: 'he is very much failed and fallen-away from his Close – he seldom comes to the shop now'. One of

many things that kept Bewick busy was putting together a set of impressions of birds and vignettes for Dovaston on fine India paper, with several carefully coloured by Richard Wingate. After nearly losing a batch on the coach, Dovaston stuck them on the coral-coloured sugar paper of his scrap book, a ravishing miniature aviary.

These small, delicate birds were the opposite of the glowing, life-size plates of *Birds of America* by John James Audubon, who was now in Britain, searching for a printer. In April 1827 he hunted down Bewick in Newcastle, finding him in his workshop at home. Like all who saw him, Audubon was struck by his appearance: 'a tall, stout man, with a large head, and with eyes placed farther apart than those of any man I have ever seen: – a perfect old Englishman, full of life, although seventy-four years of age, active and prompt in his labours'. Bewick showed Audubon the vignette he was working on, of a dog frightened by tree roots that he takes to be men, and took him to meet his daughters:

The old gentleman and I stuck to each other, he talking of my drawings, I of his woodcuts. Now and then he would take off his cap, and draw up his grey worsted stockings to his nether clothes; but whenever our conversation became animated, the replaced cap was left sticking as if by magic to the hind part of his head, the neglected hose resumed their downward journey, his fine

eyes sparkled, and he delivered his sentiments with a freedom and vivacity which afforded me great pleasure.

Hearing that Audubon's sons longed for a copy of *Quadrupeds*, Bewick gave him one at once. As usual, Robert played his pipes and, remembered Audubon, 'when I parted from Bewick that night, I parted from a friend'.

Soon after Audubon's visit, Jane, Isabella and Elizabeth fell ill, and in June they went with Bewick to Scarborough for the sea air. But although Bewick admired the town and the wide sea views, he felt mortified that 'from downright weakness' he could not join in the conversation with 'Geologists, Conchologists, minerologists – &c' as well as ornithologists. Slowly he regained his strength and by November he was concentrating on his memoir and the *Fishes*. 'If I continue well, as at present I am', he decided optimistically, 'my memoir may soon be done. This winter's nights (when the spirit moves me) will easily see an end to it.' Yet instead of finishing these he returned to his birds.

In 1828 he produced a short supplement, *Additamenta*, including a group with haunting names – the cream-coloured plover, the Egyptian goose, the blue-throated robin, night warbler and harlequin duck. To these was added the Alpine vulture. This hardly sounds British, but a pair had been blown across to Devon in winter storms in 1826. Bewick's staunch old supporter, Sir John Trevelyan, now in his ninety-third year, sent a full report and his daughter Julia made a drawing, the only woman to contribute directly to *British Birds*. This work could never be completed: it was like mapping the world. Bewick's own two volumes of the 1826 edition were by now heavily annotated in pencil. Over twenty years later, when she went over his notes 'with a crow quill' in case they should fade, Jane wrote that her father 'looked over this book every morning after breakfast, from its publi-

cation to within ten days of his death. He appeared to have great pleasure in doing so.'

The summer of 1828 was one of terrible storms, heavy rain and violent winds: in July a gable head collapsed at a paper mill in Gateshead, and in West Street the family took shelter indoors. Bewick was anxious. Conscious of passing time, he wanted to push all his projects ahead, and had even tried, unsuccessfully, to sell the workshop so that Robert could get on with the fishes. Now he was determined to set his affairs straight. One plan was to sell his entire stock of books to Longman, but he now realised that to achieve this he would have to go, at last, to London. At the end of August he realised that he could put it off no longer. Instead of boarding the old colliery vessel, Bewick, Jane and Isabella stepped up the gangplank of the *Hylton Joliffe*, 'a large and elegant new steam packet'. Bewick, however, was never to enter the new steam age: because of something 'going wrong with the boiler &c or drunk Capt & crew', they all came home again. Next morning they took the old-fashioned coach, via York and Stamford.

After a day or so they settled in lodgings in Norfolk Street, just off the Strand. Bewick called on Longmans and sold all his remaining stock in the *Quadrupeds* and *British Birds* – gaining ready cash at the expense of a hefty discount – and Jane sent efficient letters to Robert, telling him precisely how to send the books, drafting the shipping note and reminding him where the receipts for the carrier were.

The business side settled, Bewick embarked on more enjoyable visits. An early stop was at the well-known fine printer John Johnson, who had produced Northcote's impressive fables: Bewick also met Northcote himself and agreed politely – though it was contrary to his own finest work – that cuts with borders looked best. Then came the naturalists: George Leadbitter at the British Museum; Mr Wood,

the natural history bookseller in the Strand who lent him 'Bloch on Fishes'; and William Yarrell, whose generosity and knowledge touched Bewick deeply. 'I never in my life was so gratified at seeing any thing, as I was with Yarrell's Museum,' Bewick told Dovaston; 'he has left nothing untouched that could assist him in probing ornithological knowledge to the bottom.' But he declined an invitation to dinner with Yarrell because by now he felt too 'buzzed & fatigued'. When Edward Hodges Baily took them up to Hampstead and Regent's Park, he was too weary even to get out to see the new Zoological Gardens and exhaustion was also his excuse, undoubtedly genuine, for declining an impromptu dinner arranged by the London wood engravers.

Friends greeted him warmly, including James Ramsay and his wife and the Bowman family and Audubon, who thought the old man looked well. But Bewick's most poignant meeting was with his fellow apprentices Robert Pollard and William Bulmer. For a few years now, Pollard had visited Bulmer's villa at Clapham Rise every year when the 'grozers' were ripe. This year they were too late for gooseberries but Bulmer invited the Bewicks out to his house, showed them round and provided a feast from the garden – apples, peaches, currants, pears and mulberries. A day or so later Pollard arrived at Norfolk Street while the Bewicks were out (watching the boat race from their roof and polishing off their joint of lamb, to Jane's disapproval), and while he was there, Bulmer called with another invitation. The following Sunday he sent a carriage for his two old friends. It was over fifty years since this trio had first met in Gilbert Gray's workshop, rangy boys, learning their trade, full of hopes and dreams, running up to Elswick and walking the banks of the Tyne.

Bewick's dislike of the scurrying anthill of London remained unchanged, but he was pleased that his affairs were, as he put it,

almost wound up. In early September he and his daughters returned slowly to the north, bravely taking the overnight coach to Buxton and arriving there the next evening. After staying for a few days to recoup ('Ale once a day at the Shakespeare & King head'), they clambered up on to the high seat of 'Badger's Jaunting Car', in which they had explored Derbyshire with Dovaston, and rattled over the hills to Manchester. In the booming mill town, Bewick saw the new Museum and met the brewer Robert Hindley, a keen angler, eager for the *Fishes* to be published. Then they drove east across 'wild moory country' to Halifax and Leeds – 'damp Bed &c' and 'Bell lost her Umbrella'. On 25 September they reached Gateshead. In late September Bewick's brief notes on the passing days were full of the names of old friends: Edward Walker, the booksellers Robert Gisburn and John Bell, William Maving the brushmaker, and the Blue Bell inn, still called Cants although the old landlord and piper had died.

26 with Mr Walker to Heworth – Saturday over the water called at Guisburn's – Mavings & Wingates – at Cants with Robt Burnett – Willm Johnson & 4 Sunday 28 call at John Bells – 29 or 30 along the new turnpike in Mr Walker's Gig.

The busy round continued into October and he had little time for the projects that he had started earlier in the year. In June he had told Dovaston, 'I have lately been spending a few days in visiting the place of my nativity & the scenes of many happy days (but the House, in which I was born is I fear *agoing* to be pulled down – it is very old).' Perhaps that elegiac visit jogged his memory with regard to the large block prints of his boyhood, seen in the cottages and farms. In his memoir, he urged that this art should be revived, and as if to prove his point, he began work himself on a large cut, joining four blocks together, backed by mahogany to make a large single block about ten

inches by eight. This was easier for his eyes, too, although he never worked so well on a large scale.

'I have now struck out on a new subject of employment that will keep me closely engaged,' he told Dovaston. The subject looked back in time, to the day he left home to become an apprentice, when he had drawn the old horse tethered to a tree, and had written an account of its life which anticipated Anna Sewell's *Black Beauty* in its narrative curve from promise to decline, and its vehement plea against ill-treatment. He had used the image again as a tailpiece to *Aesop*. But his last grim version of 'Waiting for Death', a tribute to his long fight against cruelty to animals, also bore an echo of Hogarth's final print, 'The Bathos', with the bony workhorse replacing the fallen artist and the rough tree stump standing in for the broken classical column.

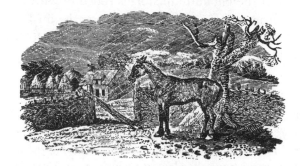

Waiting for Death

Bewick had worked on the old horse on and off over the summer but now, as the days shortened, he felt that his London trip had left him unsettled: he could not summon the energy to finish his memoir and his hand seemed to have forgotten how to work on his large print. On Saturday, 1 November, he wrote to William Pickering, asking for

some fine vellum for special impressions of 'Waiting for Death', and took the block round to Walkers where he had four proofs printed. George Atkinson also visited him that day, and he always remembered how, in his last years, Bewick was still full of awe at nature, unable to believe that everyone did not feel the same. 'Ah! – I've wondered and wondered', he said, 'to see the little water spiders dancing so light on the top of the water, and then – down they go in an instant, its very wonderful.'

Atkinson found him in 'excellent health and spirits'. But the next day, taking everyone by surprise, Bewick fell ill. He was well enough by Tuesday to check the first proofs of the old horse and to look approvingly at a fine drawing by Robert, happy that they now agreed about working on the fishes. All his thoughts were on what lay ahead. But as the first of the big autumn storms rolled down the river, sending the flames from bonfires sparkling through the dusk, Bewick was weakening. Four days later, on 8 November 1828, Robert wrote a short note to John Dovaston:

My Dear Sir
As the most valued Friend, I beg to acquaint you with the Death of my dear & excellent Father, he expired this morning at ½ past one O'Clock, after a few Days illness. His health & Spirits had been so good that we were but ill prepared for an event which has plunged us all into the deepest distress. – The Funeral is to take place at Ovingham on Thursday next.

<div style="text-align:right">

I remain
Dear Sir
faithfully Yours
R E Bewick

</div>

EPILOGUE: NATURE'S ENGRAVER

Bewick was buried with his wife, Isabella, in Ovingham churchyard, with the graves of John and his parents nearby. At Cherryburn, Jane planted two walnut trees given by a young man he had befriended and helped. In a corner of the garden, she explained, 'beneath an elder bush & surrounded by trees of my father's planting, is placed by his desire, the remains of the "frail memorial" formerly erected by him, to the memory of his parents'. The walnut trees thrived by the new house that Bewick's brother William built, where his descendants lived until the 1950s.

Six months after Bewick died, Jane wrote to John Dovaston suggesting that if the *Memoir* was ever to be published, it might benefit from his editing, and telling him how she and Isabella had been urging Robert to leave Newcastle to work on the *Fishes*, 'not only to explore the treasures of the Great Deep, but to the side of every Lake, river, & Streamlet'. As she signed her letter 'Most faithfully yours', she added a postscript: 'I enclose a Flower: Viola Lutea? Gathered at Sunny Buxton – 1826.' It was a kind of farewell. Robert did not go to the lakes and rivers and Jane did not marry Dovaston.

The following year his articles on Bewick appeared in Loudon's *Magazine of Natural History*. These included an account of Bewick's early life, based on the memoir that he had read during his stays at

Gateshead, and an enthusiastic appreciation of the woodcuts, but also described his meetings with Bewick and the stay in Buxton, complete with his rendering of the old man's rough dialect and his lyrical appreciation of the charms of his 'darling daughter'. Jane recoiled from this invasion of her privacy and from the unconsciously patronising tone, writing coolly that she had erased all the 'erroneous passages' as well as those relating to herself. She was sure, she said, that Dovaston would see that however much she valued his good opinion 'it could not but be highly hurtful to my feelings to have my name brought before the public'. She and her sister Isabella would never be satisfied with any of the descriptions of their father that they read, against which Jane invariably scribbled 'Nonsense', especially truthful ones that acknowledged his quarrels as well as his generosity and genius.

In June 1830 the twenty-one-year-old Atkinson read a paper on Bewick to the new 'Natural History Society of Northumberland, Durham and Newcastle upon Tyne'. He was speaking to an audience who owed much to the old man. Among other early members of the Natural History Society were Proctor, with whom Atkinson went birdwatching in the Shetlands, Richard Wingate and John Laws, who explored the Farne Islands together and exchanged comic letters in verse, and the two young Hancock brothers, Albany and John. To the ornithologists of his day Bewick was a hero: when Wingate and John Hancock discovered a new species of swan in Northumberland it was officially named, in 1830, by William Yarrell. He called it *Cygnus bewickii* – 'Bewick's Swan'.

Atkinson spoke as an admirer and a naturalist, close in time, his appreciation of Bewick uncluttered by critical jargon. 'His power of giving each characteristic of animals, even at a distance, was extraordinary,' he noted: 'it is exemplified in his distant flights of birds, which can always be recognized; and when he gives to them any cause of

excitement they are highly entertaining.' As an example he cited the apparently simple vignette of two cows drinking, 'above which we have most intelligibly depicted the futile attempts of a hawk to make his escape from the buffetings of two tyrannical crows; the magpies, like schoolboys, only being there to see the fun'.

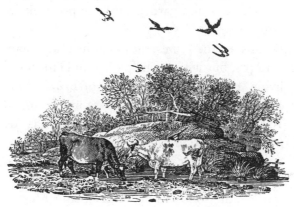

After Bewick's death Robert took on no more apprentices and the engraving trade dwindled: 'we keep most of the Old Customers yet, but I think it will be likely to decrease rather than increase,' young William Bewick told his brother in 1830. Jane, Isabella and Elizabeth intervened as much as their diffident and uncertain brother would let them. Jane dealt with orders and correspondence and undertook all negotiations with Longmans, writing to Robert from London with firm instructions on domestic life as well as business: 'have you found the chain in the Cupboard above the Kitchen closet, & do you padlock & chain the yard Gate every night?'

As business became more predictable and less creative the sisters gradually withdrew, living on the income from Bewick's modest investments, meeting their many women friends. They enjoyed them-

selves a great deal in their middle age, going on holiday to the Lake District with the Hancock family, painting watercolours and working at their lace and crochet. 'I have just completed you eight night caps,' Jane once informed Elizabeth. They took the waters at Buxton and Cheltenham, where Jane was a trenchant critic of silliness but enthused over good food and gardens and shopped like a zealot for shawls and silk dresses.

Robert never finished the *Fishes*, although he made many exquisite sketches in the 1840s, but with the help of John Hancock he did publish the last 'living' edition of *The History of British Birds* in 1847, with fine impressions of the woodcuts. More important, Robert had his own art. To later generations he became known as the last great piper of the old Northumbrian tradition. In the late 1840s, the artist William Bell Scott – who later included Bewick among his murals of Northumberland worthies at Wallington – saw Albany Hancock advancing towards him, 'followed by a heavy, slouching, able-bodied countryman, as I thought, about 55 or so, with an absent bewildered expression of face, the snow still lying white on his penthouse eyebrows. This was Robert, the son of Thomas Bewick.' Scott was attracted by his diffidence and although some people blamed Bewick's autocratic ways for his son's shyness, 'between the rough honesty and simple manners of Robert Bewick and his father's genius', he wrote, 'I found a close relationship'. Later he was invited to a friend's house to hear Robert play:

He appeared carrying the union pipes under his arm, accompanied by two old fashioned maiden sisters; but when the time arrived for his performance, he seemed as scared as some men are who have to make a public speech, and was evidently inclined to run away. Our host, however, who knew him well, proposed that he should tune his instrument on the landing outside the drawing room door, which was a formula he appeared to understand; and after tuning

he played there, and we heard him perfectly, and applauded him much. The ice thus broken, he soon gained confidence, re-entered the room, and walked about excitedly playing scotch airs with variations in the loveliest manner on that most delicate of instruments.

Robert died in July 1849, aged sixty-one. At the end of her life, Isabella gave his pipes to a local school, 'as Miss B— would like to have them taken care of, as they belonged to a near and dear relation of hers'. His manuscript books of songs and variations, like those of his master Peacock, are now regarded as priceless.

With Robert gone, the family's connection with the workshop ceased. It was almost ninety years since Ralph Beilby had founded his business, and by now the Newcastle of Bewick and Beilby was drastically altered. The fine streets and facades of Grainger Town marched up the hills behind the old markets and quays, and the arches of the railway station covered the Forth, where the Bewick children had played under the lime trees. The fields that Bewick looked out over at Gateshead were slowly swamped by bricks and the station was at the bottom of West Street – handy for Robert and his sisters when they set off for London or southern spas.

The woodblocks, drawings, proofs and tools remained in the house at Gateshead, where the Bewick sisters became keepers of the hoard. In 1851 John Gray Bell's *Descriptive Catalogue* galvanised collectors and ten years later Jane was finally persuaded to edit the *Memoir* for publication, helped (although she did not always see it that way) by her relation and printer, Robert Ward. Much was lost, as Jane scrubbed out lists of Bewick's friends, struck her pencil firmly through his Deism, cut his more vehement political onslaughts and ruthlessly expunged all mention of the apprentices. She was determined to immortalise her father as the lone reviver of wood engraving. Before

Bewick died, George Atkinson had tried to find out about the contribution of the apprentices to the *History of Birds*, but Bewick could only come up with a handful of cuts that they had done and turned to his daughter – 'Jane, honey dost thou remember any more?' She did not. John Jackson made the first attributions in 1839, drawing up a list that has been adjusted ever since. And readers had to wait until 1975 to read the original text of Bewick's *Memoir*.

Elizabeth, Bewick's 'dear Bessy', grew increasingly frail. In 1858 she was in the care of the distinguished Dr Macintosh of Dinsdale Park, Darlington, 'excited and confused': she died of a disease of the liver in 1865, in 'The Park Retreat', a Yorkshire asylum. Jane and Isabella stayed on at Gateshead, surrounded by their father's portraits, going over old times and wondering what to do with all the papers and proofs. Feeling that Bewick had not been sufficiently recognised in his home town, for a long time the two old ladies rejected all suggestions of local galleries or archives. In 1873, Sidney Colvin, the Slade Professor of Fine Art at Cambridge, tried to persuade Jane to leave these to the Fitzwilliam Museum. Eighteen months later she wrote a firm note on his letter: 'British Museum or *National* Gallery – rather inclining to the former.' When Jane died in April 1881 at the age of ninety-four, Isabella gave two large scrapbooks of drawings, watercolours and proofs to the British Museum. Two years later, just before she died aged ninety-three, she weakened and allowed her executors to decide where the rest of the material should go. She had already given part of Bewick's library to the Natural History Society and the prints, drawings and portraits followed, eventually to be housed in the Hancock Museum.

Bewick's reputation was at its height in the later nineteenth century: Ruskin said that he knew no drawing as subtle since the fifteenth century, except Holbein's and Turner's, and that 'the execution of the

plumage in Bewick's birds is the most masterly thing ever done in woodcutting; it is worked just as Paolo Veronese would have worked in wood if he had taken to it'. His work was also still much loved by the landed gentry and farmers: in August 1858, the brewer, farmer and artist Samuel Lucas wrote to a friend to thank him for a pamphlet on owls. Describing the birds he had seen, he turned to Bewick's books, which he had inherited from his father, eagerly comparing the delicacy of cuts in different editions: he had duplicate copies but would part with none, he wrote, 'except to my children'.

Styles of book illustration, however, had changed by the 1860s, as reproductive engraving increasingly took the place of original work and Bewick's direct influence faded. Instead it ran like a deep stream underground, to surface again in the great revival of wood engraving in the early twentieth century, particularly in the work of Paul Nash and Eric Ravilious, of whom it has been noted that his 'brilliant inventive use of textured and patterned surfaces and his delicate, precise cutting, unprecedented in his own time, are reminiscent of Bewick'. Fellow craftsmen have always appreciated Bewick's skill, from W.J. Linton in 1889 to Reynolds Stone, Joan Hassall and Gwen Raverat, who discovered the book as a child on a rainy afternoon in Cambridge and longed, above all things, to be Mrs Bewick:

Surely, I thought, if I cooked his roast beef beautifully and mended his clothes and minded the children – surely he would, just sometimes, let me draw and engrave a little tailpiece for him. I wouldn't want to be known, I wouldn't sign it. Only just to be allowed to invent a little picture sometimes. O happy, happy Mrs Bewick! thought I, as I kicked my heels on the blue sofa.

For a century, Bewick's work was often a child's first introduction to studies of animals and birds, from Frank Edgeworth treasuring the *Quadrupeds* in the 1790s, to Charlotte Brontë copying the cormorant

and Charles Kingsley admiring his broad flowing rivers, and on to the eighteen-month-old Virginia Woolf, described by Leslie Stephen in a letter to his wife in 1883: 'Ginia most affectionate. She sat on my knee to look at Bewick & every now & then said Kiss and put her cheek against mine.'

Bewick is a rare artist in that he speaks directly both to adults and to children, who respond at once to his small scenes. Today, we recognise him as an artist of true originality and an engraver of unsurpassed skill. His unpretentious tailpieces of travellers and farmers, streams and windy moors, make the past live, and his woodcuts of animals and birds let us share his own wonder at the human and the natural world, from the 'Mufflon Zebu' to the swallow sweeping through the northern skies.

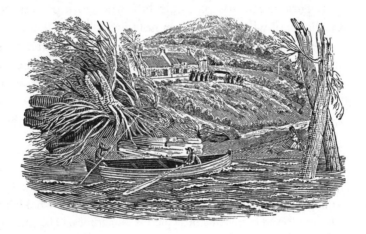

Bewick's art is universal, but it is rooted in Northumberland and in the valley of the Tyne. All his life he walked the banks of the river and he knew it in all its moods, sleepy under early morning mist, driving on in flood, ruffled by wind. In woodcut after woodcut he had

returned to the difficulty of crossing such waters – the small boy scrambling over a tree branch, the pedlar carrying his wife and baby, the blind man tiptoeing over the plank, guided by his dog. The great river flowed through his art, and at the end it was waiting for him still. Bewick thought of Cherryburn as 'the place of my nativity', but also as the place where he discovered drawing and nature, and as the scene of his final departure. The last vignette he engraved, according to Jane, shows a coffin, followed by a small procession, being carried from the house on the hill down to the river to be rowed across to Ovingham. It is winter and the leafless branches bend in the wind as the boat waits on the water, ready to carry its cargo to the shades. The rough, strong strokes of the woodcut reveal the stiffness of Bewick's elderly hands, but they conjure the moment for us still, across the currents of time.

ACKNOWLEDGEMENTS

One of the many enjoyable aspects of working on Bewick has been the friend-ship shown to me by scholars in the field. My first debt is to Iain Bain, who has lent me transcripts of countless letters collected over many years, taught me about printing, paper and ink and the lovely Northumbrian pipes, and con-stantly clarified muddles and made me laugh. He has also assisted with the illustrations, providing several from his own collection: it is hard to express adequate gratitude. I would also like to thank Sue Bain for warm welcomes and good conversations. Another pleasure has been working alongside Nigel Tattersfield, whose meticulous three-volume catalogue of works illustrated by the Bewick workshop is currently in the press: his knowledge is unparalleled and I hope that my notes bear witness to how much I owe to him. In Northum-bria, David and Alisoun Gardner-Medwin have been generous hosts: David has followed up elusive clues in local archives and illuminated many dark cor-ners, historical, topographical and ornithological. June Holmes, Secretary of the Bewick Society and Archivist of the Natural History Society, has proved a fund of information, and has also helped with illustrations. I am grateful to all of them for their comments and corrections, enthusiasm and encouragement.

Among the many curators and librarians I would particularly like to thank are Sheila O'Connell of the British Museum Department of Prints and Draw-ings; Dilys Harding and then Kath Cassidy of the Local History Collection, and Anna Flowers of Tynebridge Publishing, Newcastle Central Library; Sue Crabtree, Special Collections, University of Kent; Melanie Wood, Robinson Library Special Collections, University of Newcastle; Elizabeth Rees, Tyne & Wear Archive Services, and Andrew Russell, National Art Library, Victoria

and Albert Museum. Thanks, too, to all the archives and institutions who have granted permission to quote from unpublished material or to reproduce illustrations, and to individual owners, especially Graham Carlisle, Hugh Ford, The Hon. Hugh Gibson and Graham Williams.

This book has gained immeasurably from the production and design skills of Kate Ward and Ron Costley at Faber. I am also grateful to Julian Loose for his perceptive editing, to Stephen Page for his encouragement, Henry Volans for his comments and help and Anna Pallai for her warmth and skill. In addition I have benefited from the copy-editing of Wendy Toole, the proofreading of Peter McAdie, the index by Diana LeCore and the map by Reginald Piggott. I would also like to thank Deborah Rogers in London and Melanie Jackson in New York, and Jonathan Galassi of Farrar, Straus & Giroux.

My thanks also go to the members of the Bewick Society, particularly Hugh Dixon of the National Trust, who kindly arranged for me to see the Cherryburn collection, and Sarah Walter who guided me behind the scenes at the Laing Art Gallery, and also Frank Atkinson, David Gray and Felicity Stimpson. For individual insights, I am grateful to David Bindman, A. S. Byatt, Hugh Cunningham, Diana Donald, Mary Evans, Bill Griffiths, Stephen Hall, Shirley Hughes, Robert Poole, Alison Samuel, Angela Thirlwell, Stella Tillyard and Peter Firmin. John Barnard has been an unfailing resource on the book trade and my friend Hermione Lee, as always, has kept me going from start to finish. Finally, I have explored Northumbria with Steve Uglow in snow and sun, with great delight: I cannot imagine writing without his support, or without the amused toleration of our grown-up children, to whom this book is dedicated.

A Note on the Text
All quotations follow the spelling and punctuation of their source. There is a current debate about the correct style of naming animals and birds: I have followed the camp who prefer lower case rather than capital letters for the names of species, except where they are capitalised in the original quotation.

WORKSHOP APPRENTICES

For information on the workshop time of apprentices, their backgrounds and later careers, see Bain I 220, Appendix 1, and his *ONDB* article 'Thomas Bewick: Apprentices'; Angus; and Tattersfield I, Part II, chapters 3–17.

David Martin, b. Gateshead, bapt. 29 March 1755. App. 1773–80. Moved to Sheffield. Emigrated to America 1795. d. 1796

Abraham Hunter, bapt. Halton Shields, 11 March 1759. App. 3 April 1777–1782. Set up own workshop in Newcastle, 1786. d. 1808

John Bewick, b. Eltringham 1760, App. 1777–82. Successful wood engraver in London, esp. children's books. d. 1795

John Laws, b. Heddon Laws, 1765. App. 1782–89. Left workshop 1790. Silver engraver and farmer. d. 1844

John (Jack) Johnson, b. Rogerly nr Stanhope, Co. Durham. Pupil 1781, App. 1783–90, then journeyman. d. 13 September 1794

Robert Johnson, b. Ovingham September 1771. Pupil 1784, App. 23 August 1787–23 August 1794. Watercolour artist and drawing master. d. 1796

Charlton Nesbit, b. Swalwell, Co. Durham, September 1775. App. August 1789–22 August 1796, engraver in London. d. 1838

Henry Barnes, b. 1777. App. April 1791, left 1794

John Anderson, b. Aberdeenshire 1775. App. 10 September 1792, left 1795. Engraver in London, emigrated (?) 1805. d. ?1808

Henry Hole, b. Newcastle 1782. App. 24 March 1794–3 October 1801. Engraver in Liverpool, then Devon landowner. d. 1852

Charles Hickson (Hixon), b. London 1779. App. 1795 to 1800

Luke Clennell, b. Ulgham, nr Morpeth, 1781. App. 8 April 1797–April
1804. London engraver, painter. Breakdown, 1817, d. 1840

Mark Lambert, b. Fourstones, nr Hexham, 1781. App. c. June 1797–1804,
copper engraver, Newcastle. d. 1855

Edward Willis, b. Swalwell, 1784. App. July/August 1798–17 August 1805.
Left for London 1809, returned to workshop 1814–1817. d. 1842

John Harrison (Bewick nephew), b. Hedley July 1785. App. 1802–9, copper
engraver. d. May 1818.

Robert Elliot Bewick (son), b. 1788. App. 26 May 1804–26 May 1810,
partner 1812. d. 1849

Isaac Nicholson, b. Melmerby, Cumberland 1789. App. 18 August 1804–6
July 1811. Independent engraver in Newcastle. d. 1848

George Armstrong, b. c.1799. App. 1804–6. Engraver in Newcastle

Henry White, b. London 1784. App. 29 November 1804–9 January 1808.
Successful engraver in London. d. 1851

John Bewick (nephew), b. Eltringham, 1790. App. Jan 1805. d. 1809

William Harvey, b. Newcastle 1796. Joined November 1809, App. 1810–17.
Wood engraver/designer, in London, d. 1866

William Bewick (nephew), b. Eltringham. App. 1811–18, copperplate printer.
d. 1832

William Temple, b. Newcastle 1798. App. August 1812–14 August 1819.
Engraver in London, joined family drapery business in Newcastle. d. 1837

John Armstrong, b. App. October 1813–20, engraver in London

Matthew Bewick (nephew), b. Eltringham, 1801. App. August 1817–24,
copperplate printer, left 1826. d. 1832

Thomas Young, b. Newcastle, App. June 1818–1825, journeyman

John Jackson, b. Ovingham, 1801. App. Jan–April 1819, returned April
1823–June 1824. Engraver in London. d. 1848

Alexander Reid, b. Leith, 1804. App. 1820, left 1824

James Revely, b. c.1801. App. August 1824–31. Independent wood-engraver

William Hardy, b. Wooler 1814. App. December 1827–34. Successful trade
engraver in London, d. post 1880

ABBREVIATIONS, SOURCES AND NOTES

ABBREVIATIONS

B	Bewick (family name)
JB	John Bewick
Jane B	Jane Bewick (daughter)
JD	John F. M. Dovaston
REB	Robert Elliot Bewick (son)
RB	Ralph Beilby
RO	Richard Oliphant
RP	Robert Pollard
SH	Sarah Hodgson
TB	Thomas Bewick

ARCHIVES AND SOURCES

Some archives, sources and published works are abbreviated in the notes as below. Otherwise a full reference is given the first time a source is mentioned in each chapter.

Surveys of archival holdings include Iain Bain's early pamphlet *Thomas Bewick, Engraver of Newcastle, 1753–1829: a Check-list of his Correspondence and other Papers* (1970) and his 2003 article 'The Correspondence of Thomas Bewick', *BS* 23–50. Around 2,000 letters (three-quarters to Bewick) are known to survive, largely relating to workshop business. Account books, cash books and engraving books are held in the Tyne and Wear Archives (1269/1–265), with three additional books in the Victoria and Albert Museum (1961/857–9). A bibliography by Peter Quinn is posted on the Bewick Society website www.bewicksociety.org.

Bain	Collection of Iain Bain
BM	Department of Prints and Drawings, British Museum, London
BL	The British Library, London

HL Henry E. Huntington Library & Art Gallery, San Marino, California: Box Mss
 HM17300–17354
JJ Coll John Johnson Collection, Bodleian Library, Oxford
Laing Laing Art Gallery & Museum, Newcastle upon Tyne
Leeds Wrightson/Batty archive, Leeds Public Library BW/N/IV
LL London Library
NCL Newcastle City Library
NEWHM Natural History Society of Northumbria, Hancock Museum, Newcastle
NHSN Natural History Society of Northumbria (publications)
NLP Newcastle Literary and Philosophical Society
NRO Northumberland Record Office
NTC National Trust, Cherryburn
Pease Pease Collection, Central Library, Newcastle upon Tyne
RLSC Robinson Library Special Collections, University of Newcastle
SRO Scottish Record Office
TWAS Tyne and Wear Archives, Newcastle upon Tyne; BEW Bewick Collection
V&A National Art Library, Victoria and Albert Museum, London: Boxes 86 JJ. 17,18

Beilby–Bewick Workshop archive (TWAS, V&A) CB: Cash Book; DB: Day Book;
L: Ledger; SB: Subscription Book; WEB: Weekly Engraving Book

ABBREVIATIONS FOR PUBLISHED SOURCES

AA: *Archeologica Aeliana*
Allen: D. E. Allen, *The Naturalist in Britain* (1966)
Angus: Alan Angus, *Thomas Bewick's Apprentices* (1993)
Ashraf: P.M. Ashraf, *The Life and Times of Thomas Spence* (1983)
Atkinson: G.C. Atkinson, 'Sketch of the Life and Works of the Late Thomas Bewick',
 NHSN *Transactions*, I (1831)
Bailey and Culley: John Bailey and G. Culley, *A General View of the Agriculture of
 Northumberland* (1797; 3rd edn 1813)
Bain: Iain Bain, *The Watercolours and Drawings of Thomas Bewick and his Workshop
 Apprentices*, 2 vols, 1981
'Bicentenary': David Gardner-Medwin, 'The Bicentenary of Thomas Bewick's *History of
 British Birds*', NHSN *Transactions* (2006 forthcoming)
Bookplates: Nigel Tattersfield, *Bookplates by Beilby & Bewick* (1999)
Boyd: Julia Boyd, *Bewick Gleanings* (1886)
BS: The Bewick Society, *Bewick Studies* (2003)
Brand: John Brand, *The History and Antiquities . . . of Newcastle upon Tyne* (1789)
Brand *Letters*: *Letters of Rev. John Brand to Mr Ralph Beilby* (1815)

Chatto and Jackson: W.A. Chatto and John Jackson, *A Treatise on Wood Engraving* (1839)
Colls and Lancaster: Robert Colls and Bill Lancaster (eds), *Newcastle upon Tyne* (2001)
Croal: Thomson David Croal Thomson, *Life and Works of Thomas Bewick* (1882)
Chronicle: *Newcastle Chronicle*
Courant: *Newcastle Courant*
CT: *Cherryburn Times: The Newsletter of the Bewick Society*
Dobson: Austin Dobson, *Thomas Bewick and his Pupils* (1884)
Dovaston: Gordon Williams (ed.) *Bewick to Dovaston, Letters 1824–1828* (1968);
 includes extracts from JD, 'Some Account of the Life, Genius and Personal habits of the
 late Thomas Bewick', *Magazine of Natural History* (1829–30)
Holmes: June Holmes, 'The Many Faces of Bewick', NHSN *Transactions* (2006)
Hughes: Edward Hughes, *North Country Life in the Eighteenth Century, 1700–1750* (1952)
Hugo: The Revd Thomas Hugo, *The Bewick Collector* (1866)
Hugo *Suppl.*: *A Supplement to the Descriptive Catalogue* (1868)
JB: Nigel Tattersfield, *John Bewick, Engraver on Wood, 1760–1795* (2001)
LB: *A History of British Birds*: Vol I, *Land Birds* (1797)
'Library': David Gardner-Medwin, 'The Library of Thomas Bewick', BS 51–72
Library Checklist: David Gardner-Medwin, *A Provisional Checklist of the Library of
 Thomas Bewick*: Bewick Society website
LHTB: M.A. Richardson, *The Local Historian's Table Book*, 4 vols (1844)
M: *A Memoir of Thomas Bewick, written by himself*, ed. Iain Bain (1975)
M (1862): *A Memoir of Thomas Bewick, written by himself* [ed. Jane Bewick] (1862)
Mackenzie: E. Mackenzie *Descriptive and Historical Account . . . of Newcastle* (1827)
Memento: *Bewick Memento, with an introduction by Robert Robinson* (1884)
Newcastle Museum: G.T. Fox, *Synopsis of the Newcastle Museum* (1827)
O'Connell: Sheila O'Connell, *The Popular Print in England, 1550–1850* (1999)
ODNB: *Oxford Dictionary of National Biography* (2005)
Pease Cat.: Basil Anderton and W.H. Gibson, *Catalogue of the Bewick Collection* (1904)
Raven: James Raven, *Judging New Wealth: Popular Publishing and Responses to
 Commerce in England 1750–1800* (1992)
Rejoicings: John Sykes, *An Account of the Rejoicings, Illuminations &c. &c. in Newcastle
 and Gateshead* (1821)
Robinson: R. Robinson, *Thomas Bewick, His Life and Times* (1887)
Roscoe: Sydney Roscoe, *Thomas Bewick. A Bibliography Raisonne of . . . Quadrupeds, the
 History of British Birds and the Fables of Aesop* (1953, 1973)
Select Fables: *Select Fables, by Thomas and John Bewick, 1784* (1820)
Sykes: J. Sykes *Local Records* (1833)
Tattersfield: Nigel Tattersfield, *Complete Illustrative Work of Thomas Bewick* (including
 Apprentices), 3 vols: I Biographical accounts, II and III Catalogue (2007 forthcoming)
Vignettes: *Thomas Bewick: Vignettes,* ed. Iain Bain (1979)

WB: *A History of British Birds*: Vol II, *Water Birds* (1804)
Watson: Robert Spence Watson, *The History of the Literary and Philosophical Society of Newcastle- upon-Tyne (1793–1896)* (1897)
Welford: Richard Welford, *Men of Mark Twixt Tyne and Tweed*, 3 vols (1895)
Weekley: Montague Weekley, *Thomas Bewick* (1953)
Workshop: Iain Bain, *The Workshop of Thomas Bewick: a pictorial survey* (1989)

PROLOGUE: A PLAIN MAN'S ART

xvi 'slovenly stamps'. Horace Walpole, *A Catalogue of Engravers* (1782) 4n.
— John Clare. Margaret Grainger (ed.) *The Natural History Prose Writings of John Clare* (1983) xxxviii.
xvii fingerprint. See Charles Rosen and Henry Zerner, *Romanticism and Realism* (1984). With thanks to Ron Costley.
xviii John Rayner, *A Selection of Engravings on Wood by Thomas Bewick* (1947), 21.
— 'this sublime'. M 208.
xix John Piper. John Piper, *British Romantic Artists* (1942).

I THE BANKS OF THE TYNE

4 'my late evening wadings'. M 10–11.
5 'broken or divided'. Ibid. 23.
6 'rented the eight-acre smallholding'. Agreement with Wrightson steward John Morpeth, 9 October 1751. Leeds Public Library, lease BW/N/IV/48, 29 October 1751. John Bewick's first wife was Anne Toppin, m. 1744, d. 23 June 1751. Bywell Parish records.
7 'snow storms'. Ibid. 8.
8 'Crook Wood etc'. Enclosure Act 1812, and Commutation of Tithes 1840: NRO.
— Bewick's grandparents. Thomas Bewick m. Agnes Arthur, 1709 in Kirkharle.
9 'tenant right'. See Hughes 113–51.
— Duke of Northumberland. The first Duke, 1716–86: M 33 n1.
— Progressive farming. J. Bailey and G. Culley, *General view of the agriculture of the County of Cumberland* (1794), and *County of Northumberland* (1813 edn). See also Norman McCord, *North East England: a Social and Economic History* (1979). Also Bewick notebook, TWAS 1269/254.
10 'I'll give as Much for them'. JB Snr to John Batty, 1 January 1760: Leeds. See Stephen Cousins, CT2, no. 9 (1995) 6–7, and E. Clavering, Leases: 11 November 1715, 29 October 1751, CT1, no. 5 (1989), 6–7.
— 'the Conveniences'. JB Snr to John Batty, 7 June 1760, Leeds. Bewick baptisms: Thomas 12.8.1753, Hannah 20.3.1755, Agnes 5.12.1756, Ann 25.7.1758, John 30.3.1760, William 5.4.1762, Sarah 23.3.1766, Jane 12.11.1769.
11 'lying for hours'. JD, *Magazine of Natural History* 9, September 1829, 314.

— 'lowsening his skin'. *M* 28.
12 'mostly intrusted to'. Ibid. 2.
— 'a senseless System'. (Mickley school) Ibid. 3–4.
14 'so very unguideable'. (Ovingham school) Ibid. 4–5, 10–15.
16 'uncommon or frightful exploit'. Ibid. 11.

2 NATURE AND DRAWING

17 'Hitherto'. *M* 19.
18 *'bonnyer & bonnyer'*. TB to C. Gregson 18 April 1803: Pease 371.
— 'The poor lad'. *Vignettes*, 18, 57a note.
19 'besides the King's Arms'. *M* 5.
— large block prints. Ibid. 105, 192–3. See O'Connell 87–8.
21 'pen & Ink'. Ibid. 5.
22 'screemed out so pitiously'. Ibid. 6.
— 'all that he had seen'. Atkinson Mss. NEWHM.2008.H3.1.
23 'Little Mathew Martin'. *M* 15.
— Joseph Priestley/Gilbert White. Timothy Priestley, *Funeral sermon for Joseph Priestley* (1805), 42; Richard Mabey, *Gilbert White of Selborne* (1999 edn), 20.
24 'Nation of pismires' / 'Tyrant' spider. *M* 20 .
25 He wept bitter tears. Jane B annotation, *LB* (1821) 110: V&A RC, N2–3.
26 'forgot himself over a Glass'. Ibid. 15.

3 THE COMMON

27 'As on commons'. W. Hutchinson, *View of Northumberland, Anno 1766* (1778), I 244, I 71, 258; Bailey and Culley 27–8.
28 Will Bewick/Anthony Liddell. *M* 24–6.
29 Farmers. *M* 32.
30 'the greatest rejoicings'. Brand II 531.
— 'great antiquaries'. Roger North, *Autobiography*; Hughes 14.
31 'Derwentwater's lights'. Welford II 174. See *M* 8.
— 'No more along the banks'. Robinson 7; see also *M* 232.
— 'Hawk, Glead, Falcon'. *M* 31–2.
32 Agnes and the Faa. 'My mother', Jane Bewick memo: TWAS 4388.
— Henry Bourne. H. Bourne, *Antiquitates Vulgares* (1725), ed. Brand (1776).
33 'any errand at Night' / 'I saw the Devil'. *M* 16–18.
34 'the crime of fornication'. 'Excommunication at Ovingham!' *CT* Vol. 3, No.7, 1.
35 'her well intended lectures'. *M* 37.
— George Parkin. Ibid. 88–90.
— 'very much amused'. Ibid. 30.

36 Punch and Toby show. Childhood memories, probably by Bewick's apprentice John Jackson, in William Hone, *The Every-day Book* II (1827), 1653–9.

38 'and among the rest'. M 34.

4 'BEILBY'S WILD LAD'

40 'I can only say'. M 36.

42 'perhaps from his having heard'. Ibid. 38.

43 The Beilbys. See J. Rush, *The Ingenious Beilbys* (1975) and *A Beilby Odyssey* (1987), and Nigel Tattersfield, 'Fresh Light on the Ingenious Beilbys', *BS* 73–84.

44 'the best master in the world'. M 40.

45 Bewick's library. Books included Nisbet's *System of Heraldry* (1722) and Edmundson's *Complete Body of Heraldry* (1780): MS lists, HL. See *Bookplates* 2, Library Checklist and 'Library'.

— 'canny lad'. RP, Mss 'Sketch of Three Apprentices', V&A 1956/3163; printed in *Newcastle Magazine*, October 1830, 464–6.

46 Joseph Barber, John White etc. Welford I, 181. For Newcastle printers and booksellers see R. Welford 'Early Newcastle Typography', *AA* 3 (1907) 127–9, Peter Hunt *The Book Trade in Northumberland and Durham to 1860* (1975, and Supplement, 1981), Peter Isaac, *Bewick and after: wood engravings in the Northeast* (1990).

48 Fifty years later. Charles Hutton, *Newcastle Magazine* (June 1822), 321–2.

51 A bill head. RLSC, Bell Collection, Book Trade Box, Hodgson file.

— William Bulmer. Ibid. See Welford 431–5, Peter Isaac, *William Bulmer; the fine printer in context* (1993) and RP 'Three Apprentices' 464–6.

— 'The first difficulty'. M 188.

52 'who was himself'. Ibid. 51.

— 'Slowly he mastered'. For Bewick's technique see Bain (1981) I, and M xxvii–xxxv.

53 'this I instantly resented'. M 57–8.

— 'I wandered in the fields'. Ibid. 43.

— 'Goody Coxon's'. Ibid. 51 n.3.

5 LIFE IN THE TOWN

54 'crown glass, bottles'. Joyce Ellis, 'The Black Indies', quoting Ralph Carr in the 1750s, Colls and Lancaster 5.

— 'the conversation'. E.J. Climenson (ed.), *Elizabeth Montagu: Her Correspondence 1720–61*, I, 149.

55 'to take no Scotsman born'. Brand II 342, 343, 349.

57 'employment more suitable'. Mackenzie, 731.

— Matchem. Charles Bird, 'Bewick and Animals', *CT* 4 No. 8 (2005).

58 'a main of cocks'. Chatto and Jackson 479. See George Jobey, 'Cock-fighting in Northumberland and Durham', *AA* 5th ser. (2002), 1–26.
— 'On cock-fight'. Thomas Wilson, *The Pitman's Pay: A Tale of 45 Years ago* (1843), 6.
— 'The Colliers and their Wives', Edward Chicken, *The Collier's Wedding* (5th edn, 1778).
59 'Music is an emanation'. *M* 74.
60 'the spirits being bouyant'. Ibid. 55, 41.
— Northumbrian pipes. 'The Folk Music of North East England', in W. Gilles Whitaker *Collected Essays* (1940), 38. With thanks to Iain Bain.
61 Billy Walker. Correspondence, *CT* 1, no. 9 (Autumn, 1990).
— Tyne flood. Mackenzie I, 62.

6 PRETTY HISTORIES

64 'My time of apprenticeship'. TB to RB [1772]. V&A 3252.
— 'Fumbling is ruinous'. George E. Mackley, *Wood Engraving* (1948, 1981 edn), 25.
65 Jean Papillon. TB to Matthew Gregson, 23 December 1790: Ford. See *M* 194, and Tattersfield I, ch. 1. *Traite Historique et Pratique de la Graveur en Bois* was written 1738, published 1766.
— *Pilgrim's Progress*. DB May 1776, TWAS 1269/12.
67 'Jack Whirler'. *The Idler*, 19 Aug 1758.
— 'Ball and Pincushion'. Advertisement of the 'Little Pretty Pocket-Book', *Penny Morning Post* (1744). Percy Muir, *English Children's Books* (1954), 65.
— John Clare. Margaret Spufford, *Small Books and Pleasant Histories* (1981), 4.
69 overlooked his piracies. Tattersfield I, ch. 5.
— Cuts for Charnley. DB 1767–72 TWAS 1269/11 and 12.
70 Small treasures. List taken from DBs 1776- 83, TWAS 1269/11–12, WEB 1269/41.
72 'furnish us with rules'. G. Grey *The Complete Fabulist* (1782).
73 'Strike him not, *Jenny*'. V. A. Dearing (ed.), *John Gay: Poetry and Prose* (1974), II 312.
75 'covered with a kind of Armour' / 'Exulting! with what Fire and Force'. *Tommy Trip's History of Birds and Beasts* (1867 edn).

7 'GOD GAVE THE EARTH TO YOU'

77 'the most valuable'. (Gilbert Gray) *M* 43–4.
78 small, cheap books. Dobson 36. G. Grey, *The Countryman's Treasure* (1780) BL; *The Complete Fabulist: a Choice of Moral and Select Fables* (1782): Bodleian.
— 'which to me was a kind of home'. *M* 52–3.
— Aesop. See 'Library', *BS* 54.
— 'a most active'. *M* 47.
79 'got myself into a labyrinth'. Ibid. 47–8.
— 'good Sons, Brothers'. TB to William Harvey: NRO.

— Nathaniel Bayles. (TB has 'Bailes') Welford I, 210–24. A.W. Woodruff, 'Thomas Bewick – his Life and Health', *Proc. of the Royal Society of Medicine*, 69 (October 1976) 777; *JB* 37–8.

80 Thomas Spence. M 52–3. See ODNB article by H.T. Dickinson, also Malcolm Chase, *The People's Farm: English Radical Agrarianism 1775–1840* (1988); P. M. Ashraf, *The Life and Times of Thomas Spence* (1983).

81 James Murray. Introduction to James Murray, *Travels of the Imagination* (1772).

— 'ringing of bells'. Welford I 212.

82 'Success to the brave Americans'. *Chronicle* 24 June 1775. The Constitutional Club was founded in 1772 during the Town Moor debate.

— 'the petition against the war'. *A List of the respectable Inhabitants of Newcastle who signed the Petition from thence, presented to the King on Wednesday November 3 1775*: RLSC, WCT 299. The names are listed in order of signature, including Joseph and Thomas Bulmer, Richard Swarley, John Kidd, Walter Cannaway, John Collier, Edward Humble, William Charnley, John Bell, William Turner, George Gray.

83 'Improvement'. Paul Langford, *A Polite and Commercial Society, England 1727–1783* (1989), 434.

— 'The poor man'. M 24.

85 Newcastle Philosophical Society. *LHTB* II 238.

— 'Tim Bobbin'. With thanks to Robert Poole: see *ODNB* article on John Collier Snr.

— 'By a majority of two'. *Chronicle* 30 Sept, 28 Oct 1775. The Rules of the Philosophical Society, 1777, and Spence's pamphlet, are in *The Reports, Papers, Catalogues etc of the Lit & Phil*, I: NLP. See also Kathleen Wilson, *The Sense of the People: Politics, Culture and Imperialism in England, 1715–85* (1995), 343–5, 348, 68.

— At sixty. M 93–4, 95.

86 the club expelled him. *Journal* 4 Nov 1775, *Chronicle* 25 Nov 1775.

— Alphabet. See DB 17 March 1775, 'Mr Thos. Spence Engraving a Plate with new Alphabet 16s. od. (bill not paid), TWAS 1269/11.

87 'The Parson's Rate'. T. Spence, *History of Robinson Crusoe* (1775).

— 'For instance'. John Collier, *An Alphabet for the Grown-up Grammarians of Great Britain* (1778), Preface.

8 NORTH AND SOUTH

91 'a very beautiful woman'. Jane B notes on correspondents, 1861: Laing. (Jane names her great-aunt as Harriet.) Sally Dicker baptism, 4 July 1765.

92 'The countenances of all'. M 59.

— 'Society for the Encouragement of Arts'. See D.G. Allan, *William Shipley, Founder of the Royal Society of Arts* (1968).

— 'flew from Ovingham'. M 42, 41.

93 Kit Gregson. Samuel More, n.d.; C. Gregson 12 February 1777: TWAS.
— 'remember man'. 'Library', *BS* 72.
94 'totally frozen'. *LHTB* II, 243 and Sykes I, 305.
— 'like a bird'. *M* 61.
— Betty Gregson. Revd C. Gregson, 20 April 1776.
95 'vapouring fops'. *M* 61. Quotes relating to Scottish journey are from *M* 60–68.
96 'I would have married her'. Ibid. 57–8.
98 '*affeared*'. Ibid. Quotes relating to London are from *M* 69–76.
— Kit Gregson was working. For London careers, see Tattersfield I, ch. 3.
100 Thomas Hodgson. *M* 42, n.1.
— hard to settle. TB to Elizabeth Hymers [November 1776]: draft, Bain.
101 'this poor fellow'. *M* 93.
— 'not much surpris'd'. David Martin, 29 January 1777: TWAS 4388. See *M* 75 n.2.
102 'I fancy if you had Dy'ed'. John and Jane B Snr, 15 March 1777: NTC.
— 'Such a Contest'. See vivid Trevelyan papers on the 1777 election: RLSC, WCT 299.
103 'It appeared to me'. Revd H. Miller (ed.), *Memoirs of Dr Robert Blakey* (1879), 36–7.
104 He told John Jackson. Chatto and Jackson 567.

9 PARTNER

106 'I think you would'. John and Jane B snr, 15 March 1777: NTC.
107 Andrew Picken, Dancing Master. DB November 1777, TWAS 1269/12.
— As December came. WEB 1777, TWAS 1269/41, and Rough CB 1269/10.
— *Isaaci Newtoni Opera*. Charles Hutton to RB, 6 March 1778: TWAS 4388.
108 'this whetted me up'. *M* 105.
— 'a Natural History of Quadrupeds'. TB to W. Fenwick, 10 November 1781 draft: Bain.
— 'dear Tommy'. RB, 5 May 1779: Bain.
109 'Rapid and Amazing'. William Gray, 16 August 1778. See *JB* 15.
— 'With my brother'. *M* 79.
110 'much caressed'. John Gray Bell, *Descriptive and Critical Catalogue* 10.
— George Gray portrait. Doubts have been raised by Bain, after comparison with later Ramsay portraits, but Holmes (Cat. 2) thinks it is Thomas: it was painted for Bewick's mother and hung at Cherryburn.
111 'Pompey be quiet'. *Universal Medley and Book of Pictures*, NTC A132.
112 'fine and far off'. See Bertram Glass, *The Border Angler* (1858), 27.
— 'I have Rafy with me'. TB to John and Jane B Snr, 12 November 1782: TWAS 4388.
— His first plan. David Gardner-Medwin, 'Thomas Bewick, the Barber surgeons and the "Cot" at the Forth', *CT* 4, No. 2 (Spring 2002).
113 moving house. Memorandum 11 August 1781, V&A 3252.
— Their sister Hannah. Hannah B 29 April [1782–3?], franked with sig. of Sir Matthew

White Ridley. Ridley papers at NRO note wages to Hannah, November 1781–March 1784. ZRI 47.5, and 13.
— 'the spectators'. [John Baillie] *Impartial History of Newcastle* (1801), 160–1.
114 David Martin. See David Martin to RB 18 November 1784: Bain.
115 'John should have return'd'. John Johnson, 31 December 1781: TWAS 4388.
— 'a great favourite'. *M* 196.
116 'indeed, in this way'. *M* 198.
117 'the decorative charm'. See Bain (1981), I 18.
— 'the tallest and straightest'. *M* 22.

10 'ESTO PERPETUA!'

118 Swarley's ticket. Robinson 60.
119 'Political writings & debatings'. *M* 93.
— 'I cannot but compliment you'. William Gray, 16 August 1778: Laing.
— Keppel 'Freedom' box. Laing gallery. See WEB 1779, TWAS 1269/43, *Workshop* 47.
120 'I suppose you have seen'. RP to TB, 8 March 1779: V&A 3258.
— 'a little Man'. RP to TB, 12 June 1779: NTC.
— ancient models. See e.g. Adam Ferguson, *Essay on the History of Civil Society* (1767).
— 'epidemic democratick madness'. Reginald Blunt, *Mrs Montagu 'Queen of the Blues'; her Letters and Friendships 1762–1802* (1923), II 92.
121 'the philanthropic . . . Major Cartwright'. *M* 154.
— 'pint of ale'. *M* 95.
— 'no fiddler, piper'. BL, Bell Collection I, 128, 29 November 1781; Brand, II 353.
122 'with his old tunes'. *M* 97.
— Brotherly Society Card. Robinson 60. Bewick was 'No. 32'.
— John Langlands. *M* 92. For Langlands and Robertson TWAS 1269/56–62.
— 'as its not in our Power'. RP, 27 February 1780: Watson.
123 a stonemason. TB to Philip Adison, 20 December 1780: Bain; TB to Mr Robinson, 22 September 1783: Pease 175: 2–3. With thanks to David Gardner-Medwin for location.
— monuments on rocks. *M* 185–6.
125 'Plague, Pestilence and Ruin'. C.M. Fraser, *ODNB*, and see J.C. Hodgson 'William Hutchinson', *AA* 3rd ser. 13 (1916) 166–83.
— Bewick wrote patiently. TB to William Hutchinson, 21 March 1786: Pease 172.
126 Even Ritson. See Nigel Tattersfield, introduction to Bodleian facsimile (2003), 11.
127 'yet on Mrs Beilby's account'. Brand, *Letters* 26–7.
— 'to pay his devotions'. William Hone, in J.C. Hodgson 'John Brand', *AA* 3rd ser. 14 (1917), *Bookplates* 72.
— 'Brand's Antiquarianism may lie'. With thanks to David Gray. See Brand *Letters* 27–8.
128 Henry Grattan. Eamon de Valera quoted Grattan as President of Sinn Féin in 1917.

11 WALKING

129 Walking. See Donna Landry, *The Invention of the Countryside: Hunting, Walking and Ecology in English Literature, 1671–1831* (2001).

— 'P.G. a hungry chap'. Mss notebook, Pease: 'Printed by J. Saint for M. Vesey and J. Whitfield, 1778': Pease 446. See Boyd 32–4. Vesey had now moved to Newcastle.

131 'The high villages'. W. S. Gibson, *A Memoir on Northumberland* (1860), 6.

— 'This is the short'. M 82.

132 'want of strength'. TB to John and Jane B Snr, November 1782: TWAS 4388.

— 'poignant grief'. M 100 .

— 'Charity to a dum man'. Boyd 34.

— 'often partly dug out'. TB 21 December 1826, *Dovaston* 93.

— '& would be happy'. RP 22 April 1781: V&A 3258.

133 Holy Island trip. M 101–2, and see TB to Mr Younghusband 27 June 1785: Pease 371.

134 'facing then the snow storms'. Cherryburn walks, M 81–4.

135 John Cowie. M 31.

136 'To be placed'. M 81.

137 'The Dyers of Ovingham'. Jane B commentary on vignettes, 4 November 1869: Bain.

139 Family deaths and premonitions. M 85–90.

140 Hannah Bewick. m. William Chambers 4 August 1784, St Mary's Marylebone.

12 BELL AND JOHN

141 'the most delicious beverage'. M 83.

142 'her character'. Ibid 109.

— 'Oh! Sir, guide'. *Natural History Magazine*, September 1821, 314.

— Her father / family history. Jane B. 'My Mother', TWAS.

— 'being of a very active'. Family memo, 'TB's courtship', V&A 3265.

— 'Let Virtue be a Guide to you'. See Tattersfield I, ch.5.

145 'every Seam'. TB to William Wrightson, 26 March 1789: draft, Pease 371.160.

— 'as bad a fellow'. Jane B notes on correspondence,1861: Laing.

— 'any thing I can do'. Cash account for A. Snowdon, 18 April 1783, V&A 3252.

146 'I mean to pay'. TB to JB July 1787: draft, Bain.

— 'It blow'd'. JB 16 August 1786, ms Dobson, sold Sotheby 28 March 1983.

147 Stubbs. JB 9 April 1788.

— 'It appears'. JB 7 June 1787: TWAS 4388.

148 'add one more'. TB to JB 9 January 1788: TWAS 4388.

— ''tho its like buying'. JB 24 July 1787: TWAS 4388.

— John's designs. See letter from Joan Hassall to Susan Doncaster: Pease 615.

149 'I am much pleased'. TB to JB, 9 January 1788: Pease.

— 'as I can work'. JB 1 November 1787. See 19 February, 9 April, 29 May 1788.

150 'to forget a wrong'. JB 30 September 1788: Bain.
— 'I do assure you'. JB 9 April 1788, 4 January 1789: TWAS 4388.
— 'there is not a young fellow'. JB to Thomas Dobson 10 August 1788: Pease 178–9.
151 'to see all the Paintings'. JB 4 January 1789: TWAS 4388.
— Lunardi. Tues September 19 1786, Brand II 553, *LHTB* 307–8.
152 'two sparrows'. *Courant* June 1787.
— 'My compl.' JB 30 September 1788: TWAS 4388.

13 AMONG THE ANIMALS

153 'An anxious desire'. TB to W. Fenwick 10 November 1781: draft, Bain.
154 'a creature of mettle'. Geoffrey Grigson, *Horse and Rider: Eight Centuries of Equestrian Painting* (1950), 11. For Matchem see *Chronicle* 24 Feb 1781.
155 Voyaging to Australia. Harriet Ritvo, *The Platypus and the Mermaid* (1997), 1.
156 Classifying. See David Knight, *Ordering the World: A History of Classifying Man* (1981).
157 'Such Animals'. M 106. Smellie's abridgement is William Smellie, *Natural History: General and Particular*, 9 vols (1780–5).
— 'he most ardently'. Ibid.
159 'it may perhaps'. TB to Fenwick Bewick, 6 January 1786: ms Dobson, sold Sotheby 28.3.1983.
160 'want of knowledge'. *Quadrupeds* 120.
— Bewick bought the antlers. Robinson 80–1.
— 'The 2 Curious old Books'. TB to William Hutchinson 21 March 1786: Pease 172.
— 'I have not seen any thing'. JB 7 June 1787: TWAS 4388.
161 'very beautiful'. Quoted in Keith Thomas, *Man and the Natural World* (1983), 277.
— 'show'd yours'. JB 1 November 1787: TWAS 4388.
162 'a large Collection'. TB to JB 9 January 1788: Pease 174.
— 'Royal Numibian Lion'. *Chronicle* 3 May 1788.
— 'exhibited at Newcastle'. *Quadrupeds* 185.
— 'This Country'. Richard Oliphant, 15 March 1790: V&A 3259.
— His brother. Jane B notes, 1861. Laing.
163 Thomas Hornby. M 107.
— print run. See Roscoe 5, and for comparisons, Raven 34–6. The next three editions had runs of roughly the same size, amounting to 6,000 demy, 1,000 royal by 1800 (over 14,000 by the last 'live' edition. of 1847, Nigel Tattersfield).
— 'could hardly stand'. Iain Bain 'The Quadrupeds – A Bicentenary', *CT* 1, No.7 (Spring 1990), 2.
164 'A concise Account'. Proposals, 2 April 1788; Bain I 25.
— 'the most industerous'. JB 9 April 1788: TWAS 4388.
— 'Make no ceremony'. RP [n.d. after 1786]: V&A 3258.

165 'as to your saying'. JB 29 May 1788: TWAS 4388.
— 'for the Use of Youth'. TB to Samuel More 22 May 1788, TWAS 4388.
— 'Considerable progress'. TB to Samuel More n.d. [1788]: TWAS.
166 'an occupation'. Rashleigh Holt-White (ed.), *The Life and Letters of Gilbert White* (1901), II, 177.
— 'like a school boy'. Richard Mabey, *Gilbert White*, 204.
— 'if your language'. JB 4 January 1789: Laing.
167 'Marmaduke Tunstall'. G. T. Fox, *Memoirs of Marmaduke Tunstall esq, and George Allan esq* (1827), M. J. Boyd and L. Jessop, 'A "truly amiable gentleman"', *Archives of Natural History*, 25 (1998), 221–36. Copies of Tunstall's notes are in NHSN.
— 'once the unlimited rangers'. Marmaduke Tunstall to Sir Joseph Banks, 20 June 1790: Ford. See Tunstall to RB and TB, 6 November 1788; 11 February 1789; 15 July 1789: *Newcastle Museum*.
168 'looking wildly'. *Quadrupeds* 35.
— 'ventured myself'. TB to Francis Douce, n.d. 1795: draft, Bain.
— 'driven to seek shelter'. M 110 For this print see the lengthy discussion in Tattersfield III.
— 'massive power'. Simon Schama, *A History of Britain 3, 1776–2000* (2002), 96.
169 'In this state'. M 136.
170 'New South Wales Wolf'. RP 24 October 1789: V&A 3258. Preliminary drawings for *Quadrupeds* are in BM, NHSN, Pease and Laing.
— 'on Mr Hodgson seeing this'. M 106–7.

14 *QUADRUPEDS*

173 One critic. Harriet Ritvo, *The Platypus and the Mermaid* (1997), 23.
174 'those which so materially'. *Quadrupeds*, Advertisement, 2 (all quotations 1797).
170/180 animals: Ibid. Fox 276, Mastiff 307, Baboon 421, Foumart 229–30, Newfoundland 26–7, Otter 453, Weasel 218, Goat 69, Dog 296, Badger 259, Bear 263–4.
182 'fellow mortals'. Humphry Primatt, *The Duty of Mercy and the Sin of Cruelty to Brute Animals* (1776), 7, 92.
186 Frank Edgeworth. Edward Ford to Jane B 1 June 1865: V&A 3261.

15 FROM FUR TO FEATHERS

189 'We have never heard'. *Critical Review*, 70 (1790), 414–5. For Bewick's celebrity see John Brewer, *The Pleasures of the Imagination*, 499–530.
— George Byles. M 108
190 Beilby's brothers. Tattersfield I, ch. 6.
— Sutton Sharpe. JB 16 June 1790: NHSN *Transactions* (1878).
— major periodicals. *Analytical Review*, VII (1790), 284–8; *English Review* XVI (1790), 270–3; *Monthly Review* NS III (190): Tattersfield I, ch. 6.

— Charles Dilly. JB 4 December 1790: Pease 174.
— 'the Animals printed'. JB 16 June 1790: NHSN *Transactions* (1878).
— 'much superior'. Matthew Gregson [1790]: Bain.
191 'The work has met'. TB to Matthew Gregson, 23 December 1790: Ford; TB to
 Samuel More, 22 December 1790: draft, Pease 175.
— 'fine wove atlas vellum paper'. Roscoe 6, Hugo.
— workshop profits. See Tattersfield I, ch. 6.
— 'as to its appearing'. JB 4 December 1790: Pease 174.
— Isabella's christening. Jane B notes, 1861. Laing. See RO, 15 March 1790, V&A 3259.
192 'I cannot help admiring'. JB 4 Decenber 1790: Bain.
— sell them the lease. CB 13 Aug 1790, TWAS 1269/2.
— On 2 September. RB 2 September 1790: Bain. For the furnishing see Tattersfield I, ch. 6.
193 'I never thought'. TB to RB December 1790: draft, V &A 3252.
— Richard Oliphant sent. RO 22 February 1791: V&A 3259.
— 'Truffle Dogs'. JB 20 March 1791: Bain.
— 'they are much admired'. Thomas Pennant 4 May 1791: National Library of Wales.
— 'as I consider'. John Mackenzie 13, 22 April, 1791: Pease 175: 17, 18.
194 'I believe we must'. RB 30 September 1790: Bain.
— 'with these I had long been'. *M* 116. Books include: R. Brookes, *A System of Natural
 History*, 6 vols (1783); John F. Miller, *Various Subjects of Natural History* (1785);
 Eleazar Albin, Pierre Belon, John Ray, *The Ornithology of Francis Willughby* (1678).
195 'Walked to Wycliff'. Notebook, TWAS 1269/54.
— 'and yet these three'. *M* 118.
196 *Annual Register.* Allen 30.
— 'looking thro *part*'. TB to RB 24 August 1791: ms Dobson, sold Sotheby 1983.
 Copies of Tunstall's annotations of Pennant are in the NHSN library.
— He looked at works. 'Notes on illustrated books seen at Wyclif', TWAS 1269/54.
 These include George Edwards, *Natural History of Uncommon Birds* (1743–5;
 3 suppl. vols to 1764) and *Gleanings of Natural History* (1743–51); John Latham,
 General Synopsis of Birds, 3 vols (1781–5), Thomas Pennant, *Genera of Birds*, (1773)
 and *Arctic Zoology*, 3 vols (1784–7).
197 'I mean for the figures'. TB to RB 24 August 1791: Dobson, sold Sotheby 1983.
— But while he was at Wycliffe. Some foreign birds appeared in 1805 and later editions.
 See Peter Davis and June Holmes, 'Thomas Bewick 1753–1828), Engraver and
 Ornithologist', *Archives of Natural History* 20 (1993), 175–9, and 'Bicentenary'.
— 'rather inconveniently situated'. TB to RB 24 August 1791: Dobson.
198 variolation. Jane Bewick memo (Laing), and for inflamed eyes, Robinson 239. My
 reasoning follows Tattersfield I, ch. 8, n.35, based on the opinion of Dr Denis Gibb:
 with thanks to them both.
— 'I never opened'. TB to Isabella B, 8 August 1791: Bain.

— 'I have dulled myself'. TB to Isabella B, 24 August 1791: NLP.
199 'that little earthly paradise'. *Water Birds,* Advertisement.
— 'I can imagine'. TB to John Goundry: 28 October 1791. Croal Thomson 166.
— 'very great difference'. *M* 122.
— 'This place abounds'. RO 29 March 1791: V&A 3259.
— 'I cannot hope'. TB to unnamed London bookseller 2 July 1791: draft, Pease 175: 19.
200 The great books. 'Library', *BS* 59–60.
— 1792. Apr 4. TWAS 1269/135. Gardner-Medwin suggests the Buffon is the *Planches Enluminées,* borrowed from Michael Brian. Some Wycliffe books were sold in 1797. See Library Checklist 119, 120.

16 'YOUR LADS'

201 'Teething'. RO 29 March 1791: V&A.
— 'I am seldom'. TB to Mr Jameson, 22 February 1792: draft, Pease 175: 26.
— 'got him broken'. Atkinson MSS.NEWHM.2006.H3.1.
202 'I have quite set'. Matthew Gregson, 13 February 1791: Bain.
— Thomson's *Seasons.* TB to Mr Jameson, 22 February 1792: draft, Pease 175: 26.
— 'delay in the execution'. William Bulmer to TB 20 Jan 1794: TWAS.
204 'I cannot help thinking'. JB to TB 16 June 1794: Bain See *JB* 137–8.
— 'if you wish to immortalize'. JB 13 July 1794: Bain 159–63.
— *Ostervald's Bible. The Holy Bible; or, Christian Library . . . with practical observations on each chapter, by the late Rev. Mr. Ostervald.* In later editions most plates were engraved by Fittler (Philip Loudon Slager). See *JB* 11. (An earlier 1782 edition became the Bewick Family Bible. NEWHM:1997.H42 Hancock Museum.)
— 'liable to severe Penalty'. RP 16 March 1791: V&A 3258.
205 'Your acceding'. RP 16 March 1791, 5 October 1791. V&A 3258.
— 'as I cd of got yr. Brother'. RP 25 February 1792: V&A 3258.
— Always concerned. CB 1787–179. T &WA 1269/2.
206 Poor House: TB to 'Revd Sir', n.d. Pease 175: 31. Jane B, in notes 1861, confuses this with Robert Johnson's parents.
— Dr James Anderson·. TB to Dr James Anderson, n.d. [1792]: draft, Pease.
— 'to the great injury'. Weekley 144–5. Committal paper for panel of arbitration, and John Anderson to Robert Johnson, 9 October 1795, Bodleian, JJ Coll. Bewick Boxes 1 and 3. Nesbit and R. Johnson were witnesses. For later career, Tattersfield I, ch.13.
208 'Isaac Dixon'. RLSC, Bell Collection, Book Trade Box Johnson file.
— The court decreed. CB 30 March, 26 November, 24 December 1796, TWAS 1269/4. The total costs were £32 7s. 5d. (Bute eventually paid 15 guineas.) See Robinson 252–4, Tattersfield I, ch. 7.
— 'with every pains'. *M* 78–9.

209 'smother & suppress'. JB to Miss B. n.d.: pencil draft, Pease 175.
— 'I have wished much'. JB 4 December 1790: Pease 174.
— *Looking-Glass for the Mind*. See *JB* 122–4, for reissues, and pirated editions.
210 'Yr Brother John'. RP 7 March 1791: V&A.
— Paine, Library Checklist 248. Bewick owned nine of Spence's works.
211 '& am at present'. JB 22 October 1792: Pease.
— 'Your advice'. JB 31 March 1793: Pease 175.
212 'English fellowship'. Simon Schama, *Landscape and Memory* (1995), 183.
— keeping his pony. JB 13 February 1794: Bain.
213 But by the summer. JB 13 July 1794: Bain.
— 'Dear Charles'. Weekley 152n. For frontispiece see *JB* 104.
— All he wished. JB 23 August 1794: Bain.
214 'J. Johnson badly'. WEB 1791–7, TWAS 1269/40.
— 'great promise'. *M* 195.
— 'she (poor Soul)'. JB 7 December 1794: Pease.
— 'I wou'd with the greatest pleasure'. JB 3 March 1795: Bain.
215 'plan'd my garden'. JB June 1795: Bain.
— 'I hope to have the pleasure'. JB to Matthew Williamson, 18 June 1795.
— There he worked slowly. *Fabliaux, or Tales by Le Grand*, trans. by Gregory Lewis Way, 2 vols, 1796 and 1800: Somervile, *The Chase: A Poem* published by Bulmer in 1796.
— 'of its richest beauty'. JB 18 September 1795: Bain.
— 'whisper out my wants'. JB 11 November 1795: Bain.
216 'Dr Brother'. Ann Dobson 5 December 1795: Pease 371.

17 RED NIGHTCAP DAYS

217 In his preface. See also *M* 80 and William Bulmer 10 December 1795: TWAS. Bewick engraved his own memorial: 'In Memory of John Bewick, Engraver, Who died Dec. 5, 1795, Aged 35 Years. His ingenuity as a Artist was excelled only by his Conduct as a Man.' Illus. *JB* 59.
— 'Schedule of Sundry Effects'. JB Account book, TWAS1269/258, *JB* Appendix.
218 'Come down and get dressed'. Robinson 176.
— Miss Stevenson's seminary. Ibid. 186.
219 'the best spice cake'. Jane B 1 July 1796: HL.
— Molly Hencles. TB to Jane B 2 July 1796: HL.
— 'I hope to hear'. TB to Jane B 2 August 1796: HL.
220 'and as she always'. Jane B. notes, TWAS.
— 'manufactured every winter'. Robinson, 187.
— *Red nightcap day*. *M* 206.
221 a passionate letter. TB 20 April 1827, *Dovaston* 94–7. For Bewick as religious artist

see John Brewer and Stella Tillyard, 'The Moral Vision of Thomas Bewick', in Eckhart Hellmuth (ed.), *Transformations in Political Culture in late 18th Century England and Germany* (1990), 89–101.

222 'when the vital spark'. TB to RP, 29 January 1816: Laing.
223 Bewick respected Turner. *M* 113.
— 'a cheerful home'. Henry Holland, *Recollections of Past Life* (1872) 8–9.
— charitable donations: CB February 1800, TWAS 1269/5.
— 'my Mother'. Jane B memo, NTC 260 (catalogued as REB).
224 'the first is his habit'. Jane B 4 October 1807: HL.
— 'cash lock'd up'. TB to Jane B 27 September 1809: HL.
225 'Mrs Bewick used to say'. Robinson 76. Donation, CB 25 January 1792, TWAS 1269/3.
— 'derainged in her mind'. JB 23 October 1793, 13 February 1794: Bain.
226 'Religion, *British* Politics'. Watson, 25.
— Thomas Walker. Thomas Winstanley 2 July 1794: Laing.
227 'before I get the Birds'. TB to anon, 4 October 1794: *M* (1862) 339.
— David Martin. See Tattersfield I, Part II ch. 13.
— 'I frequently'. *M* 132–3.
228 Unicorn. *M* 134.
— 'superlatively wicked'. Quotations on the French wars are from *M* 136–7.

18 DAILY BREAD

229 Walter Trevelyan. W. Trevelyan to TB, 8 May 1790: V&A 3260.
— Accounting systems. Clearly described in *Bookplates*, 10.
230 'To see the rattlesnake'. See Margaret Ellison & Margaret Gill (eds.), *Thomas Bewick: Marginal drawings & notes* (1978).
— 'It would be inconvenient'. C.J. Clavering 19 January 1800: Bain.
— 'The doing of these Jobs'. TB to Miss Bailey 6 December 1814: Williams.
232 'Our Trust in God'. William Stevenson 8 December 1808: TWAS, BEW 330.
— 'only I should not wish'. Thomas Appleby 23 December 1812: Pease 175.
233 'he at first startled'. *M* 191: Proof in BM.
— Sadler's Balloon etc. See Hugo *Suppl.* 165–7. Proofs in BM Box 10; Drawings, NHSN.
234 One anxious letter. Robert Payne 4 February 1812: TWAS 4388.
— Claggett benefit ticket. 1 February 1797, JJ Coll. Bewick Box 3.
235 'A Grand Display'. *Chronicle* 26 September 1789; 22 June 1799.
— 'The Stags heads are Gold'. Ann Hunter. See also *Bookplates* 147.
— A mother. Mrs Baker n.d. 1804: Bain.
— A countrywoman. Margaret Batey 16 July [1804]: TWAS, BEW 17.
— canals. See letters from James Ellis and John Humble, October 1795–December 1796: Bain. Engravings in Tattersfield III.

236 requests arrived. e.g. from John Croft 22 December 1793: Pease; James Bisset
 10 March 1797: Laing. Cuts appeared in works by J. Ferraby of Hull and Wilson,
 Spence and Mawman of York, Davison of Alnwick.
— 'would want the cuts done'. TB to D Walker 27 March 1795, D Walker 24 November
 1796: Pease 175:53.
238 'with miniature like minutiae'. TB to John Bailey, 5 February 1818: Boyd 65.
— Tools. See Walter Chamberlain, *Manual of Wood Engraving*, (1978) and G.E.
 Mackley, *Wood Engraving*, (1981).
— Revd Bache Thornhill. TB to Revd Bache Thornhill, 22 September 1824: draft, Laing.
239 'and it may easily'. *M* 190.
240 'A wonderful piece'. Iain Bain to the author.

19 *LAND BIRDS*

242 'so far as I know'. TB to George Mark 19 February 1794: draft, Pease 175: 42.
— 'the first impulse'. Thomas, *Man and the Natural World*, 275.
— Brocklebank. Revd Brocklebank n.d. [May 1793], TB to Brocklebank May 1793,
 Pease 175: 49, 50, 35.
243 hoopoe. *LB* 124.
244 'The second John'. John Trevelyan 11 November 1795, 12 October 1796 ; *LB* 305–7.
 See e.g. CB 10 October 1796, and many other entries, TWAS 1269/4.
245 Walter Blackett Trevelyan. W.B. Trevelyan 29 March 1796: NTC ; 6 and 17 April, 24
 November 1796, 16 January 1797 and Revd Trevelyan 6 April 1796: V&A 3260.
— a Plymouth clergyman. George Prideaux Harris, 6 November 1794: draft, Pease 175.
— Writing from Somerset. *LB* 253.
246 James Pearson. Ibid. 249–51.
— In 1800. Revd Walter Trevelyan 10 September 1800: V&A.
— 'It sat on the bench'. *LB* (1826)291–2.
— 'I have, all my life'. TB 21 December 1826, *Dovaston* 91, see Allen 88.
— 25 Jan. 1794. See 'Bicentenary'.
248 'Its well known cry'. *WB* (1826)130–1. Bewick's corncrake (Pease Collection) was
 stuffed after death, and displayed in an oval case in Newcastle's Hancock Museum
 for many years.
249 'much annoyed by'. Atkinson MSS. NEWHM. 2006. H3.1.
— 'Systems have been formed'. *LB* iii.
— One of their correspondents. Revd J. Davies 13 November 1795: NTC.
250 an old shepherd. Jane B commentary, 4 November 1869: Bain.
251 a standard rule. *WB* (1826), 65: TB recommends Werner's 'Nomenclature of Colours'.
— 'anonymous streaky grey-brown'. *Birds Britannica* (2005), 364.
— White. Quoted in *Birds Britannica*, 365.

252 'This busy little bird'. *LB* 239–40.

253 'A sitting hen'. Ibid. 280–1.

254 'sparrow clubs'. Keith Thomas, *Man and the Natural World* (1983), 274.

255 birds: House Sparrow. *LB* 155–6, Ring Pheasant 284, Black Grouse (1826) 342.

— 'A Robin Red breast'. 'Auguries of Innocence', *The Complete Writings of William Blake*, ed. Geoffrey Keynes (1966), 431.

256 eating birds. Honey Buzzard *LB* 18, Yellow Bunting 144, Larks (1826) 215.

257 Partridge. Ibid. 306–7.

258 'We arrived in this great city'. RB, 26 September 1796: Bain.

— A fortnight later. RB 6 October 1796: Bain.

259 subscribers. SB TWAS 1269/136 lists 335 subscribers for 1st Edition of *LBs*, 38 more for second (1798); SB1269/35 lists 45 for 1804 *WBs*. See 'Bicentenary'.

— 'Beilby & I'. TB to RP, 10 February 1797: Laing.

— he explained later. TB to Charles Fothergill, 9 November 1812: Hugh Gibson.

260 He tried to write. Four drafts, February 1806: Bain.

— 'Is it meant'. TB to RB, n.d. [1797]: draft, V&A.

— 'Then Sir said I'. *M* 123.

— 'taking upon himself'. TB to William Charnley 9 September 1797: V&A 3252.

261 'it may be proper'. *LB* Preface vi.

20 ON HIS OWN

262 'I never before saw'. Captain J. Stuart 25 October 1802: Pease 175.

— 'dispositions', lark and jay. Atkinson Mss. NEWHM 2006.H3.1.

263 'Bewick so often conveys'. John Rayner, *Wood Engravings by Thomas Bewick*, 21.

— 'as good as disposed of'. TB to Anon, n.d. [1798]: draft Pease 175.

— 'I am in more raptures'. George Allan 13 November 1797: Bain.

— the engraver John Landseer. TB to John Landseer, 21 June 1798: draft, Pease 175.

— A Doncaster artist. George Haugh, c. 1797: Bain.

— 'and the breach is widened'. RB to William Turner, 11 September 1797: NLP.

264 'Why am *I* to be rudely cast aside'. RB 7 September 1797: Cambridge University Library Ms Add. 8520, see *M* xxi.

— Sol Hodgson. Solomon Hodgson [1797]: V&A 3257.

265 'I am / your injured'. TB to RB 9 December 1797: V&A 3252.

— 'Finis to'. WEB 31 December 1797: TWAS 1269/41.

— Overseer of the Poor. TB to George Allan: Pease 172.

— 'Paper, copper, seals'. Dissolution of the Partnership, 4 May 1798: V&A 3250.

267 'The Gentry whirled about'. *M* 138. See also Bermingham, *Landscape and Ideology* (1987), 73–5.

— 'these fat Cattle makers' *M* 141. See Robert Colling 16 May 1799: Bain, and also

Joseph Alexander, 27 September 1802 ; S. Welburn, and TB's reply, 10 and 17 February 1804: TWAS, BEW 3, 372.

268 'I cannot help thinking'. *M* 139.
— 'a tiger, a porcupine'. 'Gilbert Pidcock', *ODNB* article by Mark Sorrell.
— 'Mr Bewick'. Gilbert Pidcock 20 June, 21 September 1799: Bain.
— 'two nondescript animals'. NLP Minutes, 10 December 1799: Watson 296.

269 Hulsinbeck. TB/ Hulsinbeck correspondence 2 July 1800: draft Pease 175.
— special sets. Bain I, 47–8: REB's in private collection, Jane's NEWHM:1997. H54, Elizabeth's is bound into Charnley and Robinson Album: Pease 172.
— Christmas feast. 'Matthew Brown's printers' 22 December 1798: T &WA: BEW 63.
— John Marshall. See substantial correspondence with Marshall 1799–1807, TWAS 4388.
— Beilby engraved silver. RB 17 April 1800: Bain.

270 'an engraver of the very lowest order'. *Encyclopaedia Britannica* 1801 supp. Vol II, 801, repeated in the *European Magazine*, 1802. See Tattersfield I, ch. 8.
— 'I must have TB'. SH 30 March 1800. For quotations from SH see Hodgson correspondence in V&A and BL Add. Mss 50240, 50241.

271 John Bell. RLSC Newcastle Booktrade, Box 2, SH to John Bell, 28 March, 8 July 1800.
— '*he* was the original projector'. SH 8 April 1802: V&A 3257.
— 'but in my opinion'. TB to SH, 12 April 1802: BL Add Mss 50241.
— I am not surprised. Richard Phillips 4 May 1802: Bain.
— 1799 Jan. Alan Angus, 'Bewick's Apprentices', *CT* 2, no. 3 (Autumn 1992), 4.

272 'of a poetic'. TB to Thomas Vernon 4 December 1801: Pease 171: Vol II.
— Hole . . . gave advice. Henry Hole, 7 January 1807: TWAS 4388.
— Charles Hickson. Sir John Lawson 15 and 28 September 1800: TWAS 4388; TB to Sir John Lawson 2 September 1797: draft, Pease 17.5.
— 'His minced reply'. RO 23 September 1800: TWAS 4388.
— 'Apprentice Absconded'. *Courant* 11 October 1800: Angus CT 2, No. 3 (Autumn 1992).
— 'Farewell to Charles!' WEB 18 October 1800: TWAS 1269/50.

273 'I hardly know what to say'. TB to Thomas Vernon, 6 January 1801: Pease 171.
— 'my little Boy'. TB to Thomas Vernon, 4 December 1801. 18 May 1803, 12.
— 'Portraits, Views &c'. RLSC Bell Collection, Book Trade box 6, Kidd file.

275 'make the letters'. TB to John Harrison 9, 25 March, 7, 15 April, 4 May, 13 September, 2 November 1815: Pease, 371.120.

276 Beilby had bought. CB19 October 1789, TWAS 1269/1: 'Pd for Rolling Press 1–1–0'.
— George Barber. *Workshop* 42.
— 'He is a harum-scarum'. Robert Kirkwood 16 February 1811: Bain.
— Through contacts in London. *M* 127–8. The official was the brother of Sir Thomas Frankland: see fragment from letter from Frankland 19 January 1801: NTC.

277 'would do well enough'. *M* 127–30. See Frankland correspondence 4, 6 March 1801: TWAS 4388; TB to Joseph Banks December 1801: Graham Carlisle; Sir John Sinclair

9 October, 14 November 1799, 6 January 1801: Bain.

— 'A Proclamation'. NEWHM:1997.H46.1 See June Holmes, no. 6 (1998).

21 HOME AND FRIENDS

280 illuminations. *Rejoicings*, 15.

— Waldie. See *Bookplates* 242.

281 'He is a large, fat dark man'. Journal of Hannah Gurney, quoted in *Bookplates* 132.

— William Gill. Jane B notes on correspondence, 1861: Laing.

282 'You are the only person.' TB to David Sivright, and reply October 1812: Pease 175.

— 'for Godsake'. David Sivright 6 February 1818: NTC.

— John Rastrick. *M* 180–1. John Rastrick, 25 February 1824: V&A 3262/1955.

— George Gray. Ibid 54. See also Marshall Hall, *The Artists of Northumbria* (2005 edn).

283 nettle stockings. The pair are divided, one leg in NHSN the other with Bain.

— 'Pray how is our old friend'. RP 23 December 1815: V&A 3258.

— In 1802. Wiilliam Bulmer 21 July 1802: Pease 178.

— 'My Old Friend Bewick'. RP 10 March 1801: Graham Carlisle.

— 'Tell your Eldest Daughter'. RP 27 &28 October 1801: V&A 3258.

— 'There they go!' Croal Thomson, 189 and *British Quarterly Review* (1845) II, 566.

— Robert learning the pipes. CB 7 September 1798: CB TWAS 1269/5.

284 'in the style of Rembrandt'. William Bewick to T.H. Cromek, 16 April 1864, March 1865: Holmes Cat. 16, 16a. For John (bookseller) and Joseph Bell see *Bookplates* 59–60.

285 'wearied and tired out'. For the daughters' memories see Robinson 77, 175–8, 186.

— 'I was never more delighted'. John Bell 19 February 1803: TWAS, BEW 20–4.

— 'very poorly'. TB to Jane B 19 July 1798, 22 June, 25 June 1799: HL.

286 'Where I met'. REB to Jane B 9 July 1799: Laing.

287 'a very canny Country Church.' Jane B 28 June 1801: HL.

288 'of contemplating'. TB to Christopher Gregson, 18 April 1803: Pease 371.92–3.

— 'except Laughing'. Dr George Davidson September–November 1802: Bain.

— 'one pot after another'. TB to George Davidson, c. 30 September 1802: draft, Bain.

289 'Dear Aunty'. TB to Esther Elliot, 13 October 1801: Pease 172.

— 'Mr Bewick'. Jane B 21 June 1802: HL.

22 WATER BIRDS

293 'If possible'. Thomas Pennant 28 June 1798: *Newcastle Museum* 25.

— 'Lacking Beilby's notes'. TB to RB 9 December 1799: draft, TWAS 4388.

— In January 1801. Edward Oxley 25 January 1801: V&A 3259.

294 'The Twite'. Thomas Pennant 13 February 1798, *Newcastle Museum* 25.

— 'a small bird'. George Silvertop 15 October 1798: Bain.

— 'Jn Surtees'. John Surtees 7 April 1802: TWAS.BEW 332.

— 'and many a letter'. *M* 117.

— 'It runs with great Facility'. Revd R. Brocklebank 18 May 1801: TWAS.BEW 81. *Bookplates* 334n.

295 'Mr Walter Trevelyan'. Walter Trevelyan 9 October 1802: V&A 3260.

— Farne Islands. *WB* 204.

— 'I have in vain'. Lt Col John Dalton, 7 November, 1798 ; 3 March, 3 May 1799: Bain.

— 'sometimes a dozen'. TB to anon 4 June 1802: draft, Houghton.

— puffin bite. *WB* (1826) 406.

296 'the fenny part'. George Strickland 29 July 1801: Bain.

— woodcock. *WB* 63, 61–2.

— 'the most perfect likeness'. Chatto and Jackson 495.

297 birds: Tame Goose, *WB* 299, Tame Duck 336, Coot 132, Common Gull 220.

298 'like little boats'. Ibid. vi.

299 guillemot. Ibid. 178.

300 apprentices. See Chatto and Jackson 497–8. Hole engraved the Red-breasted Merganser, Whimbrel, Lesser Tern, Velvet Duck and Crested Corvorant (cormorant); Clennell, the Lesser Imber, Brent Goose and Non-breeding Cormorant. See CB 1800–3 TWAS 1269/5, and Bain II.

— In his descriptions. *WB* Heron 40, Water Crake 11–12, Stormy Petrel 251.

301 'This tribe'. Ibid. 387.

302 'on the Tree of Life'. *Paradise Lost* III, lines 194–8. Bewick alludes to, but does not quote.

— 'scaup duck'. Revd Henry Cotes 1 February 1802, TWAS.H; CB 2 February TWAS 1269/5, *WB* 339. See also 'Bicentenary'.

303 'I pray, Mr Vicar'. *Bookplates* 99. The *Water Birds* mss. is in NCL Bewick Coll. 505.

— 'to undertake a job'. TB to Mrs Matthew Brown, 23 April 1803: draft, Pease 175.

— 'the paper'. TB to Thomas Vernon, 18 May 1803: Pease 171.

304 'for I will not suffer you'. TB to Mrs Matthew Brown, 4 June 1803: Pease 175.

— George Simpson. William Garret to Thomas Hugo 10 March 1851: Pease 178.80a.

— 'First edition'. SB TWAS 1269/135.

— 'In exploring the track'. *WB* vii, xii

305 'Let the imagination'. Ibid. xv-xvi.

23 'WITH BEWICK, I WAS THEN HAPPY'

306 'nearly forgotten art'. *Annual Review 1804* (1805) 729–37, Stothard. Weekley 126.

— Akin. James Akin, 28 January 1803 TWAS 4388.

— *British Critic*. *British Critic* xxvi (1805) 292–7.

— Howitt. William Howitt, *The Rural Life of England* (1838; 1844 edn.) 333.

— Bowman. Croal Thomson, Appendix.

307 Kingsley. Charles Kingsley to Jane B, 16 April 1867: Bain.

— Tennyson. Quoted in Weekley 14.

— de Morgan. Quoted in Martin Greenwood, *The Designs of William de Morgan: A Catalogue* (1989) 10. With thanks to A.S. Byatt.

— 'a sticky black mess'. Quoted in Margaret Lane, *The Tale of Beatrix Potter* (1946) 33.

308 'still Nature'. R.B. Becket (ed.), *John Constable's Correspondence*, II, 31–31.

309 'Had I been a painter'. M 203.

— Audubon. John James Audubon, *Ornithological Biography*, III (1835), 300–4.

— comparison with Burns. Atkinson 149.

310 'the very Burns'. Howitt, *Rural Life*, 334.

— 'however failing in grace'. For Ruskin on Bewick, see *Elements of Drawing*, Appendix; *Ariadne Florentina* (1872, publ. 1890); *Aratra Pentelici* (1870, publ. 1890).

— 'subjects of common and familiar life'. *British Critic* xxvi (1805).

— 'incidents and situations'. Preface to the *Lyrical Ballads* (1802).

311 'Oh now that the genius'. 'The Two Thieves', *Poetical Works of William Wordsworth*, ed. Ernest de Selincourt and Helen Darbishire, 5 vols, (1940–9) IV, 245–6. For Wordsworth and Clare in this context see Jonathan Bate, *Romantic Ecology* (1991) and *Song of Earth* (2000).

312 'I saw an aged Beggar'. 'The Old Cumberland Beggar', *William Wordsworth*, ed. Stephen Gill (1984) 49.

— 'mid the din'. *Tintern Abbey*. Ibid. 133.

313 'the brilliantly studded canopy'. M 211.

— 'No, no, this sublime'. Ibid. 208–9.

314 'the fair sex, pass *overleef*'. TB 9 February 1825, *Dovaston* 40.

— 'the fixed love of *ugliness*' Ruskin to M.H. Spielman, Weekley 121.

315 'When the baby's all be[shit]'. John Clare, Jonathan Bate, *John Clare* (2003) 279.

— 'Hares at play'. *John Clare, Poems of the Middle Period 1822–1827*, ed. Eric Robinson (1984) 233–4: punctuation, *Selected Poems*, ed. James Reeve (1954), 61.

316 'Like mighty giants'. From 'Enclosure', *Selected Poems* 22.

— 'To see a World'. From 'Auguries of Innocence', *The Complete Writings of William Blake*, ed. Geoffrey Keynes (1966) 431, 432–3.

317 'with her eyes close to the paper'. Colin Campbell, CT 2 no. 6 (1994)3–6.

318 The Brontë children. Juliet Barker, *The Brontës* (1994) 150.

— 'There rises some lone rock'. Unpublished poem NCL 2003.31.12.

— 'With Bewick on my knee'. Charlotte Brontë, *Jane Eyre*, (1847: 1996 edn) 14–15.

319 visiting churchyards. M 184–5.

320 'To have the scull'. TB to RP, 29 January 1816: Laing.

— 'the roar of the dashing surge'. TB to RP 3 February 1824 [dated 1823]: Laing.

24 BACK TO BUSINESS

321 'Bewick carrying the jug'. Croal Thomson 205.

322 the workshop paid. Tattersfield I, ch. 15.

— South Shields. Tony Barrow, *Trafalgar Geordies* (2005), 30.

— Thomas Dobson. TB to Mr Pemberton, 26 January 1810; John Harrison, 13 October [1815]: Pease 371.149,148.

— *Annual Review*. See Roscoe 2.

323 'Bantling'. TB to William Bulmer 30 September, 1805: draft, NTC.

— printing. TB to SH May 1805: draft V&A. This edition appeared in 1807.

— five drafts. TB to SH 4 February 1806: Bain: final letter BL Mss 50241.

— Longmans. 100 letters between TB and Longman (and differing partners), 1810–28 are scattered between V&A, Bain, Pease, NTC, TWAS and Longman & Co.

— 'desire him likewise'. SH to William Preston, 22 February 1804: V&A 3252.

324 In charging you. TB to SH 25 January 1805, copy of reply on verso: BL Mss 50241.

325 'The shield'. Robert Southey n.d. 1813: Bain

— 'a curious spy' Nigel Tattersfield, in conversation. Letters: Sir Cuthbert Sharp 29 November 1814, n.d. January 1815, 20 October 1815: Bain. See *Bookplates* 8, 212.

— Fenning's Spelling. John Stafford 11 January 1806. See mass of correspondence about orders, in Bain and TWAS. For work undertaken, see Tattersfield, II, Catalogue.

326 Sending blocks. John Thurston, 26 April 1806: Bain.

— 'white touches'. John Poole 18 March, 28 April 1806: Bain.

— 'The upper part'. John Poole 2 September 1806: Bain.

327 'but not without much trouble'. RP 2 March 1805 and later: V&A.

— 'As you observe'. RP 18 October 1806, V&A 1956/3258.

328 'to drop these few lines'. TB to Jane B 4 September 1807: NHSN.

— 'a most excellent *protector*'. Jane B to TB 26 September 1807: HL.

— 'we cannot prevail'. Jane B to TB 4 October 1809: HL.

— 'spent many a social evening'. *M* 141, See *Bookplates* 172.

— 'for all we know'. TB to Miss Watson, 18 January 1808: Rosenthal, sold Bloomsbury auctions 9 June 2006. The bill was £18.10s 11d for a half-year as Bessy left on Mayday 1808.

25 SHIFTING GROUND

329 'the pleasantest mode'. TB to Jane B 30 August, 2 September 1808: HL.

330 'amidst the rolling Waves'. TB to Jane & Robert Bewick 14 July 1809: HL.

— 'An excursion from home'. RP 10 October 1809: V&A 3258.

— retirement. TB to anon: *M* (1862) 343–4. Guest-burn plan with Jane B's notes: HL.

331 'Ought if possible'. *M* 201.

— William's family. TB to William Wrightson 16 September 1807: Pease 371.

— 'I used no ceremony'. *M* 110–11.

332 'Words are inadequate'. Elizabeth Bowman to Jane B 8 July 1815: Bain.

— 'We are all well'. TB to Jane B 30 August, 2 September 1808: HL.

333 Digging in his heels. See Clayton & Donkin 21 August 1812: Bain, annot. Jane B.

— Gateshead. See notes on Gateshead places and characters in Thomas Wilson, *The Pitman's Pay: a Tale of Forty-five years Ago* (1843).

— Mirk Lane. Joseph Dixon, 28 July, 21 August 1811: Bain. The asking price was £900, Dixon offered £850, Bewick paid £785. Thomas Carr's bill was £65.15.11. See Thomas Carr, 7 November, 8 November 1814: Bain. The lane was also called Back Lane, then West Street: the house was first no 8, and finally 19.

334 The doctors. Jane B memo, NTC 260.

— 'pined to a Skeleton'. *M* 131.

335 In November. Robinson 126.

26 FAME, FABLES AND APPRENTICES

336 'otherwise than scrawling'. TB to Charles Fothergill, 9 November 1812: The Hon. Hugh Gibson.

— 'like a *petted Bairn*' /'Frothy Duchess'. TB to Jane B 30 June 1813: HL.

337 Chillingham Feast / panoramic view. TB to REB 6 July 1813: NHSN.

— 'I am not now afraid.' TB to Jane B, 30 June, 10 July 1813: HL.

338 'Good Old Time Revived'. *Rejoicings* 13–14.

— 'I dare say was very glad'. TB to REB 23 June 1814: Laing.

339 'Robert is at his usual study'. Jane B 27 June 1814: HL.

— 'he ought never'. TB to Jane B 28 June 1814: NHSN.

— spent his allowance. REB notebook, 1813–24: V&A 3251/1955.

340 'my Lasses'. TB to Miss Bailey 6 December 1814: Graham Williams.

— Nicholson portrait. Laing. See Holmes Cat. 8.

— Engravings. TB to TF Ranson, 12 December 1815: draft Pease 178.71. John Summerfield, 16 January, 11 April 1815: Bain. See Holmes Cat. 8 a-e, and 5, 5a.

341 Ramsay portrait. TB to TF Ranson, 12 December 1815: draft Pease. Ramsay also painted Bewick in *The Lost Child*, 1823 See Holmes Cat. 12,16, 18a, 19.

— 'you exactly'. Jane Bewick to TB 15 July 1815; TWAS.H.

— 'When we were'. RP 8 May 1816: V&A.

— 'his peculiar humour'. Edward Jenner 26 November 1822: copy, Pease 175.

— 'How do you do?' Atkinson 150,155; Chatto and Jackson 509.

— Mavings the brushmaker. Atkinson MSS. NEWHM. 2006. H3.1.

342 Isaac Nicholson. Armorer Donkin to Isaac Nicholson: V&A 3254.

— flare-up with Ralph Beilby. RB 10 October, 16 October 1816: V&A 3253. This impression was by REB, see RP 2 September 1816: V&A 3258.

— 'he sometimes calls in'. TB to Miss Bailey 6 December 1814: Graham Williams.

343 'that I had not published'. M 131 .

— 'ever since I *intended anything*'. TB to Charles Snart 5 September 1814: Hornby Library, Liverpool since May 1811. Tattersfield I, ch. 10.

— many of the basic designs. John Jackson (Chatto and Jackson) alleged that the Aesop designs were based on watercolours by Robert Johnson in the 1780s: Bain suggests these are by Johnson for an earlier edition for another publisher. Bain 1981, 52.

— 'occupied with a work'. Sir Cuthbert Sharp n.d. 1815: Bain.

344 'a delightfull employment'. TB to Miss Bailey 6 December 1814: Graham Williams.

345 William Harvey. TB to John Bailey, 5 February 1818, Boyd 65.

— James Losh. 21 November 1817, *Diaries and Correspondence of James Losh*, ed. Edward Hughes I, 74.

— A few days' fishing. TB to Sir John Trevelyan, 3 July 1818: Yale.

— 'delay is terrible'. TB to William Harvey 18 August 1818: Boyd 99.

346 'Rob Roy'. Jane B to Mrs Isabella B, 7 and 11 June 1818: HL.

— 'more minute'. Dobson 138.

— 'they have failed'. TB to William Bulmer November 1818, to William Daniell 23 November 1818: Pease 175:130, and the Bishop of Bristol 5 January 1819: Hugh Gibson.

347 'a Bait to hook'. TB to Emerson Charnley and to *Courant*, 11 May 1819: Pease 172.

348 Walker's foreman. Thomas Kay, see Hugo 256–8.

— 'a brilliant book'. TB 5 March 1828, *Dovaston* 112.

349 'little did I think'. TB to George Lawford, 19 February 1828: Laing.

— 'I know nothing beside'. New apprentices included Thomas Young from Newcastle; Alexander Reid, an Edinburgh bookseller's son. Ebenezer Landells began, but terms were not agreed and he was apprenticed to Isaac Nicholson.

— 'cheerfully pursuing'. Chatto and Jackson 508–9. Jackson had been unhappy in a previous apprenticeship, and William Laws of Prudhoe and William Bedlington of Ovingham raised a subscription for his premium. See also Robinson 193.

350 Edward Willis. The Willises' move to Stephenson's household was unearthed by Nigel Tattersfield, after long and diligent research. Tattersfield ch.16.

351 A moving letter. Proposal, 15 January 1819: JJ Coll., Bewick Box 3. See Thomas Unwins, 17 January 1819: TWAS 4388, and Charles Warren (Clennell's father-in-law), 20 December 1820: Bain.

352 'Poor Clennell'. Stephen Oliver [William Chatto], *Rambles in Northumbria* (1835) 15–16.

27 TAKING STOCK

353 'you must be tender with'. TB to REB, 11 October 1816: Bodleian.

— The full moon. M 180.

— Gillray. See Charles Bird, 'The Fate of Empire', CT 4 no. 4 (Easter 2003), 4.

— 'Demi Oligarchy'. *M* 137.

354 Burdett meeting. Cuttings from John Bell's multi-volume *Le Melange*: NRO. SANT/PRI/5/5 – 486–491. With thanks to David Gardner-Medwin.

— 'partizans'. Other members incl. John Bell, Thomas Carr, Armorer Donkin, William Turner (declined, in view of his position as a minister).

355 paralysed the coast. N. McCord, 'The Seamen's Strike of 1815 in North East England,' *Economic History Review*, xxi (1968).

— 'You say that Bonyparty'. Clive Emsley, *British Society and the French Wars, 1794–1815* (1979) 174.

— William Hone. See Ben Wilson, *The Laughter of Triumph: William Hone and the Fight for the Free Press* (2005), and Philip Martin in *ODNB*.

— Bewick subscribed. CB 1818, TWAS 1269/6.

— It was appalling. *M* 152–3.

— 'The Alarm'. Chatto and Jackson 596. M(1862) 325, see *Dovaston* 33.

356 'neat and appropriate'. *Rejoicings* 15.

— 'He is not a Queen's man'. RP16 August 1820, 6 February 1821: V&A 3258.

357 John Ambrose Williams. *M* 180. See TB to REB 23 October 1822: Bodleian.

— 'I fear that'. TB to Thomas Ranson, 12 December 1822: HL.

— 'such a hell o' a thwacker'. *Dovaston* 134.

— Howdy and Upgetting. Mss Bodleian, John Johnson Coll, Bewick Box III. Published by Bell 1853, reprinted as Appendix to Robinson.

— 'Ae-hy'. 'The Howdy', Robinson 313. See variant in Atkinson 148.

358 When he cleaned. TB to Mr Rowntree: draft Pease 175.

— 'Would not know'. TB to RP, 30 November 1819: Laing.

— 'she is now'. TB to RP 10 March 1823: Laing.

— *'perfectly inexcusable'*. Jane B to Elizabeth B, 3 October 1821: HL.

— his account books. REB account book 1821–3: Bain.

359 'was glad to lie'. Jane B to TB 10 August 1821: HL.

— 'Isabella and I'. Jane B to TB 12 August 1821: HL.

— 'pleasant intelligent Scotch woman'. Jane B to TB 29 August 1821: HL.

— 'after a great deal'. Jane B to Isabella B, 8 July 1822: HL.

360 Bewick warned him. TB to REB 19 November 1822: HL.

— Robert's lists. REB's mss lists, May 1822, December 1822 and 1826, and one by Jane B, 1865, in HL (microfilm NCL).

— Memoir. Mss in BL. Add MS41.481.

361 'I feel it to be'. TB toThomas Ranson, 12 December 1822: HL.

— 'a ramble among the rocks'. TB to RP 3 February 1824: Laing.

362 'she seems very unwilling'. TB 23 November 1827, *Dovaston* 109.

— 'Your daughter Janes'. RP 30 April 1822: V&A 3258.

— 'little Colleges'. *M* 230.

363 The key incidents. See John Sturrock, *Thr Language of Autobiography* (1993) 24–7.
364 'committed to paper'. TB to Henry Hole, 20 January 1827: TWAS.H.
— Dr Robert Blakey. H. Miller (ed.), *Memoirs of Dr Robert Blakey* (1879) 35, M xvi.
— Bewick on war. *M* 144, 145.
365 'In all the varied ways'. Ibid. 204.

28 SALMON AND SWALLOWS

366 'long entertained'. Charles Snart, 5 February 1813: Bain.
— 'abundantly supplied'/'seclusion'. Charles Snart, 14 March 1813: Bain.
367 'his whole countenance'. Nicholas Bailey, 22 October 1836: Tattersfield I.
— 'I shall not forget'. TB to Charles Snart 5 September 1814: Hornby.
— 'Information *quite new*'. TB to Snart, April 1822: draft, V&A 3250.
— the common species. TB to Robert Jameson, September 1823: Pease 175: 45.
— 'The Scales must be'. G. T. Fox 7 October 1820: NTC.
368 'this would make it'. TB to Revd Robert Tweddell, 16 November 1820: copy, Laing.
— 'is the *small sum*'. James Ramsay, 15 December 1827: NTC.
— 'With all these bright prospects'. TB to Jonathan Couch, V&A 3250; Charles Snart 16 December 1823: Quayle; RP, 3 February 1824: Laing.
— 'from mounting the last stile'. *M* 170.
369 game laws and regulation of fishing. Ibid 172–6.
— a vehement letter. TB to [Ralph?] Hopper, 26 April 1824: Robinson 151. Bain notes on transcript that a Ralph Hopper was a cooper and salmon pickler on Side.
— 'severe and even cruel'. See *M* 175–6.
370 'I have seen a shoal of porpoises'. Ibid. 175.
371 herring. *WB* xiii–xiv.
— warnings from Pollard and Bulmer. RP n.d. August, 3 December 1822: V&A 3258.
— 'My Son is busy'. TB 3 June 1824, *Dovaston* 33.
372 Emerson Charnley. Note from Charnley's manager William Garrett, Hugo 294–5.
— 'minute and proportional copying'. Atkinson MSS, NEWHM. 2006.H3.1.
— 'little progress'. TB to Robert Hindley, 29 April 1825, and to Revd S. Bale, 1 June 1825: drafts, Laing editions. See Roscoe 136–144, Tattersfield II, Catalogue.
— Blackwood. TB to William Blackwood, 27 June 1825: NLS. The article was by Professor Wilson, *Blackwood's Edinburgh Magazine*, July 1825.
373 'a fresh supply'. Longman & Co. 12 January 1818: draft Longman I, 100, no. 204.
374 'I still want'. TB to GT Fox, December 1823, Roscoe 126.
— 'rummaging the stores'. *M* 161 See *Bookplates* 300.
— 'for I find it extremely'. TB to G T Fox May 1823, Roscoe 126.
— Yarrell. G.T. Fox, 20 January 1824: Laing; 17 July 1825: Bain.

— Selby. Prideaux John Selby, 26 October 1822, 23 September 1823: Bain; TB to Selby, 11 September 1823, Houghton.

— Mitford. Jane B's notes, 1861: Laing.

375 Revd Cornish. Revd William Floyer Cornish, 10 April 1826: Laing.

— 'I feel proud'. H.T. Liddell, December 1820: Pease 175.

— Thompson. Samuel Thompson, 11 July 1821: NTC.

— a nightmare to the pressmen. See annotated proofs of *Supplements*: Laing.

— 'The new Edition'. TB to Dr Buxton, 22 September 1825: draft, TWAS 4388.

29 SORE TIRED

377 'My lasses'. TB to RP 26 May 1824: HL.

— 'I longed to see it'. (Edinburgh visit) *M* 182–4.

378 *King* of one of the Orkneys'. Jane B to Elizabeth B 18 August 1823: Bain.

— Scottish airs. Patrick McDonald, *A Collection of Highland Vocal Airs* [1784], given to Bewick by Mr Blackadder, 18 August 1823: Bain. See Library Checklist, 82.

— Stowe and lithography. TB to Dovaston, 26 February 1824, *Dovaston* 31. See *M* 184.

379 'His father and grandfather'. Atkinson, 1831, p.153: see Holmes, Introduction.

— 'For my part'. *Dovaston* 129–30.

381 As an ornithologist. See Allen 88, and his 'J. F. M. Dovaston, an overlooked pioneer of field ornithology', *Journal of the Society of the Bibliography of Natural History*, 4 (1962–8), 277–83.

— Highland journal. Tour journal and music book: Bain.

382 'with small pieces of quill'. Robinson 155.

— 'Get awa' bairns'. *Dovaston* 134.

— William Proctor. Address at award presentation 1864, Robinson xii–xiii.

383 'Cursorious'. Atkinson MSS. NEWHM. 2006. H3.1. With thanks to David Gardner-Medwin.

— 'questioned Dick repeatedly'. Ibid. Bewick's habit of making notes was constant. Annotations appear in the 1809 edition for both the 1814–16 and the 1816 editions (Private Collection), in the 1816 edition for 1821 (Pease 86), in the 1821 edition for the 1826 (V&A) and in the 1826 edition (NEWHM:1997. H43).

384 'When animated'. Atkinson, 150; 149.

— 'The Idea of Socrates' / water spiders. Ibid. 149.

— 'very low & sad'. TB 8 September 1825, *Dovaston* 58. See also TB to William Bulmer 23 December 1825: V&A 3252, and Tattersfield I, ch. 11 for identification of her illness.

— 'the last pitious appeal'. TB 1 March 1826, *Dovaston* 73.

385 'gout of the stomach'. Jane B to George T. Fox 28 March 1826.

— 'A little longer time'. TB 27 May 1826, *Dovaston* 77.

— 'you would be surprized'. Ibid 79.

— 'We dined'. Ibid 137–8A.

386 'graceful and fascinating'. Ibid 50.
— one biographer. Weekley, 181. See John A. Pybus, 4 April 1828: Pease 175: 151.
— 'Pretty darlings'. *Dovaston* 141.
387 'I am glad you are alive'. Edward Walker 24 June 1826: Bain.
— 'he is very much failed'. William Bewick to [? Matthew Bewick], 12 November 1826: Pease 371.153.
388 Dovaston scrapbook. Bain.
— 'a tall, stout man'. J.J. Audubon, 'Reminiscences of Thomas Bewick', *Ornithological Biography*, (1835) 300–4.
389 'from downright weakness'. TB 15 August 1827, *Dovaston* 105.
— 'If I continue well'. TB 23 November 1827, *Dovaston* 109.
— Alpine vulture. TB to WC Trevelyan, 3 November 1826; TB to Sir John Trevelyan, 29 December 1826; BL Add mss 31,027.
— 'looked over this book'. Ms annotation on flyleaf of TB's copy of *LB* (1826), I: NEWHM:1997.H43. See also Jane B's annotations to *LB* and *WB*: V&A.
390 'a large and elegant new steam packet'. Iain Bain's annotation to 'Last Autobiographical Notes', pasted by Jane B into bound proofs of *Memoir*: Bain.
— Jane sent efficient letters. Jane B to REB 21, 29 August 1828: Laing.
— Northcote. Jane B notes, 1861: Laing.
391 'I never in my life'. TB 1 September 1828, *Dovaston* 117.
— 'grozers'. RP 16 August 1820, and later letters: V&A 3258.
— to Jane's disapproval. Jane B to Elizabeth B, 29 August 1828: HL.
392 'Ale once a day'. TB 'Last autobiographical notes': Bain.
— 'I have lately'. TB 23 June 1828 *Dovaston* 114.
393 Pickering. TB to William Pickering 1 November 1828.
394 Atkinson. Atkinson 158–9.
— 'My Dear Sir'. *Dovaston* 121–2, REB 8 November 1828.

EPILOGUE: NATURE'S ENGRAVER

395 'beneath an elder bush'. Jane B to JD, 20 June 1830: SRO.
— 'not only to explore'. Jane B to JD, 16 July 1829, *Dovaston* 124–5.
— Dovaston's articles. 'Some Account of the Life, Genius and Personal habits of the late Thomas Bewick', *Magazine of Natural History*, Nos. 9–12 (1829–30).
396 'it could not but be'. Jane B to JD, 28 November 1829: SRO.
— Bewick's swan. W. Yarrell, 'On a new species of Wild Swan', *Transactions of the Linnean Society* xvi (1830), 445–54.
— 'His power of giving'. Atkinson 157. Another tribute was William Turner's 'Memoir of Thomas Bewick', *The Naturalist's Library*, Vol 18 (1836).
397 'we keep most'. William B to [? Matthew B], 5 February 1830: Pease 371.

— 'have you found the chain?' Jane B to REB, 15 July 1832: HL.

398 'I have just completed'. Jane B to Elizabeth B, 26 June 1836: HL.

— William Bell Scott. *Autobiography* (1860) II 194–6. Quoted by Bain I 85–6.

399 'as Miss B'. Isabella B Jnr to Mrs Higginbotham, n.d. after 1881, draft, Bain.

— workshop. The workshop was demolished in 1902.

400 'Jane, honey'. Atkinson 145. See Chatto and Jackson 491–2, 497–8, and slightly
different list in Chatto papers, LL. Bain I 69–70, further corrects the attributions.

— Elizabeth's illness and death. Dr Mackintosh to Jane B, 16 March 1858: TWAS 3538.
For death certificate, see Tattersfield I, ch. 12.

— Colvin. Sidney Colvin to Jane B, 13 October 1873: Bain.

— Isabella's donation. Isabella gave 26 works (45 vols) from TB's library to NHSN in
August 1881. See 'Library', *BS* 55, and June Holmes 'A New Bewick Manuscript',
CT 3, np.8 (Christmas 1999).

— Reputation at its height. The five vol. *Memorial Edition* was published by Quaritch
1885–7, including the *Memoir*, edited by Austin Dobson.

— 'no drawing as subtle'. John Ruskin, *Ariadne Florentina* (Lectures of 1872, pub.
1876), 1890 cd. 86, 88, 247; and on plumage, *Elements of Drawing* (1892) Appendix
344. Ruskin's annotated *Birds* is in Sheffield City Library.

401 'except to my children'. Samuel Lucas to Alfred Ellis, 19 August 1858: Graham
Carlisle.

— Ravilious. Walter Chamberlain, *Manual of Wood Engraving* (1978), 64.

— 'Surely, I thought'. Gwen Raverat, *Period Piece: A Cambridge Childhood* (1954) 105.

402 'Ginia most affectionate'. Leslie Stephen to Julia Stephen, 10 October 1883, *Selected
Letters of Leslie Stephen*, ed. John W Bicknell, (1996) II, 305. With thanks to
Hermione Lee.

LIST OF ILLUSTRATIONS

ILLUSTRATIONS IN THE TEXT

All the illustrations and vignettes are by Bewick, and are taken from *Quadrupeds*, 1790, *Land Birds*, 1790, *Water Birds*, 1804, *The Fables of Aesop*, 1818, or from proofs in the Pease collection and British Museum. The following are the exceptions:

LIST OF ILLUSTRATIONS

441

Picture credits:
The author and publishers are grateful to the following for permission to reproduce illustrations. Iain Bain, colour 8, 19, 23, 33, in text 5, 76, 379; The Bewick Society, in text 334; Trustees of the Bodleian Library, Oxford, in text 144,149; British Museum, Department of Prints and Drawings, colour 10, 13, 16, 25b, 26, in text 49, 59, 126; Laing Art Gallery, Newcastle, colour 1, 3, 4, 7, 24; The Natural History Society of Northumberland, colour 2, 11, 12, 14, 15, 20, 21, 25a, 29, 30, 31, 32, in text 6, 278; Newcastle Libraries and Art Galleries (Pease Collection) and Tynebridge Publishing, colour 17, 18, 20, 22, 28, in text 42, 169, 203, 237, 280, 323, 380, 439; Robinson Library Special Collections, University of Newcastle, in text 73.

INDEX

Figures in *italics* indicate captions.
'TB' indicates Thomas Bewick.

Thomas Bewick

his *Mark*